The Life of a Painter

The Life of a Painter

THE AUTOBIOGRAPHY OF GINO SEVERINI

Translated by Jennifer Franchina

PRINCETON UNIVERSITY PRESS

PRINCETON, NEW JERSEY

Originally published in Italian under the title *La Vita di un Pittore*, copyright ©
Giangiacomo Feltrinelli Editore, 1983

Library of Congress Cataloging-in-Publication Data

Severini, Gino, 1883–1966.
 [Tutta vita di un pittore. English]
 The life of a painter : the autobiography of Gino Severini /
translated by Jennifer Franchina.
 p. cm.
 Includes index.
 ISBN 0-691-04419-8 (cl)
 1. Severini, Gino, 1883—1966. 2. Painters—Italy—Biography.
I. Title.
ND623.S45A2 1995
759.5—dc20 95-22065
[B] CIP

This book has been composed in Linotronic Sabon

Princeton University Press books are printed on acid-free paper
and meet the guidelines for permanence and durability of the
Committee on Production Guidelines for Book Longevity of the
Council on Library Resources

Printed in the United States of America by
Princeton Academic Press, Lawrenceville, New Jersey

10 9 8 7 6 5 4 3 2 1

Contents

Introduction

GINO SEVERINI begins *The Life of a Painter* with a moving description of Cortona, the city where he was born. He identifies himself with the toughness and independent spirit of its rugged inhabitants, and it is exactly this toughness and independence that is revealed again and again in the story of his life—a life shadowed by financial struggle, illness, and loss, but constantly directed by his continuing spiritual quest.

Severini's straightforward account of his early years tells of the poverty and determination of his family. Woven into it, however, is a chronicle of joy, discovery, and his youthful love of the arts. Severini acknowledges that he drew "a bit better than my schoolmates," but his real interests lay in acting and theatrical design. His childhood memory of a destitute commedia dell'arte touring company, transformed by his imagination into glamorous figures, was to flower in the early 1920s in many drawings and paintings of commedia dell'arte characters.

Severini writes that he lost all enthusiasm for scholarly achievement because of his early expulsion from school, but this is surely not the case. He continued to draw, to experiment with paint, and to read constantly, probing philosophy and social history and laying a strong foundation for his own later theoretical writings.

Severini's mother sensed that his gifts could not be developed in Cortona, and in 1899 she accompanied him to Rome. This was a courageous move. Severini was not yet sixteen years old and they soon found themselves unable to live on his mother's earnings as a dressmaker. Severini found work that kept him busy for long hours and left him little time for drawing lessons. When his mother was obliged to return to her family, Severini was left to find his own way in that magical city. He made friends with ease, and grasped every opportunity to draw and paint.

Severini met Umberto Boccioni some time in 1900 and Boccioni was to remain an important influence in his life. The two young men immediately liked and respected each other and soon became partners in discovering an exhilarating world of art and ideas. Later, when Severini had developed a group of friends in Paris, he felt a growing irritation at Boccioni's Futurist gusto, but such feelings were always tempered by a strong

loyalty to his friend. When Boccioni came to Paris in 1913 to work on his sculpture exhibition their friendship was rekindled and they enjoyed an almost euphoric exchange of ideas. Severini's grief at Boccioni's early death in 1916 was deeply felt. They had spent a vital part of their youth together.

Giacomo Balla also played an important role in Severini's early life in Rome. Slightly older than Severini and Boccioni, he became informally the teacher of the two young friends. When they met he had just returned from Paris full of news about French art, particularly Impressionism. Yet, according to Severini, the technique he taught them was "divisionism." Throughout his book Severini uses such terms with little explanation, but it must be remembered that in the first years of this century important avant-garde art movements were still in a formative stage.

The new color theories of the early twentieth century, whether Italian or French, go back to the basic concepts put forward by Michel Eugéne Chevreul in his seminal work of 1839, *On the Law of Simultaneous Contrast of Colors*. They were elaborated and expanded in the developing studies of optics and the physics of light by Helmholtz, Maxwell, Rood, and many others. Their discoveries revealed that opposite hues placed close together intensify each other, and that extremes of value (black and white) have a similar effect. They also observed that small dots of paint of equal size but different hue would appear to merge at certain distances and under certain conditions of light. French color studies culminated in Paul Signac's *From Delacroix to Neo-Impressionism* of 1899 which explains Seurat's working methods and traces the history and theory of "Neo-Impressionism," thus establishing a label for the new movement. Severini's admiration for Seurat, however, was based not only on what was understood to be scientific physical phenomena of color and light, but also on the stately and controlled effects Seurat achieved in composition as well — effects that Severini emulated and tried to assimilate into his own works.

Italian art had its own powerful spokesman, Gaetano Previati, a painter and writer, who published two important works on painting practice and color theory, *La tecnica della pittura*, in 1905, and *I Principii scientifici del divisionismo* in 1906. Again the title of an influential book confirmed the name of the school, Divisionism, which flourished in Italy at the turn of the century. (The word "division" was also used in France and Italy for the breaking-up or dividing of white light into spectral hues.) In February 1910, as the Futurist artists were forming their group, Previati's colorful and light-filled paintings were on display at the

Società per le Belle Arti in Milan. It is significant that the *Manifesto of the Futurist Painters* signed by Balla, Boccioni, Carrà, Russolo, and Severini, and published while the exhibition was on view, should have mentioned favorably only three artists, the sculptor Medardo Rosso (whom Severini respectfully describes elsewhere in his story), Giovanni Segantini (a noted Divisionist painter), and the writer and painter Gaetano Previati.[1] A second manifesto by the same group of writers, *Futurist Painting: Technical Manifesto*, appeared only two months later in April. It states that "painting cannot exist today without Divisionism," and coins the term "innate complementariness" as a necessity for this method.[2] While Previati's writings provide extensive scientific information about color theory, they also encourage the expressive use of color. The aim of the Divisionists was not necessarily to make individual hues appear to merge (although this happens in many instances). They did not follow Seurat's use of finely calibrated dots and their brush marks do not establish a consistent surface, but vary in size and shape to reflect the texture of the objects painted or to create directional compositional forces. Such surface textures and precisions of color are difficult to see in reproductions, and this is probably why the differences between the two movements are generally so little understood. With its stress on sensation and expression Italian Divisionism was, indeed, the appropriate starting point for Futurist aspirations to capture and express the sensations of modern life.

Throughout *The Life of a Painter* Severini returns again and again to questions concerning the function of color. The first instance is a memory from his childhood where he describes meeting a young woman painter in Radicofani one summer who encouraged him and showed him her works. "I . . . was dumbfounded. . . . She painted in spots of color that harmonized when seen at a distance." Indeed, she may have introduced Severini to Seurat's ideas without his understanding that to be the case. In Rome with Boccioni a few years later, Severini states that Balla "introduced us to the modern technique of 'divisionism' without, however, teaching us its fundamental and scientific rules." By 1912, when the Futurists' major exhibition was on view in Paris, Severini remembered proudly that Apollinaire thought his *Pan Pan at the Monico* (fig. 18) the most important work painted by a Futurist: "Movement is well rendered in this canvas, and since no optical fusion of colors occurs, everything is in motion as the

[1] *Futurist Manifestos*, ed. Umbro Apollonio (New York: The Viking Press, 1973), 26.
[2] Ibid., 29

artist wished."[3] "No optical fusion . . . occurs" seems here to be a contradiction of Neo-Impressionist theory and Seurat's practice, but painters know that color effects depend on many variables. Apollinaire, as an astute critic, was commenting on the effects of colors on each other when they are not broken up or divided into dots of regular size and character. This intuitive understanding becomes an issue when Severini discovers Matisse, who explains to him, sincerely and cordially, his reasons for changing a color area from red to green. Over time Severini shifted his position from a commitment to scientific color theory to "a method of reasoning and discussion intrinsic to painters."[4]

This change can be seen in examples of Severini's own work. The Futurists believed that they could capture the energies inherent in objects through the effects produced by the division of light. In 1913 and early 1914 Severini carried this idea almost to complete abstraction, appearing to dissolve objects into energy particles of the prismatic colors that together constitute white light. He did this in his pictures titled *Sea=Dancer*, and more completely in a series of works, *Spherical Expansion of Light* (fig. 34). By 1916, for a number of reasons, Severini felt the need to reconstitute the tangible object, and he had begun to use colored pigment in large areas of resonating hues. As if announcing his shift away from the intentions of his energy-filled Futurist pictures he called one of his still-life paintings of that year *Centrifugal Expansion of Colors*—not an expansion of "light" but of paint.

This long aside on color has led us away from Severini's account of his stay in Rome—his description of an Italian artistic life parallel to that of Bohemian Paris, his widening circle of friends, and daily opportunities to talk of art and literature. Nevertheless Severini was still not earning his way. Rome was at that time a small, provincial city, and Severini yearned to be in the center of the art world to seek his fortune and fame. He left Rome and arrived in Paris in October 1906.

Severini now entered a new phase. He still suffered from constant poverty and periodic illness, but he enjoyed a new circle of friends and the vibrant life of the city of Paris. He lived with a special kind of exuberance, dancing the night away in Paris night-spots, learning to fly an airplane, and meeting the great figures in art and literature. He began to focus his youthful intellectual appetite and to explore writers such as Mallarmé,

[3] *L'Intransigéant*, 7 February 1912. *Apollinaire on Art: Essays and Reviews 1908–1918* (New York: Da Capo Press, 1972), 200.
[4] See below, p. 170.

Bergson, and Romains, who were more relevant to his concerns. He was enormously proud of the Bernheim-Jeune exhibition that introduced Futurism to Paris in 1912, yet greatly embarrassed by Futurist rhetoric. He struggled with the texts of the two manifestos which he had signed but could not entirely accept. He rightfully feared that the true tenets of Futurism would be misunderstood, that the Futurists would be judged by their performances and not their art, and that his own position in French circles would be compromised by the Futurists aggressive stance.

That a Futurist exhibition was held in the prestigious Bernheim-Jeune Gallery has been treated as a curiosity, but there were good reasons at the time. Soon after Severini arrived in Paris, his neighbor, Lugné-Poë, had introduced him to Félix Fénéon, a critic and major writer on Neo-Impressionism and related movements. In November 1906, the Bernheim brothers agreed to let Fénéon run the section of their gallery devoted to contemporary art on a trial basis. It had an entrance through a side door, and therefore a different address. Fénéon made it a commercial success, building up an international clientele and also forming a center for artists and writers. What better place to show the works of the young Futurists, all of whom had begun their careers with a commitment to Divisionist color.

Like most autobiographies *The Life of a Painter* was written long after the events it describes and, not surprisingly, Severini sometimes errs on specific dates or sequences. However it fully and fairly describes the key moments in the artist's life up to 1924. Severini seems to have worked like a professional scholar, using contemporary published reports and even his own letters as sources of dependable information. There is an interesting exception to this pattern. Severini devotes no more than a page to a situation that distressed him for almost a year.[5] Severini had written an interesting essay for the catalogue of his exhibition in London in 1913 and as a result, Marinetti had asked him to write a manifesto, "but the idea never appealed to me, and I felt it contrary to my nature." Nevertheless, as a Futurist, he felt obliged to try. "However I did not have a gift for spontaneously forcing ideas. . . . So I left the question in mid-air and, today, am very glad not to have that 'special' literature on my conscience." With these few defensive words Severini brushed aside a struggle that lasted from October 1913 to the following August 1914, during which Severini drafted one version after another that were repeatedly rejected by Marinetti. Many letters from this period tell of his anger and pain. (In the Marinetti Papers at Yale University alone there are more than twenty letters that mention the

[5]See below, pp. 138–39.

manifesto, before Severini abandoned hopes for its publication. Severini's text was not published until 1957.) When it no longer mattered he ceased to look back on this unproductive event. His passing mention of it is an example of the resilience with which he overcame difficulties and moved ahead to more important tasks.

During the months when Severini struggled to express his ideas in writing, he also produced his "plastic analogies," a particularly beautiful group of paintings devoted to the study of sensory experience. Just as color contrasts could be used to intensify chromatic effects, disparate places and things could be depicted together to stress their expressive oppositions. While this focus on light captures the vitality of matter, it also consumes objects in energy and Severini felt a growing need to address the problems of the representation of tangible objects. It was not long before he began to reinvest the object with its traditional solidity and stasis and to enrich his theory with sets of opposing thoughts, characterized by his new slogan "Ingres plus Delacroix" or "form and color."

Severini began to explore concerns outside the doctrines laid down by Futurist writings, and, at the same time, he began to separate himself from the control of the Futurist *governo centrale* in Milan. In 1913, he was invited to take part in the Armory Show in New York. He agreed provided that other Futurists were included in the invitation, but after much discussion they decided not to participate. Out of loyalty to the group Severini also refused, but not without feeling that he had made a career mistake. Shortly afterward, when he was offered a one-man show in London he accepted without consulting his colleagues. This was a significant liberation from the demands of the Futurist circle, and it was consistent with his need to break with Futurist doctrine and to find a position of his own.

Severini and his wife were in Italy in August 1914 when war broke out and they immediately returned to family and friends in Paris. When Italy joined forces with the French in May 1915, several Futurists enlisted, but Severini was prevented from doing so by his persistent lung disease. However, Marinetti made it clear to all Futurists that they could serve the cause by redirecting their art to war subjects. He wrote to Severini, "Try to live the war pictorially, studying it in all its marvelous mechanical forms (military trains, fortifications, wounded men, ambulances, hospitals, parades, etc.)."[6]

[6]20 November 1914, Maria Drudi Gambillo and Teresa Fiori, eds., Archivi del Futurismo, 2 vols., Rome: De Luca Editore, vol. 1, 1958; Vol. 2, 1962, I, 349–50.

This directive coincided with Severini's new ideas about representation. He returned to nature—that is, to the views outside his studio window of trains carrying war supplies and the war wounded. "Although my inspiration derived from those objects that passed before my eyes, these became more and more synthetic and symbolic, to the point of becoming, in my paintings made the following winter, true 'symbols of war.'"[7]

Although war-time conditions in Paris were difficult, Severini soon felt that he had enough new work for an exhibition. The First Futurist Exhibition of the Plastic Art of War and of Other Earlier Works opened at the Boutet de Monvel Gallery in January 1916. Several of the war pictures included displayed a radically new approach. Two works of 1915 are entitled *Plastic Synthesis of the Idea "War"* and are comprised of elements taken from recognizable objects, or symbols for those objects (fig. 36). This combination of images harks back to *Souvenir de voyage* of 1911 where the tumbling forms of disconnected objects arouse memories of travel. There is a major difference, however. The later works are governed by strong compositional order and selectivity, and point to Severini's new /resolve to balance luminosity and solid form. More confidant about his developing new theories, Severini wrote two articles for *Mercure de France*, one in 1916 another in 1917 where he discusses "division of form" with the interpenetration of planes, as well as "division of color."

In 1915 the Panama Pacific Exposition in San Francisco included a room of Futurist works which had been shown in London the previous year. Unfortunately this exhibition was not in the main pavilion of Fine Arts but in the Annex . It received no publicity and little critical comment and essentially remained invisible. The opposite was true of *Drawings, Pastels, Watercolors, and Oils of Severini*, which opened at Alfred Stieglitz's "291" gallery in New York in March 1917. This exhibition was organized with the active assistance of Walter Pach and Marius de Zayas. It included twenty-five works, several of them more Cubist than Futurist. As might be expected, the exhibition received mixed criticism. However, it was Severini's first financial success: John Quinn bought ten of the twenty-five works, and the last words of Part 1 of *The Life of a Painter* describe Severini's joy at receiving a check from America with another to follow. Because of the war it was not possible for the remaining works to be shipped back to France, and Severini asked Stieglitz to care for them and show them when possible. They remained in Stieglitz's collection un-

[7]See below, p. 156.

til his death when his widow, Georgia O'Keeffe, donated them to several American institutions. They still represent the core of Futurist works in the United States.

The new drawings and paintings in the "291" exhibition predicted new directions for Severini. Several combine planar Cubist compositions with extremely intense areas of color. Then in 1916, Severini painted two studies of his wife, *Maternity* and *Portrait of Jeanne*, both totally unlike his other works to date. They derive from realistic drawings and are resolved in a classical mode that anticipated the "return to order" in French art a few years later. This singular style was not repeated, and for the remainder of the decade Severini explored still-life compositions with his eyes on the works of Gris and Picasso as he sought his own more volumetric style.

About this time, Juan Gris brought the dealer Léonce Rosenberg to Severini's studio, who liked what he saw and in 1919 signed Severini to a contract with his gallery, L'Effort Moderne. Finally Severini was to have a secure income to meet his daily needs. A prolific worker, Severini published in 1921 *Du cubisme au classicisme,* his major theoretical compendium, rich with discussions of mathematical systems, numbers, and proportion. Color was considered but it was now to be dominated and contained by form.

In the same year Severini's work took another new direction with the first of his decorative projects, a commission to paint frescoes in a room of the Castello di Montegufoni near Florence. Severini credits his ability to do frescoes, a technique he was never taught, to the fact that he had helped his father with construction work as a young man, and, he explained, he followed the rules of Cennino Cennini. As so often with Severini, ordinary experience is transformed by ambition and imagination. The owner of the castle, Sir George Sitwell, was father of the famous writers, Edith, Osbert, and Sacheverell Sitwell, and a client of Léonce Rosenberg who warmly recommended Severini to him. They easily agreed on the subject of the commedia dell'arte, in a joyous combination of still life, landscape, and music-playing Pulcinellas and Harlequins, "a subject that allowed me to keep within the realm of humanism and abstraction, between fantasy and reality."

Toward the end of *The Life of a Painter* Severini comments on artistic life in Paris after the war with its new journals and art movements like Dada, Surrealism, Purism, and Constructivism. The autobiography ends in 1924, nearly a half century before Severini's death. After a period of rewriting and editing of several versions of the manuscript, the first part,

Tutta la Vita di un pittore, was published in 1946. The second part, *Tempo de "L'Effort moderne"* published in 1968, did not appear during Severini's lifetime.

In the decade from 1924 to 1935 Severini had a variety of commissions for fresco and mosaic decorations in churches and public buildings. Paris was still his home and there he was part of a circle of Italian artists. In 1935 he returned to Italy and then moved back to Paris again in 1946. He continued to be enormously productive, working in his own adaptations of both Cubist and figurative styles. In the 1940s his still-life studies become more animated, often with lines detaching themselves from the objects depicted. This separation of compositional elements led to abstractions where lines become the animating forces that fill these canvases with a new energy. Although they are liberated from figural representation, many of these works still retain suggestive titles of dancers or commedia dell'arte figures. Toward the middle of the decade agitated brush marks recall the surfaces of Severini's first Futurist ventures, and seem at times to reflect Picasso's games with color-dotted areas of the same period. Although Severini returned to an earlier pictorial language, his works of these years display originality and confidence.

A growing interest in Severini's work was marked by a number of events in the 1950s. Rose Fried wrote Severini from her gallery in New York offering an exhibition and begging him for more works to sell. Lydia and Harry Winston were then forming their stupendous collection of Futurist works and bought directly from the artist. Severini's powerful works began to receive international recognition in its most practical forms: exhibitions, prizes, and sales.

Gino Severini died on 26 February 1966 in his studio at 11 rue Schoelcher in Paris. His body was returned to Cortona, the town of his birth. His devoted wife, Jeanne, outlived him by 26 years.

Anne Coffin Hanson
June 27, 1995

The Life of a Painter

ROME-PARIS

Cortona-Paris, via Rome

THE TWO CITIES to which I am most deeply attached are Cortona and Paris: by birth to the first, intellectually and spiritually to the second. It is only natural to feel that instinctive bond that every man, from peasant to intellectual, feels for his birthplace, but, personally, my fondness for that soil runs much deeper.

Cortona is a small Tuscan town of Etruscan origin built on a hillside near the Umbrian border. It is characterized by steep, narrow, roughly paved lanes. There are two beautiful, spacious town squares and a single wide and level main street that, in my days, was called the "Rugapiana" or "flat wrinkle." There are also a number of convents. The inhabitants are notoriously rugged, fiercely proud, and independent. Among Cortona's most illustrious natives are Luca Signorelli, Pietro Berrettini [called Pietro da Cortona], and Saint Margaret.

I feel in myself shades of that same toughness and independent spirit and a bit of that vital juice, that sap, running through my veins. This probably explains my special love for the place.

I attended school in Cortona until I was fifteen when, on the verge of earning my middle (then called technical) school diploma, I was expelled from the entire Italian school system. Together with six classmates, I had stolen the school's final examination. Sneaking into the school through windows we had deliberately left unlatched, we entered the principal's office with a homemade key, thanks to the manual skill of one of my companions, and snatched all the prepared question sheets we could find. I was particularly anxious to get my hands on the mathematics exam, but was only able to find those for French. Expelling our entire group should have been severe enough punishment, but the authorities determining the fate of Italian culture thought otherwise and referred us to the Italian judicial system. We were forced to appear in court in Arezzo, and then, by decree of the King's Attorney General, at the Court of Appeals in Florence. Both benches recognized our tender age as an attenuating factor and, allowing for our youth, refrained from sentencing us penally for our crime. But our formal studies were terminated forever. It seems that many years later, the Minister of the Italian school system (called the Public Instruction Ministry) revoked our expulsions, but I was never notified.

Any enthusiasm I might have had for scholarly achievements had long since vanished by that time.

André Gide remarks about a young character in one of his marvelous books[1] that sometimes a mistake committed in early youth governs the destiny of an entire lifetime. This episode marked the beginning of a particularly dismal phase of my life, and my departure from Cortona seemed more like the "retreat from Russia" than the "triumph of Julius Caesar"!

My parents were away from Cortona during my final year of school and I lived with my paternal grandparents. My grandfather was a master bricklayer and my grandmother, a weaver. Regardless of his age, the old man climbed up and down building scaffolds and ladders in winter and summer, and I followed behind whenever possible. I learned everything about masonry from him. My grandparents were terribly poor. Several years earlier, an entire season of torrential rains had caused the collapse of a number of houses built by my grandfather as contractor. Prior to this calamity, our family of peasant/blue collar workmen had owned several properties near Cortona, where they lived. This accident, however, ruined my grandfather's career, and the family was forced to sell almost all its farmlands to rebuild those damaged houses. He was obliged to find other work in town. Somehow, one little tract of land directly beneath Cortona escaped the fate of the others. I often went there with one or another grandparent and remember those walks as the happiest moments of that time. Sometimes my grandfather would declare, "All this is yours," because he truly adored me. But we lived in utterly miserable conditions. For example, we never enjoyed the merest taste of the good wine made from the vineyards on that soil, for the entire harvest was sold as a means of survival. In its stead, we drank something called *acquerello*, obtained from empty grape skins mixed with water and put back through the winepress. My parents refused to come to my grandparents' aid and my grandmother harbored a permanent grudge toward them.

My maternal grandparents were also in troubled straits. My grandfather had died a couple of years earlier. He had made a comfortable living as a manual laborer; as a blacksmith, his principal occupation had been to forge nails and bolts, and he had been known as the "boltman" around Cortona. These grandparents lived in a pleasant little house of their own on the outskirts of town, near their olive groves. Their street was an extension of Borgo San Domenico, a road leading to the "Contesse" convent. My grandfather's shop was also located there, and I re-

[1] *The Counterfeiters.*

member it perfectly, with its two enormous sets of bellows and many large anvils where the smithies beat red-hot iron, spraying sparks everywhere. The noise still rings in my ears. I was overjoyed when I was allowed to pump the bellows for my grandfather or one of his helpers. That blacksmith grandfather was an infinitely good man, and for this reason his business affairs were in serious disarray at the time of his death. Once the shop was inherited by my uncle, a wild and reckless fellow I am told, things deteriorated even further.

It is true that my father was reluctant to send my grandparents money, but his own state of affairs was certainly far from brilliant. He was living in Manciano at the time, a tiny town in the wilds of the Maremma region of Tuscany. The only schools in town were grade schools. He was employed as a simple steward at the Magistrate's District Court, which is the lowest rung in the whole civil service system, and Manciano offered the most menial of jobs in the category. To add to the bargain, waves of malarial fever were ravaging the area. Such were the conditions where my parents lived with my little sister, who was to die a few years later in Radicofani.

As a youth, my father had studied with the Scolopi priests* and had later clerked for an attorney; his formal education should have qualified him for a much better job. Many of his old schoolmates went on to become high-level bureaucrats; even other stewards, although not particularly ambitious, climbed to much higher positions than his. Conversely, he steadily descended from one second-rate job to the next. Whenever promoted to a higher level, he could not seem to keep his new position for long, somehow managing to slide back to his original place. Yet he in no way lacked intelligence and kindness. As a true-blooded Cortonese, he was independent and unable to conceal his mocking attitude. Either too proud or too humble, he never could get along with his superiors: he would treat them either with exaggerated submission or with insults. Once he actually physically assaulted one of them. I understand his attitude perfectly, for I recognize traces of that same temperament in myself, generally tending to extremes in all things, exaggerating likes and dislikes. This was probably the reason for my father's perpetual employment in the most inferior civil service posts.

I never showed a particular gift for drawing as a student in Cortona.

*A teaching order known for its good schools, many of which are still active and thriving today. The name is a concatenation of "scuole pie" (pious, or religious, schools). The first was founded in the late sixteenth century, free and open to all, the first of their kind in Europe, meant to overcome the prevalent illiteracy.

True, I drew eagerly and correctly,[2] perhaps a bit better than my school-mates, but I was certainly no great discovery. I found subjects that required use of imagination and fantasy, such as composition or history, much more interesting. My favorite activity of all was acting in plays. My comrades and I organized amateur drama clubs, of which I was always the mainstay: I painted sets on sheets of newspaper, directed rehearsals, and, of course, also acted. This enthusiasm had its origins in a comic role I played to great success. A religious group attempting to bring young people together had begun to stage plays under the direction of a praiseworthy young curate blessed with a real talent for acting.

This passion of mine was heightened by the arrival of a touring company of impoverished actors, featuring a Neapolitan Pulcinella. The company was positively seedy and the actors were regarded as little more than mountebanks and acrobats. But to me, those performers were as glamorous as kings. I realize now that, rather coarse and not particularly talented, they exemplified a continuation of the commedia dell'arte tradition. Their semi-improvised plays always revolved around the same characters: Lelio, Columbine, the Doctor, Harlequin, Pulcinella, etc. Pulcinella was always the dominant role and center of attention. These amicable vagabonds deeply influenced me and I will never forget that particular Pulcinella. I never acted again, but much later began to paint Harlequins and Pulcinellas and am still painting them today.

My triumphs on improvised stages did not make my impending departure from Cortona any easier. Everyone in Manciano expected me to arrive with my technical school diploma in hand. Instead, I arrived with a nationwide banishment, and threats of worse to come. My mother's reception was terrible. My father, on the other hand, did not blame me at all; he only said, "You certainly behaved like a damned fool." To keep me busy and away from my mother's reproach, my father taught me to compile his citations, reports, seizures, and trial reports. He also took me with him to serve papers on people. His job, in fact, consisted of compiling and serving those papers. Sometimes the destination was remote, but he would always go on foot, in winter as in summer, through rain, snow, and high winds, or beneath a beating sun. He navigated the countryside along the little paths and shortcuts he knew by heart, sometimes covering thirty miles or more in a single day. He would come home totally exhausted. We would hear him approaching, the sound of his footsteps or walking stick echoing on the ground, and my mother would hurry to toss

[2]In the sense of scholastic proficiency.

some pasta into the soup. We always waited for him before sitting down to eat, even if he arrived at midnight. Then, as his shadow crossed the threshold, with his impossible hat assuming the most bizarre shapes, his chopped-off Tuscan cigar dangling from the corner of his mouth, she would greet him with a string of insults. On those occasions when I accompanied him, we would both be on the receiving end of her outbursts, a fact that amused him immensely.

How often we walked through that countryside together, up and down hills along little paths, crossing streams and woods. My father, who loved to hunt, would sometimes bring his rifle along, turning the occasion into a real treat.

We usually left early in the morning when it was still dark. In one of those little bars that also sell cigarettes, which dotted the countryside, we would order small cups of coffee with accompanying shots of cognac or rum. Then, at about ten o'clock, we would have a quick snack at the first farmhouse along the way. Toward one o'clock—more or less—when we came to another farmhouse, we would have a serious, and always good, meal. He knew all the peasant farmers in his district and was liked by everyone, even by the recipients of his distressing notices. As he knew every article of the legal codes by heart, just as Protestant ministers know all the psalms, he always gave the people good advice about how to dodge their troubles. It was common knowledge, too, that if forced into seizing a sack of wheat or corn, perhaps the very sack that would keep a family from starving during the oncoming winter, he would alert them ahead of time and the sack would mysteriously disappear, so that when he arrived, there would be nothing to seize and he would have to file a report of failure. Those were different times; men were not corrupt. Thus my father, a poor man himself, acted out of comprehension and a sense of human solidarity, two traits of his nature that were stronger than his sense of Law and Justice, whose orders he was employed to execute. It is understandable that such actions and such an outlook were hardly conducive to career promotions. Nevertheless, he was satisfied with his job, happy to trek across the countryside with his rifle, dressed like a bandit, his skin blackened by the sun, and good-natured unless in a momentary fit of rage.

My father was transferred from Manciano to Radicofani, a town even more bleak, if possible, than Manciano. My little sister died there. Her death was the first real sorrow of my life, stamping it indelibly, and causing me suddenly to grow up. It was also in Radicofani that I first thought about drawing and painting. For some reason I possessed an inexpensive

set of watercolors. Perhaps obeying a taste for technical research that would manifest itself later, I mixed those watercolors with a solution of rubber cement, producing the same shiny, brilliant colors as oil paints.

I took my subjects from the widest possible range of reproductions: a Cavalleria rusticana, a detail from Titian's *Assumption of the Virgin*, a picture of Saint Margaret, or the head of a Neapolitan woman—postcards, etchings, or pictures out of magazines—everything was a source and provided ideas. Rarely did I copy anything from nature. It never occurred to me that painting was work; it was all just a game to me.

A young matron, a relative of the town's wealthiest family, arrived in Radicofani for the summer. She retained the same name as her father, Senator Luchini, who played an important role on the Italian political scene, for she had married a cousin who was a captain in the Bersaglieri Army Corps. This kind young woman revealed the meaning of painting to me. She also kindled my hopes of one day becoming a serious painter.

When I learned that she painted, I was so curious that I had to find a way to approach her. I finally paid her a call and was dumbfounded. A former student of a late eighteenth-century painter, she painted in spots of color that harmonized when seen at a distance. Her work showed a fine sense of grace and natural elegance. That is my recollection and how I explain her influence on me. In any case, I could not have had a better source of information. She made me copy several of her own studies and many plaster casts (such as Donatello's *Young Saint John*); thus I began my education in painting, driven by an unfocused idea of becoming, one day, a real painter.

Unfortunately, summer vacation came to an end and my teacher was obliged to return to her home in Florence. From a distance, she encouraged me to continue my pursuits, she sent me models and advised me to move to a big city—an impossible dream for me. Such a fine lady could not possibly conceive of the poverty in which my family lived. Moreover, my mother was delivered of another little girl around that same time. The baby was farmed out to a wet nurse in the countryside nearby. I was desperate, and this prodded my mother to reveal her great courage and sense of initiative. She may not have thought of turning me into a painter, but she certainly realized that I was sacrificing any talent I might have in such a small town. There were no prospects for me there. She knew that the most important step, at that point, was to move me away. One day, whether to try to make something out of me or because she could no longer stand the terrible life with my father, she decided to leave for Rome to work as a seamstress, and to take me with her. She had very good taste

for fashion. Prior to my father's appointment as steward in the civil service, she had been the best dressmaker in Cortona. She had earned so much from her work that we had been able to purchase a little house, left in my father's hands to sell. She had no trouble finding piecework employment in Rome, but did not earn enough to support me and pay for my studies too, so she turned to a real-estate agency to find me employment.

Finding someone to hire me was not an easy task, for I had no school diploma, having failed in the aforementioned fashion. Nevertheless, the agency agreed to hire me at a salary of 15 lire a month. So, thanks to her, I found myself in Rome.

ROME

I was not yet sixteen when I first came face-to-face with the hard facts of life and the responsibilities of a job. Not that I had ever lived in the lap of luxury, but the vagabond period with my father in the country had provided many compensations and distractions. My life in Rome, too, was somewhat nomadic in the beginning, for I was hired to canvas the city all day long in search of empty or furnished rental apartments. I was also expected to wash the windows of the properties and, upon occasion, to write short letters in French. The agency was owned by a man from Milan and his sister, and there was also a gracious fourteen- or fifteen-year-old daughter whom I sometimes took to school in the morning. My courageous mother walked each day from one end of Rome to the other to go to work on the Janiculum Hill. She was often employed at the home of the Italian minister Giolitti. She would have her lunch and dinner there too and always found a way to bring something back to me, convinced that my own meals were anything but sumptuous. In fact, they never cost me more than 4 or 5 soldi, and when I had any extra change to spare, I would use it to buy brushes. We were living in a dark little room which could only be reached by crossing through another room rented to other tenants. Once in our room, we could not leave it again until the following morning. Naturally, the idea of painting there was out of the question. In order to improve our situation, I started looking for another job with a higher salary. I finally found placement as a bookkeeper for a German pipe manufacturer. I spent all day, every day, over enormous account books and made so many mistakes that, had I not decided to quit, the German would surely have murdered me in good time. I found another job in a large international shipping company, where I earned 50 lire a

month. During that period, my ideas about becoming a painter had taken shape and I was determined to achieve them.

My mother was obliged to return to my father. His life had become totally disorganized without her. They also had to retrieve my little sister from the wet nurse. Having never received payment for its services, this peasant family no longer wanted to board her. I stayed on in Rome, by myself, and spent my time studying at night or early in the morning. There was a night school called the "Incurabili" which offered drawing classes. I attended these during the winter and made many friends. In the summer, I would go to the Pincio Hill, early in the morning or else in the evening, and sketch beneath a streetlamp. I made perspective drawings of the trees, streetlamps, and houses, all bathed in the shadows and lights of the night hours (fig. 4). Meanwhile, my circle of friends was growing, but I still lived in hapless conditions. I had rented the corner nook of a kitchen in via Sardegna as sleeping quarters, where a couch and a table just fit next to the window. I met a Russian lady in that house, an enthusiastic convert to theosophy. Hoping to redirect my attention to that sort of philosophical religion, she presented me with my first box of paints as a gift, long an object of aspiration. She also introduced me to a young painter recently graduated from the Fine Arts Academy, who was vegetating in a charming little studio right in the center of Rome. He was not lacking in talent as a painter, but was far from admitting that any kind of painting other than the sort he had learned at his academy could exist. His name was Arnaldo Lancia, and he was a melancholic soul, always dissatisfied. He chronically alluded to the profession of painter by its least appealing aspects, hoping to dissuade me from my goal, but never succeeded in doing so. I wonder where all that courage and hope of mine came from? It was probably the result of naivete. At that point I was not asking myself whether or not I had any talent, or anything else for that matter. I liked to draw and paint and, to my mind, that sufficed.

Around the same time I began to acquire a new moral awareness, perhaps from the company I was keeping, or from endless discussions with my friends, or from my selection of reading material, or maybe just because I was going through a natural maturing process. An intelligent young Neapolitan by the name of Mosone Pietrosalvo frequently came to our gatherings before finally moving to New York. He was naturally inclined to social activism, which may have interested him even more than painting, as is the case with many of today's artists. A pensive man, well-read, and a good observer, he made my friend Boccioni and me read books and pamphlets by Karl Marx, Bakunin, Engels, Labriola, while

other friends introduced me to the works of Schopenhauer, Hegel, Proudhon, and Nietzsche. I later went on to read other philosophers and many of the Russian novelists, such as Tolstoy, Dostoievsky, and Gorky. All this plunged me into the current milieu of the time. "The dominant ideas of the turn of the century were those based, as a result of the latest scientific and the positivistic philosophic progress of Auguste Comte and Spencer, on the most absolute sort of materialism."[3] As for the relationship between the artist and society, I must confess that it was of little interest to any of us. Nevertheless, the general Marxist principle according to which "man is the product of his environment" forced us to accept at least the influence of politics if not actually spurring us to its formal study. Socialist and communist politics were becoming seriously influential. It must be remembered that we were living in times of social unrest, vindication of rights and class struggles, and strikes quelled by violent acts of repression. We were very concerned with such things, applying the enthusiasm typical of youth with our desires for "social justice," a deep sentimental attachment to the oppressed, and the animosity toward tyrants that normally characterizes young people.

In spite of all this, the notion of a "social art" never entered our minds. It is obvious that artistic activity can become "social art" only for certain cultural reasons and certain historical conditions, and not because someone decides it is so. Even the French Impressionists worked, I imagine, without pre-established subjects and predetermined results; and it was a logical development of history that they came to be the artists of the "French revolution."

These things are clear to me now, after years and years of experience, but back then, despite all the discussions and texts we were reading, a broad range of clashing ideologies and aspirations were feuding in our souls. How, for example, could we reconcile Engels' or Marx' materialism with our enthusiasm for masterworks of the past, all inspired by contrasting spiritual principles?

It must also be said that we made a serious and committed effort to clarify those principles, in order to get to the bottom of those ideologies. It is my impression that today's youth, in general, is more apt to accept everything with a generosity of heart and soul that, beyond certain limits and in certain circumstances, could well be called superficial. We, on the contrary, labored diligently to capture the philosophical grounds of

[3]Gino Severini, *Ragionamenti sulle Arti Figurative* (Milano: Hoepli Editore, 1936), ch. 16.

those ideologies that most interested us, rather than looking at their effects upon society. This marked the beginning of a school of *autodidattismo*, the consequences of which were numerous and varied. Self-education is a double-edged weapon: on the positive side is the fact that anyone can enrich himself by knowledge that he considers useful for himself (an excellent thing for artists, for example); on the negative side is the threat of becoming mired in a state of futility when failing to grasp desired ideas. All sorts of mistakes and misunderstandings and confusion can arise, and did.

Luckily for artists, "virtù d'arte" [natural talent], when authentic, resides in the depths of one's being where upheavals caused by the ego are not felt, and therefore, creative forces sometimes appear in an artist which generate works of art that are surprising, not only for their beauty, but because they reflect an ideology opposite to that professed by the artist himself. An artist can, in a work, be in contradiction with himself without damaging the work itself. According to Jacques Maritain, the artist can be great even if his system is false and "he can create Beauty in spite of this system and despite the inferiority of that form of art in which it is found."

I must have been about eighteen at that time. My mother wanted to return to Rome as she did not entirely trust me. She had hoped to find me just as she had left me, but I had changed noticeably. My moral and religious attitudes (I was then a complete atheist) and my revolutionary ideas caused her untold amounts of worry and distress.

MEETING BOCCIONI

By that time I had met several young men in Rome who aspired to become painters. Among them was Basilici, a handsome, robust youth who was always jovial and self-satisfied. One evening in 1900, I think, he introduced me to Boccioni during one of those lovely musical evenings on the Pincio Hill.

We took to one another instantly. We apparently shared many of the same opinions—above all, our enthusiasm for Nietzsche. Before leaving, he asked me: "What are your plans for tomorrow?" The next day was a Sunday and I did not have to go to the office to work. "I'm going to the country to paint the Nomentana Bridge," I replied. "If you will allow me, I would like to come too," he responded. So, we met at six o'clock in the morning at the Porta Pia gate. I was carrying the box of paints that the

Russian lady had given me and was very proud and protective of it. Just holding it in my hand made me feel like a real painter. Boccioni arrived instead with an enormous portfolio, stuffed with the drawings he wanted to show me. He stared at my box with envy and curiosity, all the more so as he had never seen one like it, up close. He even confessed openly that he had never touched either brushes or paints.

On our way to the bridge from Porta Pia, he told me that he lived with his father in his uncle's house. He also said that his father, encouraging his desire to become an artist, sent him for drawing lessons to one of those billboard painters* who, at the turn of the century, had defiled the walls of the city. This pseudo-painter made him copy his horrible posters, and those copies were the drawings, one worse than the next, that he had brought along to show me.

"What do you think of them?" my new friend asked me with certain qualms. To be honest, my own ideas about what was beautiful or ugly were hardly precise, nor did I know what was necessary to develop one's own personality. I proceeded haphazardly, relying on my intuition. Luckily, my instincts alert me to trouble, and let me immediately recognize intelligence or stupidity. Besides, it did not require any particular preparation or aptitude to see that he was on the wrong track, so I replied quite frankly, "I think you're wasting your time." Then, recalling Mrs. Luchini's and Mr. Lancia's advice, I said, "Go out and work from real life if you want to do some good serious work."

My advice seemed reasonable to him and was immediately accepted. While strolling along in the pale summer morning light, Boccioni, between thoughts and under his breath, would sing short Neapolitan songs or bits and pieces of operas. He had neither a good singing voice nor any special musical aptitude, but a fine, sensitive ear. So, the arias were correctly suggested and the songs sung with great sentimentality. His sentimental side was one of the important traits of his personality.

When we finally reached the bridge, he sat down next to me, on a bit of Roman ruin almost in the middle of the river, pulled out a sheet of paper and started to sketch the bridge. I, instead, started to mix my poor paints frantically, making the results unlike the colors I was trying to produce. From time to time I glanced over at Boccioni's sheet, but his drawing was always at the same point. He had done it and redone it at least twenty times, and yet never managed to make the whole bridge fit onto his sheet

*A painter named Mataloni who specialized in advertising posters. See Ester Coen, *Boccioni* (New York: Metropolitan Museum of Art, 1988), 209.

of paper. The problem was that he would start on the far left side, then detail by detail proceed to the right until he ran off the paper. Once at the edge, he would realize that he had sketched only half the bridge. My poor friend huffed and puffed, sweat poured down his brow, he turned red with rage, and then, finally, called out to me, "Tell me, how did you make it all fit onto that board?"

Bolstered by Mr. Lancia's advice, I revealed the "secret" of squaring off space, fitting the subject in properly, and finally adding the details. I now know that it is possible to draw as Boccioni did, and that everything depends on the capabilities of the draftsman and his intrinsic talent. But at that time, my master's advice was gospel. In truth, my advice seemed miraculous to Boccioni, who was actually overwhelmed by the vastness of my knowledge. For some reason, however, neither he nor I had any desire to work that morning. He suggested taking a swim in the Aniene River and I agreed. After our swim, we went to a tavern nearby to eat some bread and salami, and spent the rest of the day wandering around the Roman countryside, telling each other our personal histories and dreams for the future.

After this first encounter, we became fast friends, and for many years there were no secrets between us. Meanwhile, my altogether uninteresting job was becoming steadily more intolerable. On the other hand, my evening or early morning travails beneath streetlamps were tiring me and not producing any notable progress or results. I was desperate and tormented my wits to discover some means of dedicating my life entirely to art, when somehow, a wonderful idea came to me. Monsignor Passerini, an aristocratic prelate, was currently living in Rome. He was a member of the oldest and most illustrious family of Cortonese nobility, private secretary to the pope, patriarch of Antioch, with a promising future as cardinal— an altogether important figure. Also, he was a good, charitable man, and especially pertinent was the fact that he was always ready to help Cortona natives. I decided to write him a letter right away, asking for his support. My letter must have been quite expressive and unique, for, as I later learned, it made a great impression on the poor monsignor. After checking my credentials, he invited me to visit him. This first meeting was not particularly favorable. He made it clear that he lacked faith in me as a prospect.

"You were expelled from all the schools in the kingdom," he said, "you have been to court twice, and are not even twenty years old. Furthermore, on Sundays, instead of attending Mass, you go on trips to the country."

I had no ready answer, but tried to defend myself, and evidently did it

well, or perhaps fate had already decided in my favor, for a few days later
he sent for me again and asked, without much respect:

"What are you earning at the shipping office?"

"Fifty lire a month," I replied.

"All right. I'll give you 50 lire a month for a year. That should be time
enough to see if you have any talent."

Had he been Saint Peter, I would have kissed his feet for the infinite joy
his words provoked. From that very moment, I became optimistic about
my artistic career. My little monthly pension was accorded for a second
year, at the end of the first, but after that the monsignor wanted nothing
more to do with me, as he disapproved of my approach to studying.

In fact, the idea of attending the academy for regular painting lessons
never even occurred to me. Instead, I had enrolled in the free school for
nude studies,* and attended it especially when bad weather kept me from
going into the Roman countryside. I signed up for an anatomy course, but
after the first lesson spent drawing a dead man's head, half of which was
skinless, I was overcome with such disgust that I never wanted to go back.

Besides, I could not understand the purpose of such classes. Later I was
to realize how normal and correct my instinctive repulsion had been, and
how such teaching methods, as well as everything else that came from the
academies, are not only useless, but stupid as well. It is not the muscles of
a dead body that interest an artist but those of a living one, and his
knowledge of anatomy is shaped by observing nature and by working on
the basis of those observations, as certain Greeks had done. In short, each
artist must reinvent anatomy for himself. I also attended a sort of private
academy, where I was admitted without having to pay the normal fees
and as a student without mandatory class attendance. I owed this favor to
its director, Fernand Sabatté, a retired member of the Academy of France
whose fine intelligence was evident in his methods and in the calm work
environment he created. Moreover, the academy was attended by rich
men and women students from England and America, to whom I was
able to sell an occasional landscape.

My monsignor did not approve of this type of study program. I under-
stand his attitude perfectly. When he finally asked me to do his portrait
and the result was a sort of fireworks display of reds, greens, blues, and
yellows, that sliver of hope that he felt for me completely vanished. Per-
haps he was right when he said: "I absolutely do not understand your
lack of order."

*An annex of the Rome Fine Arts Institute.

In the meantime, Boccioni, who could sniff out anyone with talent, had discovered Giacomo Balla, just back from Paris and brimming with the theories of Impressionism. Balla, who became our master, introduced us to the modern technique of "Divisionism" without, however, teaching us its fundamental and scientific rules. He was an absolutely serious man, profound, reflective, and a "painter" in the broadest sense of the word. On the model of the French painters, he loved only nature, to which he looked, even excessively, for all inspiration. Were he to see an old shoe in a landscape, he would undoubtedly include it. In fact, he once did a painting entitled *Fallimento*, which depicted the lower part of a door to a shop closed down for bankruptcy. Those shutters, which no longer opened, were abandoned dirty, and covered with childish stick figures and chalk graffiti, and certainly suggested sorrow and neglect. On one corner of the stone step was a blob of magnificently rendered spit. Independent of the subject and the "realistic" (as it was then called) spirit in which it was expressed, the painting was a beautiful and personal picture. Balla used the French painters' technique of separate and contrasting colors. His pictorial ability was first-rate and genuine, with certain similarities to Pissarro in terms of materials and quintessence. We were extremely fortunate to meet such a man, whose orientation was perhaps decisive to our careers. The state of Italian painting at that time was one of the muddiest and most injurious imaginable; under such conditions, even a Raphael would have had difficulty painting a good picture.

In fact, the few seriously gifted painters such as Segantini, Previati, Morbelli, and some others used Seurat's Divisionism as a technique for rendering naturalistic effects, which could have been achieved even without Divisionism. The only one to use the technique of Divisionistic colors for poetic ends was Pellizza da Volpedo. The great painters of the period, other than those mentioned who were the most interesting, were Morelli, Sartorio, Mentessi, Grosso, Tallone, Tito, Gola, Corcos, Ciardi, Mancini, etc. The latter, who had successfully initiated his career based on 19th-century principles, at that time had abandoned himself to extravagant technical inventions, employed in the service of the most vulgar naturalism imaginable. Concurrently in France, and especially in Paris, continuing the work of Seurat or Cézanne (the Impressionists were not yet far from the sight and mind of most of them), a group of worthy artists were busy painting, preparing the way for the period later called Neo- and Post-Impressionism. These artists were Signac, Cross, Henri Matisse, Marquet, Bonnard, J. Puy, Manguin, Othon Friesz, Rouault, Derain, etc. Renoir was still very much alive.

And in Rome, where life was utterly calm and blissful, Lionne, Inno-centi, Coromaldi, Carlandi, Arturo Noci, and so forth, were thriving. In such a vulgar, banal, and mediocre atmosphere, the stern figure of our Balla plainly stood out from the rest. As a result of his example and as a reaction to such an environment, my works and those of Boccioni became steadily more aggressive and violent. We had both made progress. Our friendship grew closer, and between us there grew a healthy rivalry.

We made friends with some of the other young artists. Besides Mosone Pietrosalvo and Basilici (always busy courting beautiful foreign women), Sironi, Costantini, Vallone (a young Neapolitan whom we met at Villa Glori), Amadio, and such sculptors as Calori and Longo, Ciacelli, and others I have forgotten, were often in our company, but the inseparable key group was comprised of Boccioni, a writer named Collini who lived at home with his family but could come and go exactly as he pleased, and me. We were known as the three musketeers, for we often dressed more or less alike. (In winter we would wear black coats which cost 9.90 lire and blue felt hats like those of French customs officers.)

Collini was a neutral and at the same time an animating element. He took an active and intelligent part in our discussions about painting, de-spite being a writer. However, his enthusiasm was often due to an exces-sive egotism evident in his every word and sometimes provoking violent verbal clashes with us. He would especially exasperate Boccioni. What really made him furious was the rude manner in which Collini would imply that he alone was of the three well-read, while we were no better than illiterates. If, for example, someone were to mention China in a discussion, he would all of a sudden stop the conversation to tell us, "China, you know, is that region of Asia near Japan," and so forth, thereby letting us see that he considered us ignorant enough to think China was located at the North Pole. This and other things sent Boccioni into fits of violent rage, and I would have to act as peacemaker. Neverthe-less, our triumvirate endured.

There was a paint shop on the corner of via del Babuino and via San Giacomo that was one of our favorite meeting places, as the owner, Pep-pino Giosi, was the most jovial and playful of friends. He told us the spiciest stories in an authentic Roman dialect and found a way of joking about everything, even about our bad-luck stories. He would make fun of our berets, our long hair, our unfortunate romantic entanglements, our poverty, but often he would also help us, either with small loans or by giving us canvases and paints on credit. Without his assistance, we never could have painted as we did.

The young sculptor Prini, who was attracting his first serious attention at the time, was the axis around which some very talented young artists gravitated. Among these were Tobaldi, a painter, and the sculptors Felci and Riccardi, the latter a very pensive man of great concentration and therefore very congenial to me. These artists too became our friends. Boccioni had discovered another sculptor, Duilio Cambellotti, an intelligent, reflective man who, like Basilici, was a great admirer of the German painter Otto Greiner, and of the Munich school of painters in general. Greiner had a certain influence over the artists in Rome at that time; he drew, paying great attention to detail, with analytic precision and not without elegance. Under his influence, Boccioni drew a pencil portrait of me that looked, however, more like a portrait by a Tuscan primitive (fig. 5).

We would often go to Riccardi's father's place near Piazza della Regina with Balla and Prini and others. He ran a bakery and we ate snacks in his shop. Another meeting place was at the foundry that cast Prini's work (I later found its owner in Paris). There was a rural inn nearby (in the Tre Madonne neighborhood that was open countryside at the time) with a boccie ball court, and we had endless fun playing this sport. A few of us worked on our projects right there on the premises. Balla painted one of his best works, *Nello Specchio*, which portrays the writer, Max Vanzi, Mrs. Prini, and Balla himself.

Balla began a portrait of Mrs. Prini, but never finished it. Sometimes young women arrived, causing general flirting and entanglements. Often in the evening, we would go in separate groups to one of those typical Roman trattorias, in Trastevere, or Prati, or some downtown Roman neighborhoods. We would sit around a table for hours, drinking a few liters of good Roman Castelli wine while holding endless discussions or singing. We sang Roman *stornelli*—it was just at that time that the famous song *O Sole Mio*, later known world-wide, came out—or *St'uocche ca tiene belli* which Boccioni liked so much.

Strolling musicians wandered through the trattorias, in the old Roman fashion, playing and singing these songs, and we joined in on the choruses. Costantini played the mandolin very well and often we would go with him and his instrument to the Colosseum. In the grandiose solitude of that monument, illuminated by a moon typical of romance novels, the impressive silence would be broken by our devilish antics that were anything but romantic. Songs, music, discussions—the Colosseum was our turf and no one would come to disturb us there. The Manciola coffee bar on via del Gambero was another haunt, where a coffee cost only two soldi. During the last part of my stay in Rome, a young sculptor from the

Romagna region, named Baccarini, became part of our group. He came, I think, from Faenza, and had fled with a beautiful young working-class girl, as she had become pregnant. They were both beautiful: he was tall and thin, with rather long black hair and a Jesus-style beard underneath babyish eyes. She had a marvelous prominent stomach and two perfectly pure blue eyes. She dressed in her simple regional clothes, while he had a wide black cape similar to our own. He was a sculptor and drew wonderfully. Another friend, Raoul De Ferenzona, a tiny, lively, and highly intelligent fellow with a French-style mustache, had convinced him to come. De Ferenzona called himself a Pre-Raphaelite painter and did not care a hoot about Impressionism, etc. He was a Fantasist, and something of a man of letters; Surrealism would have been a perfect school for him. This Roman bohemia unfortunately had no Mürger to chronicle its development, yet it would have been an interesting subject. Not that there was a lack of writers in the group. One of the closest to us, aside from the restless Collini, and just his opposite in temperament, personality, and attitudes, was Alberto Tarchiani, a young man, always bursting with curiosity, a dreamer and a realist at the same time. Nevertheless, he was always sweet-natured, unless he turned stubborn and then showed his mulish iron will; he detested all violence and Collini's exuberance exasperated him. At that point in his life, he was open to all prospects, writing poetry, criticism, or theater. I still have a one-act play of his, among my old papers, *Prima delle Stelle* (1905), with a fraternal dedication and a handwritten sonnet.* One of life's surprises was running into Tarchiani again, fifty years later. After World War II he had been appointed Italian Ambassador to Washington. We owe it to him that Trieste was returned to Italy, even if the conditions of the pact were hardly satisfactory in view of the immovable Allied position. The details of the struggle that he was forced to wage are described in his book, *Dieci Anni tra Roma e Washington.* We met again, roughly nine years ago in Rome, and our joy at finding the same old deep friendship was entirely mutual.

Another writer who often came with us, but not at night because of his fragile health, was the young poet, Sergio Corazzini, an especially good friend of mine. He died a year after my departure from Rome, in 1907 at only twenty-one years of age. I will always remember that kind friend with profound regret for his untimely demise. He was an ex-

*Severini ended this paragraph in the original edition with the sentence: "Who knows how he turned out, which of those talents he developed?" What follows here was added after Severini ran into Tarchiani again.

tremely sensitive poet. He had the same sort of passionate curiosity and deep admiration for the French Symbolist poets, especially for Rimbaud and Laforgue, as we had for the Impressionists. Around 1905–6 he had already published three volumes of verse—*Dolcezza, L'amaro,* and *Le aureole*—that were more than just promising and, as was later acknowledged, were far ahead of their time. His death deeply saddened me.

At that time in Rome, there was an annual exhibition called "Amatori e Cultori" (equivalent to the "Artistes Français" in Paris), where young artists were sometimes asked to contribute small works, and where sometimes their work was refused. In 1904, two works of mine were accepted, one of which was quite important. Boccioni participated with a nice landscape. My more important painting was entitled *Al solco* and depicted a Tuscan peasant plowing a field behind two white oxen, between rows of grapevines and trees turned golden by the sun. I instinctively kept to a sort of loose Impressionism, but it must have been fate or some angel guiding me because I still knew very little about Impressionism at that point. In any case, I received flatteringly good reviews and praise from the artists.

This was the reason that occasioned young Mrs. Prini to invite me to one of her Saturday receptions. This pleased but at the same time embarrassed me as I was rather poorly dressed at the time. Nevertheless I did go, but tried to keep somewhat apart, with my back up against a wall in order to hide the places where I had mended my pants. A young lady, who Mrs. Prini later told me had just finished her studies at a convent school and was attending her first salon, took refuge in the same corner of the room.

So she, out of shyness, and I for a more serious reason, were both interested in staying in that corner. Unfortunately, Mrs. Prini who had not taken her eyes off us, in her lively, gracious, and slightly mischievous way came over to me and, in a perfectly natural tone, said, "Severini, I suppose that you would be happy to do this young woman's portrait." You can imagine how embarrassed she made us both feel. But, undaunted, she proceeded to address the girl's mother who was nearby, "You, Madam, can pay for the paints, the young lady will pose, Severini will do the portrait, and everyone will be happy, all right?" The lady accepted, her daughter as well, and thus I found myself agreeing to do the portrait. Since my expenses were to be reimbursed, I arrived at their house with a good square canvas nearly five feet to a side and began to paint a large portrait from real life of that young girl sitting there, dressed in blue. My

model was patient and gracious and I was happy working, but clearly I had created a terrible problem for myself.

I hoped to resolve this problem chiefly through use of colors, and slapped furious brushstrokes all over the poor canvas, but the results were rather limited. I worked on it for over a month, trying various alternatives, then took it home to the studio to paint it at a distance from my model. Unfortunately, several events intervened and I had not much time to devote to the portrait. The painting was never finished and, with great regret on my part, the poor girl's family had to pay Giosi's large bill for materials without getting anything in return. The painting ended up in an antique shop in Montepulciano where I suppose it still sits.*

Mrs. Prini's Saturday gatherings, to which I eventually brought Boccioni and Collini, were attended by the most prominent young artistic talents of the moment. Zanelli, the sculptor, was there, the one who later made all those horrible sculptures on the monument to Victor Emmanuel, and Maraini, another sculptor who went on to become the general secretary of the Fine Arts Union under Fascism. Prini was just beginning a reasonably successful artistic career. His intelligence, cordiality, easy way of doing things, and an undeniably good heart earned him many friends and general approval. At the time he was employed to give the queen lessons in sculpture. But, one day, in spite of a specific prohibition, he requested a favor on behalf of a friend or acquaintance from the "august sovereign" and was relieved of his duties that very same day. It must be remarked, however, that it was not the queen's fault, for she kept his request a secret. Instead, her very strict guards were to blame.

Many men of letters also came to the Prini's, among whom were the Vanzi brothers, Grita and Schanzer, the brother of a minister, and also the musician/musicologist Gasco, a very agreeable fellow. In short, it was an artistic milieu of a certain importance. But I was never an habitué, being by nature (even when well-dressed) uneasy in salons. Boccioni, on the other hand, was in his element.

The following year (1905), the "Amatori e Cultori" show rejected my work. Although Balla had been on the selection committee, my work was refused altogether. I had submitted six or seven paintings, among which was a large autumn landscape, *Come le Foglie*. Boccioni had submitted five or six and they had chosen only one, a self-portrait, the least interesting of all. The Impressionist vision and credo (with its passionate and violent ways) was maturing both in Boccioni and in myself. Without real-

Ragazza in blu (*The Girl in Blue*), 1904. This painting is now in a private collection in Rome.

izing it, we were edging toward a type of expression not unlike that of Cézanne. Balla would have been the only one to recognize and understand this phase, and to encourage it—which he did—but did not succeed in imposing it. So, together with other painters who had been excluded, we organized the first "Refusal Exhibition," in the lobby of the Teatro Nazionale, which has since disappeared. It goes without saying that the greater part of the works on exhibit there, hence excluded from the grander show, were not very good. So Boccioni and I were able to dominate the situation completely. This was our first important contact with the critics who almost unanimously acclaimed me the revelation of the exhibit. Boccioni, too, was remarkably successful in the press.

This show provided me with my first foreign collector. Monsignor Passerini had long since abandoned me to my own fate, and I was living in dire poverty. The "Refusal Exhibition," in spite of its success, no longer interested anyone and nothing was being sold at all. One day when I was the show's only visitor, two tall foreign-looking gentlemen entered to have a look. They stopped for a long time, several times, in front of my paintings, discussing them in a strange language that I did not recognize. On the wall, hanging among the other works, was a pastel self-portrait (that I later hocked for one hundred francs in Paris to the famous musicologist, Prunières, and from whom I never requested it back). They recognized me from the work and asked me many questions about myself in French—about my intentions as a painter, and explanations of my work, etc. I did my best to answer them in the same language. One was the Dutch painter Van Welie, a famous artist who had been summoned to Rome to do portraits of the pope and of Wagner's son. The other one was a Dutch banker from Bois-le-Duc. They were both interested in me and each of them bought one of my drawings. Later, the banker wrote me from Holland wanting to buy two large canvases (one of which, *Come le Foglie*, was on exhibition at the "Refusals Exhibition," and the other, *Al Solco*, had been accepted the previous year at the official show). Thinking that my material life must be very disorganized, he paid me in small monthly sums, and finally, having received rather unedifying information about my life in Rome, he suggested that I go to Florence to make some copies of the works of art in the Uffizi Gallery.

I left for that lovely city full of courage and good intentions. I made a copy of Botticelli's *Bella Simonetta* right away and sent it to him immediately, but he did not like it. Nevertheless, I undertook a more serious copy, *L'Adorazione della Vergine* by Filippo Lippi, a picture without great plastic qualities, but painted with great mastery. It also contains so much

religious sentiment that even I, as irreligious as I was, was deeply affected by it. My lack of religious belief upset my Dutch patron, for he was a fervent Catholic. He knew that I considered him ridiculous, and that I could hardly bear his interference in my inner life, and we had more than one discussion on the subject.

While working on that copy, I met someone else who would have an important role in my life. When the Uffizi Gallery closed for the night, I generally walked across the Ponte Vecchio to the Pitti Palace and smoked my pipe in its magnificent Boboli Gardens behind the Gallery. One evening a woman, neither young nor beautiful, passed by; she was an elderly member of the French bourgeoisie, dressed in a way that immediately identified her station in life. She asked me for directions to the garden's "Belvedere" and when I saw how difficult it was for her to climb the steps and paths to it, I offered her my arm and my company. This wonderful woman took an interest in me, wanted to know what I did, and came to the Uffizi the following day to look at my copy in its final stages. She told me that were it not committed to someone else, she would have bought it herself. She called on me several times in Florence and, when she left, promised to write me from her home in Lyon. Later I learned that she was the widow of a prominent sculptor in Paris in the "Artistes Français" group, and that she was childless, but with both close and distant relatives.

Meanwhile I had finished my copy. I was about to inform my patron of this when a letter from him arrived saying, more or less, "I came to Florence during one of your very frequent absences from the Gallery and saw your copy which is dreadful. Keep it and never write to me again." I was quite upset, especially since I was utterly penniless. Nevertheless, I realized that he had been right and that my copy was worthless. As I was totally uninterested in that sort of endeavor, I had asked the other copyists to explain the tricks of their trade and, putting these to use, thought that I had made at least a decent replica.

Instead of going to the Gallery, I had spent the greater part of my time on a rather large painting that portrayed my landlord, a fine old man who seemed to have stepped out of a Beato Angelico panel. I put all my best energy into it and perhaps it turned out all right; I do not know what happened to it because before leaving Florence, I wrapped it up and consigned it to shippers by the name of Humbert & Co. and never requested it back from them.*

*Il Padrone di Casa, 1905. The whereabouts of the painting are unknown, but there is a

I was in an extremely embarrassing position in Florence, with that copy
and without a penny to my name. Had it not been for my good-hearted
landlord I would have been in serious trouble, but there always seems to
be some sort of Divine Providence for artists. I decided to write to my
friend from Lyon to suggest that she buy the copy. She accepted my offer
immediately, as a gift for the Augustinian school of Bayeux, in Nor-
mandy, and she sent me, I think, the scanty sum of 100 lire. With that in
my pocket and a small contribution from my parents, I left for Paris
where I arrived one grey, rainy Sunday morning in October 1906.

charcoal and pencil drawing of the same subject in the Severini collection, and Severini has
written on the back of it: "This drawing served for a canvas painted in Florence in 1905, on
the eve of my departure for Paris, in 1906. The canvas was approximately. . . [cm.]116 x
0.89. I left it in deposit with a large shipping company, Humbert and Co. when leaving
Florence. I never reclaimed it. May, 1956 G. Severini."

2

Paris

FEW HAVE EVER ARRIVED in an unfamiliar city as penniless and helpless as I was.* I had no friends, no money (barring the 50 francs I counted in my pocket that evening), only a scant knowledge of French, and, most important of all, I had no profession; I was a nonentity. Was I a painter? a copyist? a caricaturist, a fashion or mechanical draughtsman? I had none of those skills and no visible means of support. Nevertheless, I arrived at the Gare de Lyon in a lighthearted, ebullient frame of mind. I took the white tram that an English sculptor** in Rome had recommended, went straight to Montparnasse, and ordered my first café-au-lait at a little bar on the corner of boulevard Montparnasse and boulevard Raspail. The bar was called La Rotonde and years later would become a famous meeting-place for modern artists. But at that time it was one of the many tiny Café-Biards*** scattered throughout the city. Rue Vavin, which forks off from boulevard Raspail in the direction of the Luxembourg Gardens, was then lined with small hotels. I found a room in one of these, the Hotel du Danemark, on the right-hand side of the street, which became my first home in Paris. Having arrived at six in the morning, by nine I was settled in, and could wander out to the boulevard Raspail, where a new building was going up in a wonderfully chaotic construction site that I could start to draw.

That evening I decided to go alone to discover Nôtre-Dame. It was raining and I wandered for a long time through the dark alleyways around the cathedral before at last I came upon it. Everything that I had read about Nôtre-Dame had led me to imagine it completely different

*Opening paragraph in original ms. crossed out by the author in pencil:
["*Paris*—How many friends and colleagues of mine came to that city, paused as if in front of a closed door, and discouraged, disgusted, turned around and left. Back in the provinces, they made all sorts of remarks, although well aware of actually knowing next to nothing about it, not having seen or understood anything at all. Their excuse was the fact that Paris is, like all beautiful things, very beautiful things, difficult to conquer; the conquest must be deserved, and to deserve it, it is necessary to give oneself to it, no holds barred."]
** "Monsieur Blake" pencil addition to handwritten manuscript in the Severini archives.
*** A well-known chain of economical cafés throughout Paris.

than what I found. Being anti-literary by nature, which allows me to abandon myself to sensations and impressions, I was able to rejoice in the unforgettably grand surprise it offered. My life in Paris had now really started.

I do not remember wandering around streets as one usually does to become familiar with a new city and its treasures. Perhaps I knew deep down that I would have the opportunity to discover everything about it in due time. Instead, I began living like a seasoned Parisian. I wrote to my friend in Lyon who was vacationing in Bayeux, and she promised to stop in Paris on her way back to Lyon.

In the meantime, I had somehow run into a friend from Rome in Montmartre, Gino Calza-Bini. I do not recall his specific purpose for coming to Paris (he later told me that he and another young man had been passing through on their way to London, both elegantly dressed and well-heeled). His frequent invitations to lunch were an enormous help to me in those first days. He convinced me to settle in Montmartre, so my stay in Montparnasse lasted less than a month.

Gino Calza-Bini, a Roman-dialect poet, and his brother Alberto, a painter who later became an architect, were among my favorite friends from Rome. They lived there in an apparently wealthy family, and had not enjoyed the same freedom to wander about as Boccioni and I had. We often went to their home where Gino recited poetry admirably, and would spend hours entranced by his perfect poetic diction as he read from Pascoli, D'Annunzio, or Pascarella. They were both bright, and good friends too. Before leaving for London, Gino even loaned me his magnificent winter cloak, since my coat was one of those Italian working-class models selling for 9.90 lire.

Meanwhile my friend from Lyon was passing through the city. She was not at all happy about my moving to Paris, perhaps because she intuitively foresaw great dangers and insurmountable difficulties in my path. But she was extremely kind and I am always deeply moved by the recollection of her attitude toward me. "Call me grandmother," she would say, but I rarely dared to do so. There was always somewhat of a distance between us, a natural sign of respect toward an elderly lady (and always a lady she was, even in her simplest gestures) from a vagabond of peasant origin, uneducated, and gifted only with a capacity of instinct. I am sure that she understood much about me, both through her kindness and her intelligence, and because of the experience that age confers, while I understood her so little, and did not bother to explore more deeply. Perhaps I was only interested in receiving as much help as possible, but at the same

time I was trying to act with discretion. I have never liked to pry into or impose myself on other people's private lives. I was very upset one day when she invited me to lunch at the home of certain relations. They received me with a coolness that even I, usually indifferent to such nuances and ignorant of French customs and habits, clearly sensed. Madame Bertaux made excuses for their behavior once we had left, saying, "Those relatives of mine are afraid that I will make you heir to what little I have. But my possessions are so few that there will not be enough to fight over, once I am gone." Naturally, that sort of thing did not interest me at all. I was, however, grateful for the help that this kind woman offered me with such devotion.

Before returning to Lyon she said, "You cannot go on living in a hotel room; if you want to work and have some peace of mind, you must learn to look after yourself, cook a few things, make coffee, etc." So I was forced to tell her: "I'm afraid I don't have the funds necessary for that." And it was her turn to be amazed that I had dared to come to Paris so badly equipped, and that my parents were so very poor. She herself was not really rich; she must have had a small income, just enough to lead a modestly genteel life. In spite of this, she helped me enormously. It was she, as I recall, who had the idea of buying some furniture on the installment plan at a large store, Dufayel, which was just starting to offer that service, a real novelty in those times. It was necessary, however, to make a partial cash downpayment at the time of purchase, and for the rest, to be guaranteed by a respectable Parisian resident. An elderly painter named Signorini, to whom Gino Calza had introduced me, assumed this responsibility on my behalf. He must have made a certain name for himself both in France and abroad with his "Artistes Français" style works, for he lived very comfortably. Every Saturday he held receptions at his studio, and once invited Puccini and his wife. That evening was particularly interesting. Someone had decided to try to make contact with spirits of certain deceased acquaintances and seated us, with the Puccinis and Gino Calza, around a small table. You can imagine some of the fantastic replies that came out of that devilishly humorous mouth. Puccini was amused but tried not to show it. Nevertheless he was quite astonished. His affability and the modesty of his manners completely captivated me, especially since his *Bohème* was then one of my great passions. That generous painter, Signorini, guaranteed for me, and good Madame Bertaux paid the cash downpayment, as well as the first installment of the rent, due on a small room that I had found at 36 rue Ballu.

In all the grand bourgeois homes in Paris there is a staircase leading

from the kitchen to the top floor. On that top floor is a hallway, which runs the length of the house, lined with small doors to rooms for the servants. I found one of these (which also had a dark little antechamber) to rent. It had a square window overlooking a courtyard ringed with other such windows. Of course, running water and the other comforts were all down the hall. I discovered that there were gas tubes and was therefore able to install a burner. There was also a fireplace where I could have built fires to keep myself warm, had I been able to afford wood or charcoal. All in all, it was a very luxurious abode, considering my conditions and habits. I bought only the barest of necessities from Dufayel, nevertheless there was always a small sum to pay each month. I had not the slightest idea how I would procure it. In spite of her seventy years, Madame Bertaux insisted on climbing the six flights (there was no elevator, of course) to make sure that I was properly installed.

Upon seeing the little room with everything clean and new, her expressive face lit up and she said, "You'll be very comfortable here and I hope that you will be fortunate and will work hard." I was very touched. But perhaps what distressed me the most (aside from my sense of gratitude toward the dear woman) was that I was not at all sure that I would be fortunate, nor that I would be able to work as I dreamed. Even though I was reckless, almost to the point of neglect, I realized that many difficulties awaited me. But of course, it was not opportune to disclose my state of mind to Madame Bertaux, as happy and proud as she was about my settling in that day.

Before leaving, aware of my financial conditions, she suggested that I do a portrait of one of her friends who lived in Versailles, to earn some money. She would be offering this portrait to her friend, a spinster. I needed to meet my model, but my clothes were very worn, so Madame Bertaux said, "Gino, it would be a good idea for you to buy yourself a pair of trousers to wear to Versailles," and she handed me the necessary money. I waited, however, until the last minute to make my purchase since I found the matter so embarrassing. I ended up going to one of those cheap, off-the-rack shops along the avenue de Clichy on the night before our trip to Versailles. I chose a pair of black corduroy pants which would go well with my black jacket. The next morning I realized that the pants were cut in the "hussarde" style, blooming out along the legs and pinched tight around the ankles. I presented myself in Versailles wearing these, at one of the most bourgeois houses imaginable in the bourgeois provinces, where two spinsters lived together and where my friend from Lyon was waiting for me. I definitely did not make a good impression. Madame

Bertaux, looking me over from head to toe with that indulgent smile of hers (perhaps she was amused), said, "Gino, you look like a handyman."

I later learned that those "hussarde" pants were often worn by painters who wanted to seem "bohemian," so I disposed of them immediately. I have always detested any sort of uniform, and if sometimes I took pleasure in keeping my hair longish or my jacket buttoned up to my chin, it was because I preferred that sort of bizarre look to a disagreeable suit that called attention to my lack of means. Nothing delighted me more than being able to dress properly.

In spite of the deplorable effect I made on my model, the portrait was decided upon and the following afternoon I returned with my canvas, palette, and paints. This routine lasted for the roughly ten days that I spent making the portrait. The result was not bad. The figure was seated in her room next to a little bed covered with a red quilt which a ray of sun shining through the window had transformed. I had painted the design of the wallpaper and the objects on the table, in short, just as I still do today, although in a different way (but not really so very different).

This painting did not have a great future, as I will recount later, but at least it was finished. Madame Bertaux never laid eyes on it, for she left the same day that I started it. Her friend did not want to accept the gift and so it stayed in my possession for some time.

I was becoming accustomed to living in Paris. One evening I stopped to look at a landscape painting in a shop window along that part of the boulevard at the Gare St. Lazare, between the departures and the arrivals entrances. It was a rather slick Impressionist landscape, slightly but not too Divisionistic, which could well have hung in the "Amatori e Cultori" exhibition in Rome. Suddenly a young gentleman whom I had not noticed but who was also gazing at the landscape, asked me, "What do you think of that landscape, sir?" Taken by surprise, I replied in my hesitant, imperfect French, "I think, sir, that it is worthless."

"What do you mean 'worthless'?" And a discussion ensued, by the end of which he had learned that I was a painter, lately arrived in Paris, poor, and so forth. By then I knew that he was the son of a woodworker/cabinetmaker who aspired to become a painter, etc. This young Frenchman, as far as intelligence and personality go, was the most mediocre, commonplace sort imaginable, a perfect "petit bourgeois," that particularly French average, ordinary kind of person, just as his appearance was typically one hundred percent French: a little black beard, glasses quivering on his nose, he was the cartoon image of a Frenchman and

probably for that very reason I rather liked him. I find that I generally like those well-defined types. Similarly, I must have seemed the prototype of an Italian immigrant just off the train. He invited me home to a little house on the Ile St. Louis near Nôtre-Dame, to see his horrible paintings. Instead, I concentrated my full attention on all the little details of his house which revealed habits and customs so different from my own. Welcomed by his father and mother, a fat, affable lady who loved flowers, and with those typically Parisian gentle manners, I soon became an intimate of the household. This was my first contact with a typically French, Parisian working-class family. My first friend in Paris was Monsieur Kobus.

I was to discover that my own building was a vast source of friends and relationships with the French. The first were my concierges, a tall, fat couple that filled that tiny space called the "loge de concierge," the booth in the entryway of the building. It was all curtains, ribbons, and Henri II furniture straight from the faubourg St. Antoine.

Kind Madame Bertaux thought she was doing me a favor by particularly recommending me to these people, but it turned out to be a bad mistake that would eventually cost me my friendship with her. They were essentially well-meaning souls. The wife's mother and aunt, Mademoiselle Ravanel, lived on the sixth floor, and were excellent neighbors who often offered me a bowl of hot soup when otherwise I would have gone to bed hungry.

The little square window on the opposite side of the courtyard, facing mine, belonged to a room occupied by a dressmaker. We soon became friends for we regularly met at the fountain. It was not the country sort of fountain out of a Watteau painting, backdrop to romantic trysts, etc., but rather a humble little faucet typical of a sixth-floor walk-up, in the dark hallway of a bourgeois Parisian house. The heart of this nice little dressmaker, as well as everything else about her, already belonged to a strapping Infantry sergeant who arrived every Saturday to spend his week-ends with her. Across the hall, behind the door facing mine, lived a very strange old man, a real *vieux noceur* [old rake] (fig. 8), always dressed in a cutaway and striped pants, a high, stiff wing-tip collar folded down at the corners and a rigid hat slanting over his right eye. His suit was threadbare, the undefinable color of dust, as was his shirt. With his ever-vivacious, lustful eye (he still wore a monocle), his drooping lower lip and falling jowls, he was a marvelous subject. I seized the opportunity to make a life-size portrait of him, as he stood on the threshold of my room where he stopped each morning to greet me. His room was a hovel and his bed a foul bunk.

The rest of the vast beehive, aside from a few empty rooms, was occupied by the maids and cooks of the house. They came from all over France, from the Midi, from Picardy, from Normandy, and ranged in age from eighteen to seventy. Every night they would come upstairs, each with a "lampe pigeon"* in hand. This ritual resembled the procession of the wise and foolish virgins. Not only did I meet them all quite readily, but also soon became the center of their little world. I brought some action into their lives, things they had never dreamed of. In exchange, I obtained all sorts of favors.

Just at this same time, when I had been in Paris for only two months, I met Modigliani, quite by accident. I was walking up rue Lepic on my way to Sacré Coeur when, in front of the famous dance-hall, Moulin de la Galette, I encountered another dark-haired youth wearing a hat as only Italians can and do. We studied one another and then, after a few steps, both turned back. We exchanged the only sort of questions and answers possible in these situations: "You're Italian, aren't you?" and "That's right, and you are too, I'm sure of it." Those were the initial platitudes, but then each of us told the other that he was a painter, from Tuscany, and lived in Montmartre. He had a little studio nearby. We could see it from the rue Lepic, a sort of glass cage backed up against the wall at the far end of a garden. It was pleasant, if small. Two walls of glass made it seem either a greenhouse or a studio, without being completely one or the other. In any case, Modigliani had arrived in Paris with a bit more money than I and therefore had been able to rent a stark and rather uncomfortable, but adequate little room. He was very proud of it and, quite honestly, I, too, liked it better than my sixth-floor walk-up. However, he lived there in total isolation, while I, blissful among all the women, was too surrounded by others. He pointed out the Lapin Agile as a future meeting place for us. This was a rustic little cabaret at the intersection of two typical Montmartre streets, rue des Saules and rue Cortot. Another neighborhood cabaret adopted by artists was Mère Adèle's place, next to the Place du Tertre so often painted by Utrillo. One day as I was leaning against a wall sketching in that lovely little square (despite the bitter cold and fat snowflakes falling all around me), a small lady beneath a large hood stopped in front of me and, carefully examining me, shouted, "Are you totally mad, sir? Don't you realize you've turned purple? Stop that right away and come indoors." Without another word she took me by the arm and dragged me to Mère

*Typical lamp of the times, with a wick that was lighted. What we would call a hurricane lamp. Its shape was considered reminiscent of a pigeon.

Adèle's in the tiny street off the square. There, after a glass of hot grog, I recovered and we became acquainted. That little woman was Suzanne Valadon, my first friend in the Paris art world.

MONTMARTRE*

That moment was the real beginning of my life in Montmartre. At the time I did not realize the historical importance of living there. It was immediately clear that its atmosphere was very different from that of the "grands boulevards," but I was not yet in a position to recognize the kind of intense, interesting life seething in those little streets which practically all led to the grand Sacré Coeur church, still under construction. Until the early 19th century, Montmartre had been countryside covered with little vegetable gardens, flowering hedges, guinguettes [garden taverns], all dominated by the famous, winged windmill (Moulin de la Galette). This area was usually frequented by young artists seeking peace and seclusion, a place they would often walk with their grisettes [working girls clad in grey smocks]. Later they began to realize how picturesque the place was, how original and luminous its beauty, which must have particularly touched their sensibilities, for Impressionism was already in the air.

The first artists to live in Montmartre were Géricault and Horace Vernet, and Ziem too, who recognized (miracle that it was) an atmosphere appropriate to his Venezie! The famous painting, Radeau de la Méduse, which first made Géricault a celebrity, was started there, in rue des Martyrs. Thus, artists went to Montmartre first for its tranquility and the freedom it offered for them to dally discreetly with their little midinettes,** and then little by little they made it the subject of their paintings. Corot's Moulin de la Galette, painted in 1840, is one of these well-known works, as is Van Gogh's La Guinguette and Cézanne's Rue des Saules (1867), and others I cannot call to mind. A sort of private academy was organized, modeled on its Montparnasse counterpart. It was called the Atelier Cormon, and from it came Toulouse-Lautrec, Anquetin, Emile Bernard, and Van Gogh.

Lautrec was never to leave Montmartre, for he was Suzanne Valadon's special friend and she was already mother of the little Utrillo, a name

*This subheading and its text did not appear in the original edition but were added in the second. In Severini's own copy, part of the addition is typed, and part is written in longhand.

**Working-girls who ate their lunches outside their places of employment.

given to him in 1891 by the Spanish painter, Miguel Utrillo. Cézanne lived in the Villa des Arts, at 15 rue Hégésippe-Moreau, until 1867, where, it seems, he painted the famous portrait of Vollard. Meanwhile, several dance-halls had sprung up around the Moulin de la Galette. One of them still exists today, the one that Renoir painted in his beautiful and famous work. The Cirque Médrano was then built down the hill on the rue des Martyrs, and other cabarets such as the Divan Japonais which specialized in popular songs, and La Souris in rue Bréda, Le Hanneton in rue Pigalle, resembling Mère Adèle's where Suzanne Valadon had taken me, were opened in the same area.

But what gave Montmartre its great vitality and made it exceptionally interesting was the presence of so many artists and writers. They assembled at the Café Guerbois, around their reigning sovereign, Manet. Because of this, they were called the "bande à Manet," and when they realized that nearby Montmartre was becoming an important center of activity, they all congregated there to continue their often violent discussions. The group of artists comprised Zola, Cézanne, Renoir, Manet, Jongkind, Bazille, and Berthe Morisot. It is probable that Baudelaire occasionally joined them too, as well as such lesser-known figures as Duranty, Latour, Stevens, etc.

The two buildings that harbored the participants of this invasion of Montmartre, which are still known and standing today, were at 12 rue Cortot* where Léon Bloy, Emile Bernard (my wife's uncle), Galanis, Reverdy, and, for years, Suzanne Valadon, Utrillo, and Utter lived. The other one was called the Bateau-Lavoir on Place Emile Goudot, built essentially of wood. Here resided, temporarily at least, Van Dongen, Pierre Dumont, Jacques Vaillant, Juan Gris, Picasso, André Salmon, and other non-artists too. Then came 5 impasse Guelma where Braque, Dufy, Suzanne Valadon, Utter, Utrillo, and I too, lived. Montmartre had certainly planted the seed and become the center of the revolt against academic art, a movement that began in conjunction with the celebrated Salon des Refusés in 1863, where Manet's work *Le Déjeuner sur L'Herbe* had caused such an uproar.

Two years later, in 1865, Manet provoked another scandal with his picture *L'Olympia*. Thus the Ecole des Batignolles was founded, later to be known as Impressionism. All the aforementioned painters that we, later on, so admired and to which Degas, Pissarro, Sisley, Constantin Guys, and the American, Whistler, should be added, arrived one by one

*Now the Montmartre Museum.

to settle in Montmartre. A large canvas by Fantin-Latour, now at the Jeu de Paume Museum,* portrays them all grouped together.

It was common knowledge (in Italy as well) that revolutionary feelings against the academy were brewing in the hearts of all those who gathered and then settled in Montmartre. Thus, the "bande à Manet" was replaced by the "bande à Picasso" and in the shift from one period to another, they continued to take up diverse and sometimes opposing problems and to debate their solutions, but the violence that had characterized the meetings at the Café Guerbois, according to all accounts, was not repeated at the Lapin Agile. The "bande à Picasso" was calmer and more rational than its predecessor. However, a certain resemblance between the spirits of the two mentors, Manet and Picasso, is not as absurd a comparison as it might seem, since constant antagonism between opposite schools and a state of permanent self-criticism pervaded both groups and were clearly visible in the diversity of their works.

Naturally, criticism and intrigue were not infrequent at the Lapin either around the time that Modigliani and I began to go there. We, Gino Baldo, a caricaturist, and Anselmo Bucci (liked by all) were warmly welcomed by some of the habitués (especially by Daragnès and Max Jacob), were greeted with indifference by others, and with reservation or even silent hostility by others.

After we had become steady customers at Père Azon's restaurant, along with many other artists, Raynal had the idea of making each artist paint something on the wall. Père Azon agreed to this, but only if the Italians could be excluded. Raynal refused, and the idea was dropped. The Italian group consisted principally of Modigliani, Bucci, and myself. Picasso, Gris, Manolo, and Agero were Spanish, Galanis, a Greek, Van Dongen Dutch, and Villon, Salmon, Buzon, Raynal, Max Jacob, Daragnès, and Carco were French. In other words, we formed an international clientele which I will describe later in my allusions to my circle of friends that was expanding every day. Some of these artists had French girlfriends, and secret romantic entanglements were commonplace, but the greatest mystery was how we survived. Of course, this was so for the Italians as well. I never learned how much Modigliani received from his family, and my discretion was so complete that I only discovered that he was Jewish when he was practically on his deathbed. Nevertheless, we somehow knew that Marcoussis, Gris, Villon, Galanis, and others often supplied humorous

*Recently transferred to the Quai d'Orsay Museum along with the rest of the Jeu de Paume collection.

drawings to the *Assiette au Beurre* and *Le Rire*.* Neither Modigliani nor I attempted that sort of work; I thought myself wholly incapable of it.

But this skill as a caricaturist was, as Apollinaire pointed out to me one day, more important than usually believed in the development of "School of Paris" painting. "Caricature" and "expressionistic deformation" must not be confused. But the ability to draw caricatures certainly helped many of the artists to survive, from Picasso to Villon. This anti-academic spirit and passion for freedom inevitably drove painters to neglect the "métier" of their craft.

In my opinion, it was Seurat who first and most successfully established a balance between subject, composition, and technique. Furthermore, his method was based on new notions about color contrasts (from Chevreul, Helmholtz, Charles Henry, etc.) according so well with the modern world that Seurat wished to paint, that he realized some works of great importance.

Seurat achieved a true poetry of color through the division of complementary colors, a method that lent even the most ordinary landscapes a grand and definitive expression. Such compositions as *Le Cirque* or *Le Chahut* or *Les Modeles en Pose* or *La Parade* are world-acclaimed works of enormous importance. The famous picture, *Un Dimanche après-Midi à L'Ile de la Grande Jatte*, now at the Chicago Art Institute, is legitimately placed among the great masterworks.

I must admit that I understood his importance as soon as I arrived in Paris. In Italy, Boccioni and Balla understood, but did not fully appropriate the difficult techniques of Divisionism, nor the puzzling harmony between Realism and Romanticism that Seurat expressed in such a simple, but efficient manner. Signac, Cross, and others were closely associated with Seurat, but I chose Seurat as my master for once and for all, and would do so again today.

When I arrived in Paris, I was amazed to find that Seurat was underestimated by the other artists. They preferred Cézanne, who also had original ideas about composition and technique, but who looked to the past for his examples; I never found his famous phrase, "faire du Poussin sur nature" particularly exciting or convincing. These themes were the topics of our discussions; only Léger and Delaunay, whom I met later, were more or less of the same mind as I was.

*Two well-known publications. The former, with anarchistic leanings, was issued on a weekly basis and counted only three or four Italians among its contributors. It was the launching pad for many artists destined to celebrity (Villon, Kupka, Dufy, etc.).

Despite these disagreements, we were all hard and devotedly at work in Montmartre. It would be fair to call it the cradle of nearly all modern avant-garde art. It was also the source, in 1912 at the time of the Bernheim-Jeune Futurist exhibit, of a practical joke that was not universally appreciated.

The writer, Roland Dorgelès, devised and executed the plan. Everyone knows the story by now but in case it has been forgotten, I give a brief summary. Frédé, proprietor of the Lapin Agile, owned a donkey. One day he left some cans of paint, destined for the retouching of the walls of his cabaret, in his courtyard. Dorgelès obtained a white canvas, dipped the donkey's tail in the various cans of paint and encouraged it to switch its tail across the canvas; from time to time he would change the paintpot and hence the color. Naturally, the result was a grotesque, crazy, colorful ensemble. He then gave the canvas a title, *Sunset Over the Adriatic*, and a signature, "Boronali," and sent the picture to the current Salon des Indépendants (1912).* A notary had been present during the prank with the donkey, so that no one could later contest the authenticity of the shenanigan.

Naturally, the whole thing caused a terrible scandal. Many just laughed it off, but others were furious, under the impression that it had been executed to demonstrate that modern painting could as easily be accomplished by a donkey. Actually, as far as I know, Dorgelès never said that this had been his intention. I think he just wanted to have some fun, and whether or not he did it to make fun of the Futurists and their violent colors, rather than of the Cubists with their suppressed tones "à la Corot," really made no difference. I found the prank almost as amusing as he had, and had a good laugh over it.

From newspaper clippings that I found by chance later, I surmised that the joke had been suggested to Roland Dorgelès and to his friend Warnod by Bernheim-Jeune on the occasion of the 1912 Futurist show. The choice of the name "Boronali" for the signature (an anagram of aliboron**) caused Dorgelès to declare: "With such a name he'll be as Italian as a Futurist." Moreover, Dorgelès and Warnod designated Boronali as the leader of a school called "L'Excessivisme" and composed a manifesto in the style of Marinetti. "Look! great excessivist painters, brothers, look! innovative brushes. It is our duty to shatter archaic palettes and lay down

*According to John Richardson, *A Life of Picasso* (New York, 1991), 1:375, the canvases were three, titled *When the Sun Went to Sleep*, *On the Adriatic*, and *Seascape*. He gives a full account of the stunt.

**Meaning jackass or ignorant fellow, in French.

the principles of the painting of tomorrow, etc." Dorgelès concluded: "Boronali is an Italian and a Futurist." But I cannot imagine him any fonder of Léger, Delaunay, or Picasso, for that matter.

I must confess that I paid very little attention to this parody of avant-garde art in general, and of the Futurists in particular, at the time. Moreover, a few days later the prank had already slipped everyone's mind. I have cited this unimportant story as an indication of the atmosphere in Montmartre during those years.

The really serious side of this episode was that gradually many painters, mostly foreigners, came to paint a disorganized chaos as if actually painting with a donkey's tail. In this light, Dorgelès was regarded as a precursor. But I doubt that this bolstered his pride, for he too had a serious art to pursue and defend, and the time for pranks was over. The fact remains that the real precursor of so-called abstract and informal art in 1912 was Frédé's donkey under Dorgelès' direction. And the logical conclusion is that such pseudo-art was and is more of a parody and outrageous derision of art than an aesthetic current. The critics will surely realize this in a few decades.

The point I want to stress now is that the so-called Parisian avant-garde school of painting was fortified by the entire history of those great revolutionary painters that I have mentioned, whose daring and substance were strong stimuli for all of us. The fact that this tends to be overlooked both by foreign painters in general, and by many of the young French painters today, makes the task all the more difficult.

This was the atmosphere I found upon arriving in Paris in 1906. I will refer to this again and again. Futurism, as an intellectual practice, created a "poetics" based on real life, of such a creative potential as to be inexhaustable, and therefore always present to those concerned with art.

For the sake of criticism and history, it would be helpful to make a distinction between Futurism as conceived in Milan and more or less influenced by Jugendstil, as well as being a continuation of the Lombardian tradition of Segantini, Previati, Tallone, etc., and Futurism as conceived in Montmartre, a consequence of Neo-Impressionism (Seurat, Signac) and Van Gogh, Toulouse-Lautrec, Degas, etc. I promoted the latter; several French painters became involved. Balla sided with one or the other tendency, according to the moment. This distinction may have important historical relevance that would facilitate the job of serious criticism.*

In the three months that I had been in Paris, I had accumulated a wide

*The added text ends here.

range of acquaintances and made rapid progress in the spoken language. I cannot say as much for my painting, for mere survival absorbed all of my energy. The cold in a sixth-floor Parisian room without proper bedding, enough food and heat, was absolutely murderous.

On the other hand, the artistic calendar was not then as full as it is now. Still there were the Indépendants and the Salon d'Automne. There were Bernheim-Jeune, Vollard, Mademoiselle Weill, Sagot, and Durand-Ruel, but I ignored all such things at that time. Durand-Ruel was pointed out to me on some occasion or other and later I went several times to visit his gallery. I must confess that I was not very enthusiastic about it. As a dealer he wanted to "standardize" Impressionism and had Impressionist landscapes "fabricated" in assembly line series, all of which were just too perfect to be real and were destined for the American market. I could not understand the reason, but my whole instinct rebelled against that sort of forced production which I found suspect. Later, my own dealer, Léonce Rosenberg, longed to do the same thing with Cubism, but was unsuccessful because the artists who interested him were qualitatively superior to those pseudo-Impressionists, and refused to play along.

So, I was dissatisfied with the state of my art, and conversations with Modigliani shed little light or clarity for either of us. Moreover, we both felt, in a vague but certain way, that it would be damaging to pin things down too precisely. We needed to let the ideas mature naturally. So we went ahead, doing a bare minimum of work, destroying a great deal of our output and struggling hard to keep our heads above water. Modigliani probably received some help from his relatives but always appeared as penniless as I, who had nothing at all.

While I found Durand-Ruel's Impressionists unconvincing, those that I went to see at the Luxembourg Museum excited me enormously and I often went back to look at them. My initial reason for coming to Paris had been to see these works. How many times I blessed Balla for having indicated them to me as the undeniable point of departure for any modern painter, like it or not. In fact, I realize today that those who did not have a good understanding of Impressionism were unable to construct anything solid or genuinely new in modern art.

Claude Monet's famous painting, *Gare St. Lazare*, was one of the paintings that made the greatest impression on me. So great, in fact, that I decided to tackle the same subject. I easily obtained permission from the train station office, and with my authorization could wander around the tracks, or wherever else in the station I wanted, by day or night. Today it would be more difficult or even impossible to obtain such a permisssion

(in Italy, for example), or else the multitude of formalities it would require would discourage anyone. I made many studies, sketches, pastels, and drawings at the Gare St. Lazare. Unfortunately, these later disappeared, having been seized by my landlord's rent collector.

What a pity to have lost those early paintings, for I would be interested to see those first attempts at liberating myself from objects, from that naturalistic view that weighed so heavily on Italian art for over a century and that, as a consequence, often blocked my first steps as an artist. Luckily, as a beginner, it was reasonably easy for me to forget that petty dialectical language. I must have been quite successful at disregarding it in those first few works, for when Gino Baldo, a friend of Boccioni, came to see me, he was immediately impressed by my sense of color and form, by my application of pure and separate colors and by a general pictorial freedom, lacking in recent works by Boccioni that he had seen.

Modigliani was also struggling with similar problems. I saw works he was doing then which must also be lost, like my own, that bore traces of that Italian provincial view from which Italians staying on their native soil hardly ever manage to entirely divest themselves.

Gino Baldo was an intelligent, young satirical illustrator from Padua, where he had met Boccioni. Fascinated by the spirit of the Parisian illustrators, he too had come to learn from them and make a career for himself.

At almost that same time, I met another group of young Italians in Place St. Pierre, beneath Sacré Coeur in Montmartre: Bucci, Colao, Dudreville, all painters, and Buggelli, a writer. Aside from Colao who was of medium height, they were all large young men with long hair, Lavallière ties, etc. All four lived in a little hotel room on top of Montmartre, and led a rigidly organized life. Colao and Dudreville drew more or less humorous or artistic works, while Bucci, a *debrouillard*,* more enterprising and passionate than his companions, walked around all day selling them. Buggelli was the cook. They had bought an alcohol stove, one enormous pot, a few plates, and with these made many wonderful, inventive meals. One day they invited me to lunch, a meal that seemed a banquet to me, of spaghetti and various other succulent things that had all been prepared in the single pot. I invited them back to my sixth-floor room, and we all became good friends. Each one of them, in his own way, was interesting and intelligent, somewhat crazy but serious. Either dreamers or realists, these four friends, together with Baldo and Modigliani, kept my memories of Italy alive.

*A resourceful, clever fellow who has the gift of "making do."

At that point, neither Colao nor Dudreville showed any indication of their later contributions to painting. Bucci alone, when working, showed a brilliant Impressionistic spirit which promised well for the future. Impressionism was in the air in Paris, so that any painter with serious talents abandoned himself to that prevailing current without the slightest effort. This was the case with Bucci, whom I saw painting some marvelous landscapes and a few good portraits. Later, when the other three had returned to Italy, he set himself up in a studio with his girlfriend and created a circle of friends in Montmartre that respected and cared for him, although they sometimes made gentle fun of him for his commedia dell'arte attitudes and spirit, reminiscent of the Capitan Fracassa or Lelio characters.

I would often meet Baldo and Modigliani at the Lapin Agile where we had made other friends such as Gabriel Daragnès, a very intelligent, warm-hearted youth, Pirola, Deniker, Buzon, and many others whose names escape me, but all excellent companions, ready to help and bolster one another. Even the owner of the cabaret, Frédéric, or Père Frédé as he was called, was a model comrade. He dressed like a pirate with a red handkerchief wound tight around his head, always in shirtsleeves, black velvet trousers, and boots. Every night he sang the typical songs of Montmartre or Vieille France, accompanying himself on the guitar. If he happened to discover one of his customers in need, he would sing on his behalf. This formula, always the same, would precede the song: "For our comrade so-and-so, who is in some hot soup." After finishing his song, he would pass a hat around and then give the fellow its contents. To tell the truth, he would use the same method to clear outstanding debts owed to him, but these were always amicable gestures.

In the meantime, my circle of friends continued to grow. I found Suzanne Valadon again at the Lapin, this time with her son, Utrillo, and her friend, Utter. There was also a writer, Francis Carco, who often stood in for Frédé, singing the rather crass songs of Mayol so fashionable at that time in Paris. Carco sang them magnificently. Max Jacob would also turn up, and André Salmon, Raynal, Juan Gris, and more or less regularly, Braque and Picasso. Of the habitual customers at the Lapin, those are the ones I best recall. Later on I would meet the others who formed the so-called bande à Picasso. In the summer, we would sit outside on a sort of terrace bordered by a cement railing. Conversations and discussions started earlier in various studios would continue well into the night on that terrace. In the winter we would sit inside, in two little rooms covered with paintings that had been presents from the artists. At the back of the

second room was a large plaster Grunewaldian, realistic crucifix,* which dominated the whole room. Everyone, including Picasso, had works on the walls. This cabaret had a bad reputation with the bourgeoisie. They called it the "Cabaret des Assassins" and told sinister stories about it. The fact was that Frédé's son, a robust young man, had been murdered one night for mysterious reasons on the threshold of the cabaret by some "apaches," so the story went.

One New Year's Eve, I took a foreign friend and his wife there, and we happened upon a uniquely exciting evening. In the middle of the festivities, the singing, toasts, dancing, etc., pistol shots were heard outside. A window near our table, used as a shelf for liquor bottles, was hit by a bullet. The bottles shattered and their contents spilled all over us. The plaster Christ-figure lost an arm and part of its head, pieces of the ceiling came down, and women screamed and fainted. People sought cover in the small kitchen behind the one large room or else flattened themselves along the thick doorways. Everyone was terrified. Frédé, retiring to his upstairs living quarters, fired back as if defending a fort. As I recall, the worst wounds were those caused by broken bottles, but everyone was very frightened all the same.

This was a very rare event. The Lapin Agile was the cabaret-meeting place for the artists in Montmartre, as the Closerie des Lilas was for those in Montparnasse. Many of those artists who frequented the Lapin have become famous today, but each one surely bears traces in the inner recesses of his being of the terrible conditions of his own early career. I say terrible not only because of the unimaginable poverty that tortured our bodies but also for the clashing ideas that tortured our minds. I doubt that those artists ever imagined that such exaltations of intelligence and intuitive exasperations carried to such dizzying heights would pave the way to potentially limitless descents or ascents. Each of them experienced a daily personal struggle within himself and against society.

The intemperance of these artists was often the subject of conversation among members of the bourgeoisie (there is an entire literature on Modigliani). But the intemperance, and similar things of which we could speak, were the result of the need for a deeply intense, heroic human existence, and was often a reaction to many problems, humiliations, and great suffering.

On the other hand, some of Nietzsche's poetic madness had found its way into our souls and could be detected in that generosity with which

*By Wasselet.

each was quick to sacrifice himself in order to attain something more human, even superhuman; as artists, we craved a style that would reflect the whole of Mankind, the unveiling of Nature, and the whole of History considered in a modern key.

That was the atmosphere created by Cézanne, Renoir, Seurat, Van Gogh, Gauguin, and in the wake of such masters, Signac and Cross followed with a vaster, more systematic Neo-Impressionism. Matisse and the so-called Fauves, ever more determined to attain a new level of pictorial poetry, discussed this subject with excitement and made comparisons and confrontations with Verlaine, Rimbaud, Laforgue, Mallarmé, and the Symbolist poets in general. Bergson's theories about intuition began to circulate among the artists.

Clearly, Impressionism, atmosphere, and light, at least in the Impressionistic sense, had to be considered from a new perspective. The problem was not shifted exactly, but rather was broadened and developed. The new issues were rhythm, volume, bodies in three-dimensional space. We studied the substance of color and of drawing as separate entities, not in relation to reality. "Local tone" was reexamined. Aesthetic taste prevailed over any other and became increasingly more refined. As Cézanne had already perceived, this bred a repugnance toward painting real things in an objective, descriptive sense, and an urge to express the invisible nature of things in painting them.* Not all of my Italian friends were deeply concerned about such problems. In fact, some of them left Paris after having barely been touched by this conflict.

Bucci's mutual association with his three companions was not as fruitful as he had hoped. Their "business" was progressively less productive and one fine day they were turned out of their hotel. They found temporary shelter in my sixth-floor room, but Bucci, as I recall, slept elsewhere. Our friendship flourished, thanks in part to several shipments of food from the lady in Lyon and also to my constant fraternizing with the maids in the building. All those wealthy bourgeois families, including that of a government minister, could hardly have imagined the well-organized traffic taking place between their kitchens and my room, and that they were often being served second-rate butter while the better quality butter was on its way upstairs.

*In the original edition, Severini writes, "in an objective and descriptive sense." In the two subsequent editions, the phrase is elaborated and becomes "in an objective sense, and the urge to express the invisible aspect of things, by painting them." I have combined the two versions in English, for reasons of clarity.

All of this was undertaken in the jolliest of spirits, typical of the happy-go-lucky young people that we were. Our exuberance must have been catching, as even the concierge's elderly aunt and the old cooks employed in various kitchens became active participants. Sometimes, after ten p.m. when not heading to the Lapin, we would have parties in my room and once even brought in an accordianist who played all the old Italian regional polkas and mazurkas. Everyone danced and had a fine time.

Things were going too well not to have obstacles appear. Another little dressmaker came to live with a working girl in the room near mine. We soon became friends and then Baldo fell seriously in love with the new seamstress. There was nothing extraordinary about this, as such things often happened on our top floor. But for some reason, this alliance rubbed the concierge the wrong way, while the other dressmaker's affair with a sergeant met with her approval. Therefore, each time that Baldo came to see me or his girlfriend, he had to get by those two watchdogs, and often called for my intervention. The situation became so hostile that the concierge, evidently hoping to damage me, wrote a letter to my lady in Lyon. I never saw the actual text, but can imagine it from the consequences that the letter provoked. Madame Bertaux, my kind, gracious defender, stopped writing to me and would no longer answer my letters.

Meanwhile, my friends trickled out of Paris, back to Italy, with the exception of Bucci, who settled into a small studio on rue Caulaincourt with a girlfriend. His career was going fairly well and he had become accomplished at drypoint. He had exhibited at the Grand Salon (Salon des Artistes Français et Société Nationale) and not only had he been admitted but he had also had a certain success. My own career was going very badly and my earnings were nonexistent. I had done portraits for two ladies, but had been compensated by invitations to dinner and small loans. On Place St. Pierre, I made the acquaintance of a blond man who spoke a few words of Italian. Actually, it was Buggelli who struck up a conversation with him, but as he was interested in showing me an antique painting, it was with me that the acquaintance developed. The portraits I did were of his wife who ran a large hat store, and of his sister-in-law, the head milliner in her sister's shop. My friendship with this man (Costa-Torro, of Italian origin) was later a source of immense help. His house was always open to me and he often allowed me to invite my friends, such as Baldo and Boccioni.

Everything was going so badly in rue Ballu that one day all my paintings and the few possessions I owned were impounded and I was evicted from my room.

22 Rue Turgot

One depressing day, as I sat in the little room that I would soon have to abandon, Monsieur Costa appeared at the door. A fat, jovial fellow with a radiant expression, he smiled a great deal. It was his job to supply his wife's large shop with material for her hat manufacturing business, and he also sold Bordeaux wines and champagne on the side. A kind-hearted man, he would often slip me pocket money. He camouflaged his kindness beneath a brusque manner and, as soon as he entered, said, as if to insult me, "What the hell are you going to do now?" "I have no idea," I replied, "but I would be very grateful if you would store the bed and trunk left behind by the eviction officers, in an empty corner of your cellar." Baring his white teeth in a wide smile, he said, "Come on, you'll find some way to manage. Start looking for a studio. I'll make the first payment and give you a table and a couple of chairs." I had been rescued. I started hunting for a studio and found one to my liking. It was in an old building on a nice, modern street, divided into an approximately 225 square-foot sky-lighted studio and a small second room. I had emerged victorious from catastrophe. I was even more fortunate than I realized at the time, as the adjacent offices were occupied by the Théâtre de l'Oeuvre administration.

This theater, founded in 1893 by Lugné-Poë and Camille Mauclair, was very famous in Paris. It had replaced the Théâtre d'Art founded by Paul Fort in his youth. Paul Fort's artistic career had originated in that same theater, where everything unproduceable in ordinary theaters (such as the plays of Maeterlinck and many others) had been staged using whatever means and funds he happened to find. His painter friends—Vuillard, Gauguin, De Groux, Maurice Denis, and others—designed the programs for him. All the women sewed costumes and a friendly, comradely atmosphere characterized the organization.

Paul Fort's mother had a flower shop on rue St. Placide, and held a tiny salon in the backroom where dramas, tragedies, and poetry were read. The most illustrious poets of the day passed through and participated, from Gustave Kahn and Albert Samain to André Salmon and Paul Claudel.

Today, especially in Italy, if you want to organize anything creative and interesting, you have to have an office full of armchairs, letterhead stationery, rubber stamps, telephones, and thousands of other indispensable trivia. At that time it sufficed to have a backroom or a tiny space like the room in rue Sophie Germain. There was nothing luxurious about the Théâtre de l'Oeuvre, which carried on the Théâtre d'Art traditions, as I

observed it from my window. Our shared wooden stairway was very inconvenient, lit only by a miserable gas-ring light, and there was a constant danger of tripping and falling. This did not prevent the Théâtre de l'Oeuvre from becoming one of the most interesting, important chapters in the history of theater.

When I took possession of that studio (1907–1908), the Oeuvre was at the height of its glory, or just beginning the downslide toward a slow, inevitable decline. But what great accomplishments it had already realized! Plays by Ibsen, Björnstierne-Björnson, Hauptmann, Maeterlinck, Gorky, Oscar Wilde, D'Annunzio, Marinetti, and many French authors such as St. George de Bouhélier, Henri de Régnier, Albert Samain, Rachilde, Alfred Jarry, Tristan Bernard, Henri Bataille, etc., and great actors like Eleonora Duse, Giovanni Grasso, and Isadora Duncan had found, in the Oeuvre and its audience, just and well-deserved acclaim.

This proximity was a stroke of luck for me, although, as usual, I was unable to profit fully from it, to make contact with that environment. I soon met Lugné-Poë, a large bald man with a huge nose who looked like a comedian or a monk. I became such a constant fixture at the theater that I was called "the Oeuvre kid." I found an unexpected outlet there for my former theatrical instincts, not that I wanted to become an actor myself, since I had already rechanneled that desire into painting, but I took an active interest and was very curious about the theater in general. I went to all the rehearsals and all the performances.

Lugné-Poë was the catalyst to my many friendships with stage actors, actresses, and writers; he also brought in people from other walks of life. He introduced me to Fénéon who was then secretary to Bernheim-Jeune and was later responsible for Matisse's first contact with the Bernheim family gallery. But the timing was not right and it was too soon for him to be of use to me.

One day Lugné brought Björnson's son to my studio. He was married to one of Ibsen's daughters and bought one of my landscapes. In other words, Lugné helped me whenever and in whatever way he could. When things were *really* disastrous for me, I would go to a set designer on his behalf and would be put to work for 30 centimes an hour. Once I had earned enough for my immediate needs, I would take my leave, but my work was rarely of any use to the designer as it was very clumsy indeed.

Meanwhile, I was developing an individual pictorial thrust along the lines of the Neo-Impressionists. I interpreted these in steadily freer, more completely digested techniques. Old Monsieur Sagot began to take an interest in my results and to appear on my studio doorstep to buy a little something here and there. Modigliani was accomplishing very little and

earning even less. Drawing seemed his most successful or skillful medium and he had even found a buyer for that type of work. How often I accompanied him to the door of that collector's house on avenue de Villiers on the far side of Place Clichy (I was later to learn that it had been Paul Guillaume, still a youth). He would come back with five or ten francs in his pocket, which we would spend on a dinner or to go to the Lapin. I painted one of my best works of the period just at that time. There was a kiosk full of toys, multi-colored balls, windmills, etc., on avenue Trudaine, on the sidewalk by the entrance to Square d'Anvers. This little shop with its vivacious colors and the rows of trees along the avenue covered with fresh spring leaves, became the subject of this painting, which has unfortunately somehow disappeared.[1]

Gino Baldo, too, had settled into a career of satirical drawing and was able to set up house with his little dressmaker who had also been driven out of rue Ballu by the ferocious concierge. At times, the two lovebirds would find themselves penniless and would come to me. I would somehow scrape together 10 or 20 cents for them. I clearly remember one of those evenings that almost ended in catastrophe. Facing my studio on the rue Turgot was a small "bistro" in the Parisian sense, half café, half restaurant, with a long metal counter called a "zinc" near the door. The owner was a dry, stingy Florentine, always angry with everyone. Somehow I managed to convince him to allow me small amounts of credit. During one of those "credit periods" I was eating quietly at a sidewalk table one summer day, when Baldo and his companion happened along, discreetly indicating that they were both urgently in need of food. "Dear friend," I told him, "I haven't a penny. The only thing we can try is to have you sit down, order a meal, and once you've eaten, we'll see what happens." My two friends sat at my table and ordered. The owner, true to his nature, launched cruel, suspicious looks at us, that had the virtue of putting me into an extraordinarily boisterous mood. Modigliani too, arrived during our meal. He also manifested a most urgent need to satisfy this need, so, repeating my words to Baldo, I told him to sit down and order whatever he liked. The Florentine became progressively more puzzled and dour, but was unsure whether or not those unseemly characters actually might have some money in their pockets. So, reluctantly, he brought something for Modigliani too.

Our meal was very jolly. Nevertheless, as we finished eating, my heart started to beat rapidly at the sight of the proprietor circling our table

[1]This painting titled *Marchand d'Oublies* (*Knickknack Vendor*), or *Avenue Trudaine*, was for many years in Paris in the collection of Mademoiselle Marianne Prunières.

threateningly. Modigliani suddenly had an idea. He pulled a small round wooden box out of his vest pocket where he kept his hashish and said to me, "Take a little hashish to bolster your courage, and to better its effect, let's have them bring us some coffee."

We both took it, but Baldo and his wife abstained. I had always been reluctant to try that Indian drug, but judged that I needed it that evening. I started to chew it, while drinking my coffee, and soon fell under its effects, which were far greater than I could ever have imagined. Modigliani, used to it, stayed calm. He smiled happily, the very image of bliss. I, however, already amused by the ridiculous situation, exploded in a nervous hilarity that left me breathless between one fit of laughter and the next. In this state, I called the owner and asked him for the check. "For all of us," I added, laughing so hard I almost broke my jaw at the sight of his deeply troubled expression. By then he must have been certain that I was about to say, "Put everything on my bill." What should have been a disaster seemed a victory to me. The effects of the drug on me were to force and distort reality, turning everything sumptuous and sublime. I imagined myself in a grand restaurant arguing with someone, anyone; the fact was that I replied to the Florentine's vile insults with wild laughter. This exasperated him more and more, as did my pompous, mocking comments. As could be expected, a crowd began to gather around our sidewalk table. Everyone found us amusing, especially because we were all Italian and insulted one another in our native language. Someone commented, "a quarrel among macaronis," and it was expected that someone would pull out a knife. In fact, Modigliani was about to assault the owner with a bottle when he, the patron, realized how damaging this Italian scene was for his image. So, he said disdainfully, "Just get out and never set foot in here again."

My friends helped me cross the street and climb the horrible stairs that looked like a regal staircase to me that night, and put me to bed where I woke up, fresh as a rose, the following morning. The previous day, I had recovered the portrait of the elderly spinster from Versailles, commissioned by my lady from Lyon at the end of an exhibit, as I recall. Too lazy to cart it back up to my studio, I had left it temporarily at the bistro. The terrible Florentine sent me a message by word of mouth to forget about ever having the painting back; in fact, he kept it for himself.

Such was the fate of that portrait, painted with such diligence, that my benefactress was never to see. It was unwittingly exchanged for that insignificant debt that, in any case, would not have weighed heavily on my conscience.

Modigliani, Baldo, and I laughed heartily over the Florentine's epic anger for days afterward. I want immediately to avert any tales that this episode might provoke concerning Modigliani's excesses and his taste for narcotic drugs. Even his admirers (among whom were many of questionable moral and intellectual caliber) left him, in this respect, to people's mockery. But nothing could be more unjust.

Modigliani was not prone to vice, he was neither a vulgar alcoholic nor a degenerate. Even his double doses of absinthe, consumed upon occasion, were a "means" and not an "end." The sense of elation such substances produced was channeled toward explorations deep into his soul. Drinking absinthe was common practice among artists at the time. As for hashish, he always kept a small quantity of this in his vest pocket, but used it only rarely, in exceptional cases when he needed some of the Arabian serenity that the drug induced, to counteract the failure surrounding him when he had even lost faith in himself. Where are all those abuses that have created volumes of literature? What did the bourgeoisie think, after all? That the same mentality necessary for calculating total sums in account books or for duping customers could also give rise to the creation of paintings? So much of humanity, without drinking a drop of wine, is more vulgar than Modigliani ever was, even after two or three absinthes! Furthermore, it would be an error to believe that Modigliani's brilliance, vivacity, and interest in his surroundings at any given moment of his life were produced by stimulants. Everyone in Montparnasse was fond of him and not because of his rare moments of excess after having had a couple of absinthes in the course of an evening. Instead, he was liked for his natural self, for the personality visible in his day-to-day relationships with companions at any point in the day.

One often meets rather interesting characters in small Parisian restaurants. In one of these on rue Blanche where I went sometimes with Gino Calza, I met an employee of the nearby St. Lazare train station, who also wrote poetry. His name was Brillant and he was both a pessimist and a marathon talker. In his opinion, it was better to abort any career in the arts before letting it begin. Through him I met my great friend, Pierre Declide. Declide was a young man from the Poitou region who had come to Paris to study dentistry. At the time I met him he had just finished his studies and had earned his diploma. Brillant had known him for a long time and was familiar with one of his great passions which I found rather touching. The young dentist was a curious individual. He had all the requisites of a typical provincial and at the same time, those of a Parisian. The first he acquired at birth, the others came from his reckless student

days. He liked painting in general, and we concluded a small transaction. He agreed to treat and fill a tooth which was giving me trouble, and I was to do his portrait in return. In fact, he came to my studio numerous times with the tools of his profession and the necessary pain-killers, and cured my aching teeth perfectly during these house calls. As my part of the bargain, I painted a portrait of him which is one of my best works of that period (fig. 11).

Pleased with it, he returned to Civray, near Poitiers, to his parents' house. Before leaving he said to me, "When things are going badly for you, close up your studio and come stay with me. You will always be welcome in my home." I did not think him serious, but soon afterward this young man convinced me of his extensive good intentions and generosity. In fact, a while later (I forget exactly how long after his departure from Paris), I wrote telling him that everything was going rather badly and that my health too, left much to be desired. Not only did he reply immediately, inviting me to Civray, but also enclosed enough money for the fare, under the (correct) impression that my means would not permit me to make the trip. So, I closed my studio and left for Civray. What a beautiful, clean, orderly and prosperous town! There was a superb 12th-century Romanesque cathedral on the main square, with one of the most beautiful façades known to history. Pierre Declide's parents welcomed me literally with open arms. They lived in a comfortable house on a steep street called rue des Arts. Pierre's father was the most fashionable tailor in the region and had a shop on the ground floor. Meanwhile, Pierre had established his dentistry practice, opening his office in a small pavilion off a little garden behind the house. On the floor above, his father had a workshop with four or five employees, among whom were a couple of lovely girls. The dentist's office was equipped with all the most modern surgical instruments. There was a wonderful chair. When the patients had gone for the day, we would quarrel over it to see who would get to recline there while smoking his pipe. Pierre was very serious about his work and established a large practice right away. He had studied hard and was very up-to-date professionally. Moreover, he was a nice person and well-liked. Small, robust, and as blond as a seraph, he wore his hair in a question-mark-shaped tuft over his forehead and had a typically French, down-turned moustache and a pointed beard. His father tried everything to spruce him up and would have made him a new suit every day, but it was a hopeless task. Pierre was always either unbuttoned, or badly buttoned, and his jacket and pants bore traces of disinfectants or other unsightly evidence of his profession.

As soon as I arrived in Civray, he introduced me to his friend, Marcel Pierron, who had just finished his degree in medicine and had set up a doctor's office in the town. We visited him every day and he plied me with medicine, gave me shots, and took care of me in general with all his freshly learned medical cures. What really helped me were the abundant meals prepared by kind Madame Declide. Being a mother, she understood a great deal about me and tried to improve my health.

Their munificence went far beyond that. They also hunted for commissions for me, and actually found some. My first portraits there were one of the son of another doctor, then one of the wife, and then several others. I was paid small sums, but they were more generous than what the meager art market in Paris could offer. Madame Declide took the money I earned and put it away for me. I had absolutely no expenses in Civray, and Pierre would even fill my coin purse just in case I might happen to want a cup of coffee somewhere. He treated me like a brother. Furthermore, his father, realizing how negligible my wardrobe was, made me a summer suit of light-colored English material, an overcoat, and a tuxedo. Since it was customary for the well-to-do in Civray to organize balls to which I was invited, thanks to my friends, I made my entrance into the social world of the provinces. I was highly respected and made a large number of friends.

I did nothing extraordinary in Civray; I just let myself exist. I spent three truly happy months there. Thinking back, what touches me most is the recollection of family life in my friend's house. His mother, goodness personified, was a sensitive, intelligent woman. She revealed her innermost feelings about her son to me. She would have liked to have seen him married by then, and already the head of a growing family. All the local "prospects," and those in the surrounding areas, were passed in review. Such-and-such a girl had so much of a dowry and would inherit so much from an old uncle, etc., but the girl herself was not outstanding. Then there was that other eligible girl, and so forth. They would go on like that for hours while Pierre was busy in his office and father Declide in his workshop. Pierre was oblivious to such calculating; he seemed indifferent. They introduced him to many charming girls, all wealthy to varying degrees, and I, in cahoots with his mother, would encourage him to decide upon one of them. He would say, "Listen. I can't decide on one because I don't love any of them. I can't seem to fall in love. One day, when that happens, I'll get married." I knew all about his past romance from Brillant. He had set up house with a ballerina from the Opéra, during the last part of his stay in Paris. She loved him to such an extent that she even enrolled in the same dentistry school in order to allay any objections that

his parents might have to her. She thought that if she had a comparable diploma and could practice the same profession, his parents would accept her as a daughter-in-law. But she had not gauged the strength of provincial prejudice. Pierre's parents, although they adored him, would not hear of such a marriage. So, Pierre submitted to their decision and his girlfriend probably took up dancing again. After that, his heart was never again captured by another woman. His parents were punished cruelly over the course of the years for having preferred their own expectations to their son's happiness.

I have often heard it said that the whole of France is concentrated in Paris or that Paris is the intellect of France. This is only partly true. If the provinces can be considered the body and the capital, Paris, the mind, then it is certain that the body is full of intelligence and conducts an individual and particularly interesting life. Many sensitive, highly cultured persons live in the provinces. If France has reason to be proud of the outstanding quality of its civilization, this is due, in part, to that vital juice, that substantial intelligence so measured and orderly, comprised of the inner riches of its provinces.

Aside from young Doctor Marcel Pierron, I made other friends in Civray, among them a law student by the name of l'Abbé. Originally from Montaubon, he had been elected mayor of that town and was France's youngest mayor. Another very gracious, nice fellow was a young humanities graduate, Geay, who later became prefect in a French alpine town. He would often come to Civray to pick me up and take me back to his villa in the country. During the afternoon, we often went by boat along a small river that ran through his property. He would read me Flaubert, Maupassant, Baudelaire, Verlaine, etc., as we floated along for hours. Time would fly by, and at dusk he would take me back to Civray by horse-drawn carriage.

Alone or in the company of friends, I visited that beautiful region full of castles with their pointed towers. Leonardo da Vinci's residence near Tours must have resembled one of these. I visited Tours and Poitiers and several others, and was amazed that such lovely places were so little-known and so rarely visited. There was everywhere a richness, an intense, generous style of life which encompassed all classes of society. I witnessed as happy a population as can be found on the face of the Earth.

My walks did not distract me from my work, nor from trying to solve my particular problems. In landscapes I was sometimes able to find a way to reconcile my ideas about pure and separated colors with those of a broad synthetic and extremely expressive form. But often, just as I man-

aged to envision this goal, I would ruin everything and have to start over again.[2]

During my stay in Civray, Monsieur Declide's cousin (or perhaps brother) came to spend the summer. He was a captain in the gendarmes in Pau. His wife and daughter, a youngster of fifteen or sixteen, accompanied him. The whole family was very tall, especially the wife who must have been well over six feet. They had absolutely no interest in anything cultural and, instead, were very interested in sports. Pau was a town renowned for its winter sports. Nevertheless, they were nice people and good company. I made two portraits of the daughter to please Madame Declide. The girl was exuberant in her youth and vitality. Her commotion excited, brightened, and dominated the household.

Madame Declide would sometimes take me aside with her particular smile, and would confide to me that a union between the two cousins would not be displeasing. Then she would add, "Pierre is so small and Yvonne already so tall. When they were little, they used to play together all the time, like brother and sister." In fact, neither of them ever considered entering into any other sort of relationship. Meanwhile, summer had ended and fall had begun. My friends' relatives had long since returned to Pau when I, too, left Civray to resume my life in Paris.

1908

My Parisian friends hardly recognized me, so prosperous an air did I have. All my clothes were new and my health splendid. Once I had paid off my back rent, I still had some money left over, and I was in a state of exceptional affluence. I was very impatient to learn what was happening in the Paris art world. I hurried to Montmartre, but it took me several days to reestablish my contacts.

For some unknown reason, even though he continued to receive money from home, Modigliani was ever poorer. He had been working very little, was dissatisfied with himself, but definitely seemed to me to have made progress. He was surer about his ideas and had finally emancipated himself from the naturalistic, superficial viewpoint, a legacy from Italy, and had decisively turned to a life which, for the sake of comprehension, I will call Matisse-like. This consisted of a search for a lyrical, expressive style, sustained by abstract, spiritual colors. In other words, he was firmly ori-

[2]One of these landscapes was purchased by Björnson's son the following autumn.

ented toward Fauvism, endowing it with his own sensitivity and chromatic palette.

Fauvism was in the air. The word in Montmartre was that even Picasso was working under its influence and, prior to him, Braque and Derain too. Certain African influences in Picasso's new orientation were also noted. But no one had seen his most recent work, for he did not exhibit it and was clever about creating a certain cloud of mystery around himself. There was already a certain aura about his personality that attracted attention and stimulated curiosity. Perhaps this was provoked by his ever disquieting, pensive air.

The art world still thought of him in terms of his first exhibition at Vollard's in 1900 where works particularly inspired by Degas, Toulouse-Lautrec, Manet, Steinlein, etc. had been on view. That show had been very successful and the paintings had focused on subjects taken from Paris nightlife, dance halls, cabarets, etc., in which I, too, was beginning to take an interest. I never saw any of those paintings, only reproductions of them some ten years later.

In short, the general atmosphere in Montmartre was dominated by Fauvism, and artists were searching for the form, linear rhythm, and technical means to express that harmony resulting from a reconciliation between Realism and Romanticism. Each tried to attain this according to his own temperament. Above all, each artist's own creative, spiritual potential was presumed to drive him toward greater humanizing than pursued or expressed by Manet and Cézanne.

I did not object at all to such explorations, nor did I consider them remote. Matisse may have already started to work in that direction, but I did not meet him or begin to appreciate his ideas until much later. I was interested in achieving a creative freedom, a style that I could express with Seurat's and the Neo-Impressionists' color technique, but shaped to my own needs. Proof that I found it is in my paintings of that period, among which is the famous *Pan-Pan à Monico* (fig. 18). My preference for Neo-Impressionism dates from those works. At times I tried to suppress it, but it always worked its way back to the surface.

I began to frequent the dance halls and so-called nightclubs more assiduously: Moulin de la Galette, Bal Tabarin, and, further into the night, the after-theater restaurants such as the Royal Souper, Rat Mort, Monico, etc. They were expensive but, being a good dancer, I soon was admitted free and received special favors in all of them.

This point marked the beginning of a series of drawings of dancers that I wanted to do in a very different way from those of Degas who always

painted them in static poses. I thought that the Neo-Impressionistic technique considered in the broad sense in which I interpreted it, extended to form, would allow me to achieve effects of movement, never yet attempted, and a more pronounced lyricism. In fact, to my mind, my paintings of ballerinas, cafés, and dance halls, have little in common with what my predecessors, those great painters, had achieved.

I led a very active, interesting life. It was exhausting, too. I would often dine with my friend, Costa-Torro, in the basement of his fashionable shop on the rue Damrémont. From there, I would continue on to the Moulin de la Galette or, more often, to the Tabarin, until after midnight. At that point I would move to the Monico which was almost my exclusive battlefield, for various practical reasons. I was enlisted to encourage Costa-Torro to consume as much champagne as the occasion permitted. The difference between the Moulin de la Galette and the Tabarin was the clientele: working girls, department store employees and their "friends" came to the former (that is where I danced so often with Henriette, nicknamed Riotto, then the girlfriend of a proofreader and later Reverdy's wife), while the little *noceuses*,* still inexpert about gallantry, and their procurers were customers at the latter. There were also the can-can dancers who rushed in with their quadrilles after every two regular dances. They seemed dressed like all the other women until they raised their skirts during their dance. When caught under bright spotlights, all you could see was a blur of contrasting blacks and whites, a splendor of greys in a whole range of purples, greens, and blues. They were painted by many artists, but are best remembered in Toulouse-Lautrec's works and later in Picasso's paintings dating from 1900.

Saturdays at the Tabarin were famous in Paris for the generous display of scantily clad beauties and a carnivalesque inventiveness. There were always "theme" parties on those nights, such as: "The Conquest of Fez" (counting on the inevitable pun), or beauty contests, leg contests, contests for strategically placed moles, etc. In other words, they were carnivalesque parties with carriages full of beautiful masked and underdressed women, with showers of confetti, multicolored streamers, etc. The atmosphere was one of total frenzy, undoubtedly animated by quantities of champagne.

When I escorted my Futurist friends from Milan there sometime later, they were, quite frankly, amazed. I painted one of my best canvases in this locale, *Le Bal Tabarin*, now at the Museum of Modern Art in New York.**

*Ladies of easy virtue, equivalent to male rakes.

**In the original ms., "in the collection of Mr. Wyndham Lewis," which should have read, "in the collection of Mr. Richard Wyndham," according to a list in the personal archives. Severini evidently confused the two names.

1910

My situation had once again become desperate. I suffered another expropriation and eviction (fortunately I was able to save many things, passing them out the window of my studio into the offices of the Oeuvre). My health, too, was poor. Informing Pierre Declide of my condition, I received the expected reply: "Put your paintings in a safe place and take the first train to Civray." His father confirmed the invitation in a postscript. I returned to Civray, welcomed by everyone with open arms.

My ideas about painting were now much clearer, and in the peace of my little room, relieved of encumbering material worries, I painted several canvases, among which were *La Modiste*, some still lifes, and a few landscape studies. It was in these works that my division of form was developed. I was enjoying a peaceful, industrious life when an important sports event was about to turn me away from my chosen path (even though I had always been indifferent to such things). Bielovucic, the Peruvian aviator whom I had met in Paris at the Monico, made the first important trip from Paris to Poitiers and then to Bordeaux in a Voisin biplane. He was on his way to a reunion of important aviators. I never thought that such an unathletic and apparently unenergetic youth could ever accomplish such a feat.

In any case, I hurried to Bordeaux with Pierre and his father, but left them there, for I entered the airfield with Bielovucic who used the performers' entrance (counterpart to a backstage door) and not the normal public entrance. I was gripped by an inexplicable enthusiasm at the sight of those ten or twelve airplanes in the sky over Bordeaux, and of course also during my own first-person experience of this new type of sport.

Pierre and his father returned almost immediately to Civray. I stayed on to the end of the meet. Then I passed through Civray for a few days on my way back to Paris. I had decided to become an aviator myself. But Bielovucic, who was financed by the Voisin brothers, was of little help to me. I mentioned this to Lugné-Poë, who found a way to come to my assistance. According to a scheme devised with his wife, Suzanne Desprès, he invited me to lunch together with Georges Besançon, then president of the Aero-Club of France. In turn, Besançon introduced me to Maurice Farman.

I could not have hoped for a better recommendation, and, thanks to Farman's particular interest in me, I could have rapidly become a pilot and started a new career. The Farmans also offered to find me a limited partnership for the acquisition of an aircraft. Otherwise, I would have no

choice but to become part of an organization furnishing sky "chauf-feurs." It was my month-long companionship with these celestial "chauf-feurs" that persuaded me that it was not the career for which I was born, rather than the insistent advice and disapproval of all my friends. So I abandoned my ambitions of becoming a pilot. That experience, however, stayed with me, as did the ideas that really made me understand, better than any available literature on the subject, the beauty, life, and function of the "machine." Nevertheless, it was an experience that cost me dearly. Art took revenge on me for my acts of infidelity and banished me from its breast (in fact, art is extremely jealous). I lapsed into destitution, no longer merely that of the starving artist, but more like a displaced person, a human being without direction.

I no longer had a studio, had spent all my money, and I had no work; I was like a shipwreck victim in the middle of the ocean. I forget the cir-cumstances that led me to take up residence in a hotel on rue des Martyrs, between Place Blanche and Place Pigalle; it was a tiny hotel with an inter-national clientele near the Médrano Circus. Lodged in it were clowns, horseback acrobats, wild-animal trainers, circus people from all over the world. The rest of the clients were sidewalk vendors who prowled the boulevards with their sidekicks, and a group of displaced persons, as well as some others of dubious resources. Overall, it was a highly interesting group of people, rich in humanity. I met some very intelligent, generous characters. I also met a member of the Pezon family of wild-animal trainers and I entered the lions' cage with him several times where a vio-linist was playing modern music*—a number that was eventually aban-doned. One of my new friends devised a simple way for me to make some money. A street vendor of watches, for example, would set up his wares on a corner of the boulevard. As his shills, we would approach as he was hawking his merchandise, and when enough of a crowd had gathered, we would buy a watch with money that the vendor had previously given us. Our example invariably attracted other sales, and we received a percent-age of the transactions. The game was even amusing, but I soon grew tired of such a life. I sold whatever clothes I could and went back to Civray, to my friends the Declides, who welcomed me like a prodigal son.

5 Impasse Guelma

With my head above water once again, I returned to Paris with the works done in Civray. To be truthful, they had not excited any of my friends

* "A Beethoven symphony" in the original edition.

there. On the last day, Madame Declide, probably recalling my mishaps in the past and imagining those in my future, looked at me tenderly, as if to say, "Poor child!" Pierre would often mutter into his beard, "Donkey's ass" or "Salami." These were allusions to my recent adventures as an aviator and to my paintings of the moment. But, what real affection that family showed me!

I regularly received news of my own family in Italy. My father was still his old self, insubordinate, and irregular in his duties. He passed from one prefecture to another, sometimes in better places, sometimes in worse. My sister, whom I barely knew, was growing up and my mother was always in a state of torment about everything and everybody. That was my real family and of course I was attached to it, but my new family had almost taken its place. Pierre was like a brother and closer to me and more of a brother than my little Italian sister. My heart was torn between my home country and my adoptive one. This time the separation from my friends in Civray was more painful than ever before. Perhaps it was an omen of the future. In any case, this was my last visit to Civray under those circumstances.

Upon arriving in Paris, I began to hunt for a studio and was soon fortunate to find just what I wanted. Five studio apartments had been built in a large courtyard on impasse de Guelma leading to Place Pigalle. There was a large one on the ground floor and two on each of the upper floors. None had yet been rented so I was able to choose a corner studio on the second story with a window over the impasse. In less than a week all the studios had been let. The next tenant to arrive was Raoul Dufy. With his blond beard and curly blond hair he looked like the Saint Joseph pictured in church missals. Georges Braque and his wife then arrived, having taken the two studios on the floor above. Last of all, on the ground floor, came Suzanne Valadon with her friend Utter, her son, Utrillo, and her elderly mother. All of these figures are portrayed in one of her well-known paintings.

Dufy's studio was separated from mine by a wooden partition, a sort of large door, which allowed every sound to pass from one studio to the other. I soon realized, from the constant noise of saws and hammers, that my neighbor was building dividing walls and heaven knows what else.

The only tenants I already knew were those on the ground floor. I knew Braque by sight but had never spoken to him. It was not long before I became friends with Dufy, a very likeable man, and his wife. One day Dufy introduced me to Braque and at that point cordial relations were established throughout the building.

Nineteen-ten was probably the most important year of that great his-

torical epoch between 1900 and 1925. It was not a year of sensational
events, but, instead, full of artistically important milestones. Certain
schools were defined and others formed. I recall an extraordinary feel-
ing of dynamism that year. Even if it was not yet possible to draw clear
conclusions since everything happened in such a chaotic manner (we were
unconscious of the importance of our experiences), I still remember the
situation very vividly and can summarize it in the following way: the
predominant influences were those of Cézanne, Van Gogh, and Gauguin.
Two collective shows, the Indépendants and the Salon d'Automne,
revealed daring personalities and infinite possibilities. There was a fren-
zied desire for freedom in the air, an inexpressible appetite for innovation
and adventure, and a profound need to reestablish contact with a reality
not distorted by the academies. The chains of logic imposed by those
institutions had already been demolished. Anything was possible, above
and beyond Impressionism, which had been relegated to the status of
"pompierism" or stereotyped art. So, choosing one of the three aforemen-
tioned masters, each of us attempted to push his model to its extreme
consequences. Painters such as Paul Signac, Cross, and Theo van Rossel-
berghe took Seurat and Van Gogh as examples and, relying on Charles
Henry's scientific theories, expressed themselves in methodic, light-
hued, and light-imbued paintings. This tendency was christened Neo-
Impressionism. A parallel tendency called "Fauve" was developed by
such painters as Matisse, Rouault, Marquet, Vlaminck, Friesz, Dufy, De-
rain, etc. Their goal was to introduce ideas of composition, of rhythm,
and a broader range of contrasts (replacing simultaneous contrasts with
zonal contrasts) into Impressionism. Between these two, the Symbolist
school persevered. Its concepts were based on classicism and tradition, to
such an extent that they were originally called "Neo-Traditional." Its
members intended to utilize the renewed Impressionist "vision," taking
their subject matter from modern life and their methods, those of order
and measure, to the degree they thought necessary, from their masters.

Gauguin was the nucleus of this movement, whose members were Odi-
lon Redon, Emile Bernard, Sérusier, Maurice Denis, Edouard Vuillard, K.
X. Roussel, Pierre Bonnard, Vallotton, Hodler, and the sculptor Maillol.
Their theoretician was Maurice Denis, responsible for the famous defini-
tion, "It should be remembered that a painting, before being considered a
horse in battle, a nude woman, or any other anecdote, is essentially a flat
surface covered with pigments arranged in a certain order."

The desire within that group to reconcile such different things and aspi-
rations which, to us of the younger generation, seemed so irreconcilable,

drove us finally to consider them closer to the "pompiers" than to the moderns. Nevertheless, Maurice Denis' formula could readily be considered acceptable by anyone, even by the avant-garde. What I would like to convey is the youthful exuberance that burst out of all this activity like sparks from a fire. However, the most important of these tendencies, for its later consequences which we will see, was the one that looked to Cézanne.

I had been hearing about African statues in Montmartre for some time, but none of us had ever seen one. At most, we had caught a glimpse of them in some "bric-a-brac" shop on rue de Rennes where later I, too, bought a beautiful African mask. However, word had it that Matisse and Picasso had used them, each to his own purposes, as a source of stylistic and poetic reference, so that it was later claimed, and seconded by Max Jacob, that black African art was the source of Cubism. This is not entirely correct.

Much later, when I had the opportunity to see Picasso's paintings of that period, I was convinced that they never would have been painted without Cézanne. It is true that African art helped to extend the limits of the possibilities and intentions inspired by Cézanne, and to contribute to a recuperation of real poetic intent. It showed artists that this could only materialize by direct contact with a renewed and so-called virgin sense* of reality. Cubism (which was not the purely Spanish concept claimed by Gertrude Stein) was the consequence of a whole state of things which included the evolution of literature, philosophy and science, and the condition of the entire contemporary civilization at that particular moment. To understand this, it is only necessary to examine the history of French art starting with Ingres. Cubism, like Impressionism, is a turning-point in history. They are both inevitable consequences that will become clear with the passage of time.

The lessons taught by African art were learned first by Matisse, and then by Picasso and Braque and by the best artists of the period. Today, some fifty years later, it seems amazing that this progression was so logical and that there was such a rapport, more substantial than it appeared at the time.

The Fauves, already dominated by Matisse, were more and more oriented toward a lyricism of form and color that would have become essentially "decorative" or "ornamental" had it not been for the serious

*"Una realtà non sfigurata" (a non-disfigured, non-deformed reality) in the original ms.

pictorial skills and good sense of its artists. In fact, echoes of Gauguin and the Pont-Aven School can be seen even in Matisse. He was painting such works as *La Joie de Vivre* (1908), *La Musique* (1911) now in Moscow, *La Danse*, and certain still lifes like *La Desserte* where the decorative aspect threatens to predominate over the purely pictorial aspect, but is always kept under control. Those works certainly contained the substance and foundations of decorative mural art that echoed far back to the Byzantines, or later to Giunta Pisano or Berlingheri or Coppo di Marcovaldo.

First Picasso, then Braque, then the Cubist group created a parallel current as the result of their reaction to Impressionism. At that same time, Léger, Delaunay, Lhote, and I, too, held our ground between these two currents, each with his particular goals and skills, always those inherent in Impressionism, whose true successors we were. I am under the impression that each of us suddenly had a clear idea of the absolute independence of a painting from any sort of representation or imitation of reality, which, at the same time, we did not deny. A painting became an *object* unto itself, and we realized (unconsciously) that this concept was a distant point of encounter with the ancient masters.

This, as I recall it, was the soil that engendered Cubism. Any attempt to determine the first artist to conceive of "geometrizing" forms is probably of secondary importance, but the intention to extend Cézanne's constructive design was already hinged to a geometric conviction (an intention that coincides with the reaction to Impressionism). If forced to name one artist, I would say that it was Derain. One of his landscapes was exhibited at the 1908 Indépendants; then another, by Braque, painted with identical intentions, was shown at the Salon d'Automne that same year. In the meantime, Picasso returned from a trip to Spain with several similar landscapes. I saw these much later at the Stein house, since I did not know Picasso personally at that time, and he never participated in exhibits. These landscapes date to 1908 and 1909, I believe.

However, it was the 1910 Salon that confirmed Cubism as a general tendency. In fact, several artists, principally Gleizes, Metzinger, Le Fauconnier, exhibited their first works, intentionally conceived and constructed according to Cubist concepts, at that show. It was said at the time, and later I was convinced of its truth, that Picasso was not happy to see the creation of a "school" (in the most elevated sense of the word) taking shape and substance beyond his control. On the other hand, according to André Salmon, if someone asked for his explanation of this phenomenon, he would send such troublemakers to Braque, Metzinger, Gleizes, etc., about whom (with the exception of Braque) I later heard

him speak with a certain irony. Salmon also called those painters that followed Picasso "the disciplined troop," but this was an unjust attribution. Even he admitted that "it is not possible to defend Picasso without supporting Cubism and the Cubists."[3]

I never belonged to "the disciplined troop," perhaps out of an instinctive abhorrence to "formulae." Also, the dangers of "cliches" and "formulae" could already be sensed, not so much with respect to Picasso, but to the Cubists in Montparnasse. This does not detract from their sincerity or their talent. Even the "reactionary frame of mind" was never favored by me.

Naturally, I, like everyone else, endorsed that orientation toward the geometric tendency that was in the air; had I been in Rome rather than Paris, I would have acted quite differently. Therefore, I am very grateful to Paris and to "that artistic climate." Even Picasso, had he stayed in Spain, would have been a different painter.

It is certain, too, that it was mainly Seurat, rather than Cézanne, who suggested decomposition of forms to me, and that African sculpture had no influence on me whatsoever. I later bought African masks just like everyone else, but then sold them, as for some reason I found them disturbing.

These are my recollections of early Cubism, as something that happened naturally and whose seriousness and importance we ourselves were to understand only much later. It is not easy for me or for others to remember precise dates. I came across many inaccuracies in André Salmon's memoirs. Picasso's beautiful friend, Fernande Olivier, also wrote her recollections and added a certain amount of fantasy to them, often changing the look of things. For example, she turns that puerile story about my socks in complementary colors into a fantastic event.

It happened by accident. Getting out of bed one morning in Civray, I put on one red sock and one green one in the dark of the bedroom. I was already on the train back to Paris when, in the daylight, I realized my mistake. I found it amusing and turned it into a joke for eight or ten days, providing my friends with a good laugh. Unfortunately, there was a reporter from the *Intransigéant* in their midst, which explains the subsequent diffusion of the anecdote. There is no truth to the story that Boccioni adopted this innocuous prank, or that he came with me to the Brasserie de l'Ermitage to show off his complementary socks too, or that the Brasserie was the meeting place of Cubist friends. I never saw anyone

[3]*L'Esprit Nouveau*, no. 1.

such as Braque or Gris, or those from Montparnasse there. We used to go there by ourselves, every evening: Picasso and Fernande, Marcoussis and Eva and I. Sometimes Van Dongen's wife would come, and Serge Jastrebzoff, but rarely any other painters.

As for Miss Gertrude Stein, she, too, confuses the influence of African sculpture on Picasso and the geometric landscapes that he brought back from Spain. Even if they had been done after our friend's contact with African sculpture, it is Cézanne's influence, not that of the sculptures, that is evidenced. For this reason I said that Cubism would have emerged regardless of the Africans. Even the epithet "Cubism" attributed by Miss Stein to Apollinaire's inventiveness, was actually coined by Matisse.

Certainly, were a historian dedicated to anecdotal precision to try to name the first painter, after the Byzantines, to paint a form directly inspired by real life, he would be in a very embarrassing position. The same thing happens in the opposite case: the passage from direct visual reality to conceptual reality, and that is the process accomplished by Cubism. But, back to our story.

About this same time, around 1910, Kahnweiler opened his little shop on rue Vignon, where Picasso's and Braque's paintings could be purchased. They were both painting in such a similar style that it was difficult to distinguish between them. Artists wondered which of the two initiated this reaction to Impressionism, for this is exactly what the first Cubist period was, in the intentions of these two painters.

You can imagine my curiosity to see the works in their respective studios. I soon climbed the stairs to Braque's studio on the next floor, where both his paintings and his means of expression, so simple and precise, fascinated me.

Braque was a tall, robust man, like a boxer, while his wife was small and round. At that time he always wore a tall, stiff hat with its wide brim rolled up in the 1880's style. Who knows where that came from? Beneath his rough exterior, he was friendly and extremely sensitive. Directly over my head, I would often hear him practicing his accordion. The sound of it made me vaguely nostalgic. Braque also took an interest in what I was doing. I had just started the *Pan-Pan à Monico*, but was able to show him *La Modiste*, various still lifes, and *Le Boulevard*, in which I had broken down forms just as I had colors.

One early summer evening in 1910, at the Lapin Agile, Braque introduced me to Picasso who immediately invited me to visit his studio on rue Ravignan. Quite the opposite of Braque, Picasso was a sturdy, little man. In those days straw hats called "pagliette" with very wide brims were

fashionable. Naturally, I had a stylish one, but Picasso's was even smarter, with a wider brim than mine, which accentuated his air of a Spanish bullfighter. He also wore a light-colored suit very similar to my own, but his had a "sporty" elegance, like that of a mechanic in his "Sunday best," while mine was closer to fashions of the so-called outer boulevards.[4] Shortly thereafter, he invited me to his boulevard Rochechouart studio where he lived with Fernande, and that is where I met Apollinaire.

He immediately struck me as a latter-day Pietro Aretino. He was cultured, refined, and caustic under his warm-hearted exterior, aristocratic and distant under his simple, cordial appearance. His corpulent figure released a great force of attraction.

Picasso's work of the moment was situated somewhere between the geometric simplification of the landscapes he had brought back from Spain and a more elevated abstraction which he culled from a growing independence from the reality of appearances and subject matter. He had just started, in some paintings, to dismantle objects, in order to present different points of view. Such freedom of thought and action was an important example for me. Rather than his "means of expression," I (as well as Braque) felt an immense affinity to and a stimulation from the quiet confidence of his free act of creativity, that affirmation of *freedom* that was to sustain me through the rest of my life.

Thus, I continued to paint my enormous canvas, adding all the resources of my fantasy to it without remorse, and freely employing my observations and real-life studies. While Picasso and Braque had adopted Corot's color palette, perhaps in an attempt to accentuate the force of their reaction to Impressionism, I preserved the Neo-Impressionist formula as a foundation, adding to it pure black, white, and grey, convinced that the formula for the division of colors was better suited than any other to the division of form. While I was still working on *Pan-Pan*, I did one final pastel portrait that was a kind of tribute to Seurat, as the recollection of this master was, and still is, very much in the forefront of my mind. Utter, Suzanne Valadon's painter friend, posed for the portrait. I never finished it, as my other works in progress, especially the large canvas, drained all my time and energy. However, even in its unfinished state, Matisse and Picasso repeatedly praised it.[5]

[4]These observations on clothing and appearances may seem unimportant to some, but they are important in a certain sense, for they are signs that reveal one's character.

[5]This work followed me for some time to my various residences, but I lost sight of it in Italy, having sold it at the insistent persuasion of a man from Brescia. His taste was mediocre and it seems that he resold it shortly thereafter. [This refers to Signor Feroldi. The pastel

I still had trouble abstracting myself totally from visual reality. In one corner of the Pan-Pan painting, there is an elegant lady climbing the stairway at the Monico. She is painted in a somewhat Toulouse-Lautrec style, and, therefore, almost realistically. On the other hand, a contrast between a realistic element (transcendental realism, that is) and other elements expressed in terms of absolute abstraction, like all contrasts, generates a sense of dynamism and vivacity.

I suppose that is why Picasso even put stenciled numbers and letters in some of his paintings. Later he abandoned this mechanical procedure and he, too, included some realistic elements evident enough to contrast with the abstraction of the rest of the painting. These "means" were also used by our primitive painters of the distant past.

It was about this time that I met Reverdy, the poet. He had just arrived from the southern French provinces (Narbonne, I think) and was dressed in mourning, after the recent loss of his father. Nevertheless, he had the merry, round appearance of a young abbot. He was a curious analytic soul, rationalizing and obstinate, but very lively. His indolence was typically southern and he would spend entire afternoons lying on my sofa, busy analyzing and demolishing the big canvas I was working on, *Pan-Pan*. We often quarreled over it and one fine day his visits abruptly stopped. In the meantime he had met Gris and perhaps had gone to that painter's studio to vent his critical nature. Later he met Braque and Picasso and, by then more mature and better-informed, he often wrote highly intelligent articles about painting.

As I have said before, the year 1910 was an auspicious and productive year for the arts. Yet it was in 1911, at the Salon des Indépendants and the Salon d'Automne that Cubism became crystallized as a general aesthetic theory. Those two exhibitions were of great importance. The number of Cubists had increased, to include new artists of different temperaments, such as Marcel Duchamp, Jacques Villon, Picabia, etc.

I remember the work of Metzinger and Gleizes very clearly. A painting by the first, *Le Gouter*, and one by the latter, *La Chasse*, were generally well-received. Even today, I recognize the pictorial worth of those paintings, but must, in all sincerity, admit that they reminded me a little of "museum" colors, which prevented me from fully appreciating them. This was due to the fact that it took these painters some time to rid themselves of the "vision" they had learned at school. With the exception

then passed into a collection in Crema. In the original footnote, Severini says that his work was sold together with one by Utrillo.]

of Léger who emerged, as I did, from Neo-Impressionism—therefore we always saw eye-to-eye—the others came from the academy, and their colors showed the effects of those traditional mixtures repudiated by the Impressionists. And, for the same reasons, finding Corot's greys and ochres in Picasso's and Braque's canvases prevented me from fully appreciating their works.

All things considered, a new era of painting was in the process of developing, and now, so much later, its importance is even more evident.[6] Even those painters who were not yet my friends at that time completely agreed with me later, more or less openly, and their color schemes became brighter. But in 1911 I saw them only rarely and mainly at exhibitions, as the center of their activity was Montparnasse, at the Closerie des Lilas, and they came to Montmartre only rarely.

[6]This is not the place for an extensive theoretical explanation or criticism of Cubism which, later displayed a clearer, more precise development. I think it important to indicate and emphasize the fact that a new era had really dawned with the advent of Cubism: an era in which the word "create" canceled the word "imitate" in painters' lexicons. Cubism substituted a perspective of the soul for that of the eye, which put art back onto the "main thoroughfare."

La Closerie des Lilas

THIS LITERARY CAFÉ is of the greatest importance to me, for it was where I met Jeanne Paul Fort. She was later to become my wife, a fact that determined the course of my entire life. The importance of this café to me is eclipsed only by its importance to the history of poetry. Poets and writers from all over the world made it their meeting place. I am sure that there are still many of these intellectuals and literary figures, in Paris and abroad, who remember it well.

Located on the corner of boulevard Montparnasse and avenue de l'Observatoire, its outdoor terrace is flanked by the smaller rue Notre-Dame-des-Champs. Opposite the terrace in a small, tree-lined square, sits a monument to Marshall Ney—by Rude, I think.* On the other side of the avenue, where the marshall was shot by a firing squad, stands the famous Bal Bullier which was called the Closerie des Lilas before it let the facing café appropriate the name. This is a beautiful area of Paris. From the terrace of the café, especially if you move a little toward the monument, you can look down past the magnificent fountain of horses by Carpeaux, along the lovely tree-lined prospect, to the entrance to the Petit Luxembourg palace. The Closerie des Lilas was above all the café of the Symbolist poets and the literary review *Vers et Prose*, founded and directed by the poet Paul Fort.

The review had existed since 1905, as stated in the inaugural issue, where the aims of the publication are described in these few words: " 'Vers et Prose' proposes to reunite the heroic group of poets and writers of prose who renewed the essence and the form of French literature, reawakening the taste for superior literature and for the lyricism that has been abandoned for so long. . . . Hence, the glorious movement which claims its origins in the first days of Symbolism will continue to exist."[1]

This tells us something about the historical state of poetry at that mo-

*The monument dates from 1853 and was erected on Place de l'Observatoire where the marshall was executed for treason.

[1] Actually, as long as *Vers et Prose* was published, it accepted poetry of all tendencies. Therefore it cannot be said that the review was exclusively dedicated to the Symbolist poets; the same consideration applies to the Closerie des Lilas.

ment. Symbolist poetry, especially in its campaign for innovation and its reaction to academism, was a movement parallel to Impressionist painting, which nevertheless preceded it.

Given this common point of departure, it is evident that the aims and means relative to the two activities only partially coincide, even though the sources of inspiration, in both cases, were equally renewed by direct contact with real life and the real world.

It is likewise important to remember that the poets, just as the painters had done since early Impressionism in raising questions about pure painting, struggled with problems concerning pure lyricism. Verlaine led the poets on this quest; Manet, the painters.

It is not my intention to write a history of art. Nevertheless, these and other brief reflections seem necessary in order to place my story in time.

By 1905, in the field of painting Seurat and Cézanne had already realized their innovations, causing the ambitions and intentions of painters in general to be projected far into the future. Verlaine and Mallarmé had also paved the way, albeit in opposite directions, not only to greater freedom in literature, to a sort of independence of words from their meanings, but to a sublime and unsurpassed poetic plateau. For example, these four lines of Verlaine's verse

Je devine, à travers un murmure,
Le contour subtil des voix anciennes,
Et, dans les lueurs musiciennes,
Amour pâle, une aurore future!*

contain the same spirit for poetry as Cubism has for art: that bare minimum of intelligibility and adherence to the meanings of words or to the exterior aspect of things indispensable for communicating with the rest of the world.

Verlaine and, to an even greater degree, Mallarmé were not concerned about the clarity or intelligibility of their works. What mattered to them was the musicality of words, just as the degree of plasticity and pictoriality of objects mattered to painters. It should be possible to enjoy a poem even if the sense of the words is obscure: the poem ought to be clear inasmuch as it is a poem. A beautiful painting, said Delacroix, ought to

*I can imagine, through a murmur,
 The subtle contour of ancient voices,
 And, in musical glimmers,
 Pale love, a future dawn!

be recognizable, even at a distance, when what is represented is not discernable.

This was emblematic of the general mentality and atmosphere of the era which have not, at least in substance, changed much since then, for they are basic ideas upon which subsequent generations can build.

Before the Closerie des Lilas, the Café Vachette (on the corner of boulevard St. Michel and rue des Ecoles) had been the meeting place where poets gathered around Moréas. At the same time, reunions were held at the Deux Magots Café on Place St. Germain, where the leading character, if he can be called that, was Alfred Jarry. Paul Fort also went there, as well as Moréas, Guy Charles Cros, Fritz Vanderpyl, and especially Rachilde, the writer who aided Jarry in his sometimes dangerous pranks. These gatherings were always characterized by Jarry's legendary eccentricities. I never had occasion to meet this writer whose mischievous nature, when carried to an exalted plane of poetics, I staunchly admired. He died in 1907, when I had been in Paris for only a year and was struggling desperately to keep my head above water. But I heard so much about him, at the Closerie, from Rachilde and from my mother-in-law, that I felt almost as if I had seen and known him personally.

He was considered a "fumiste" by many, which is a Parisian way of saying "a practical joker." He often wore women's blouses decorated with lace and embroidery; he would drink strange concoctions of liquor, insult customers entering a café, and even go so far as to shoot bullets into the ceiling, and not always into the ceiling. But in his mind, all of this was part of the Ubu personality, his imagined, metaphysical, mathematical construction of the character he yearned to represent in its natural state.

Alfred Vallette, publisher and editor of *Mercure de France* who loved and respected him, said in an article written upon the occasion of his death: "He created according to his imagination and to the laws of a rigorously mathematical nature."

Literary scholars specializing in the history of this period of French literature will surely recall Jarry's posthumous work, "Gestes et Opinions du Docteur Faustroll, Pataphysicien, Suivis de Spéculations."

This work is about the "surface of God" seen as a geometric-mathematical problem. Step by step, he arrives at the identity:

$$\infty - 0 - a + a + 0 - \infty$$

and at the definitive conclusion:

God is the tangent point between zero and infinity
Pataphysics is the science . . .

Later the Surrealists would adopt this same duplicity of joking and
being terribly serious.

One greatly impressed with Jarry was Marinetti, which says something
in his favor. *Le Roi Bombance*, obviously owing a debt to Jarry, was a
satirical tragedy that he staged in Paris in 1909 at the unconventional
Théâtre de l'Oeuvre. It was a sort of timeless socio-political farce, a cari-
cature, nonetheless, of today's parliamentary system. The characters are
all ironical and overstated. From what I could gather later from those at
the Oeuvre, Marinetti had succeeded in presenting an absurd drama, per-
haps short on human intensity but nevertheless picturesque and lively.

In any case, Marinetti's farce was useful in presenting Italian literature
to a French audience. To be honest, he devoted a great deal of energy to
introducing Italian poetry onto French soil, aware of its inferior reputa-
tion compared to that of Paris. He translated Giosuè Carducci and Gio-
vanni Pascoli, whose works often appeared in *Vers et Prose*. D'Annunzio
and Ricciotto Canudo, who lived in Paris, did not need to be translated as
they wrote directly in French. These then, along with Marinetti, were the
Italian collaborators of *Vers et Prose*, and were also its faithful sub-
scribers, together with my dear, young friend, Sergio Corazzini. This goes
to prove that, in spite of his tender age, he considered it important to keep
up with contemporary French poetry.

Before becoming a literary café, the Closerie des Lilas was a poor little
place frequented mainly by office clerks and a generally lower middle-
class clientele. Around 1909, or rather in the winter bridging 1908 and
1909, the *Vers et Prose* poets began to hold their weekly "Tuesday soi-
rées" there, gathering around Paul Fort. Not all of the review's collabora-
tors went to the Closerie. Many esteemed poets, either because they lived
outside Paris or for other reasons, came only on rare occasions, if at all.
Among these were Francis Jammes, Pierre Louÿs, Albert Samain, Mal-
larmé, Jules Renard, Verhaeren, Maeterlinck, André Gide, Paul Claudel,
etc., but a large number of remarkable poets and writers were faithful
habitués of the spirited "Tuesdays." They created that unforgettable at-
mosphere that still today is recalled wistfully and with nostalgia.

One of the more important, famous habitués was Gustave Kahn who,
together with Jules Laforgue, was then and is today considered the father
of "free verse," despite the fact that Verlaine's poetic license, his theory of
the musicality of words, and verses of unequal rhythm, had paved the

way. Jules Laforgue sparked great interest in the other poets and was
often the subject of their conversation, although he did not himself come
to the Closerie. It was said that he meant to express his poetic thought
without "deforming" it; hence the origin of poetry emancipated from the
rigors of prosody. A step ahead of the Surrealists and for the same poetic
reason, he strived for a sort of automatism, a spontaneity originating in
the Unconscious. Perhaps this caused him to be considered a decadent
soul, and perhaps it was in response to Mallarmé who, at that same time,
conferred poetry with such a full, clear awareness of itself that Laforgue
wrote these notes, published in *Vers et Prose*:

> But the unconscious does not lie solely in the realm of infinitesimal percep-
> tion. That monstrous force which guides me! The force that shapes and
> develops me according to my nature! The property that heals my hand
> when it is wounded! The force that drives me to implore things, I know not
> what, of women, of the opposite sex! etc. To discover instincts without,
> wherever possible, any deliberate calculation, fearful of making them devi-
> ate from their natural course, of influencing them.
>
> Everything today is predictable, directed toward the exclusive cultivation
> of reason, logic, and awareness.
>
> The blessed culture of the future and the annihilation of culture, laying it
> to rest.
>
> We are heading toward desiccation: leathery skeletons that are ratio-
> nalistic, anatomical, with eyeglasses.
>
> Brothers, let us turn back to the great basins of the Unconscious, and let
> us mix this Jordan, whose baptismal water on our foreheads "all the per-
> fume in Arabia" could not cancel, let us mix this Jordan with the Ganges of
> our ancestors.
>
> The prevailing tendencies of laziness, of inebriation through dreams or
> artificial paradises, ease our consciousness (anguish, doubt, awkwardness,
> etc.) nowadays.[2]

I insist and linger over the transcription of this apology to the Un-
conscious because, later, it became one of the cornerstones of the for-
mation of those important poets called Surrealists. Furthermore, they
never seemed to recognize Laforgue as one of their major inspirations. I
think it important to once again emphasize that particular environment
created by poets and artists. It was an atmosphere saturated with the
fervor of discovery, with a burning desire for innovation and revolt. The

[2] *Vers et Prose*, vol. 3, September-October-November 1905.

most noble, exalted aspirations inhabit the hearts of poets, who are eager to guide the human mind and poetic soul to the highest pinnacles of creation.

Besides Gustave Kahn, poets like Guillaume Apollinaire, André Salmon, Maurice Raynal, Roger Allard, Hourcade, often visited the Closerie. They were all, at the same time and each in his own way, defenders of modern painting and sculpture. Elderly Georges Izambard (Rimbaud's professor of rhetoric) came, and Francis Carco, Fernand Divoire, François Bernouard, Henri Hertz, Ruben Dario, the Argentinian poet, O. W. Milosz, Lithuanian poet and a close friend of Paul Fort, Léon-Paul Fargue, Rosny Aîné sometimes, and many other prominent writers and poets such as Saint-Pol Roux, Fontainas, Stuart Merrill, Jules Romains, Maurice de Faramont, Saint Georges de Bouhélier, Hans Ryner (the prince of narrators), Carlos Larronde, Mercereau, Henry Spiess, etc. In addition, the painters Metzinger, Gleizes, Le Fauconnier, Diriks, the Villon brothers, Marcel Duchamp, Léger, the Roumanian sculptor Brancusi, and the Italians Brunelleschi, Mazzei, Rossi, and Giannattasio.

In the midst of so many poets, the pure poet, the "integral poet" as Maeterlinck called him, was Paul Fort. He had structured his own prosody somewhere between the Alexandrine and free verse; a rhythmical, musical prose as it was then described, from which poetry freely gushed, yet was, in its own way, orderly. Poet of youth, spring, and romance, rarely had such a spontaneous accord between nature and art, and rarely had such a rich abundance of poetic talent been seen.

Universally loved and respected as later shown by his designation as "Prince des Poètes," many saw in him the perfect union of so many poetic intentions and possibilities, more or less clearly expressed, before they were expressed by the Symbolists, by Laforgue and Rimbaud. So much was this so that when the Fantasist group of poets emerged in 1913 (Salmon, Apollinaire, Fagus, Klingsor, Jean Pelerin, Divoire, etc.), Francis Carco, given the responsibility of introducing them in Vers et Prose, hailed Paul Fort as the first of the poets to be discussed.

He was truly the center of the group that crowded together at tables, around him, his wife and his barely fourteen-year-old daughter. The conversations and discussions in that overcrowded café were always animated. Foreigners passing through, friends of the habitués and their wives, came and went, so that not a moment passed without some sort of excitement or commotion. On that particular day of the week, the usual upper-class clientele were frightened away.

My first visit to the Closerie was not on a Tuesday. Marinetti, on his

way through Paris one day, insisted on taking me there. I knew the café by name (and many of its customers as well), but had no desire to go there myself. I liked my Montmartre neighborhood better and was not eager to meet too many other people in the art world.

Besides, many of those same people attended the openings of the Indépendants and the Salon d'Automne. Some, like Gris, Carco, Apollinaire came to Montmartre from time to time. The slight compatibility that Picasso and I felt with the Montparnasse crowd stemmed from the fact that we considered many of its members typically anachronist bohemians, of the Romantic kind straight out of Mürger, with long hair, etc. In truth, we, too, were bohemians, but a more up-to-date version in blue or brown overalls, and peaked caps, or else in our classic dark suits and melon-shaped, bowler hats. At one time I possessed only one pair of overalls, the cord shoes called espadrilles, and a tuxedo with its companion evening "slippers."

Marinetti took me to the Closerie one uncrowded evening. The customers were primarily middle-class and, out back in the second room, Paul Fort sat with his family and a few friends.

Marinetti, in a typically rude Italian manner, left me alone for ages in the front room to smoke my pipe over a cup of coffee, until one of the ladies, Madame Paul Fort I think, as much out of curiosity as from politeness, reminded Marinetti that he had kept me waiting long enough. I was called in and Marinetti introduced me to the group which greeted me very cordially.

Paul Fort, a large, trim, dark-skinned, dark-haired, and dark-eyed man, was really a classic character, who radiated endless energy, vitality, and intelligence. His own self-portrait closely resembles him:

My eyes, like two black diamonds, shine
beneath my Rembrandt hat; my overcoat is
black; black my gleaming patent leather shoes.

Black hair cupping my pale cheeks. A long
drooping Valois nose. And blooming with malignity
I have the stiffness bestowed by pride.

A false smile, a sincere gaze (the fault of Nature too!),
and I've the look of a hedge-trimmer
when chatting with a pseudo-friend.[3]

[3]Paul Fort, "Paris Sentimental, ou le Roman de nos Vingt Ans," *Mercure de France*, Paris, 1902.

Despite his long hair and Rembrandt hat, I liked him immediately. The whole group was very nice. His daughter, then fourteen (in 1911), was a beautiful young girl with two black braids to the right and left of a perfectly oval, dark-skinned, expressive, and vivacious face, like her father's. She already showed a strong temperament, a decisive, serious, willing personality, a tendency toward action. I certainly never thought, at the time, that she would become my dear, lifelong companion.

The family circle included several persons who took no active part in the art world. Nevertheless, these people always participated in the Tuesday soirées, as much members of the group as anyone else, I realized later.

Madame Ricou attended with her two sisters, Madame Dugas and Mademoiselle Marthe Roux, a girl only slightly older than Paul Fort's daughter. Madame Ricou was thirtyish, of pleasant and up-to-date appearance, especially well-versed on all the latest facts, lives, and affairs of the poets' wives and/or companions. Together with the married sister and Madame Paul Fort, they were more thoroughly informed than the police. So full of high spirits were they that they never imagined themselves bored.

A certain Crémnitz was also there, a large, devilish character with red hair, rabbit-like eyes, a nice man but always drunk. No one was sure of his profession or why he attended those gatherings, but everyone had adopted him anyway. That night I suddenly understood the "intimate mood" of the Tuesday literary evenings to which I was so courteously invited and which I promised to attend in the future. In fact, when I did go, I found them so pleasant and interesting, that I, too, became a regular participant.

Do not imagine that all the conversations at those gatherings focused on the arts or poetry. Not at all. News of budding or terminated romances, affairs, and flirtations of all sorts took precedence over everything else. Business was another topic of much discussion, as well as many of the most trivial subjects. Never, if not jokingly, did I hear anyone talk about politics.

Once in a while, to bolster interest, a Tuesday would be dedicated to an individual poet, sometimes a foreigner on his way through Paris. On those occasions, special written invitations would be sent to all the friends, artists, and poets, and the crowd would be even larger.

There were also parties, such as that at Epiphany called the "Fête des Rois," and at Mardi Gras and Jeudi Gras. Many delectable, flat round cakes were made for the "Fête des Rois" according to Parisian custom.

They were made of buttery pastry and inside each, as tradition would have it, a little porcelain figure called a "baigneur" was hidden before baking.

The cake was sliced and handed out. Whoever found the "baigneur" in his slice became king and was obliged to choose a queen, or, vice-versa, were the lucky recipient a woman, she had to choose a king. This was occasion for a great deal of drinking, and many glasses of beer and innumerable bottles of wine were consumed in interminable toasts. I attended one of these parties in 1912, once I had became a true intimate of the group. The recollection of that evening still amuses me, for the poet's very clever daughter who was carefully distributing the slices of cake, by some obscure trick managed to make me king, then king of kings, and of course I chose her as my queen each time. We put the crowns of gilded cardboard on our heads and were honored by all like real sovereigns. The previous year, the king of kings had been Saint-Pol Roux, who, that night, had offered champagne to everyone present. Unfortunately, I could not match his generosity, but no one took offence and we all had a marvelous time.

The Carnival parties were amusing too and those lunatic artists and poets always fabricated wonderfully original costumes and masks. At the 1912 Mardi Gras, as I recall, the poet's daughter was dressed as a "squaw," and with her dark skin and black braids, the costume became her perfectly and she was absolutely beautiful. Everyone in the café danced on those nights, and the whole place was decorated with garlands and multi-colored paper chains. There was an atmosphere, where the light of youth irradiated even the faces and expressions of the most elderly participants. Madame Paul Fort and Madame Kahn, Madame Ricou, her sister Madame Dugas, and their contemporaries presided over these parties with an air that the grandes dames of the Champs-Elysées would have envied.

To be quite honest, I must admit that between the day of my first visit to the Closerie and that of the 1913 Jeudi Gras party, my friendships and intimacies with many of the regulars had become more intense, especially with the little Jeanne Paul Fort. I had never before felt the immense danger of seriously falling in love. Having for once and all established that a vagabond adventurer and miserable soul like myself would not fall in love, I thought myself impervious. I later had to admit that certain apriorisms, like all presumptions, mean little in the face of life, which sweeps them away with no more than a tiny puff of wind. Jeanne, whom I can now call by her given name, was an obstinate, unmannerly young

lady, with whom it was impossible to reason for more than five minutes without a quarrel. She would bicker with everyone at the Closerie, yet everyone adored her. They considered her the princess of the Closerie, not only because of her father, who had succeeded Verlaine, Mallarmé, and Léon Dierks to the rank of "Prince des Poètes," but because of her own charm, albeit rough-edged and prickly, which revealed a strong personality that distinguished her from all the others. Needless to say, we quarrelled innumerable times, since I do not have an entirely docile nature either. But our arguments, evidently, were part of the strategy of all lovers. So, one fine day, we decided to get married. It was around Mardi Gras in 1913, as I recall. Jeanne was dressed this time as a Chinese Mandarin maiden in a very flattering costume. We were dancing serenely and blissfully alone, on the crowded floor, when Paul Fort, also paired off with one of his lady friends, glided by and murmured, "It would seem, dear Severini, that you plan to marry my daughter." I was flabbergasted and he, laughing at my embarrassment, danced away saying, "We mustn't be too severe with Severini." Upon recovering, a good five minutes later, Jeanne and I had a good laugh over this and then made the announcement to all our friends and everyone celebrated with great expressions of affection and many toasts. It is curious to note that, twenty years later, my own daughter, Gina, behaved in a similar fashion; this was not to make a point, but rather was dictated by circumstances.

Among the most bohemian poets at the Closerie was the group of self-proclaimed "Compagnons de l'Action d'Art." They published a little bimonthly newspaper called *L'Action d'Art-Organe de L'Individualisme Héroique*, in which they expounded their not entirely uninteresting ideas. Everyone at the Closerie liked them, yet their theories were not taken very seriously. The group was composed of Atl, Banville D'Hostel, André Colomer, René Dessambre (the last two were brothers and Colomer would be killed in action in 1914). Other young members were Gerald de Lacaze-Duthiers and Paul Dermée, later involved with *L' Esprit Nouveau*. Without doubt their ideas more or less coincided with those of the anarchists, nevertheless their anarchy was of a particular sort. It was, in any case, a movement that placed the aesthetic side before the social one in problems that concern Mankind. According to the anarchistic principle, they had structured their movement on the basis of absolute independence and absolute individualism. They called it the "Aristocracy" to distinguish it from the "Mediocracy." Their ideology

was also based on a passionate research on existence, in the ontological sense, and therefore an intentional harmony between the physical and the intellectual. Despite an amorality more apparent than substantial, they tended toward the ethical and the spiritual; in fact they regarded life as a work of art. Like the anarchists, they struggled against society's established hierarchies, however these might be organized, and claimed that society was classless, that there exist only people who are "for Beauty" and those "against Beauty." In the former category were the "free" spirits who look toward towering summits, while the latter group was comprised of souls destined to "slavery," their eyes on the ground. Even if such ideas seemed like preposterous dreams and adolescent utopias at first glance, these young people had totally dedicated their lives to this end, a fact that warrants a certain respect. And, after all, is applying an aesthetic standard to each of our activities, or to everything, such an absurd principle?

Shifting the problem to the moral plane, and using the same principle as a basis, the Russian philosopher, Leontiev, saw "good" in "beauty" and "evil" in "ugliness." "As far as the criterion is concerned, aesthetics is applicable to everything," he says, "to minerals as to Mankind. Consequently, it is applicable to human society, to problems of sociology and of history."[4]

In opposition to the democratic ideas of equality, they launched these aphorisms of the complete Ego: "All men are unequal," "No two beings are identical," etc.; this coincided with the moral doctrine of the religious Russian philosopher, a moral of inequality, a moral of life and beauty and Christian spirit. At that time our young friends were not familiar with the philosopher Leontiev (nor was I), but we all knew Nietzsche, and no one would deny his paternity. Moreover, Marinetti, also inspired by Nietzsche, would sketch out with Futurism a few years later a theory of

[4]Constatin Leontiev, Nicholas Berdiaev, Editions "Les Iles," Desclée de Brouwer, Paris. These aspirations toward a "society" organized so as to give culture in general, art and therefore "beauty" in particular, a predominant role, can also refer to the concept of a state that is artistically perfect (aesthetic state) as predicted by Schiller; or to the idea dear to Goethe, of a harmonic organization of the universe in which there exists collaboration between life and culture. It is true that these two great Germans thought in terms of Germany as the basis for such concepts of social perfection. It seems to us that they could be extended beyond the borders of one nation or one nationality. Especially at a time when we are faced with the proposal of an exclusively economical and technical internationality, an internationality in which even transcendent elements, among which beauty, play a role, it might better satisfy that eternal human need for justice and perfection.

the supremacy of the aesthetic, but unfortunately for him, it became a matter of aestheticism and literature.[5]

Despite my best intentions to limit these transcriptions to events rather than to ideas, I cannot seem to restrain myself from brief lapses into quick descriptions of ideas, in an endeavor to provide a clearer sense of the atmosphere in which these events took place.

Such, then, was the atmosphere of that café, famous worldwide and in the history of poetry. I am afraid that I have failed to paint a sufficiently realistic picture, for it was so very vibrant that it is difficult to describe, and for this reason so influenced and attracted the poets and artists of the era.

However, in Italy especially, there are many unable to assess correctly the effectiveness and importance of such a milieu, which is infinitely more functional than any academy ever could be. Many of these same people, some of whom I heard with my own ears, believed that something equivalent could have been created in Italy. I disagree. First of all, such a large group of talented people had not been seen in Italy since the Renaissance. Second, such a flowering of poetry and art, for thousands of reasons that are synthesized in the word "civilization," could only have taken place in Paris.

But to experience the real impact of Paris, it is not sufficient to travel there "as a tourist," to go there and stand off in the wings as a spectator, and a hypercritical spectator at that, who finds nothing to his taste. It is necessary to enter that world—and become a real part of it—not just in appearance. Then one is a Parisian, and belongs to Montmartre or to Montparnasse, even if born at the North Pole.

Many of my Italian acquaintances came as tourists. Many artists were disaffected spectators, locked inside themselves. They stayed in Paris just as long as their money held out and then went home. What do such people know about Paris? Among the artists of our generation, only Modigliani and I really knew Paris, for we endured real suffering there. He died in that city, and I can say that I accompanied most of my Italian friends to the train station. More than once I was obliged to return all the way home on foot from the Gare de Lyon, not having sufficient funds for

[5]Basically, these so-called "aristocrats" were the most direct precursors of Futurism, as their first manifesto, called the "Mouvement Visionnaire" dated from 1907 and Marinetti's first manifesto, from 1909. In the ideas they expressed, they claimed it necessary to resort to violence to defend "the dignity and the pride of art." "Long live violence against everything that makes life ugly," was their battlecry. In a pamphlet by Mino Somenzi, even Futurism is called "Artecrazia."

the metro, smoking the last cigarette that my departing companions had left me.

"Tuesdays" at the *Mercure de France* coincided with the "Tuesdays" at the Closerie. The former were held on the second floor of the building where the review was compiled, on rue de Condé. Rachilde's* salon was something out of the 1830s; it seemed as if ladies with Empress Eugenie hairdos should be arriving any minute. But if hairdos and costumes from that epoch were missing, strange styles of dress were certainly on view. Madame Huot was unforgettable, dressed as a lady-in-waiting to Catherine de' Medici, or else, Madame Catulle Mendès, her face so thickly painted that she seemed inhuman, sitting under an enormous hat. Rachilde herself, in recognition of the *Mercure*'s purple bookjackets, by that time a trademark of the review, always dressed in a lot of that color, and she too, wore a sort of medieval bonnet, very flattering to her. In a strident, acid voice, she would hurl strange, paradoxical phrases across the salon, which brought any private conversation to a halt and provided the topic for more general discussions. One went to the *Mercure* after five in the afternoon. At about six, one would climb the narrow staircase to the floor above, and there, awaiting the visitors would be one of the most bountiful, elegant "buffets" imaginable.

These "Tuesdays" had a great historical importance—first, because the *Mercure* was one of the most serious, important literary reviews of the time, and second, because the personalities most in view, foreign or French, those of the highest caliber, controversial or not, were involved with the *Mercure* and this salon.

"Right bank" and "Left bank" elements mingled at these "Tuesdays." In short, all of the "Paris that counted," in high society or literature, attended them. I saw Yvette Guilbert, Princess Bibesco, Apollinaire (of course), and Francis Jammes, Henry de Régnier, Valentine de Saint-Point, the Swiss, Dumur, Mademoiselle Monnier, a very intelligent young lady who later opened a bookshop on rue de l'Odéon which became a center for literati. Naturally, Marinetti would come to the *Mercure* on his trips to Paris, and was warmly welcomed and honored by the ladies, for he was an amusing and handsome man.

I met Rachilde at the banquet offered by Gustave Kahn in honor of the Futurist painters after the opening of their show at Bernheim's. I was seated to the right of the novelist and she, as always, dominated the

*"Rachilde" née Marguerite Eymery (1860–1953) was an early feminist author and critic, and wife of Alfred Vallette, founder of *Mercure de France*.

conversation with her devilish "verve." I never heard, even later when I was familiar with literary circles, more spirited fireworks, radiant in all senses. I listened to her in such a state of amazement that I forgot to eat or to pour wine for her; in short, I behaved like an ill-bred bumpkin. I must confess that I had never seen such a banquet. That night, Rachilde invited me to the "Tuesdays" at *Mercure de France*, and from then on, I was one of the fortunate guests. It was not easy to obtain an introduction or an invitation, as Rachilde was a highly capricious, difficult woman.

In Touch with Futurism

HAVING RECEIVED practically no news from Boccioni since his return from Russia, I was glad when a letter arrived from him, in 1910, I think. He wrote me about Futurism and about Marinetti. My friend Lugné-Poë, director of the Théâtre de l'Oeuvre, had often spoken of Marinetti; his play, *Le Roi Bombance*, had been staged earlier at the theater. But I knew nothing about Futurism as a collective movement. Boccioni spoke of it enthusiastically in his letter, and then described his plan to create a comparable movement in Italy for painting.

In fact, a preliminary manifesto had already been signed by Boccioni and other Italian artists I did not know. Quite frankly, I have never appreciated that sort of overt display. Moreover, it would have been inappropriate in Paris, where each artist was free to work as he pleased and to decide whether or not or where to show his accomplishments. It was simply a matter of taking or not taking works to the Indépendents show every year, or else trying to sell something through one of the dealers. At that time, our only advertising was in the form of a few pictures hanging at old Monsieur Sagot's shop on rue Lafitte or at Mademoiselle Weill's in Montmartre. It was probably Futurism that gave rise to the demons of over-advertising and journalistic demagoguery, which came to plague artists. But, at that point, Boccioni's enthusiasm and good faith were sincere and, from all points of view, admirable.

He wrote several letters keeping me informed and up-to-date. As I had talked to various Italian friends about this movement (Cominetti, Bucci, etc.), he also entrusted me with the delicate task of selecting those artists who were, in my opinion, suitable candidates to join the group. He wrote:

> Dear Gino, I am writing to ask you *secretly* (!) for your opinion whether those names that follow Cominetti's signature in the letter to Marinetti are appropriate to sign our manifesto.
>
> We trust your opinion completely. But I have to warn you that the signatures must belong to young artists absolutely convinced of the affirmations in the manifesto.
>
> They must adhere to it unconditionally and without any intellectual reservations. It is essential that the intellectuality designating the complete

Futurist be securely welded to an absolute faith in *congenital complementarism*. We need young men (and few such exist) of sure faith and abnegation, highly cultured and active, whose works, while allowing for a certain amount of uncertainty, clearly demonstrate an aspiration to that comprehensive perfection marking the radiant path toward ideals. . . . May I remind you, in the name of our entire group, to exercise the greatest severity in your decisions. . . . We have already refused candidates by the dozen, including Dudreville, whom you know.

He then reported news of certain mutual friends, such as Balla, our former mentor:

Balla in Rome, discouraged about some faltering paintings, but still strong. He is being suffocated! Three years without a sale, he is forced to give lessons and is almost starving!!

I haven't seen Costantini, but am told he is thriving.

Sironi completely crazy, or at best neurasthenic. Always soul-searching and always locked in the house. He doesn't have anything to do with women any more, doesn't talk, and has stopped studying! It's really painful. He was on the verge of being shut away in a clinic. Just think, his house is full of plaster casts, and he copies a Greek bust from every possible angle twenty or twenty-five times in a row!!! He disapproves of us, of course.

My opinion of all the artists who had written to Marinetti was negative. I had talked this over with Modigliani, the only person I would have liked to see join our group. He was against such manifestations, and found congenital complementarism laughable. He was right; he advised me, instead of adhering, not to become entangled in these matters. But I felt too strong a fraternal bond to Boccioni and was and always have been ready to embark on adventures, innovations, so I wrote to Boccioni telling him to add my signature to the famous manifesto. I also told him that I considered Divisionism, to which he was very attached, still and more than ever my idiom. In fact, after having successfully penetrated, in a literal and spiritual sense, the work of Seurat (the principal object of my journey to Paris), I had started to divide forms the same way that I divided colors. I told him, too, that I was glad to see that this resulted in wholes that were totally new and not in the least arbitrary.

This manifesto eventually appeared in Paris, in French (1911, I think), but failed to arouse the success that the painters in Milan had anticipated. André Warnod made fun of it in one of his drawings for *Comoedia*, and the Milanese Futurists mistook this demonstration of solidarity (in which

the taste for jokes and witticisms played a large role) for proof of specific interest in the movement. The art world had a good laugh about the whole thing, and I was not spared their jibes! Modigliani was fierce; as for Picasso, with whom I later discussed it, his opinion is easily imagined.

Meanwhile, Boccioni had convinced Marinetti to organize an exhibit in Paris. At the same time, the signers of the manifesto, Russolo and Carrà, whom I did not know, and Boccioni and Balla, toured Italy, holding conferences in numerous cities that inevitably ended with the audience hurling rotten fruit and insults at them, and actual scuffles. I was very glad to keep my distance and not have to participate in those jousting matches, but was immensely amused by Boccioni's reports of them in his letters. Nevertheless, the Milanese Futurists held their first exhibition in Milan, at the art-oriented Intima della Famiglia, and a second at the open art show in the Ricordi Pavilion. As could be expected, they caused a scandal and would have been delighted by it had not Soffici written an article for *La Voce* in which he panned them unmercifully. Soffici was the sole Italian painter in any position to criticize them. He had been to Paris where he had met the most daring and modern of contemporary painters. He had written about painting in general, and about modern painting in particular, in intelligent and often profound articles that in any case were always full of good sense and based on a solid, clear sense of history and aesthetics. Therefore, in Italy, as far as the intelligent public was concerned, his opinion was law. Of course, Soffici, who was acquainted with Cézanne, Van Gogh, Gauguin, Matisse, Bonnard, and even Picasso (even though it was during his Pink period when he was painting acrobats), thought that the Milanese exaggerated in proclaiming themselves the world's most daring painters, and that, compared to all the French painters mentioned, they were actually not very interesting or innovative at all. Several articles to this effect appeared in *La Voce*, attacking the innovative Futurists who, in turn, were intensely irritated.

Because of this, they decided to go to Florence to demand an explanation for such hostility in person. Theirs was in truth a punitive expedition which Boccioni described to me, and later, Soffici. Upon arriving in Florence, the Futurists went to the Giubbe Rosse Caffè where they were sure to find Soffici, Papini, Prezzolini, Slataper, and all the editors of *La Voce*. Boccioni asked one of the waiters, "Which one is Soffici?" Once he was pointed out, Boccioni approached Soffici and without the least explanation, slapped him twice. In no way deflated, Soffici rose and responded with a string of punches. General commotion ensued, with tables and chairs overturned, broken glass, and plainclothes officers who carried ev-

eryone off to the police station. Luckily, they were taken to an intelligent inspector who understood the kind of people in his custody. As Soffici and the others from *La Voce* decided not to press formal charges for the aggression, he dismissed everyone as if nothing had happened.

Once the Futurists had evened the score, they went to the station to catch a train back to Milan that was leaving more or less immediately. But the Florentines from *La Voce*, despite having honorably defended themselves, were not satisfied, and they too hurried to the station. Just as the train was about to pull in, another fracas started up, and another brawl erupted that nearly prevented the Futurists from catching their train. They managed to board it somewhat bruised, but satisfied.

While this was taking place in Italy, I was at work on my large canvas, *Pan-Pan à Monico*, where my decomposition of forms and colors was becoming progressively more defined. The painting was taking shape, but I still struggled with thousands of material problems. I hesitated to sell my small canvases for next to nothing (as I had done in the past), because of the coming exhibition, and because it was a period of hostility toward painters of the so-called avant-garde. I lived a hand-to-mouth existence and, even worse, owed at least two back payments on my rent (rents in Paris were paid in three-month periods called "termes"). The landlord wanted to evict me, but wherever could I have gone with that huge four-by-three-meter canvas? Besides, I was very fond of that studio on Place Pigalle, primarily because of my immediate neighbors with whom I had established cordial, friendly relations. Second, it was a strategic location for the sort of life I was leading. My slightly more distant neighbors were no less interesting, for Picasso and Fernande had recently moved into a nice studio with adjacent living quarters on the far side of the square, at the beginning of boulevard Rochechouart. Down the street in a building next to Picasso's former studio on rue Ravignan was Juan Gris, and near him, on a little street perpendicular to rue Ravignan, lived Max Jacob in a humid, dark groundfloor place at the far end of a melancholy little garden. The Lapin Agile was not far from his home and, down toward Place Pigalle, along boulevard Rochechouart, was the Brasserie de l'Ermitage where I joined Picasso and Marcoussis every evening. This brasserie, unlike the Closerie des Lilas, was not a regular meeting place for artists or groups of artists, so we were usually alone and untroubled.

The very thought of having to change my present situation even slightly made me utterly disconsolate. So I considered writing to Boccioni in hopes that he could convince Marinetti to lend me the rent money, at least

for the time necessary to finish the principal painting that I wanted to include in our exhibition.

Boccioni, with his usual generosity, undoubtedly defended my appeal as well as he could, but Marinetti did not want to comply with his request, so Boccioni wrote me back saying that even were it to cost me dearly I should get myself to Milan and that Marinetti, seeing me in person, would ultimately relent.

Not that I mean to make insinuations about Marinetti's occasional lack of generosity, especially toward his friends in Milan, but he did often lack discernment about the recipients of his largesse. At times, a person of little worth, as long as he declared himself a Futurist, would obtain more from him than someone truly deserving.

Also, he was already beginning to look at things less *from the point of view of art* or *interest in art* than from that of the effect it produced; therefore *quantity* became more important to him than *quality*. This is a serious observation, for such ways of acting and thinking would eventually have immense repercussions on the arts and on politics too, since all of these Marinetti-like techniques and activities would be adopted subsequently by Fascism.

To illustrate how easily the leader of Futurism would grant his favors, regardless of the real worth of a person, I will tell you the following episode: at that very time an elegant young man calling himself an Italian Futurist poet presented himself at my studio, apparently warmly recommended by Marinetti. He appeared attractive but not likeable. He did not impress me as being particularly knowledgeable about the artform he professed to practice, yet I made an effort to find him a room and helped him to meet certain people.

His principal activity, however, was to follow me to nocturnal "restaurants" where I had a particular and personal entrance pass. He soon used up the little money he had and was turned out of his hotel. He landed on the doorstep of my studio, suitcases in hand. I had lodged many friends there, and it would have been perfectly natural for me to take him in, except that he was not a friend of mine at all. During the time I had spent in his company I had come to realize that he was intellectually and culturally mediocre, and that, in truth, he was shiftless, completely without goals, expectations, or intelligence. He turned out to be yet worse than I feared.

Having made friends with a pretty, regular customer of the Monico who was always arrayed in costly jewels, he decided to steal them from her. He procured some chloroform and waited for her each night at the door of the Monico, offering to accompany her home in a carriage so that he could put a chloroform-soaked cloth over her face and take her jewelry.

But this "demi-mondaine" had seen through him. She graciously allowed him to accompany her, but not alone, and therefore, he could never execute his plan; but I spent many nights fretting anxiously, fearing to see him arrive sooner or later with the stolen jewels, and that I might have to bear the consequences with him. I really did not know how to get rid of this strange, stupid poet, and scoundrel to boot, when Boccioni's advice relieved me of the embarrassment. I managed to collect enough money for the trip to Milan, closed my studio and left Paris. I never heard another word about that individual.

Boccioni's idea had already had this one good result, but also had two other equally good ones: full satisfaction for my request to Marinetti, plus a trip to Paris for three of my friends, a trip they sorely needed.

As I said, I did not yet know the signers of the manifesto Carrà and Russolo; this was our first encounter. I thoroughly liked Carrà, with his air of a socialist parliamentarian, small and squat with a serious, gravelly voice and a discursive logic that was always lively and somewhat elementary. Russolo too, I found very likeable, with his subtle ways I would call almost convoluted. Just as Carrà was stocky in his appearance, in his speech and thought, Russolo was made like a spiral inside and out. But his intelligence was subtle and considerable.

I was very curious to see the works they were preparing for our future exhibition, which were totally unknown to me; however, I found them disappointing. Not that they were lacking in talent which, actually, was varied and abundant, but because they were all working along lines closer to Jugendstil than to Cézanne or Seurat.

Pictorially speaking, my three friends had different physiognomies. Carrà and Boccioni, especially, were seriously talented painters, but none of the three was in the least aware of the modern painting movement. It was evident, and this was also clear in the ideas disclosed in the manifesto, that they looked to their subjects for the innovative contribution to art, while from Cézanne on, in Paris, painting itself had become the new, original element.

Boccioni painted with a Divisionistic technique located between those of Previati and Segantini, therefore very objective, not musical and free as that of the French Neo-Impressionists. He was convinced that he had found a key subject with his three paintings he called "States of Mind" and that represented *The Farewells*, *Those Leaving*, and *Those Staying Behind*. This was an eminently literary sort of painting, executed in an unsure manner, and the pictures could just as well have been called *The Flood* or *The Shipwreck*. In those past twenty years of painstaking efforts in the art world, such uncertainties of expression and technique, which

lent themselves to various ambiguous readings, became rather fashion-able. However, Boccioni was not responsible for the interpretation and exploitation of his research by interested parties and artistically un-cultured people.

As for Carrà, the subject of his key painting, *The Belfiore Martyrs* was political—four or five gallows with bodies that stood out against a red sky. Carrà's serious pictorial talents have always suffered from the influ-ence of his early familiarity with and observations of Grosso and Tallone, two essentially Lombardian painters. Carrà is still painting like Tallone today, but then, his *Belfiore Martyrs* also reveals the clear influence of the Munich school.

The least pictorially gifted of the three was Russolo. The most impor-tant painting that he showed me was titled *Music*—a large canvas, with seven variously colored masks, against a blue background, as I recall; symbols of the seven musical notes.[1]

I then realized that Soffici's severe articles had been based on serious premises, and suddenly I imagined how an exhibit of such paintings would fare in Paris.

I told Boccioni, with whom I was especially close, my point of view and made him understand that it was absolutely imperative that they come to Paris to see first-hand the directions they should be taking.

Boccioni was convinced, in turn convinced the others, and all together we convinced Marinetti who decided to offer them a two-week visit to Paris. I obtained my loan for six months of back rent and a good supply of paints. I returned to Paris alone, but my friends were not long in joining me.

It is impossible to imagine their joy, their surprise and astonishment at discovering a world of painting of whose existence they never dreamed. I took them to see my neighbors, then to meet Picasso, and then every-where else they could see modern paintings and modern painters. Parisian life itself delighted them. They were very sad on having to depart, but left au courant and full of ideas and knowledge, and they could not thank me enough.

The visit to Paris impressed Boccioni enormously, even more than-Carrà and Russolo. Thanks to my hospitality, he was able to stay eight or ten days longer than his companions and delve deeper into the art world with which I associated. One thing is certain, upon his return to Milan he set to work with immense fervor. But with him, periods of great enthusiasm were often, almost always, followed by others of pro-

[1]The previous year, in 1910, Matisse had painted his large canvas, *La Musique* which is now in the New Western Art Museum in Moscow.

found discouragement. All artists have alternating moments of hope and despair, but I have never seen anyone else slide so far down into the depths of gloom as he.

He had been subject to these crises even when we lived in Rome, and we would walk alone together along the deserted banks of the Tiber, often in a winter fog, examining our souls and beliefs from every possible angle. Eventually he would infect me with his sense of despair, I who tripped through life with a mindless joy, without experiencing extremes of hope or doubt. I went through life because I felt I had to and did not question my actions. I only wished to progress. Sometimes, as I said, he managed to communicate his depression to me and sometimes this led to a quarrel, and violent arguments; they say that Van Gogh and Pissarro also argued like that. When both of us had finally sunk into the depths of black desperation, Boccioni would pull one of his hilarious, clever tricks, and we would laugh insanely until we would find that we had again surfaced from our gloom.

On one of those nights the Carabinieri stopped us, but after we explained the situation, they let us go.

Back in Milan, after his visit to Paris, endless horizons must have appeared in Boccioni's rich fantasies, followed by a period of chaos, confusion, and despair. Neither gruff Carrà nor murky Russolo could be expected to cheer him up. So he wrote to me:

> I am in a strange state of mind: I am coming to life! In my mind I climb to the highest pinnacles of art, while my actual work seems like dung to me! This is a strange period, not entirely bad, but it leaves me fundamentally sad.
>
> I am working hardly at all!!! . . . Men, women, things, everything inside of me is in a state of chaos! I am trudging toward thirty, completely in the dark!!! I who thought I knew so much.
>
> It's like that with painting, like that with everything! Everything is upside down and I am suffering, slowly, slowly, deep inside.
>
> I would like to love intensely yet see the uselessness of it! I would like to work hard and be creative, but fear that I am not high-minded, nor pure enough; it is terrible.
>
> I am alone and empty! Shallow exterior life entices me! I feel that I'm at my physical peak and am sad.

Like all egocentrics, Boccioni was always working himself over to analyze his mind's most insignificant motivations, to bring his most secret feelings to the surface, like certain beautiful women constantly in front of the mirror analyzing the texture of their skin or the tiniest blemish which

they fear indicates the decline of their beauty. By then I knew him well; I knew the large quotient of theatricality in his crises, and did not pay much attention to them.

The heart of the matter was that both he and the other Futurists, after Paris, had their ups and downs but were working hard and, yet more important, had shifted their sights toward new goals. Thus, the "States of Mind" assumed broader and more geometrical forms, and looked entirely different. Carrà too, in such pictures as *Sobbalzi in Carrozza* (*Jolts of a Cab*) and in the others he finally sent to Paris, turned toward a way of conceptualizing the picture and painting that was more Parisian than Milanese. As for the *Martyrs of Belfiore*, *Masks*, and all the prior works, they all disappeared from the face of the earth, never to be seen again. Even Russolo's essentially literary fantasy became more pictorial after his contact with Paris. His *Speeding Train* was very good pictorially; his *Recollections of a Night* together with my *Souvenirs de Voyage* were constituent precursors to the Surrealist school. With these new works, far more interesting and up-to-date than our previous efforts, we opened our exhibition in Paris.

The Futurist Exhibition in Paris

The date of the exhibition was 5 February 1912. It opened at the Bernheim-Jeune Gallery then located at 15 rue Richepanse. Marinetti, with his demagogic and publicity-seeking ways, and Carrà, later in his memoirs, depicted this show as a wonderful success, so I think it time to be frank and set the record straight. Otherwise, what use is history?

The truth of the matter is that, at a time when the quality of art in Italy was at a particular all-time low, these young artists used every possible means to update their knowledge of European artistic activity as it was manifested in Paris. That endeavor in itself deserved praise, not criticism. Their courage to exhibit works in an arena where they would suffer comparison with the best artists of the era, should have earned them respect instead of blame.

Unfortunately it was a mistake and a lack of tact for these newcomers to exhibit in Paris as challengers and antagonists, instead of availing themselves of the many doors already open. They should have tried somehow to fit into the French painting movement already growing more and more European, to put their best foot forward using the paintings themselves, which would have really displayed their fresh intuitions and their true personal worth, instead of manifestos, stormy conferences, and spectacular displays.

It was only natural for their aggressive behavior to provoke reactions, and their ideas, while both good and innovative, to be misunderstood and deliberately undermined. It should be noted that neither Marinetti, nor my Futurist friends, ever made mention of these reactions; on the contrary, they denied them completely (only Soffici would speak of this later). Instead, they talked so much about the exhibition as a success, about the praise in the newspapers, that they ended up believing this version themselves. In an article written for Futurism's thirtieth anniversary,[2] Carrà himself still cited the exhibition's positive outcome and a "flattering" article by Apollinaire. The following are some of the more important excerpts from that "flattering" article:

> The Futurists are young painters who should be recognized, were it not for the arrogance of their declarations, the insolence of their manifestos, which nullify any indulgence that we might be tempted to accord them.
>
> They declare themselves—absolutely opposed—to the art of the extremist French schools, yet are nothing more than imitators of the same. Boccioni's best canvas of the lot is the one most directly inspired by Picasso's latest works. He has even included some of those stencilled numbers and letters that lend such a simple and grand sense of reality to Picasso's most recent canvases.
>
> The titles of Futurist paintings often seem borrowed from scholarly Humanist terminology. The Futurists should be wary of those syntheses that cannot be plastically translated, that lead painters toward the cold sort of allegory typical of the "pompiers."
>
> *Danse du Pan-Pan à Monico*, the most important work to come from a Futurist brush to date, deserves further, closer examination. . . . I am less impressed by Severini's other canvases, overly influenced by Neo-Impressionist technique and by the figures of Van Dongen.
>
> Turning to Carrà, he seems a more vulgar version of our own Rouault, and sometimes resembles the forgotten painter, Merodack-Janneau, in his academism. Russolo is the one least influenced by young French painters. His models can be traced to Munich and to Moscow. . . . These young Futurist painters may vie with some of our avant-garde artists, but for the time being they are nothing more than insignificant disciples of a Picasso or a Derain and, as far as grace is concerned, have not the slightest idea of the meaning of the word.[3]

This is the substance of Apollinaire's "flattering" article to which Carrà referred. However, Apollinaire did dedicate a much more important essay

[2] *Tempo*, 10 August 1939, 3, no. 11.
[3] *L'Intransigéant*, 7 February 1912.

to us, on the same topic and developing the same themes, in *Le Petit Bleu*. Indeed he wrote:

> They (the Futurists) declare, with an insolence that could more aptly be called irresponsibility: "We can declare without boasting that this first exhibition of Italian Futurist painting is also the most important exhibition of Italian painting offered thus far to the verdict of Europe."
>
> This is pure imbecility. It would be ridiculous to pass judgment on such stupidity. . . . Later they (the Futurists) continue: "We have become the leaders of the European painting movement."

I must admit that it takes an immense measure of folly to make such proclamations, especially in view of previous accomplishments by such artists as Cézanne, Gauguin, Renoir, Van Gogh, Matisse, Derain, and even Picasso.

All the same, in this second article, Apollinaire is seriously concerned with the intentions proclaimed in the manifestos:

> The originality of the Futurist school of painting lies in its attempt to reproduce motion. This is a perfectly legitimate endeavor, but French painters have long since resolved this problem, insofar as it actually can be resolved.
>
> So far, the Futurist painters have shown more philosophical and literary ideas than plastic ones.

This is a malicious but correct observation. However, it should be acknowledged that these ideas were not really so contemptible since they later influenced to a certain extent almost all the modern artists, from the best of them to the most mediocre. Apollinaire continued:

> The point where they (the Futurists) veered away from the new French painters is, in my opinion, where Futurist art is doomed.
>
> The new French painters' work distinguishes itself from the academism of the *pompiers* in their violent, persistent observation of Nature. These young artists scrutinize Nature, dissect and patiently study it. So, it should not be surprising that such pure plasticians do not preoccupy themselves with "subject matter" and that their paintings have such generic titles as "painting," "study" or "landscape."
>
> Recently, I have also wondered if such purely plastic preoccupations might not have led to an absolutely new art which would be to painting what music is to literature.

The Futurists are rarely interested in plasticity. Nature does not interest them. They are principally concerned with *subjects*. They are trying to paint *states of mind*. That is the most dangerous sort of painting imaginable. It will lead the Futurist painters straight toward careers as mere illustrators.

Nevertheless, among their ranks is Gino Severini who seems determined to rely on the realities so severely prohibited by the Futurist declarations. By doing so, he has produced the most animated work in which his colors that do not blend at all provide us with the impression of movement. . . . In any case, this Futurist painting exhibition will teach our young painters to become more daring than they have been in the past.

Without that audacity, the Futurists would never have ventured to exhibit their yet so imperfect attempts. . . . All in all, recent French art seems arrested at the melody stage, while the Futurists have appeared to teach us, with their titles and not their works, that it could raise itself up to symphony level.

After some stern reflections on the suppression of the nude, Apollinaire concludes his lengthy article: "As for Futurist art, it makes us smile here in Paris, but it must not make the Italians smile too, for then they would be in real trouble."[4]

These were Apollinaire's ideas on Futurist painting in general, at the time of our first exhibition. Of course, there were many articles in other publications, for example in *Le Temps* by E. J. [Jacques-Émile] Blanche, in *Mercure de France* by Gustave Kahn, in *Gil Blas* by Louis Vauxcelles who, not at all fond of the Cubists, found it amusing to juxtapose the Futurists against them as the more modern and audacious of the two groups. All of this was gossip by journalists or amateur critics, and utterly unimportant. Those articles that did carry some weight were the ones by Apollinaire and André Salmon, who wrote a piece in *Paris-Journal*, similar in content and feeling to that of Apollinaire.

Far from being that "great success" that Marinetti would have everyone believe for reasons of his own, this first exhibit outside of Italy was a severe and well-deserved lesson, despite its repercussions in Paris. As far as I was concerned, the lesson was only partially deserved, for, as Apollinaire himself later acknowledged, my point of departure was indeed Neo-Impressionism. However, the results I derived from it were entirely personal and, even today, independent of any critical considerations, would defy anyone to ignore the traits of a well-defined personality in those works.

[4]*Le Petit Bleu*, Paris, 9 February 1912.

Quite frankly, I was already acquainted with Apollinaire, having met him at Braque's and Picasso's studios and at the Lapin, but we were not yet the good friends that we were to become later. Nor did I intend to force my way into a friendship with him, by inviting him, for instance, to my studio, because of the forthcoming exhibition and out of a sense of solidarity with and sincerity toward the Futurists. After all, having agreed to sign the essays and manifestos, I, too, had to shoulder the consequences.

My friends insisted on treating those kicks in the seat of their pants by Apollinaire and Salmon as praise. Well-acquainted with the art circles in Paris, I knew that they were anything but complimentary. Blinded by the momentary celebrity, they actually believed themselves in possession of all aesthetic verities. The only positive aspects of the exhibition were its air of youth and a decisive orientation toward innovation, which, at least, were real.

A great deal of harm was undoubtedly done by that below-the-belt sort of journalism which, today, ruins everything, and about which my friends were hypersensitive. For example, *Excelsior* published our portraits, a fact that sent Carrà into spasms of joy. Russolo was more reserved. Boccioni, hungry for publicity to the point of being manic, was driven absolutely delirious with pleasure. At roughly eight every evening, working men and women, employees from the department stores and high-fashion houses, all spilled out of their places of employment onto the crowded streets of Paris. Graceful, elegant young girls, known as "midinettes," were on the streets by the hundreds at that time of day. Boccioni would run after them, first one, then another and another, to show them his portrait published in *Excelsior*. His outrageous French and his pleasing, elegant appearance caught the attention and aroused the curiosity of many of those girls. He amused us immensely, especially when he mistook that momentary interest and curiosity for success with the ladies.

To tell the truth, we had a very good time for the duration of the exhibition. I perhaps had the most fun of all, watching my friends' reactions to the intense, varied, and picturesque life of Paris. Led by me, they were received cordially and courteously everywhere by my many friends. I even took them to meet Gertrude Stein (who mentions the encounter in her famous *Autobiography of Alice B. Toklas*, adding that everyone found them boring). They *were* boring really, with their impossible "petit-nègre" French, but Miss Stein, although highly intelligent, was probably unaware of how much more amusing she was in her books than at her parties. In fact, it always amazed me that Picasso, a maniac about inde-

pendence, could put up with her. However, aside from his geniality he, who also had turned tact into an exact science, knew just what he was doing.

In any case, it is true that my friends were not amusing. Their habit of discussing painting, art, and related topics within their closed, isolated group in Milan, and of turning these subjects inside out had led them to create their own sort of dialectic—Boccioni's book, *Futurist Painting* was a result of this situation, as well as many other examples of mediocre critical essays—which they considered wonderful and which instead, was a whole mixture of stale, old arguments: relative dynamism and absolute dynamism, subjectivism and objectivism, concrete forms and abstract forms, congenital Divisionism, all soporific debates. To make matters worse, these things helped enormously to complicate the subject of art. Picasso detested these discussions. "What's the point of all that talk? One paints, and that's all. Painting is painting, and doesn't need all those explanations." That was Picasso's answer to their arguments, stating in another way Cézanne's words on the subject: "Talking about art is practically useless."

One day I decided to take my friends to see Gertrude Stein's brother, who owned several paintings by Matisse and Rousseau. We went to his house but, either we had arrived too early or else he had risen late, we found him bare to the waist, sitting in a sort of wooden frame on the ground, seriously rowing, as if he were really afloat. The Matisses and Rousseaus were hanging on the walls all around us, but my friends, especially Boccioni, were trying so hard not to laugh that they got very little out of that visit. We left soon afterward and returned to Montmartre.

Despite this success as "curiosities" understandable in the Paris atmosphere, and our carefree youth which gave us license to put off until later our serious responsibilities, we often had violent discussions among ourselves. However, I sought in every way to concentrate on current events in the art world of Paris. Carrà, more reflective and contemplative than the others, often sided with me, but still I was sure that all the publicity, and the use Marinetti made of it, tended more and more to distract my friends from the main object of their aspirations.

Without realizing it, they were treating art as a "means," a "pretext," simply out of vain, materialistic exhibitionism, and not, as later happened with the Surrealists, as an ethico-social goal. Marinetti, already attaching a vague political and nationalistic logic to art, had become something of a "manager" to a variety show and was organizing exhibitions in London, Berlin, Bruxelles, and Holland.

Had Marinetti not imposed his decisions, or had my colleagues, aware of their own interests and those in the name of art, opposed him, what should they have done? In my opinion, they should have left Milan and moved immediately to Paris, even at the risk of starvation. First, because they needed it and they should have realized their need to investigate the serious problems posed by art and to link them to an art that was becoming progressively more European. They also needed to learn more about our immediate predecessors. Second, because Paris, as they had already had occasion to see, was the international center of the art world. It was where everything converged morally and materially. Carrà was to realize this later and in a letter he wrote me from Paris in 1914 while I was in Anzio, he acknowledged that I had been right. Their objections about ethnic values, that is, of a typical Italian character to be preserved in art, were pretexts without any critical or aesthetic foundation. One can be "Italian" even at the North Pole. My paintings, often on exhibit at Rosenberg's gallery, were Italian, just as Braque's were French and Picasso's Spanish. And were not Modigliani's Italian? Too often even today, "ethnic values" are misconstrued as *provincialism*.

I purposely want to explain these points in detail because many of the consequences still seen in Italian art today can be traced to that first affirmation of the art called Futurist, and to the direction that such activity took at the time.

My relationship with Picasso and the Cubists was remarkably cordial. In particular, the friendship with Picasso grew closer and closer. He did not have much respect for the Montparnasse Cubists, as he was from Montmartre. Actually, those from Montparnasse were really quite strange. Gleizes, always dressed in a "frock-coat," had the air (and not only the air, but also the personality, to a certain extent) of a schoolteacher. Metzinger flaunted an elegance and the manners typical of the Parc des Princes socialite racetrack set (and actually did participate in a bicycle race there). Le Fauconnier, the Dutchman, with his thick blond beard and sporty "outfit," looked like a rich foreigner just passing through. The most amicable of them were Léger, who resembled a boxer, and Delaunay, looking like a racing-car driver. Picasso, who was rarely effusive and rather uncharitable, always treated them distantly.

We met often, in Montmartre, with Braque, Dufy, Suzanne Valadon, Utrillo, Modigliani, Gris, Max Jacob, and others. But with Picasso, as I mentioned, we would get together every evening at the Brasserie de l'Ermitage on boulevard Rochechouart, along with Marcoussis who, at that

time was not painting but making satirical drawings for *L'Assiette au Beurre*. Picasso would bring his lovely friend Fernande, and Marcoussis his Eva, a small, spicy girl who looked like a Chinese doll. Fernande, her opposite, was a classic French beauty, with regular, well-proportioned features.

The two glamorous girlfriends shared thousands of topics of conversation, so we were left to converse among ourselves, about painting and painters, of course. Marcoussis, a Polish Jew, possessed no end of intelligence and finesse. They puffed on their pipes during lengthy silences over glasses of beer because Picasso said little (although he liked to speak in aphorisms). However, we never lacked for topics of discussion.

"It is possible to make a very modern painting depicting Greek warriors," he would say regarding subjects. While not considering the "subject" of absolutely prime importance, I preferred and found it interesting to paint things that were around me in real life, such as the ballerinas and "boîtes de nuit," the Bals Tabarin, subjects that were also favored by Toulouse-Lautrec and Picasso himself.

It should also be remembered that Picasso lived a rather conventional life with his ladyfriend, as if they were a married couple, and therefore all around him were still-life objects, home-like objects, which caught his eye a hundred times each day. Perhaps that was, if not the determining factor in his frequent choice of the still life, at least one of the explanations for it.

In fact, after my marriage when I began to lead a more sedentary life, I, too, understood the beauty inherent in certain trivial objects, and the idea that a painting or a poem might be composed around anything at all became quite clear to me.

But at that time, I was full of immense ambition. I wanted to paint many large canvases like *Pan-Pan à Monico*. I wanted to paint a picture of the mammoth Lafayette Department Stores. I wanted to paint elevators in stairwells and many other subjects, all with that lyricism and freedom that made the job of painting so enjoyable to me.

What set me apart from Picasso was that he, basically, looked to Corot as one of his masters at that historical moment.[5] I, instead, looked to Seurat as my point of departure and my master. Picasso thought my attitude a bit passé, particularly after the "Fauves." He was perhaps not wrong about this, but it was no reason to turn back to formulas predating Impressionism. Moreover, he moved away from Corot little by little and

[5]More than master, Corot was like a poetic canon.

moved closer to Seurat. In fact, he once made a copy of one of the old masters, all in little dots of color, like Seurat.[6] Certain jokes and acts of bravado were part of his nature, and he practiced them with a happy, childlike smile. He was just like a little "gamin" who boasts to his companion "gamin," "I'll bet I can climb that tree, or jump off that wall, better than . . . ," and no one can deny that he actually did climb the highest trees and did jump the farthest, where others, many others, would have broken their necks. He accomplished these feats without any apparent damage.

Once, before the Futurist exhibition as I recall, he came to my studio and I showed him my painting, *Souvenirs de Voyage*, which he liked very much. In that picture, I had assembled all the things that had impressed and captivated me during a trip to Italy and also in Paris, without worrying about the unity of time and place. Objects were depicted only because I liked them, so they had to harmonize and fit together. A short while later in his studio on rue Ravignan, he showed me his painting, *Souvenir du Havre*, completely different from mine. Mine was ultra Neo-Impressionistic, ultra Signac, and his, ultra Corot. Braque was present and seemed surprised at the painting. In a sweet-and-sour tone he said, "The rifle has changed shoulders," but Picasso held his tongue. He went on smoking his pipe behind us, wearing that typical smile of his which probably meant something like: "How do you like my little joke?"

Picasso and I understood one another extremely well, perhaps because I had the body and soul of a rascal, of a Tuscan vagabond, and he, the body and soul of a rascal from Malaga. Baroness d'Oettingen used to call him "the gypsy," and became angry if others did not agree with this designation.

One evening Soffici arrived while we were seated quietly at a table at the Ermitage. He talked to Picasso for a while and then as Soffici, perhaps guessing my identity, looked at me from time to time with hooded eyes, Picasso introduced us. I suspect that he knew about the brawl of the Futurists with Soffici in Florence, but of course made no mention of it, nor did anyone else. Amazingly enough, Soffici and I got along well and we all spent the evening together, into the small hours. We left in a group and went our separate ways at Place Pigalle, but not before I had made an appointment with Soffici for the following day to see Medardo Rosso.

[6]I believe it was Louis Le Nain's "Le Retour du Baptême"; in any case the dots would also often recur in his Cubist paintings.

We found that great sculptor in an immense studio, half hangar, half foundry, located in the "Batignolles" neighborhood. The visit was tremendously interesting for me, a revelation actually. I only knew his work through the specialized press and had seen few reproductions of this extensively misunderstood Italian sculptor. I was very surprised and excited. I think that we went back together a second time, and a sincere friendship grew between us. He clearly considered me apart from the band of Milanese Futurists. On the other hand, well aware of the state of art in Italy and of the ignorance of its public and critics, he revealed a certain understanding of the Futurists' exploits, and may even have looked upon them with some indulgence as he later demonstrated, despite the fisticuffs episode.

When Soffici had left Paris, I wrote to Boccioni about our encounter, which he undoubtedly mentioned to Carrà and Marinetti. Subsequently, I received a horrible group letter in which they treated me almost like a traitor. As a demonstrative gesture, Carrà even sent me an issue of *La Voce* (11 July 1912), which I recently found by accident among my papers and periodicals of that year, in which Soffici had written a new article under the title "Anchor of Futurism." I replied that Soffici was better informed about modern art than they were and that, basically, he was not so wrong in his criticism. I added that it was clear from his latest writing that he was not inflexible (and I was speaking from personal experience about him), and that it would be worthwhile to try to convince him to embrace our cause. My opinion coincided essentially with their own fervent desire to reach an understanding with the *La Voce* journalists.

Nonetheless, the article did continue in a somewhat impertinent vein. Soffici takes as a pretext the two letters written by his friends, the Baroness d'Oettingen and her brother, Serge Jastrebzoff, two interesting figures on the Paris art scene that we shall often encounter. She wrote to Soffici, as a good friend, about the Futurist exhibit: "I saw the Futurists yesterday, both in person and in their works, and it seems to me that no punishment is severe enough for them, nor are there any words coarse enough to describe their real function in life and to art. I just feel that the humiliation one feels is too great, terrible almost, for their impudence to go unpunished!"

As for his friend Serge Jastrebzoff (who later assumed the name of Serge Férat), he alludes to Valentine de Saint-Point's famous conference on lust in these terms: "I attended a conference by Valentine de Saint-Point, a unique spectacle, organized by the Futurists to promote their own grandeur. She talked about Futurism and about women, and especially about

lust as a source of great strength. Fistfights broke out on the staircase. But alas! there were a few imbeciles who, together with the Futurists, took everything she said seriously, yet were at odds with each other, unfortunate creatures."

I have faithfully quoted excerpts from these two letters not only because, as Soffici said, they express the sentiments of the majority, but also because these two persons are not just average members of this majority, but persons in the absolute forefront of the modern art movement, friends of Picasso, Max Jacob, Apollinaire, etc. The letters put the repercussion that the Futurist events, especially the painting exhibition, produced in Paris into perspective. In other words, they give a good idea of the so-called success, bruited by Marinetti.

Soffici began with a repetition of the terms of the two letters, adding:

> I could underwrite these. But there is something in these outbursts, present to an even greater degree in the sneering of the periodical essayists, reporters, coffee house aesthetes, and all those who, without lifting a finger, consider themselves authorized to sneer at and scorn whoever dares to change the air in a stale intellectual milieu, that irritates me absolutely and, even if hardly worth the effort, it makes me want to put things in their rightful places.
>
> This is the age-old, invincible aversion to innovation and any sort of audacity.
>
> But the objection could immediately be raised: Futurism does not provide new ideas and its audacity is pure quackery. And once again I refer back to my earlier affirmations. All right. Futurism is three-quarters a medley of old, foreign and local rubbish, rehashed over and over, a chowder made of rancid ingredients, of Belgian and American rhetoric; its theories are full of bestialities and its goal may be rabid publicity for horrible trash. All right. I wrote those things too. Its audacity consists of the rashness typical of the make-believe insane, is the spiritual vulgarity of the empty-headed, and Valentine de Saint-Point is Valentine de Saint-Point.
>
> And still we agree. I will leave the fourth point aside, even if it does exist, in order to answer only that: Futurism is a movement, and movement is life.

It is obvious that Soffici gets malicious satisfaction from repeating his severe opinions of the Futurists and does not let an occasion pass without doing so. However, his conclusions have changed: he now thinks that something, even the most unexpected of results, can emerge out of a "movement," that is, out of an expression of life.

He goes on to say, about the exhibit at Bernheim's:

> Everyone, and who better than myself, knows that the Paris exhibition was not, as the interested parties might want it to seem, a triumph for Italian art.
>
> Instead, it was quite simply a scandal, and its success was deserving of a scandal. Who could take Divisionism, improvised Cubism combined with pictorial dynamism, seriously? Who did take them seriously? No one. But the episode resulted in tremors for that legend/truth of a dead Italy buried beneath the stupidity of its conservatism and its academies. . . . Art and Beauty certainly gained nothing from this, but had we sent our Bistolfis, our De Marias, or our Titos and our young ones? We should think hard about that.

Seen through Soffici's eyes, even Valentine de Saint-Point's conference became a hard blow

> to the philistine morality, to the hypocritical modesty of putrid, stunned masses. . . . If we mentally change human beings, their works and their style we will have a demonstration of life and freedom.
>
> Futurism's problem lies in the people who represent it, and how they represent it, and not in its substance, that of an innovative movement, which is excellent.
>
> Here is what I would like to say against those with gout of the mind, against the spiritually lazy, against the eunuchs and backward people of all sorts. Against persons too serious and prudent; against Italians, in general.

These are the tone and the conclusions drawn in Soffici's new article that Carrà took care to send me.

These conclusions clearly show that Soffici, while not esteeming the Futurists, was not averse to Futurism. What is important to discern is that the aims, considerations, and external goals of art, its intrinsic nature, took the upper hand in him from that time on, overriding those ends strictly relating to art. In other words, before establishing personal contacts with the Futurists, Soffici, sufficiently informed and intelligent enough to situate their works critically and to measure their worth, drew certain conclusions; for the Futurists, despite their arrogance, insolence, and the scant consistency of their works, were nevertheless preferable to the Ettore Titos, Bistolfis, and so forth. Also because the over-serious and over-prudent Italians, besides being philistines and in a daze, actually needed an Italian movement to shake and wake them up.

I want to emphasize Soffici's attitude because not only does it explain his future behavior, but also it progressively outlines Futurism's sole raison d'être. It is worth noting that Soffici was perfectly right and so were the Futurists, since Italy really was in the condition they describe, and even worse. It has not changed much since, in that respect. I must admit however, that I have always considered those reasons of secondary importance. I may be anti-patriotic, but I was never bothered by the fact that the Italians were philistines or drowsy. I could and would use it as a topic of conversation, of regret, and of observation with colleagues, but to think of conditioning my activities on the basis of such secondary matters never seemed to me becoming of a true artist. I was interested in my own skills, my own progress both in clarifying and enriching my critical judgment, and in "realizing" my works. I also thought that in this way I would fulfill my duty as a good citizen, in the bargain.

So, without verbalizing it, we were conditioned by Montmartre: Picasso never talked to me about the Spaniards nor Braque about the French, and there must have been plenty of dim philistines and overly cautious people in both of those countries too.

I confess that Soffici's article took me a bit by surprise. But I did not abandon the idea of going to see him and to try gradually to bring him to view the Futurists in a more appreciative light.

Meanwhile in Paris, or I should say in Montmartre, our life continued in an almost provincial way. Each quarter of Paris has an intimate and independent life of its own; each is almost a small city unto itself with its own customs and characteristics. Everyone knows you, your tobacconist, your baker, the employees in your post office, and if you meet them on the street they greet you with a "Good day, sir." In the evening we often strolled in groups along the outer boulevards around Place Blanche and Place Pigalle, in overalls and espadrilles, smoking our pipes, as we might have done in any small country town. Underneath Juan Gris' studio on rue Ravignan there was a simple family-owned restaurant. The owner, old Monsieur Vernin, would feed us on credit, and we would go there almost every evening. Besides the group of painters, there was a comparable flock of writers made up of Apollinaire, Salmon, Max Jacob, and Raynal. The latter once proposed that each of the painters in our group do a panel for the restaurant. To tell the truth, Père Vernin was not exactly enthusiastic about the idea, but finally gave his approval. Nevertheless, the project was never realized.

It was around this time, or perhaps a little earlier, that all of a sudden

Modigliani disappeared from Montmartre. Later we learned that he had moved to Montparnasse and was busy sculpting. I went to see him in his new studio, another glass cage like the one he had in Montmartre, but with a nicer garden. In the midst of the plants were already some stones roughly shaped by his hand. He explained, in his typical outbursts, "I wanted to renew myself completely, so. . . ." He appeared at the next Salon d'Automne, in 1912, or perhaps at the Indépendants, exhibiting those elongated stone heads inspired by African art, which formed a basis for him to better and more completely satisfy his calling as a painter.

Juan Gris showed a portrait of Picasso at that year's Indépendants, painted according to Cubist principles but interpreted with a certain ingenuity. His first endeavors in Paris had been illustrations for various satirical papers. Having won Picasso's friendship, he could reveal his talent as an artist capable of true painting. But the portrait that introduced him into the arena did not earn him anyone's friendship. In black and white geometric outlines, Picasso looked decidedly grey and radiated a cold expression. Gris had titled the painting *Hommage à Picasso* as a way to confirm his commitment to Cubism, but Picasso, far from being flattered, was extremely irritated, and Gris was rather mortified.

I often saw Max Jacob at that time. He lived nearby in a small room that was comfortable in the summertime but grim in the winter. Located on the ground floor, its windows looked out onto a dirty little courtyard squeezed between high walls, so that Jacob was always obliged to work by the light of a petroleum lamp. He dazzled me with his learning and vivid imagination, and often confided his crises of conscience and love life to me. When he converted to Christianity, he became very angry at Picasso who insisted that he be baptized with the name "Fiacre."* His little room was covered with small watercolors, gouaches, and drawings that he did to keep himself amused. They were interesting and inventive, done in Post-Impressionist or Fauve styles. Some were reminiscent of Matisse or, more often, Dufy. The seeds of more important things were planted in these small pictures. Later, Jacob painted more Impressionistic gouaches in a style reminiscent of Toulouse-Lautrec. These were tasteful, showed good pictorial sense, but had less poetic content than those from 1911 and 1912.

When Max Jacob is mentioned, he is often considered a sort of clown

*"Faicre" = hackney coach, a cab. According to Jeanne Severini (1991), Picasso chose the name of an anonymous object that was typical of the era, just to irritate Jacob.

or juggler by some, by others a magician or a mystic, and yet others see predominantly his vices and excesses. Perhaps he actually is, or rather once was, all of these things together, but what a refined and elegant man! To tell the truth, he enjoyed predicting our futures, compiling our horoscopes, telling each one which colors were favorable and which unlucky, but anyone who portrays him by his unfavorable aspects alone, twists the truth and does not understand this noblest of poets.

Picasso, Marcoussis, and I continued to go to the Brasserie de l'Ermitage every evening, but our sense of peace and serenity was totally destroyed by a true drama of passions. Picasso showed his generosity of spirit by not holding it against me and never mentioning it, but indirectly and involuntarily I was the cause of this drama which deeply distressed my great friend for quite a time. I allude to his definitive separation from Fernande in the spring/summer of 1912.* Gertrude Stein makes only vague mention of this separation, merely citing the fact.

A young Italian painter had come to see me the previous winter, sent by the Futurists and Marinetti. (He often sent me the most incredible people, the least interesting imaginable, only because they showed some interest in Futurism, and I had many annoyances from them.) This time, however, the painter was pleasant and intelligent. U.O. was a very young, handsome fellow, and not without talent. He came to my studio while I was working on the *Pan-Pan à Monico* and was, of course, immediately seduced by Parisian life and by the artistic fervor he found there, uncluttered by clamorous declarations of creed.

One evening, when we had become better friends, I made the mistake of introducing him into our intimate Ermitage group, an act I would sorely regret. Lovely Fernande who was always something of a flirt, partly as a joke and partly to test her charms on a young man from the provinces, began an assault that my young friend could hardly resist.

Of course, the next day I reprimanded him and tried to censor his actions in every way I could imagine, but my efforts were to no avail and the inevitable finally did happen. It did not take Picasso long to discover the betrayal and one night, after a violent argument, he threw his girlfriend out the door. Eva vanished at the very same time.

The comical aspect of this drama was that Marcoussis and several others in Montmartre, aware of my friendship with Eva, thought for a time that I had kidnapped her. That is also what Fernande and her friend

*In a letter from Picasso to Braque (18 May 1912): "Fernande ditched me for a Futurist identified as U.O. [Ubaldo Oppi] by Severini."

had hoped, in order to justify their actions somewhat. However, this was absolutely not so, as became evident when we learned that Fernande was living in the young painter's studio and that Eva had left for Spain with Picasso. The upshot of this drama was that I somehow inherited a magnificent Siamese cat that Picasso abandoned upon leaving the country. It did not stay at my studio for long since I was obliged to get rid of it, passing it on to either Dufy or Braque, I forget which.

Picasso satisfied his pride with that masterly turn of events and, at the same time, was consoled by it. But not to any great extent, from Gertrude Stein's accounts: during the coming fall, while setting up house with Eva on boulevard Raspail, he disclosed to her that he was still tormented by Fernande's beauty.

Meanwhile, Fernande, whom I saw several times after her alliance with my friend and who bitterly defended her actions against my protests, soon began to realize the foolishness of her behavior and showed signs of repentance. But Picasso was firm and abandoned her to her own destiny, not a brilliant one at that.

I continued to work along the same lines at my studio on impasse de Guelma. I had painted some portraits and two pictures of ballerinas (*Blue Ballerina* and *Chahutteuse*, in black and white) which I subsequently took to Milan to show my friends, at their request, and later sold in Florence.

I was still fascinated by subjects in motion, but this did not prevent me from working on other, static subjects, such as portraits. Among these was the important portrait of Mme. M.S.* which shows my primary interest in the plastic element. Was I closer to the Cubist or to the Futurist idiom? I confess that I did not worry about such matters at all. Like Picasso, I did not consider these "isms" of any great importance. I possessed all the "means" necessary to me and did not pay much attention to the particulars of their origins, not bothering to trace them to the Neo-Impressionists or to Corot or to Cézanne. The ballerinas that I painted were mine (as were the portraits), and Apollinaire was wrong to declare that the French had already solved the problem of reproducing movement, inasfar as it might be resolvable.[7] Perhaps he was referring to Delacroix or to other 19th-century painters, for there was not one among the French painters of the moment who was trying to paint movement as I was. Later, after the Bernheim exhibition, pictures by La Fresnaye (*Artill-*

*Madame Meyer-See, wife of the art and antique dealer, Robert-René Meyer-See.
[7]*Le Petit Bleu*, Paris, 9 February 1912.

ery in particular), Marchand's *The Harvesters*, and other works by young painters visibly concerned with the problem, began to appear.

The fact that I did not insist on those subjects and willingly alternated them with others, was provoked by my abhorrence of narrow specialization. Certainly the critics, as vulgar or intelligent as they may have been (at the head of the list, were Zervos and Tériade, who fought and obstructed me in Paris), would have been glad to stick me with the label of "movement painter," a strategy they tried later with my Pulcinellas and Harlequins, and after that, with my pigeon subjects. But the minute I detect the merest hint of such classification, I immediately abandon the subject matter in question.

In any case, I painted a sufficient number of works inspired by movement to demonstrate and confirm my capabilities in that domain. "Inspired by movement" does not mean that I proposed to render the optical illusion of a thing or body that changes its place in space. My aim was to create, making use of that context, an even newer and more vital whole from it.

As usual, the other Futurists grasped this idea of movement in its literal sense. Had they remained in Paris, as I already said, this problem, and others too, would have become apparent to them, and their intentions would have been realized in a more positive and spiritual way, enriched by the contributions of each individual. A sojourn in Paris at that time would have been useful to everyone concerned. But they wanted to return to "home shores," like peasants who return to the old country, having earned their fortunes in America.

Meanwhile, our paintings were traveling throughout Europe as "curiosities" accompanying Marinetti who used the publicity for the sake of Futurism. In this respect, that is, in subordinating everything to an extrinsic end, to a "given effect," Marinetti was a master and innovator. He would say, "Futurism before everything else; the abilities of the Futurists, their lives, their needs, all secondary things." It was very difficult for us to stop him from admitting the coarsest of idiots into our ranks.

We managed to sell all our works in Berlin, but the conditions we were offered! Walden, the editor of *Der Sturm*, a German avant-garde magazine, had organized the exhibition. We were not even consulted on the matter of sales, naturally. So, my painting, *Pan-Pan à Monico* (a 4 x 3 meter canvas), which had taken me two years to create, was sold for a mere 2000 marks. The other canvases went for prices between 150 and 300 marks. After expenses, travel, telegrams, and various other items, not much was left for us, especially since the payments were made in install-

ments which were inevitably delayed. In fact, with the outbreak of World War I in 1914, our compensations were never settled. Walden, however, had prudently pocketed his own commission in full. In Italy Marinetti, of course, portrayed these sales as a great success for Futurism, and it was played up by the press to such an extent that my mother, ever skeptical about Futurism, thinking me already rich, wrote me an enthusiastic letter from Pienza. When she saw the small sums that arrived from time to time, she reverted to her original opinion.

In Paris at the same time, Kahnweiler (another German, but more intelligent than Walden and, above all, more honest) was exhibiting Picasso, Braque, and later Gris, Léger, etc., in a tiny shop he had opened a few years before on rue Vignon. Without particular fanfare, he laid the groundwork for an art market of worldwide scope.

Marinetti was only interested in the ephemeral multi-colored butterflies of loud publicity, and my other colleagues fell into the same trap. He was prodigious, as well, in his ability to use everything toward promoting his Futurism, even love affairs. Toward the end of June, Valentine de Saint-Point (Lamartine's niece) held her stormy conference in Paris, recounted by Serge Jastrebzoff as we have already seen. A certain generation of Parisians is bound to remember the event. She entered the Futurist ranks with a humorous manifesto on lust and stepped up to the stage of the Salle Gaveau that evening to illustrate her manifesto. Although no longer young, she was still elegant, beautiful, and strong, capable of putting her manifesto to the test for a night of carnal play, and then spending an hour the following morning in fencing practice. That evening she was wearing an enormous hat, as wide as an umbrella. Not only was it wide, but also tall, and covered with bright plumes; in other words, it was a true edifice.

You can imagine the attendance; as usual, it was an audience determined to enjoy itself, and it did. The beautiful lecturer's topics were hot and spicy, as were the interruptions and exclamations by the audience. Once over, things began to take an ugly turn. The only Italian Futurists present were Marinetti, myself, and a new convert, Ugo Giannattasio. Ricciotto Canudo from Bari was also there. The Parisians called him the "Barisian" or else the "Dantist" since he had made a name for himself with a series of conferences on Dante. He was a considerate, agreeable friend and interesting from a certain point of view, given his style. René Fauchois was there and Caplan, one of Canudo's friends, was planted in the audience in the role of "antagonist." When he climbed to the stage to advocate certain purposely chosen subjects, a real row broke out.

The audience raced onto the stage and our friends had to battle their way into the orchestra. Somehow I found myself in the first row of boxes, from which I would have dropped directly down into the orchestra by the shortest route possible, had it not been for the timely intervention of Craven, a huge man and a boxer, a supposed nephew of Oscar Wilde. Arthur Craven was two meters tall and proportionately broad. Despite his gentle face, typical of large, strong people, he was actually not in the least gentle. He published a more or less monthly "notebook" called *Maintenant-Revue Littéraire* which included enough insolence, irony, and bitter criticism for all tastes. Later he invented the efficient word "voyoucratie"*with regard to "distinction." He claimed that distinction, in art, was limited by "voyoucratie" on the one hand, and by nobility on the other. Falling between these two, like all things middling, distinction was nothing but mediocrity. Therefore to call an artist "distinctive" meant that he was only mediocre. His friends were few and he did not care for the Futurists very much, although he did like me personally.

After the aforementioned battle, we all went to the Bois de Boulogne. A certain Mr. Meyer-See came along with us. He was some kind of merchant without a shop, dealing in antique and pseudo-antique paintings, and had organized an exhibition for us at the Sackville Gallery in London.

Soon after that event, I decided to return to Italy to spend the summer with my parents in Pienza. Speaking for the whole group, Boccioni urged me to make the trip in order to organize a meeting between Soffici and the Futurists. I went to Milan with my two paintings of ballerinas and a self-portrait. I also brought photographs, information, and an infinite amount of news.

My friends and I strolled in Milan's Galleria; they squeezed me like a lemon with all their questions. I was happy to fill the role of "go-between" among these friends in Milan and those in Paris, still under the illusion that they could come together on some sort of common ground. Unfortunately, that was not to happen. Boccioni and Carrà, in spite of their travels, distractions, and pseudo-successes, had made some real progress. But Boccioni's Divisionism was always to remain an Italian phenomenon, in other words, predominantly influenced by Segantini, just as Carrà was always to remain a Lombardian painter, close to Tallone.

Boccioni had a mania for elegance and ascribed great importance to his clothes. Later, when he had some money, he became very elegant. But at

*"Voyoucratie" = Mobocracy or mob rule.

the time, he had not yet reached that stage. His evening clothes consisted of a black suit with a jacket that buttoned up to his chin, like the jackets called "vareuses" in France. A starched white collar peeked out over the high-buttoned jacket and on his chest were the drooping bows of a "Lavallière" tie. A round hat with an upturned brim and patent-leather pumps with bows completed his opening-night dress. I owned a tuxedo, as the consequence of a series of circumstances and for particular reasons of my own, and Boccioni obliged me to wear it every evening, while he dressed in his finery. We would go to the Galleria in these outfits. Next to us, Carrà and Russolo looked like poor working-class specimens but could not have cared less. Naturally, they knew and were known by all Milan, so we would have to stop every step of the way and Boccioni would ceremoniously introduce me as "the great Futurist painter, Severini, who lives in Paris." In these evenings of our youth it took very little to make us happy. In his patent-leather pumps, Boccioni was as proud as a lord, dressed in the most correct and perfect "tails." We would go to simple little restaurants with practically no money in our pockets, and a half-liter of wine, not being the poison it is today, would make us very cheerful. We sang and argued about painting and love and the like. I have the impression that today's youth is far less jovial than we were, but then, there are good grounds for this.

A few days later I left for Pienza where I set to work. The large canvas, *Bal Tabarin*, which is now in New York,[8] was done there. Naturally, my friends kept after me with recommendations for the famous encounter with Soffici.

PIENZA

In Pienza lived a kind lady, Countess Piccolomini, who was a beautiful, refined, intelligent woman, very different from her husband (the direct descendant of Pius II, Enea Silvio Piccolomini). He was a man to whom intelligence had been denied, in his every activity and his deepest soul. Having learned that a modern painter was in Pienza, the wife invited me to visit the lovely Piccolomini Palace. So perfect that it is often cited in textbooks and architectural history books, it stood, on the main square of that predominantly medieval town, together with the Duomo by Rossellino, the bishop's palace, and the Pretura building. This lady was

[8]At the Museum of Modern Art.

very interested in modern art and invited me to visit several times. One evening her guests were Prince d'Orléans-Bragance, brother of the pretender to the French throne, Countess Saint-Sévérin, and various other members of the French aristocracy. As a modern painter and a Parisian, I was the object of great interest to them. Once again I took note of the fact that the two extremes of society were those most sensitive to modern art: the working-class, peasant farmers, blue-collar workers, all absolutely uncultivated, and the members of the highest social and intellectual orders. Between these two extremes lies the middle class, which is in general insensitive to any form of art that lacks a point of reference to secondary-school knowledge.

As I was obliged to return to Paris soon, it was time to arrange the meeting between Soffici and my friends in Milan. There followed an exchange of various postcards and letters with him, to set up an appointment in Florence. The Russian painter Serge Jastrebzoff, a man of exquisite refinement, cultivation and good manners, was with him there at that time. He lived in Paris with his sister, Baroness d'Oettingen. He later founded the review, *Soirées de Paris* with Apollinaire.

At about the same time I received the aforementioned issue of *La Voce*, I also received a letter from Boccioni saying, in that facetious, joking tone of his, that he could not come to Florence and that as a consequence the Supreme Futurist Council had elected me plenipotentiary trustee for the Florence Peace Treaty. (All this might seem to be a parody of Fascist ritual, whereas actually the Fascists copied it from the Futurists, but took seriously—to what extent?—what the Futurists had intended ironically and somewhat playfully.)

Boccioni was unable to come, as were Carrà and Russolo, for they were all penniless; Marinetti was elsewhere. But, God forbid, that the real reason be told (this was characteristic of Boccioni), better to feign an urgent commitment or an amorous tryst, that absolutely necessitated his presence in Milan.

"Moreover, the Supreme Council," so said our friend Boccioni, "invests you with the liberty to take action, in the sense that it cannot in any way discern our desire for reconciliation. Be courteous but firm! The Supreme Council sends its greetings to our great-nosed ambassador.[9] Signed, Umberto Boccioni, Carlo Carrà, Luigi Russolo."

As you can see, these friends were an amazing mixture of cleverness,

[9]My nose, which is not as extraordinary as they would have it seem, was always the butt of Boccioni's jokes, and he used it to vindicate himself for my barbs to him.

complacency, and ingenuity. It was really stupid of us to assume that Soffici, an astute and clever man, would not guess the aims of my gesture. Were he to agree, the reason would be, first of all, that he and I had established a cordial personal friendship in Paris, and that second, as can be deduced from his article, Futurism in its extra-artistic goals was not displeasing to him. But from that moment on, I felt less close to him.

I went alone to Florence and prepared the ground in such a way that when I passed through Milan on my way back to Paris, the fusion of Futurism and *La Voce* had been virtually completed. I forget the circumstances of my friends' subsequent trip to Florence soon afterwards, but they put the alliance into practice, together founding a review called *Lacerba*. As I recall, this came about at the end of 1912 or the beginning of 1913.

London, Marriage, Trip to Italy

THE MONTHS bridging 1912 and 1913 were a time of particularly impor-
tant milestones in the art world. A craze for the idea of the manifesto was
raging at the Futurist headquarters in Milan. Anxious to reach certain
goals ahead of anyone else, the Futurists struggled to fabricate one procla-
mation after another that could be issued to the world.

On his way back to Milan after trips to Berlin and Brussels with our
exhibits, Boccioni spent a few extra days in Paris, where he expressed a
particular interest in sculpture. All day every day he would discuss the
subject. To sate his appetite for exploring the problems of sculpture, I
took him to visit Archipenko, Agero, Brancusi, and Duchamp-Villon,
who were the most daring avant-garde sculptors of the moment.

We spent those days in a great communication of minds—probably the
peak moment in our friendship. I took him along, like a brother, every-
where I usually went myself; to visit my friend, Costa-Torro, to the Tab-
arin, to the Monico, to the Cirque Médrano. He lived like a real Parisian
in Paris, not like a visitor. Since he was also passionately interested in
popular songs, he tried very hard to learn all the latest hits. "O Manon
ma jolie!" and "Ah! l'amour c'est une belle chose" were the ones he sang
or whistled all day long. One night we spent over an hour in a little bar on
boulevard de Clichy, where a lady I knew from the Tabarin repeated a
famous song for him over and over, at least twenty times:

Il est dingo pan pan pan pan
il a tout du ballot pan pan pan pan*

There is a tendency to underestimate the importance in daily life of
such small things as songs. Of course, some songs are silly, but others are
beautiful (and some very beautiful), and these express the spirit of a given
populace at a particular moment.

Those Parisian songs, stupid or not, embodied the Paris of 1912. For
example, "St'uocchie ca tieni belli" or "Oi Marì" meant Rome 1904—

*Silly song with senseless onomatopoeic lyrics.
 He is nuts pan pan pan pan
 He plays the clown pan pan pan pan

1905 to Boccioni and me. And when those melodies start running through my head, I can see Boccioni as if he were right before my eyes.

After this good period, perhaps the last good period of our friendship, Boccioni returned to Milan and only fifteen days later, the Manifesto of Futurist Sculpture was released, roughly five months after the painting exhibition. During our discussions and visits to various sculptors in Paris, Boccioni had not once mentioned this manifesto, so it surprised and saddened me to have to acknowledge that these speed "records," these feverish searches for novelty for the sake of novelty itself, and a lack of sincerity on his part, would inevitably cause deep wounds in our relationship. Furthermore, it seemed to all my friends who had recently received him that I had been his accomplice, and I must confess that I found this very distasteful. I also began to realize that, while my friends from Milan pretended absolute solidarity from me, they were inclined to embrace whatever behavior seemed opportune to them, often not even bothering to inform me of their decisions. True, I had never displayed an intense interest in Futurism, but such methods were certainly not conducive to kindling interest on my part. In the meantime, because of the solidarity they feigned, I had missed a good opportunity to exhibit in New York, with my friends Picasso, Braque, Gris, Dufy, etc.

The American painter, Walter Pach, a pupil of Matisse and a friend of mine, had decided to organize a large modern exhibition in New York* that would include the Impressionists, Renoir, Degas, Cézanne, and end with the Cubists. Naturally, he had invited me to participate and I had accepted on the condition that the other Futurists also be invited. This was easily accomplished, but Marinetti, for his own purposes, would not hear of having us in the show. So, against their will, my friends were forced to decline their participation and, out of solidarity, so was I. So much that happened later was an outcome of that first show. Today it is clear how grave an error I made in not taking part in that magnificent international exhibition.

Soon thereafter I was offered the possibility of a one-man show in London, and this time, even at the risk of opposing Marinetti and the other Futurists, I had no intention of repeating the mistake of refusal. The show would require considerable preparation, but I knew precisely what I wanted to create and was full of enthusiasm. Besides, this would be the first exhibition that depended entirely on my own initiative—a prospect that delighted me.

*The famous Armory Show of 1913.

This was a particularly fertile moment for me artistically. The Futurist show and everything said about it had opened my mind to a much clearer critical judgment of others and of myself. Now all I needed was to set to work.

That was not the case with my friend, Boccioni. After publication of the sculpture manifesto, he suffered one of his depressive crises in which he desperately struggled against an urgent craving to succeed, to succeed quickly by any possible means (perhaps, as I have already said, he felt an obscure forewarning of his untimely end), and the no less urgent need, felt deeply, sincerely and honestly, to succeed by the proper means insofar as art and his own conscience were concerned.

I received a letter from him, perhaps spurred by his wish for me to forgive him for his unfriendly behavior concerning the sculpture manifesto. He inquired about my cough and whether I had bought myself some woolen underwear and then confided: "I am working hard but inconclusively, it seems to me. That is, I hope that what I am doing means something because I don't understand what I am doing. It's strange and terrible, but I am calm. I worked for six hours straight today on my sculptures and I don't understand the results. Planes upon planes, muscles and faces sectioned, and then what? What about the total effect? Do my creations have a life of their own? What is going to happen? Can I expect enthusiasm and comprehension from others when I, myself, wonder what emotions my work arouses? Enough. I can always find a pistol, yet I am very calm."

I wrote back, just a few lines on a postcard, convinced that he was going through one of his usual crises from which he usually emerged more courageous than ever. Almost immediately another letter from him arrived describing even more disappointment than the last. He said:

> Your postcard arrived at a terrible time. We have an enormous task ahead of us. Our obligations are terrible[1] and plastic means appear and disappear to the world of realization. It's terrible.
>
> I don't know what to say. I don't know what to do.
>
> I don't understand anything anymore! I don't know what our two friends, Carrà and Russolo, are doing. Whatever they're doing, I don't trust them . . . I don't trust myself or anyone else.

[1]He was certainly aware that becoming a sculptor could not be improvised, and that it was easier to write a manifesto about sculpture than to actually sculpt. Nevertheless, his sense of discouragement proves his great and rare rectitude. For this reason I have transcribed his letters.

Does free choice cause such chaos? What law regulates it?
It's terrible!

Sculpture is a real struggle for me! I am working, working, working and don't know what I'm accomplishing.

Is it internal? external? sensational? is it delirium? is it mind? Synthesis, whatever the h--- it is, I know nothing about it!

Form upon form . . . confusion . . .

The Cubists are wrong. Picasso is wrong. The academicians are wrong. We are all a bunch of pr---ks. I don't know what sort of life to lead anymore. I have the shakes!

Meanwhile I'm more calm. Were I to continue like this, my only choice would be to kill myself. One thing is certain, that life is becoming an insufferable torment to me.

What a difference in temperament between Boccioni, anxious to account for his every instinctive creative impulse and capable of complicating and horribly tangling the skeins of art, and Picasso, who would often say, "L'art est une chose très bête," stressing the word "bête." Later, in an interview, he would say, "I don't search, I find" to oppose the way of looking at modern painting so dear to critics with lazy minds who think they can explain everything with the term "research." Picasso, himself, said to me one day, "When I begin a work I go in one direction, when it is finished I realize that I've gone in another, that I've changed directions along the way." There is always something in a work that escapes analysis, and I (also tending to over-clarify my instinctive actions) appreciate Picasso's abandon to his creative gift. This in no way means that he fails to evaluate the work's every element.

Had Boccioni stayed in Paris, close to me and to other friends, his fate might have been very different. Certainly Marinetti, extolling some of his negative aspects, did him no favor. Marinetti, as an example, with his politico-journalistic ways, turned all the Futurists into megalomaniacs, which did them considerable harm.

At the beginning of 1913, shortly after these events, a very sad and surprising thing happened that left me deeply depressed for some time: my great friend, Pierre Declide, passed away. One morning, while I was still in bed with a touch of the flu, Monsieur Costa-Torro, whom I had put in touch with the Declides, came to announce the bad news. We were to leave immediately for the funeral, but Costa-Torro, seeing my condition, discouraged me from accompanying him. I learned later that my poor friend had contracted a sort of galloping tuberculosis during one of

his trips between Civray and Coué-Vérac, where he had a second dentistry office. He faded away in a mere six months. I felt a very deep sadness about his death for a long, long time.

During those few same days, the Salon des Indépendants was inaugurated. Unfortunately, I could not participate, for Marinetti had taken the works from the recent Futurist exhibition with him on his "tours" and I was obliged to reserve my latest paintings for London. The 1913 edition of the Indépendants was one of the most important exhibits yet to occur.

A new review called *Montjoie! Organe de l'Impérialisme Artistique Français** had recently been launched, but it was too accessible to just anybody. It was founded by Ricciotto Canudo, he of the ivyleaf, because he always wore a little ivyleaf in the buttonhole of his black jacket. "Le beau Canudo" as the ladies called him, was the archetypical southern Italian, with black curly hair and beard. He was a good friend, although not profound, but certainly more intelligent than some of the others who would write about art. He was clever enough to include everything currently of any quality in his periodical.

He published Apollinaire's article on the Indépendants in which he defended his ideas and those of his friends. The most recent school that Apollinaire wanted to highlight and defend was "Orphism" or "Orphic Cubism."

At this point, I must speak parenthetically. Following the Futurist exhibition, Apollinaire and I had become closer friends and one day he expounded a curious idea to me: undoubtedly aware of Futurism's powers of communication and divulgation, and certain, by then, that it was not a purely pictorial or purely poetic movement but a simple intellectual attitude instead, to which all the moderns could more or less adhere, he decided to incorporate all of modern art under this label; only he reserved the faculty to make distinctions useful to his detailed critiques.

I believe that he was also aware of the "life" element in Futurism, as opposed to the "idea" factor which was then at the roots of Cubist and Picassian "subjectivism," and that these two elements could, essentially, stop being incompatible and become complementary.

Furthermore, all the artwork in Paris at that time and perhaps as early as the beginning of the 19th century, tended toward universalization and spiritualization. Therefore, Apollinaire's idea, despite my initial surprise,

*Fourteen issues were published sporadically in Paris between February 1913 and June 1914; the war caused its discontinuation.

seemed to me quite acceptable, and I wrote to Marinetti about it. But he, pretending to safeguard the Italian nationality of Futurism, energetically refuted Apollinaire's idea. Actually, he was already contemplating his own political exploitation of Futurism. This parenthesis, which I will now close, shows why, after Marinetti's rejection, Apollinaire grouped all current tendencies under the heading of "Cubism," which was more logical from an artistic and pictorial point of view.

In his article in *Montjoie!* on the 1913 Indépendants show, Apollinaire says:

> The latest schools of painting are represented here: Cubism, impressionism of forms, and its most recent tendency, Orphism, pure painting, *simultaneity*.
>
> Light is not a process. It reaches us through our senses (the eye). Without sensitivity, there is no movement. Our eyes are the essential faculty between nature and our souls. The soul sustains its life in harmony. Harmony is only generated by that simultaneity wherein the measures and proportions of light reach the soul, the supreme sense of our eyesight. This simultaneity alone is creativity. The rest is nothing but enumeration, contemplation, scholarship. This simultaneity is life itself.
>
> The modern school of painting seems to me the most daring ever. It broaches the problem of beauty as an end in itself.
>
> It strives to represent beauty released from the pleasure that one man causes another; from time immemorial, no European artist ever dared such a feat. The new artists require an ideal beauty that is no longer the proud expression of the species, but the expression of the universe to the extent that it is humanized in light.

After this premise, Apollinaire launches into a more or less brisk examination of the works.

As for Orphism, in Apollinaire's opinion the painter at the Salon best representing this previously unmanifested tendency is Delaunay. In his view, other painters too, could be included in this school, such as Fernand Léger, whose artistic honesty he praises because it deterred him from exhibiting a large canvas still in the creative stage, considering it not yet mature enough.

Léger, whether assimilated into Orphism or not, was at that time, and forever after, one of the most firmly established personalities in the Paris art world.

His ideas on dynamism and on complementary contrasts of line, form, and color always had many points in common with the ideas governing my early works in Paris, for we shared Seurat as our point of reference. I later saw a pointillist landscape by Léger in the collection of our friend and defender, Granié, the "Substitut Procureur de la République." It had a great deal in common with the landscapes that, under Balla's inspiration, both Boccioni and I had painted in Rome.

In Léger's opinion too, the problem was not a matter of reacting to Impressionism, but of continuing it, of extending the development of that dynamism that the Impressionists had contributed to painting.

This intention was often cited because of its similarity to the ideas of the Futurists. Léger, too, tacitly confirmed this in one of his conferences held during the May 1913 Salon des Indépendants at the studio of one of our amiable and talented colleagues, the woman painter Vassilief.

On that occasion he drafted a theoretic composite based on a "realism of concept" which shared some similarities with Apollinaire's "scientific Cubism" but was not the same thing. A definition of classicism can be deduced from his rash definition of realism. For example, according to pictorial realism, "[classicism] is the simultaneous ordering of the three great plastic elements: line, form, and color."

If any one of these factors in a work is overwhelmed by another, the work cannot expect to achieve pure classicism, nor long duration, independent of the epoch in which it is painted. (The definition of classicism is clearly approximate and transitory.)

He says, in conclusion, "This conception of recent painting produced in France is that of a universal concept where all insights are allowed to develop: the Italian Futurist movement is certainly a confirmation of this."

Clearly it is not a question of Orphism in Léger's theoretical explanation, but it is a painter's manner of thinking and speaking, and it does not matter if there are points of encounter either with Apollinaire or with the Futurists. An examination of his paintings confirms that the potential of his talent and his "skills" are of a totally personal nature. While he may be a painter of limited "means," he is an individual of great character and interest.

At a certain point he was on the verge of adhering to the Futurist movement. The attitudes of Marinetti, Boccioni, and Carrà made him abort this plan.

Further along in Apollinaire's article, mentioning Metzinger and one of

his poetic compositions, *L'Oiseau Bleu*, he adds, "It can no longer be said that Cubism is a melancholy style of painting; instead it is the grand gala style, noble, calibrated, and daring."*

In fact the entire Salon gleamed with such vivacious colors as had not been seen for some time, thanks partially to the recent Futurist show. Certain valid artists like Roger de la Fresnaye, in his painting *Artillery*, also tackled the problem of movement. But no mention of Futurism was made in Apollinaire's article, other than a reference to the painting sent by Giannattasio, about which Apollinaire says: "*Le Tourniquet*, a Futurist canvas that seems to come from *Manège* previously exhibited by Delaunay."² Giannattasio's painting was much more important than certain other works about which Apollinaire was fondly indulgent, but his bias was only human and of little importance.

In the following issue of *Montjoie!*, in a continuation of his Salon critique, Apollinaire exclaims: "If Cubism is dead, then long live Cubism. The reign of Orpheus begins."**

Meanwhile, I continued my perfect romance with my young fiancée, and we were constantly together during the opening ceremonies of the Indépendants. All of our friends began to realize that we were planning to be wed.

Yet, nothing could distract me from the tormenting pain of the loss of my dear friend.

The time of my exhibition in London, set for the beginning of April, was approaching and I was working intently. My friendship with Apollinaire had grown very close. He had started coming to see me at work in 1912. Toward the end of that same year, either at the Ermitage or at the Lapin or at my studio, he told me about certain Italian primitives who had added real objects to their paintings, observing that such additions, and the contrasts they provoked, increased the vitality of the paintings and their dynamism as a whole. He cited the example of a Saint Peter at the Brera Museum in Milan,*** who holds real keys in his hand, and other saints with different objects, not to mention their halos made of precious stones and pearls.

*See note 2, below.
**Montjoie!*, 29 March 1913. See editorial note in *Montjoie!*, 14 April 1913, which turns the phrase into "Cubism engenders a new Cubism."
***Carlo Crivelli, *Il Trittico di Camerino* (1482).
²*Montjoie!*, 18 March 1913, supplement to no. 3.

This was the source of my idea for a portrait of Paul Fort with the actual covers of *Vers et Prose* and of other books of his poetry inserted (fig. 21), and for the composition of a ballerina with forms in relief onto which I glued some real ballerina's sequins.[3] This painting is now in the Gaffé Collection in Brussels.* Photographs do little to reveal the function of these additions, but the original paintings gained considerably in expressive intensity.

Then I did a more important painting, *Danseuses Espagnoles à Monico*, to which I also applied sequins of various colors, but in a more abstract fashion, fixing them in zones so that their function was not to describe reality, but to express it in a transcendental way.

It was a time when I thoroughly enjoyed painting ballerinas and subjects in movement, but I also did several portraits. I made use of two new themes as well: *L'Autobus* and *Nord-Sud* which was an underground train in Paris. The fate of this latter painting weighs heavily on my heart and I must recount its history. Around 1919, after the death of Apollinaire,[4] a committee was formed to erect a monument over his tomb in the Père Lachaise Cemetery. To this end, a work was requested from each of his artist friends in Paris and from those who had known him. Picasso was to do the model for the monument. I enthusiastically donated *Nord-Sud*, a painting that he had watched me compose and liked very much. Many years went by with no news of the monument. The dealer who had collected the paintings, Paul Guillaume, was dead. The monument was never built and nothing more was said about it. One day in 1930 or 1932 as I recall, I discovered that my painting had been purchased by a German man. He, in turn, had sold it to a dealer named Jeanne Bucher, before I once again lost sight of it. Upon my return to Italy, I picked up its trail again. It is now in the possession of a well-known collector in Milan** (I ignore the sources whereby he obtained it), whose understanding of art, more used to the commercial world of business than to the treatment of

[3]An ample, rather unintelligent use of these experiences and other similar ones made by Picasso have been applied in the field of advertising. Their use, for example, by Sironi and Oppo and other such artists for the famous Fascist Revolution Show, shows just how limited were the faculties of understanding and creation in Italy. This is exactly the case of using an entire beam to whittle a match, or even worse.

The same misunderstanding also took place in Russia, with Constructivism, as we shall see later.

*Now in the Baltimore Art Museum.

[4]Apollinaire died on Armistice Day of World War I, that is, in 1918.

**Emilio Jesi, who donated it to the Brera in Milan.

aesthetic values, seems to me rather remote in view of its artistic and historical significance.

I had difficulty accumulating the funds to attend the London show in person, as I had promised. My financial condition was so disastrous that, for the third time while in Paris, my whole studio was impounded.

Without the help of a dear Dutch friend, the poet Dop Bles, I would not have even been able to send the paintings to London for the exhibit, as they were under seizure. He bought everything in the studio and with this I redeemed my possessions, paid the expenses and, freed from this nightmare, I was able to enact my original plans. But I no longer owned even a chair. Later this kind friend informed me that he had reconstructed my studio in The Hague and that he would gladly receive me whenever I might like to see it. Unfortunately, the circumstances of my existence did not allow me this satisfaction.

My show was inaugurated on 7 April 1913, my birthday, and that same afternoon I arrived in London. The opening was held at midnight, in a new gallery called the Marlborough Gallery at 34 Duke Street in the St. James area. I must confess that our shows were generally held in new galleries which used us for publicizing their grand openings. It was a very social event. For the duration of the exhibit, it drew an extremely varied public, the upper middle class and the London aristocracy in particular, aside from other artists and the press. All the newspapers and magazines wrote about it and published my portraits and paintings. I was interviewed like a prime minister. Boccioni and Carrà would have gone mad with joy, had they been the objects of such success in the press. But this sort of thing has never interested me very much, not that I am not flattered by the opinion of an intelligent writer. Under these circumstances I met Roger Fry, one of the most highly esteemed critics and writers on modern art and one of the most enlightened, who was very interested in my show. I also met many modern artists, among them the famous sculptor Epstein, the painter Wadsworth, and a family interesting in its entirety, that of Clive Bell. However, the person with whom I became closest was the painter Nevinson. He was a reserved man like many of the English, but very sensitive and intelligent.

I spent over two weeks in London, invited here and there, guided through some of the more typical aspects of the city and its outskirts by Nevinson. I must admit to a fact that I have deeply regretted for many years, that is, that I did not find time to visit the National Gallery. I was not particularly attracted by the idea of seeing my Italian masters on foreign soil, on the one hand, and on the other, the actual life of that great,

marvelous city interested me a thousand times more. Besides, I expected to return again soon.

All the commotion and success in the press was not accompanied by the material success that I had hoped. Jeanne and I had relied on the probable earnings of the show to get married but, once my personal expenses were subtracted (those of the show were not my responsibility), I arrived back in Paris with only 500 or 600 francs in my pocket! Fortunately, Paul Fort, generous upon this occasion, found a way for us to get married all the same.

In the meantime, Apollinaire's book, *Les Peintres Cubistes*, subtitled *Méditations esthétiques*, was published.* The book caused great turmoil, although basically it restated and developed previously published articles as, for instance, the one on the latest Indépendants show where Orphism was first mentioned.

It is undoubtedly a good book by a poet (more poet than critic) who knows painters personally and is sensitive to painting. Raynal, a maniac for devaluating everything, tried to dress it down to minimal terms in *Montjoie!*, but the book earned a good reputation among the artists all the same.

I cannot, of course, compose a detailed critical study of it here, but it is worthwhile to note, for reasons of historical clarity regarding my "story," the subdivisions he made within Cubism. To begin with, he gave Cubism the following definition: "What distinguishes Cubism from painting of the past is the fact that it is not an imitative art but a conceptual art which tends to be heightened to the point of actual creation." (I am transcribing this definition for reasons of historical exactitude, sure that Apollinaire, were he alive today, would pay it no attention at all.)

He then classified the four tendencies of Cubism:

1. Scientific Cubism: the art of painting new wholes using elements taken from "cognizant reality" not from "visual reality." The painters representing this trend are Picasso, Braque, Metzinger, Gleizes, Marie Laurencin, and Gris.**

2. Physical Cubism: the art of painting new wholes with elements taken for the most part from visual reality. This style, no matter what, extends

*Originally published in Paris by Giguière, 1913, who transposed the title and the subtitle. In later editions (1922 and 1950), the transposition prevailed, while in that of 1965 by Hermann, it has been modified.

**He later added Jacques Villon and Marcoussis to this category.

into Cubism because of its Constructivist discipline, but is not a pure art since subject becomes confused with image.

The painter constituting this tendency is Le Fauconnier.*

3. Orphic Cubism: this is the other important school of modern paint-ing. It is the art of painting new wholes with elements not culled from visual reality, but entirely created and imbued with a strong sense of reality by the artist. The works of Orphic artists must simultaneously show an aesthetic interest, an evident sensitive construction and a sublime meaning, that is, the subject.[5] It is pure art.

Picasso, for certain aspects, belongs to this tendency, as well as Robert Delaunay, its inventor, Léger, and Marcel Duchamp.**

4. Instinctive Cubism: the art of painting new wholes with elements not taken from visual reality, but from what instinct and intuition suggest to the artist. This tendency is akin to Orphism, but its instinctive artists lack lucidity and an artistic credo. Instinctive Cubism includes an enormous number of artists. Rooted in French Impressionism, this movement now extends throughout Europe. It includes: Matisse, Rouault, Derain, Dufy, Chabaud, Jean Puy, Van Dongen, Severini, Boccioni, etc.

This summarizes the theoretical basis of the book, which concludes with an exaltation of the modern school of painting, the most daring yet to exist: it proposes the contemplation of "beauty for the sake of beauty."

The aforementioned *Montjoie!* article, reinforced by the tenor of this book, provoked violent aggravation at the Futurist center in Milan. How dare he speak of "simultaneity" and "subject" without one word about Futurism? I soon received a fierce letter from Boccioni:

It is necessary that you find out *in any case*, about the tendency (in my opinion, ephemeral) of Orphism. This is trickery performed on Futurism that they refuse to admit.

Chauvinisme! . . . [Boccioni, in the role of spokesman for Futurism, con-tinues in his letter] I have already replied in another quite salty article in *Lacerba* coming out tomorrow. It will serve to curb the foreign and Italian imbeciles before they can take possession of the new empty word that they

*Later adding J. Marchand, Herbin, and Vera.

**Later adding Francis Picabia.

[5]Apollinaire intends the "subject" as artistic matter and does not accord it the same predominant role as the Futurists who demanded modernity from the "subject" as well as originality, etc. In other words, in Futurism the subject was expected to furnish what must come from art and it tended to take the place of art. The same error is now rising to the surface in so-called popular art.

can stick up their. . . . Try to find any sort of reproductions, newspapers, magazines, and photographs.* You will be promptly reimbursed.

Get the opinions of Picasso, Kahnweiler, at the Closerie des Lilas, of Sagot, Canudo, Apollinaire. *What do they think of this Orphism, what is being said about it, and do they see that it is influenced by us?*

Who are these imbeciles and tricksters in Boccioni's opinion? Apollinaire and the painters he points out in regard to Orphism?

The painter to whom Apollinaire chiefly attributes the invention of this new tendency is Delaunay. While on the subject, let me discuss this artist in greater detail, for later he became rather ordinary. At that time, Delaunay revealed himself as a painter of great sensitivity and talent. In 1912, coinciding with the Futurist show at Bernheim's, he exhibited his large canvas, *La Ville de Paris*[6] in which three nude figures were composed like the classical three Graces against the background of Paris and the Eiffel Tower.

It was a beautiful painting, in which his desire to express light in a way different from the Impressionists while still adhering to Impressionist foundations was quite clear. His forms resembled the geometric and simplifying patterns adopted by the Cubists. Was it not his right to try to continue Impressionism in his own way or, as he called it, to create a "revival" of Impressionism? Afterward, and even prior to this painting, Delaunay painted and exhibited many other canvases portraying the Eiffel Tower and, given Delaunay's insistence on this subject matter, and having used the tower myself in my own works before he did (one of these paintings of mine was purchased by Stieglitz in New York),** I definitively renounced any further use of the theme in my own paintings.

In these paintings and in others titled *Windows*, he strove to give a plastic form to light, and he achieved this extremely well with areas of purple, greens, oranges, etc., in simultaneous contrasts.

This is the simultaneity to which Apollinaire referred—as he confirmed these things to me—when I told him of Boccioni's irritation. To tell the truth, I must admit that if now, many years later, I am able to talk about these things serenely and objectively, at the time I was fully aware of the

*In a letter from Boccioni to Severini (1912): "Get all possible indications on Braque and Picasso. . . . Go to Kahnweiler's and if he has any photos of recent works (done after my departure) buy one or two of them. Bring us all the information possible."

[6]This same painting, under the title *Fenêtres ouvertes simultanéement, 1.ère partie, 3° motif*, was reproduced in an album edited by Apollinaire.

**See *Metro - Grand Roue - Tour Eiffel*, 1911, now in the Cleveland Museum of Art.

problem and I defended the cause of my friends from Milan whenever possible. In this instance, Boccioni was right.

Apollinaire had clearly been exercising a bias toward Orphism; this did not surprise me since he had been in Paris for many years by then, and preferred, perhaps better understanding them, the French artists to the Italians.

He was also well aware that he had invented this Orphism basing it on Futurist ideas and works that he had previously condemned. For example, after having criticized the "subject" at the time of our 1912 Futurist exhibition, it now became in Orphism "an evident and substantial structure and a sublime expression."

That Apollinaire expressed himself in such a way about Delaunay, Marcel Duchamp, and Léger, who had already demonstrated their sensitivity to Futurist ideas, was relatively important, but not to mention the Futurists at all, although aware of their contribution to Cubism with their ideas about *movement*, about the simultaneity of emotive states of mind (beyond the optical state of color), and about the exaltation of the dynamics of modern life, was really excessive; Boccioni could not tolerate the omission. Apollinaire should have mentioned the Futurists in any case, if only briefly.

As he did not, I have reason to believe that it depended on Marinetti's aforementioned refusal and in greater part on the Futurists' frenetic race for priority, as well as on their insolence, which he always found irritating. In any case at the base of the Parisian artists' hostility and injustice toward the Futurists was always the latter's lack of tact and their aggressive behavior. Furthermore, no one knew better than Apollinaire how generic and approximate these subdivisions of schools could be, and how ephemeral and short-lived certain theoretic formulas were in Paris, where they regularly came and went. In fact, nobody gave another thought to Orphism barely a month later. We will come back to other Orphic painters later, but with regard to Picasso, who could deny Apollinaire's right to consider him a kind of stimulant to every undertaking, and to prefer him to Boccioni?

I continually found myself pulled by opposite poles: Paris and Milan. Nevertheless, I felt closer to my Parisian friends beside whom my career had begun.

In point of fact, the root of the problem was this: while Boccioni was strolling from one European capital to another, a traveling salesman for Futurism, or was dividing his efforts between painting and sculpture, and while in Milan they were exceedingly busy producing manifestos (Carrà

too, at that time devised an inconsistent manifesto), in Paris each artist was working and progressing according to his own personal conclusions. Naturally, Boccioni's article passed unnoticed. As for Apollinaire's theoretical proclamations, they soon faded into the background and he, himself, considered them only relatively important.

At this very moment, upon Marinetti's invitation, he, too, published a manifesto in *Lacerba*, "The Futurist Antitradition." This manifesto was not one of the more innovative, but it was a rather intelligent selection of the better elements of other Futurist manifestos. It discussed a hypothetical destruction of history, poetic sorrow, snobbish exoticisms, syntax, and various other topics that, as I see them, must have been added by Marinetti: for instance, houses, orchestras, boredom, and so forth. Then the construction of newly renovated techniques was discussed and mention made of purity, variety, pure literature, etc. The most original part was at the end where all critics, historians, pedagogues, professors, museums, philologists, ancient ruins, were saluted by a hearty "Merda," and all his friends and companions, from Marinetti, Boccioni, Picasso, Paul Fort, and even to Stravinsky, Soffici, Folgore, Carrà, etc., came under the heading, "Roses."

The publication of this manifesto in *Lacerba* would indicate that he had a very good relationship with the Futurists. In fact, his collaboration with Marinetti, Boccioni, and Carrà became increasingly intense. My colleagues could now indulge themselves and say everything bad about Cubism that they wanted, while availing themselves of its more apparent elements. Soffici participated as a guest in the Futurist exhibit in Rome, in February 1913, I think it was. At the same time, at one of those famous "Futurist evenings" organized at the Costanzi Theater (now the Opera house), Papini and Soffici took part, thus sharing with the new friends of Futurism in the abundant shower of more or less edible objects.

Furthermore, Soffici compiled a volume of some of the articles on Cubism that he had formerly published in *La Voce*. Admitting to an ulterior "broadening of the Cubist doctrine," he titled his book *Cubism and Beyond*, and included reproductions of works by Boccioni and Carrà. Of course, since those absent are always in the wrong, I was not granted the benefit of inclusion in the book, although the fusion of these two groups was due chiefly to my personal intercession. I confess that this irritated me to a certain extent, and clearly said so to Boccioni. Moreover, I found the tone of *Lacerba* annoyingly pontifical and for some time had no desire to collaborate with that review.

Meanwhile, a Boccioni sculpture show was organized at the Galerie La

Boëtie. Although assembled hurriedly, almost improvised, it was quite interesting and suggested that he might have a greater potential for this idiom than for painting.

It was certainly something of a "tour de force" to prepare ten sculptures or so (all in plaster, of course) and twenty drawings in the space of twelve months. Such a desperate display of energy and a pressing sense of immediacy employed for the purpose of a maximum degree of expression, made one wonder if Boccioni might not have felt some premonition of his imminent doom. I often reflected on this, after his premature death.

It must also be remembered that Boccioni, as well as painting and sculpting, was also composing manifestos and articles, and giving lectures. At the same time, he was preparing a volume that was published, I believe, toward the end of that year. The exhibition was of course accompanied by its own conference, attended by all the avant-garde artists in Paris. It was an extremely merry, exciting evening, without the cannonade of vegetables so typical in Italy. As Boccioni's French was very bad, I stood behind him and, knowing more or less what he intended to say, suggested the right words to him. But we got off to a bad start: having misunderstood my prompting, and wanting to rush along on his own, he said, "I do not lack words, but ideas," which was met with a burst of hilarious laughter, and the mistake, instead of damaging him, earned him considerable allegiance. The entire conference continued in this vein, with words prompted, misunderstood, and then corrected. As he did not understand what I was trying to tell him, he swore like a Turk in Italian and was furious at me. The madder he became, the harder I laughed, so that I finally could no longer speak at all. Among the many friends who had rallied around the lecturer was Prince d'Orléans-Bragance whom I knew from Pienza, and who, I think, had never enjoyed himself so much in his entire life.

All things considered, the conference was received sympathetically. It must be said that the artists in Paris were always cordial and also partial to the Futurists.

As for the artistic validity of his sculptures, there is a great deal that could be said, but it can be summarized in the following manner: certain of his figures in motion, called *Spiral Expansion of Muscles in Movement* or *Unique Forms of Spatial Continuity*, clearly demonstrate a preconceived method and theory; it is clear that they were intended to illustrate a theory. Yet, despite this horrible practice, totally contrary to any sort of creativity, here and there an architectonic sense of form emerged that was more evident in his static subject matter, as in *Forms-Forces of a Bottle*. The Cubist principle of multifaceted profiles was dominant, as was the

depiction of densities, etc. He managed, however, to construct certain grandiose still lifes imbued with a true sense of monumentality.

Boccioni could certainly have confirmed his talents in this direction, gaining the skills of an idiom whose secrets he still, visibly, ignored. He left Paris reasonably satisfied.

In the meantime, all the necessary certificates for my wedding arrived, so we set the date, August 28th.

As witnesses we had chosen the well-known American poet, Stuart Merrill, and Alfred Vallette, editor of *Mercure de France*, for the bride. Both had known Jeanne since she was an infant and were very fond of her. They were also great friends of Paul Fort. My best men were Apollinaire and Marinetti. To tell the truth, the Futurists were not exactly pleased with the idea of my marriage and could not desist from sending me bitterly critical letters. Almost at the very last minute a telegram was delivered from Boccioni, Carrà, Russolo, and Marinetti saying: "If you insist upon marrying, we will withdraw our solidarity." I paid no attention to their threat and Boccioni, supposing that the marriage would have a certain amount of notoriety, and not wanting to miss the opportunity, offered to be my witness. I gladly accepted, but then he must have realized that he could not shoulder the cost of another trip to Paris, so he abdicated in favor of Marinetti.

Paul Fort had hoped for a church wedding, not because of religious convictions but instead preferring the pomposity of the ceremony; I, who had lost faith and was a total atheist, radically opposed the idea. I had never cared for ambiguous views and had always hoped for perfect harmony between my convictions and my actions. I regretted causing my little bride disappointment right from the start, as she, too, had wanted to be married in church, but our wedding took place at the 14th Arrondissement Town Hall. The event turned into a wonderful, festive celebration, which I had not expected at all.

Marinetti had brought his beautiful white automobile to Paris and it seemed absolutely perfect for the ceremony; in fact, he lent it to us. Paul Fort was magnificent in a new suit of tails and a broad Rembrandt hat. I wore the appropriate formal English cutaway for the occasion, but the one who impressed everyone and aroused general enthusiasm was Jeanne, radiating youth and charm, in a long white dress which made her seem older than her mere sixteen years.

I tried not to show it, but I was deeply moved. Until a few days before the ceremony, I had been perfectly calm. I had even painted various canvases in my hotel room (I no longer had a studio), including *Plastic*

Rhythm of July 14th, (fig. 33) one of my best paintings, and a portrait of Marinetti composed of pieces of cloth, printed matter, and a real moustache (fig 22). However, ready to take the decisive step, I felt an obscure but deep sense of its meaning and importance.

It might have been for this reason that, as the reporters claimed, I replied to the mayor's questions with an almost whispered "I do," while Jeanne answered in such a blaring, joyful voice that the whole room broke into laughter.

As soon as the mayor had finished, Paul Fort turned to the crowd of friends and announced: "C'est le mariage de la France avec l'Italie," which aroused great enthusiasm. We were then overcome by everyone congratulating, complimenting and wishing us well, especially by the writers and most of the Cubists. Everyone made a point of showing their fondness and friendship. They all had been visibly moved by the wedding of the princess of the Closerie.

A movie camera had been set up on the City Hall steps and the whole ceremony was filmed for the newsreel of the week. Afterwards we went to the famous Café Voltaire behind the Odéon where we sipped aperitifs and engaged in merry conversation while waiting for the lunch prepared by the historically renowned café.

When everyone was ready to go upstairs for lunch, one of those artisans (an Italian) making moulded plaster casts that abound in Paris, one famous for the perfection of his forms, brought me a beautiful Victory of Samothrace as a present and souvenir. I had it carried to the vestibule of the dining room and then forgot about it.

Among the guests, aside from the witnesses and bridesmaids, were Germaine Tailleferre and Marthe Roux, Salmon, Max Jacob, Mercereau, Le Cardonnel, Rachilde, Madame Philippe Berthelot, Carco, and many others I do not remember. Of Jeanne's relatives her cousin, Robert Fort, still in the military service, came dressed in the red pants of the French Infantry, escorting his young wife, Gabrielle, Rachilde's daughter. Needless to say, the lunch was lovely. Paul Fort and Max Jacob vied with one another in "word games," in funny anecdotes, and in every sort of verbal contrivance, one more witty than the next. At a certain point, Max Jacob pushed the prank a little too far. Having noticed the elegant Victory of Samothrace in the adjoining room, he went to retrieve it, placed it in the center of the table and exclaimed: "In such a congregation of Futurists, this old statue makes no sense at all," and with that remark, he picked up a bottle and smashed the statue. Some of the guests protested, but the damage had already been done, and all that was left was to try to forget

about it and have a good time. Luckily, once the luncheon was over, Francis Carco began to sing his excellent imitations of Mayol. Carco, at that time, was a very smart, nice young fellow. He sang so well that Rachilde asked to meet him and asked if he were a writer. Carco replied: "Not only am I a writer, but I submitted a novel to *Mercure de France* a year ago and have yet to see a reply." Rachilde, being such a refined woman, understood the meaning of Carco's words; a few days later he received an answer from *Mercure*, and shortly thereafter his first book, *Jésus la Caille*, finally saw its way into print. "My luck dates back to Severini's wedding day," my friend wrote later. I was very pleased to have been of use to such an authentic writer, helping him to take his first step toward celebrity. In the early afternoon, when my young bride and I left the Café Voltaire, all of our friends and guests were at the peak of their rejoicing. The painters, among whom Léger, Metzinger, Gleizes, were mingling with Apollinaire and the other poets. Max Jacob became steadily more eccentric and from time to time the crystalline laughter of Rachilde, who was thoroughly enjoying herself, could be heard.

All the newspapers in Paris, many of those in London, and a few in Italy wrote about the wedding as an important event. They headlined their long and often detailed articles, "A Highness' Wedding," or "Princely Wedding Ceremony," or "The Prince of Poets Gives His Daughter's Hand in Marriage," referring to the honorary title that Paul Fort had inherited from Verlaine, and not to the material condition of the newlyweds which was far from princely. Other newspapers described the wedding of a Cubist painter, or that of a Futurist painter, garnishing the articles with illustrations and drawings. *Comoedia* had the unhumorous idea of publishing a caricature of me sitting on a pile of volumes of *Ballades Françaises*,* intent on painting one of my bizarre compositions, and *Intransigéant*, in the person of Fernand Divoire, composed an original letter of participation which ended:

C'est le 28 que Ginò
Se marie avec Jeannette;
Chantez, musettes, pipeaux,
Chantez, pipeaux et musettes
Pour Jeannette et pour Ginò.

In the end, Boccioni had not been mistaken about the publicity aspect, but frankly I was sincerely more irritated than pleased by it.

Furthermore, a few days later Jeanne and I left Paris.

*Opus by Paul Fort in approximately 40 volumes.

As my parents' circumstances were too modest for them to undertake the trip from Pienza to Paris for my wedding, I decided to go see them right after the ceremony. Had I been able to foresee the results of my visit, I might have temporarily delayed it. The inventiveness thriving in the Parisian art world at that particular moment had never been so intense. The interest that I and my work stimulated promised practical results not yet realized. Everything indicated my staying there, or, in the case of an absence, to keeping it short. In fact, I fully intended to stay in Italy only until the fall, but fate ruled otherwise.

With a paucity of means but our hearts full of joy, Jeanne and I boarded the train to Italy.

Our Futurist friends were waiting for us in Milan, and welcomed us with festivities despite their disapproval of our marriage. By coincidence, Soffici was in Milan too, and one day we all met for a very jovial, cordial lunch. I must describe this luncheon, or lunch, however one would call it, offered by the Futurists, for it provoked a certain unexpected publicity in the press. As I was saying, we were having an immensely good time. No one could equal Boccioni in provoking his friends to laughter, and Carrà, grumpy and coarse as he often could be, was not wanting in delicacy. As for Soffici, he was always pleasant company. The problem was that Soffici wrote a column in *Lacerba* called "Giornale di bordo"* intended as a summary of weekly events and notes of interest. Not omitting an account of our banquet, as he saw it, he presented it metaphorically as an imaginary trial where the Futurists, enemies of marriage, had put the Futurist bride and groom on the stand to testify. In his version, the violence of the accusations and reprimands was such that the young bride burst out crying, throwing herself into the arms of her new husband, who fainted from rage. Carrà then started to vomit. (Carrà, when speaking, actually seemed to grumble and mutter, and in Boccioni's accounts, always ended up vomiting.) After this unpleasantness, the Futurists reestablished a mood of serenity and the wedding was pronounced innocent.

This was more or less the gist of Soffici's tale which would not have had further consequences had all copies of *Lacerba* remained within Italy. Instead, they arrived in Paris and fell precisely into the hands of Apollinaire. Perfectly fluent in Italian, he also wrote the "Echoes" column in the "Revue de la Quinzaine" section of *Mercure de France*. He translated and published Soffici's inventive tale which was then picked up and remarked upon by other magazines. The impression this made on Paul Fort and the numerous friends who had recently celebrated with us in Paris can well be

*Giornale di bordo = log book

imagined. Paul Fort sent us an apprehensive telegram which we answered from Pienza where we had arrived in the meantime. We replied that it had been a joke invented by a journalist and that none of the tale was true. I am not sure how much of our explanation he believed. The Futurists were already earning themselves a bad reputation under certain aspects, especially regarding women, for they had often been quite rude. They had actually proclaimed their contempt for women.

After Milan, we stopped briefly in Florence where Papini, Soffici, and other local friends also welcomed us with warm festivities.

We arrived in Montepulciano after lunch, around three o'clock. My mother had hired a carriage and had come to drive us back to Pienza. The first contact between Jeanne and my mother was very simple and friendly. Only the most recalcitrant individual, insensitive to human feelings, could have looked upon a little sixteen-year-old bride as attractive as Jeanne without liking her immediately. However, there was a serious problem with the language barrier: my mother spoke not a word of French and my wife had not the slightest inkling of Italian. So I was always obliged to be on hand to translate whatever either of them wanted to say.

The rather long, boring trip finally ended and we arrived in Pienza where my father and sister, now thirteen, were waiting for us. All the young people in town whom I had met the previous year had gathered to greet us and to celebrate our arrival. My father was instantly won over. On the contrary, my sister experienced an insurgent, implacable sense of jealousy. The little foreigner, almost her own age, had such superior status!

My parents, as you already know, had always been poor. My father, in that wretched government office, earned a miserable salary and had always had trouble making ends meet, saved only by financial miracles. Unfortunately, my arrival, penniless, caused the family grave material problems. This fact, and that of Jeanne's ignorance of Italian were bound, in the long run, to cause friction and misunderstandings. I must also admit that my mother had never been an amenable, manageable, sweet woman. She was authoritarian, violent, and often very tough. However she did not lack either intelligence or sensitivity. Jeanne, too, had a combative nature and was proud and touchy. Conciliating and neutralizing these two forces was not an easy task and more than once I was embarrassed to the point of losing my patience. Without the least knowledge of marital strategy, I soon realized that the most important thing to preserve was a good relationship with my wife. So, each time, whether she was

actually right or wrong, I always gave her the benefit of the doubt. Jeanne was not afraid of poverty. She had always been familiar with it, but the poverty of an artist is nothing like that of a low-level employee. They are two totally different things.

An artist is grandiose, internally rich and never crushed, even when completely destitute. Moreover, he always has a chance to become rich, from one day to the next, or even in the coming hour. When poor, the civil servant is irredeemably, hopelessly, substantially, and obviously poor. An artist's psychological structure is totally different from that of an employee, whatever his rank (and in this respect, the lowly usher and the cabinet minister are alike). Both are actually part of a middle-class scale, each on his own step, but on the same ladder. What I mean to say is that even under conditions much better than ours, the family that begets an artist will very rarely understand the family that the artist himself forms, which is shaped by his own point of view. Therefore, there was nothing extraordinary about the fact that, after a month in Pienza, Jeanne and I became impatient with that sort of life. We ended up staying for nearly three months.

Life outside the family was pleasant, for the whole town was fond of my wife. There was a young priest with modern ideas who liked me very much and gave me permission to visit some of his parcels of land near Pienza with Jeanne, where he grew grapes and other fruit. We would often go into the country or would visit neighboring towns so that we were never bored.

But one fine morning, some money arrived from Jeanne's grandmother and we left Pienza immediately.

Fall was beginning and it was just the right time to return to Paris. I had brought my wife to meet my parents, so why not head back to Paris now? But it seemed monstrous to me not to show Jeanne the rest of Italy, at least as far as Rome. This is a deep, irrational Italian feeling, useless to fight. So, we headed toward Rome.

My great friend and master, Giacomo Balla, who had declared his solidarity with the Futurist group, welcomed us with his usual kindness. Other friends feted us and Jeanne liked Rome immensely, under its golden autumn light. Everything was going marvelously until I suddenly became very sick.

Two years before moving to Paris, around 1904, during the final year of Monsignor Passerini's patronage, I had fallen ill with pleurisy in Rome. I had been working on a painting that obliged me to spend twenty to thirty minutes each day on the corner of via Veneto and via di Porta Pinciana

carefully observing the scenery. I was studying the sunset effect; a gas lamplight had just been lit against a sky still inflamed by the setting sun. On the left side of the canvas, near the lamppost, a scaffolding was wrapped around houses under construction and both the last rays of the sun and the first flames of the gas lamp reflected against the builders' planks. How true it is that the less of an expert one is, the greater the difficulties one attempts. At that time of day I could not work directly on the canvas, so I had to impress the effect perfectly on my memory.

I had almost finished the painting when, possibly having caught cold on that street corner, I came down with an acute case of pleurisy. I was living in a little room on via Campana, along the Roman walls that surround the Villa Borghese park. My landlady, a kind laundress married to a carriage driver, took wonderful care of me, and my parents would only discover the illness when I was already cured of it. The good doctor who treated me warned that such an illness could have serious consequences. I was to lead as orderly a life as possible. You can imagine how much the life I had led in Paris strayed from his recommendations, so the result, ten years later, was to suffer the consequences.

In the wake of some alarming symptoms, Balla took me to an excellent doctor, friend of many artists and a specialist in pulmonary diseases. Professor Signorelli* welcomed and treated me with particular dedication and kindness. In his opinion, the illness was not serious and could be cured by a few months of rest and convalescence.

So, on his advice and with the little money in my possession, we left immediately for Anzio, where we found a magnificent dwelling, an old, completely ramshackle house on the far end of the wharf. That was where our real life as a family began. Jeanne was extremely courageous but could not cook even an egg. She had been born and had grown up in a house unlike any normal one. It was primarily the editorial office and retreat of *Vers et Prose*. Moreover, Paul Fort did not live there himself, just his mother, wife, and daughter, and, for a certain time, Robert, my wife's cousin. Paul Fort had made this tiny apartment, to which I will have occasion to refer again, into his center of activity. Thousands of subscription forms were mailed out of the office and letters and money orders delivered there. His wife, mother, daughter, and, when in residence, his nephew, had no other mission in life than to work for *Vers et Prose*. This

*See letters from Severini to Prof. Angelo Signorelli (1914–1932) preserved at the Fondazione Cini in Venice, published in the appendix of the catalogue by Fabio Benzi, *Gino Severini* (Rome: Leonardo-De Luca Editori, 1992).

was the "housekeeping" training that my wife received, when she came home from school. There was no reason to be amazed if everything about the running of a house was a mystery to her.

Nonetheless, she took to the task with great optimism and a gaiety that never abandoned her. Above all, she kept herself busy, as well as she could, in the kitchen. Such an improbable housewife did the housework and I, since my rather benign illness allowed it, did a little painting, sometimes even outdoors, despite the oncoming winter.

Everything would have been perfect and I would have been cured quickly and completely had I possessed sufficient means for the duration of the convalescence, approximately one year. Unfortunately this was not the case. I considered asking Marinetti for help. It would have been natural for me to go to him in such serious circumstances for, of all my friends, he was the only one who could have been of some assistance. Furthermore, I had made an important contribution to Futurism and, finally, because he held a number of my important works, in custody for the shows he organized, valued even then at a thousand times more than the sum I needed.[7] I called upon Boccioni to second my request.

The replies I received were a terrible and bitter disillusionment. I had expected some difficulty from Marinetti, but from Boccioni I could never have imagined such an attitude toward me. Without delay, he wrote basically that I had gotten what I deserved and that, if I decided to send my wife back to Paris, then perhaps Marinetti would do something to help me.

As for Marinetti himself, he went to great pains to prove that two times two makes four, that his mission as a Futurist did not allow him to become involved in personal cases. "If I were to give in for one, sole instant, to my instincts and to those for whom I care," he wrote me, "then in less than a year's time I would bring Futurism to ruin with me, as it requires greater expenditures each day. *Futurism above all else.* I care very greatly for you, I consider you one of the major forces of Futurism, but what is impossible *is* impossible."

As I recall, Carrà did not write me anything at all, while Russolo, as a sign of protest and solidarity, sent me a money order for five lire.[8]

Many pseudo-intellectuals gravitated to Marinetti and the Futurists:

[7]He could have saved me from my predicament with roughly 100 lire a month, that is, approximately 1200 lire for a year!

[8]At approximately this same time, a Futurist show was being held in Rotterdam that included six important paintings of mine, among which were the large *Bal Tabarin, Portrait of M.S.,* and the two "Dancers" brought from Paris the previous year.

poets, writers, painters, all little people, little provincial souls limited in their every gesture. With the exception of Luciano Folgore, the poet, and his very kind wife, and the young painter Prampolini, few of these could understand my plight. At a certain point I honestly felt totally lost. But practical assistance did arrive, suddenly and providentially, from an unexpected source. I had written to Nevinson, in London, to give vent to my unfortunate circumstances and he, without even knowing how desperate my condition actually was, but undoubtedly foreseeing it, took my cause to heart, together with Roger Fry and other English artists. One fine day I received ten pounds from them, accompanied by a very simple letter that, compared to those from Boccioni and Marinetti, should have been framed with a garland of laurel and hung on the wall.

Subsequently, various sums arrived from London which, added to a few money orders from Jeanne's mother, allowed us to spend close to six months in Anzio. When this assistance from abroad was late in arriving, our landlady would take our wristwatches to a state pawn broker in Nettuno and we would stay on, while my health rapidly improved.

In the meantime, a Futurist gallery had opened in Rome, run, under Marinetti's influence, by a certain Sprovieri, an inconsistent individual, both from a commercial point of view as well as from intellectual and artistic ones. It was destined for rapid failure. Boccioni inaugurated it with an exhibit of his sculptures in December 1913, and from that time on, other shows and conferences took place there, each with its relative commotion. I rarely took part in these.

Needless to say that abroad, especially in London and Paris, intense artistic and intellectual activity was ablaze. An avant-garde exhibit was organized at the Doré Gallery in London in which two works of mine were hung. Marinetti presided at a conference there and my friend Nevinson organized a banquet in his honor. That was the occasion, I believe, of Nevinson's English manifesto and his decision to adhere to Futurism.

That year's Salon d'Automne in Paris was quite important, despite André Salmon's qualifications in a critique published in *Montjoie!*. Of course, as I was absent, I cannot express any first-person opinions about that show; I can only write from the deductions I made from the various sources of information I received. Perhaps Salmon was right when he said that the Salon did not contain any first-rate works that year and that the general level was "a satisfactory average." On the other hand he was obliged to note that "it is becoming more and more difficult for the poor in spirit to appear as artists, and that thoughtful painters 'must learn to think as painters, not as literates.'"

Further along in his article, he makes another important point, that it is finally possible to see composed paintings hanging on the walls instead of "a well-painted piece" or "studies" abusively carried to the exhibit. Therefore, paintings contemplated, constructed, whose elements were assembled according to a certain order, were all a contribution of Cubism.

This is the affirmation that especially interests me, for until that time the critics in Paris, especially Salmon, had defended Cubism by defending Picasso or Derain; he had defended it, in other words, on the rebound, while finally Cubism was being confirmed as an instrumental tendency in the context of a large exhibition.

André Salmon, himself, had previously launched one of his pleasantries: "You would think you were at an academy, with the exit through the gymnasium." By that he meant that the Cubists were escaping the danger of academicism only to succumb to that of gymnastics. This summary criticism was not lost on the mediocre scribes in Paris and abroad and, in Italy, was repeated and still prevails today. Thus Salmon was right, that time, to recognize the beneficial influence of Cubism on the art of the period. His statement that the "1913 Salon was a clearly Cubist Salon" was of particular importance.

Evidently, stimulated by this tendency, a legion of artists "whose orthodoxy is less professed" was now considered interesting for the "severity of composition, for the particular economy of line and color," as Salmon had written. Among these new, more or less severe Cubists, there were undoubtedly certain valid painters. It suffices to recall Kisling, Marchand, Madame Lewitzka, Mondzain, Luc-Albert Moreau, Rivera, the Mexican who was later to become one of the most orthodox Cubists, and many others.

However, it is a fact that this was evidence of a deviation from Cubism, or more precisely, the exploitation of its "apparent aspects"; in other words, there was an emergence of pseudo-Cubism which recalled the real thing but lacked its profound intentions.

Artists such as Boussingault (later called the Boldini of Cubism) abounded. And I am not entirely certain that Salmon, when speaking of "compositional severity" did not also intend to praise the Boussingaults of the situation.

As for Gleizes, Metzinger, Jacques Villon, Duchamp-Villon, the sculptor, Lhote, de la Fresnaye, de Ségonzac, etc., it seems to me that their works this time were not inferior to those previously exhibited. Gris and Léger abstained from the exhibition, as did Modigliani.

Aside from the Cubists, the participants included the various Laprades,

Lebasques, Charles Guérins, Maurice Asselins, and above all, painters like Bonnard and Matisse which Salmon, insensitive to their art, accused of a certain amorphism.

De Chirico also participated in that Salon. In short, the 1913 Salon d'Automne was an important milestone of Cubism. Collective or social art was also mentioned frequently; the moment was at hand when that dream was about to materialize.

Coinciding with the Paris Salon d'Automne, an interesting Futurist exhibit opened in Florence, with the participation of Soffici.

It was, of course, customized to the requirements of *Lacerba*, so that all the collaborators and friends of that review took part in an inevitable evening on stage in a Florentine theater: Papini, Soffici, Tavolato, etc. Palazzeschi chose to watch from a box.

I received letters about this evening, as I did for all the others, described in impassioned terms. Among other things I was told that some young artists such as Rosai and Primo Conti were enthusiastic about Futurism and had adhered to the movement.

To be honest, I never saw the Futurist paintings of those two young artists and do not give excessive credit to the capabilities of any young painter temporarily clinging to a certain set of tastes, rather than obeying a profound internal necessity which if fully contemplated will mature over time. The fact that they never felt such an internal necessity is amply demonstrated by the artistic orientation they eventually adopted, and therefore that adhesion of theirs was never important to them or to Futurism, nor to art in general. The same could be said about Sironi when, two years later, he too decided to declare himself a Futurist.

What is important, from my point of view, is that the show in Florence was probably the best group show yet. Ten of my works were included, among which were two "dancers" (*Danseuse Bleu* and *Chahutteuse*) that I, myself, carried from Paris. Boccioni had eleven works, Carrà fourteen, Soffici eighteen. All of the works showed a certain progress. Had a similar group of works been presented at the Salon d'Automne, after the first show, we would have obtained results of much greater importance than those in Florence. But Marinetti and the Futurists were more interested in that noisy provincial success that they could only obtain in Italy.

This time our Balla was also present, represented by four works that showed the high level of his inventive spirit and ever-youthful fantasy. The serious personal problems that complicated and weighed upon my shoulders at that moment and the oncoming events of war, prevented me from following the growth of this dear friend and teacher, but I suspect that he

received little encouragement for his new, brave orientation. He, too, in a city like Paris, would have earned much greater recognition, and the ulterior development in his art that everyone reproaches him for today would certainly have been much different. In any case, for a certain time Balla was the most brilliant, most honest painter in Italy. Whatever he did later will never cancel that fact, nor the certainty that we are in his debt, nor that he deserves an eminent place in the history of those times.

As for Carrà, this occasion marked his full adhesion to Picassian Cubism.

The son of writer Fernando Agnoletti, whom I was fortunate enough to meet recently, has, despite his age at the time (ten years) a rather good recollection of the Futurist exhibit in Florence, which was noted for the great uproar over the works exhibited. He remembers that one day his father took him to the house of an English lady, Mrs. Bee, and, showing him a painting he had obliged the lady to purchase, said to him, "Look at it carefully. It is by a great artist who is now quite ill." The boy was rather irritated by his father's imposition upon his own judgment, and perhaps thought that a real and great artist would never have painted such scrawls. Today, Braccio Agnoletti is in possession of the two paintings, *Danseuse Bleu* and *Chahutteuse*,* that his father bought at that time, and is very pleased to own them.

A Florentine book dealer named Ferrante Gonnelli was responsible for this exhibition. He evidently did his job well, in a certain sense, for he managed to sell several of the works, even in a climate as refractory to modern art as Florence. Almost all the artists showing there could boast of at least one sale. I sold three paintings and two pastels. Among these were the two dancers bought by Agnoletti. I was very happy in Anzio to learn of these sales, as they were extremely timely; I received the money from Gonnelli, however, in small installments, and many years later, after the war, so that I never succeeded in recuperating all that was due. In contrast, my friends were paid immediately and in full.

The new year, 1914, found us more or less in the same circumstances. Other exhibitions were planned during the following six months: Rome in February, which hosted a complete group show of Futurist paintings, and London in April at the Doré Gallery, then finally Naples, organized by the Roman dealer Sprovieri.

Of course, all of these exhibits were accompanied by the usual public

***Danseuse Bleu* now belongs to the Mattioli Collection in Milan and *La Chahutteuse* is in the Jucker Collection in the Brera in Milan.

spectacles, the nature of which I witnessed, more or less, at Valentine de Saint-Point's conference in Paris. In Marinetti's opinion, this was nothing compared to those evenings marked by the tossing of vegetables and other objects, under way in Italy.

Today, much later, when the uselessness of such demonstrations and the enormous waste of energy have become clear, it is only natural to wonder, as today's young do, how such ostensibly intelligent artists could have strayed from their professions to appear on stage before such immense audiences, trying to demonstrate, for instance, that Italian art critics could not distinguish between Ettore Tito and Cézanne. Or to expose and diffuse the paintings of this master, and the Cubist attempts at pure painting, or else the Futurists' striving for plastic dynamism; how could they have devoted their time and troubled themselves for such purposes inevitably destined to total failure.

In fact, they themselves admit that the audiences immediately lost control, abandoned all vestiges of good sense, and that such maelstroms always ended in vulgar pandemonium and chaotic, violent fights.

So, not only did reasons of health keep me in Anzio, as a quiet onlooker in the wings, but also personal choice. I finished several works which I then grouped together under the heading "Plastic Analogies." The theory of contrasts lent itself to further development, above all as poetic inspiration, from the point of view of the analogies. My aim was to use complementary images, not to make one image more evident by juxtaposing it to its analogy, but to create a new one. In short, while staying within the essence of painting, I wanted to carry images beyond the point of metaphor to the most elevated poetic planes. Technically, I realized these images by painting almost entirely geometric forms using colors of the prism: each form went from blue-purple to orange or red across gradations of green, yellow, and yellow-orange. I regarded these colors lightcolors and not pigment-colors.

This period was interrupted by my departure from Anzio. Nearly a year later in Paris, I longed to continue my research in that direction, but other ideas, other goals, had absorbed my interest and therefore only a few such works, one of which was sold in New York by Stieglitz, remain from that special, fleeting moment.[9]

Marinetti had often asked me to formulate a "manifesto," but the idea

[9]The painting, *Danzatrice-Barche a Vela-Mazzo di Fiori* (*Dancer-Sailboat-Flower Bouquet*), reproduced in my book, *Ragionamenti sulle Arti Figurative* (Milan: U. Hoepli), table XXVI, is one of these works.

had never appealed to me, and I felt it contrary to my nature. Nevertheless, in Paris, recalling all the studies I had made and all the ideas that had blossomed in my mind while preparing my *Pan-Pan à Monico* and other similar paintings, and recollecting the contribution that the sensation of "sound and noise" had made to the determination of certain forms and certain colors in those paintings, I replied to Marinetti. I told him that it might be possible for me to collect my observations and reflections on the influence of noises and sounds to the source of the inspiration of a given work of art and also to its architectonic and coloristic structure. I had already expressed these ideas rather precisely in the preface to the catalogue of my recent exhibit in London.* "Very good, an excellent topic," Marinetti said right away, "Make it into a manifesto immediately." Unfortunately, two weeks after this, Carrà's manifesto, *Noise-Sounds and Odors* was issued. I complained to Marinetti about the timing, but Carrà wrote me that it had been a pure coincidence and, as such manifestations were of very little interest to me, I did not think twice about the incident again.

Then Marinetti charged back with his idea for a manifesto on the "Plastic Analogies," having already discussed it with our friends in Milan, who were enthusiastic. Therefore I felt obliged to make a stab at drafting a manifesto. However, I did not have a gift for spontaneously forcing ideas, manipulating them with the journalistic technique of exaggeration to drive them beyond their natural limits—that is, to flood thoughts and events with bright magnesium lights that initially blind you and then plunge you into an even deeper darkness. I realized that to compile a manifesto, it was essential to have special inclinations and notions, which I did not possess. So, I left the question in mid-air and, today, am very glad not to have that "special" literature on my conscience. Meanwhile I continued to receive copies of *Lacerba* containing endless articles by Carrà, Boccioni, Russolo, aside from those by Papini and Soffici. Considered as a whole, it was a vigorous review; its continual hammering on the same nail promised to produce better results than those evenings that turned into fistfights at the on-stage conferences. But, as far as painting was concerned, its effects were only momentary.

*"I believe that every sensation may be rendered in the plastic manner. Noices and sounds enter into the element, 'ambiance,' and may be translated through forms. The word 'ambiance' implies the word 'atmosphere.' We render plastically the displacement of a body in atmosphere as well as that atmosphere itself.

The Impressionists in painting the atmosphere surrounding a body have set the problem; we are working out the solution."

Nevertheless, I finally decided to send them some of my drawings too, which were then published.* Among these, one was particularly successful. Of course, its title was changed and it was called *Serpentine Dance*.[10]

It was a drawing in which I had employed words and forms at the same time, but in a different way from that of my 1912 paintings (*Portrait of Paul Fort, of Marinetti,* etc.), and with a different intent. This time the words were important not only pictorially, for their linear and tonal values, but also for their essential meanings, so that they became a sort of graphic poem, in which I had used, as was appropriate to the occasion, Marinetti's formula of "parole in libertà." Marinetti wrote to me right away, "We are all enthusiastic about your latest drawing in *Lacerba*."

What pleased me even more was a short card from Apollinaire saying that my intuition reminded him of some little seventeenth-century poems where words were arranged in such a way as to suggest particular shapes. In fact, shortly thereafter his well-known "Calligrams" made their appearance, to which I suppose, the memory of Mallarmé[11] must have contributed, just as it contributed to the application of such things as printed pages to the surfaces of some of my early paintings.

In any case, Apollinaire imbued his calligrams with a totally special, inventive spirit. That drawing of mine that admittedly was rather worthless as far as drawings go, suggested absolutely nothing to Marinetti and to the other Futurists.

Meanwhile, Boccioni's book, *Futurist Painting—Sculpture (Plastic Dynamism)*, had appeared. This is not the place for a critique of that book, whose validity is more of a polemical than a critical nature. Insofar as it is an espousal of theories, it contains the substance of my friend's ideas, but the reflection of the other Futurists also emerges at a certain point. Boccioni was undeniably the theoretician of Futurism, attempting to condense the intentions of the whole group into definitions and sometimes into axioms. You must keep in mind that many things were, so to say, intuitively perceived about art in Milan, an environment then still amorphous. As became evident, Boccioni had only some all-too-rare contacts

**Argentine Tango* published in the 15 November 1913 issue; *Sea=Ballerina* in that of 15 April 1914, and *Serpentine Dance* in the 1 July 1914 issue.

[10]As I recall, my title had been *Composition of Words and Forms (Dancer=Sea)*.

[11]I am alluding to Mallarmé's last poem, "Un coup de dés jamais n'abolira le hasard" which so greatly influenced contemporary poetry. In Paris perhaps, some will recall the interesting conference on the theme of this poem, held by André Gide at the Théâtre du Vieux Colombier on 22 November 1913. The conference was called "Verlaine and Mallarmé."

with the more informed and developed art world. The book also suffers from insufficient historical context; Boccioni's knowledge of French painting was weak (in his opinion the *Avignon Pietà* and the *Man with a Glass of Wine* by Fouquet are "partial studies of reality"); the Spanish can only be credited with "a few portraits" and the fact that these might be by Velázquez or Goya is of only superficial importance to my friend. When, through force of intuition, he reaches a fundamental truth, such as "physical transcendentalism," it is a universally evident truth of La Palice.*

Nevertheless, there are many points of view that I would call luminous, prismatic, that show how vitally intelligent he really was. In spite of everything else about it, the book is a good document of the period even if its principal merit is, as I have said, polemical.

In Anzio I could not imagine what effect it would provoke: as usual, many did not like it, but never has a book of that sort been received by unanimous consent.

I then received the news that Carrà, along with Soffici, Papini, and Palazzeschi, had taken a trip to Paris. This meant that the contact with Soffici, by far the best-informed of the Futurists, had finally made Carrà realize that it was fundamental to absorb more of that atmosphere firsthand.

I was no longer there to introduce him to the art world as I had done previously, but thanks to Soffici, a good friend of Serge Jastrebzoff and the Baroness d'Oettingen, he was well received and even a guest of the baroness in the apartment she destined to become the editorial offices of *Soirées de Paris*,** a review founded some time earlier which had received a more vigorous impulse under the editorial directorship of Apollinaire.

This apartment was located on boulevard Raspail, between the Closerie des Lilas and the Montparnasse cafés that were becoming "artistic." Carrà should have considered himself fortunate; on the other hand, Serge and the "Baronne" (as we called her familiarly) were the very ones who had written to Soffici about Futurism and the Futurists in such uncompli-

*"La Palisse" [sic] in the Italian editions. This refers to Jacques de Chabannes, Lord of La Palice (c.1470–1525). A distortion of a verse in memory of him composed by his soldiers, led to the use of his name as a symbol for an obvious truth, "une vérité de La Palice," something evident to everyone at first sight.

**Review founded by Apollinaire, André Billy, René Dalize, André Salmon, and André Tudesq. First issued in February 1912, it eventually closed after the July-August 1914 number.

mentary terms. That matters very little. When they began to know him better, they undoubtedly realized that Carrà was not at all stupid.

He received Boccioni's book while in Paris, but, from what I gleaned from his letters, did not like it. First, because at a certain point in the book, it seemed to Carrà that Boccioni classifies him as one of his disciples, at least theoretically, and second, because he considered it puerile, in his own words, "to base all Futurist painting on his three little paintings, *States of Mind*."

Now, much later, these rivalries and overratings of one's own abilities, reflecting Marinetti's analogous behavior, are laughable, especially since the ideas in both the manifestos and Boccioni's book, as far as such attitudes can be considered interesting, are now only deemed indicative of theories or glimpses of aesthetics, not as a real aesthetic creed. Later, however, as various sorts of ideas about the avant-garde developed, they once again were considered a valid stimulus and a source of creativity.

The arguments used by Carrà to justify, even now in a recent book,[12] one of the principal ideas expressed in the Futurist Painting Manifesto make it seem likely that not only were certain questions not clarified at the time, but also that they remain unclear to this day. I refer to the following phrase in the manifesto: "We will put the spectator in the center of the picture." Carrà claims the phrase as his own, having received the suggestion for it when he witnessed a riot, between demonstrators and soldiers, while standing in its midst during the funeral ceremony for Galli, the anarchist.

Boccioni also claims the phrase as his own, in his book (page 170), affirming that the idea came to him in Piazza del Duomo almost at the corner of via degli Orefici while observing the effect of people walking toward him, overtaking him and passing him by.

Could it be possible that these two painters had the same "revelation" on two different street corners in Milan? What is certain is that they were both, and Carrà still is, mistaken. They were searching for the meaning of that phrase outside of the work, in the objects and things functional to its execution.

By such reasoning, to understand a painting submitted for his judgment, a spectator should actually place himself in the midst of the characters or objects of which the work is composed.

The correct interpretation of the phrase is completely different and must emanate from a personal collaboration on the spectator's part, from

[12]Carlo Carrà, *My Life*, (Milan: Longanesi, 1943).

his empathy and from energy that continues the painter's own endeavor.[13]

It is not the most intelligible part of the work that must act on the spectator, but rather something internal and more secret, inherent to the work itself, which touches the sensitive spectator in spite of himself. This is the sense in which he collaborates with the artist, is in the center of the work, as is the artist himself. The deep sense of forms and their real reason to exist is not on the surface, but lies beyond their very selves, and that is what the spectator feels, as irradiation.

In Paris, this interpretation was given to the phrase, and the tardy, surprising explanation that Carrà offers today reveals the hurried, confused manner in which those manifestos were compiled, and the different attitude toward art in Paris.

I apologize for recapitulating, but each time the Parisian art world had contact with the activities of the Italian Futurists, I always deeply regretted the erroneous Futurist feeling of antagonism, of competing with Paris and Cubism; it would have been more advantageous for them to function harmoniously.

But all of that is now behind us.

The month of May had arrived and Anzio was suffocatingly hot, a condition that caused me to lose all the ground gained toward my cure. Bathers arrived and life there became intolerable, with prices soaring. So my wife and I decided to return to my parents' home, now transferred to Montepulciano where my father had been posted.

Montepulciano was a large town, or, better, a small city, and extremely characteristic. Situated at an altitude of 1400 feet, I could well have finished my convalescence there and been entirely cured. It is also the birthplace of Poliziano. All the same, it was not Pienza, where Jeanne and I had acquired a virtual court of young boys and girls, devoted to us. We knew few people in Montepulciano, all members of the lower middle class category of civil servants to whom, frankly, we were not attracted. My young bride was now able to express herself in fair Italian; she had also learned quite a bit about housekeeping. In other words, she had many of the requirements for conquering my mother. As for my father, he was always very deeply fond of Jeanne and she of him. My sister's attitude was more or less the same as before.

[13]Albert Thibaudet uses similar terms with regard to Mallarmé's poetry. (*La Poésie de Stéphane Mallarmé*).

We had therefore reached a certain equilibrium when a serious event caught up with us: my wife became pregnant. There is a whole category of literature about the essence of human life. This literature could be called hereditary, on the basis of which, in these cases, an entire portfolio of benedictions, felicitations, and happy wishes are augured. For us, it was not a happy occasion at all. It was a tragic event that complicated everything and created terrible problems for us. But there was nothing that we could do about it. We decided to return to Paris as soon as possible, but since I did not have the necessary funds for the trip, and because, in spite of everything, we wanted to take advantage of that climate so beneficial to my health for a couple of months more, we stayed on in Montepulciano.

Once again I tried to collect the money owed me for my paintings in Florence, but obtained nothing at all from Gonnelli. I also wanted to collect for a *Self-Portrait* exhibited and sold in Naples by Sprovieri, but this too was not paid, then or later, for Sprovieri declared that he had not sold but lost it. However, forty-five years later it mysteriously reappeared at the 1960 Venice Biennale where Sprovieri was listed as its owner.

This was one of the most painful and dramatic periods of my life. Furious, I finally wrote to Boccioni and to Carrà that these exhibits were more useful to Marinetti than to me, and that it was therefore his duty to see that I was paid or to pay me himself for the paintings that, for reasons for which he was responsible, I no longer owned.

Even this plea failed. Marinetti and Boccioni were steadily more interested in problems of a social order and in the political situation that was, in fact, highly electric. Therefore they could spend only minimal time and energy on friendship (and on art). In fact, World War I erupted on August 2nd.

Although my young wife was courageous and even I always reacted optimistically when confronted with the worst possible misfortunes, this time there were plenty of reasons to be discouraged.

Could we have lived on bread alone, I would have been able to stay in Montepulciano indefinitely, but it was evident that, were our stay to last beyond certain limits, I could no longer submit my wife to a trip and we would be obliged to stay there until the baby was born, and who knows for how long afterward. Although my health was not yet perfectly reestablished, such a possibility terrified us both.

So we decided to leave at all costs, and consigned everything possible to the pawn broker in Montepulciano. With the profits of this and a small sum that my father and a few friends could spare, we set out for Rome,

arriving on September 20th. We had no plans, so we took a rented room and I busied myself to find a newspaper or magazine to accept some articles. The idea of selling a work was unthinkable, but I did not succeed in placing even one short article either. Faced with the absolute impossibility of earning a single cent, Jeanne and I decided to return to Paris. How? The idea of writing to Monsignor Passerini, on the basis of my Futurist successes, came to me, but this lettered provoked the opposite response from what I had intended: we received a nasty letter and not one cent. I cannot remember whether it was Jeanne or I who had another idea that, this time, turned out to be much better. We went to visit Jean Carrère, at that time the Rome correspondent for the Paris *Temps*. He was well known and highly esteemed in Parisian literary circles. Jeanne knew that he was also a friend of Paul Fort. In fact, he received us very cordially and promised to do whatever possible to relieve our embarrassing condition. He spoke to the French ambassador, Barrère, about us, or rather, he took us to the Embassy where we were received with every possible courtesy. The ambassador knew Paul Fort and certainly was not unaware of the Futurists' activity in the field of modern painting. Thus, the problem was resolved. With the ambassador's aid, Carrère took us to the Questore of Rome, and, after having hurriedly filled out all the proper forms, we were given a repatriation certificate for France and a railway ticket to Paris. Obviously they did not repatriate us in first class, so it promised to be a long and pitiful trip in a third-class car, on the longest route, through Genoa, Ventimiglia, Marseilles, etc., and we were penniless. As we received our travel documents, our friends in Rome, among them Costantini, with a heart of gold but ever so poor himself, Luciano Folgore, and Sironi took up a collection among our Roman companions and came up with about fifty lire. With this small sum and an enormous, heartfelt sadness (for many reasons, for every reason), on an autumn evening, we boarded the train to Paris.

6

Wartime in Paris

OUR REPATRIATION JOURNEY lasted nine or ten days and was anything but a comfortable trip. The train stopped interminably at every little station. We were often required to change trains and a few times had to spend the night in some town or other waiting for our next connection. However, I must say that from the start of our union Jeanne and I have always tried to transform everything seemingly ruinous into something pleasant or useful and, together, have often succeeded. So, even this pitiful trip became basically a second honeymoon. It was a splendid autumn and all of the beautiful cities we passed through, from Genoa northward, were flooded with light. In some, the trees and houses reached down almost to the sea and everything merged with the water: boats, landscape, little town squares. Jeanne and I were very excited and in each village I would say, "We absolutely must come back here after the war," and she would agree. We stopped in Savona, Porto Maurizio, San Remo, but several of the little towns where the train did not stop seemed yet more lovely.

We finally arrived in Ventimiglia. Despite her youth, Jeanne was beginning to feel the effects of fatigue; nevertheless, our tight budget forced us on mercilessly, and we changed at the border directly onto a French train. The cars were full of soldiers, coming to and from the supply lines at the Front. Real "poilus,"* they were no longer young men but still strong, happy, and enthusiastic. They had recently won the Battle of the Marne and their hearts had been bolstered.

Those soldiers were unfailingly friendly and proper; we spent entire nights with them on hard train benches, often in total darkness. Finally one morning, we arrived in Paris utterly exhausted. No one came to meet us and I forget how we managed to get to my mother-in-law's home on rue Sophie Germain. We rang the doorbell of the tiny apartment at dawn with our hearts racing. Mémé, Jeanne's grandmother, opened the door. Although not usually one to show her feelings, she welcomed us very affectionately. "Where is mama?" Jeanne asked immediately. The fine old woman explained that she was at work at the 14th Arrondissement Town

*Popular nickname for French infantrymen (1915–18).

Hall. We went there right away, of course, and my mother-in-law's surprise and joy upon laying eyes on us were unbounded. She proudly introduced us to her colleagues, glowing over the young bride who was her daughter and, what's more, was expecting. Later we all went home together to exchange news of our various experiences. She informed us that Paul Fort was living in the country with a girlfriend named Germaine d'Horfer. He rarely came into Paris and even less frequently to the little apartment on rue Sophie Germain. After having temporarily visited another of her daughters in Tonnère, Mémé had closed up her small apartment on rue de la Tombe-Issoire and had come to live permanently with my mother-in-law.

However, at the outbreak of the war, these two women were living in very precarious conditions. Luckily, Monsieur Ferdinand Brunot, a professor at the Sorbonne and a refined literary figure, an admirer of Paul Fort who also knew my mother-in-law personally, was Mayor of the 14th Arrondissement at that time. With his help, she had been hired in the "refugees" office, where the people flowing into Paris first arrived after fleeing the north of France overrun with Germans fortifying their strongholds.

At our arrival, she was earning four francs a day, and with this sum, all four of us had to survive in the little apartment that was, fortunately, exempted from payment of rent because of the war moratorium. Naturally, *Vers et Prose* had expired; but the presence of the famous review in the house was preponderant and overpowering. Piles of copies were scattered throughout the three rooms from floor to ceiling, and were also used in place of furniture. When someone said, "Get that such-and-such from the 'buffet' or off the 'piano,'" each piece of furniture actually referred to a certain pile of reviews covered with a length of cloth. This left barely enough room for the indispensable articles of real furniture—that is, a large oval table in the dining room, a mirrored wardrobe, and a bed which had immediately been assigned to us despite the fact that it belonged to the poet's mother, "Georgette."

In another room, a real bedroom, there was a large bed, a dressing table and more piles of the review. There was also a secondary chamber with a small bed, but this was entirely invaded by and submerged under the magazines. We found temporary hospitality in this house, offered by my mother-in-law with her heart in her hand.

Meanwhile, Paul Fort had been informed of our arrival and came to Paris immediately with his girlfriend. He invited us all to the Closerie des Lilas for dinner. Unfortunately the gay, busy café was not the same as we

had left it, but we also found Paris itself very different. That evening at the Closerie was very enjoyable to Jeanne and me, despite the circumstances. We were glad to have returned to our point of departure, although we found it utterly changed. As, however, things are basically what we feel in our hearts about them and not as they actually appear, Paris and the Closerie were still, for us, Paris and the Closerie.

Paul Fort was really an astonishing individual. That evening he tried very hard to make the family reunion a spirited and happy occasion. His companion, however, played her supporting role rather unwillingly. She had a keen mind and perhaps had some idea about the difficulties that would surface, through no fault of ours. From the moment that the poet's wife accepted the situation, Jeanne and I were entirely indifferent to my father-in-law's private life.

The first of our old friends that we visited was the Baroness d'Oettingen. Naturally we found her brother Serge there too, and a Finnish friend who was very agreeable and intelligent, Léopold Survage. Everyone received us with fond cordiality. The baroness even gave me painting materials as I no longer possessed any at all: canvases, paints, brushes, and a high stool so that I could work while seated. Everyone helped us overcome our difficulties. Jeanne was pregnant, and I was not yet cured of a serious illness that threatened to recur with the change of climate, which in fact, it did.

Asking news of old friends, I learned that Picasso was in Avignon, Braque, La Fresnaye, Léger, and Apollinaire were enlisted at the Front; Gleizes was serving his country too, hidden away in a peaceful fortress, as was Metzinger. Delaunay had run away to Spain, a deserter. Marie Laurencin, who had, in the meantime, married a German,* was also in Spain. In short, Paris, emptied of those elements we considered vital to its artistic vigor, was dead as far as art was concerned.

My wife's cousin, Robert Fort, who had appeared at our wedding in his uniform, a sergeant in the 46th Infantry Regiment, had been wounded in his right hand during the Battle of the Marne and was now roaming from hospital to hospital in the south of France hopeful to regain the use of his hand, through a series of operations. The radial nerve had been injured and operations had been unsuccessful. His young wife, Gabrielle, followed him from one hospital to the next.

Giannattasio, the Futurist who had stayed in Paris, had also enlisted as a volunteer and had been sent to the Front. We met his girlfriend,

*The painter, Otto de Waetjen.

Marcelle, one day and she told us news of him. Among other things, she said that his studio was empty and locked. We asked her for the use of it and she agreed without the slightest hesitation. So I was able to start working again a little, right away. It was here that a desire to make a sculpture came over me. In fact, I modeled a sentinel with his guard-house. Once the sculpture was finished, I had it cast and then painted it in red, white and blue stripes. It was rather a strange thing and I was not very satisfied with it.

The time for Jeanne to give birth to our child was slowly drawing near. We lived in great poverty, but fortunately my mother-in-law, employed at the Town Hall, managed to get us some welfare assistance and free mid-wife care for Jeanne. We patiently awaited the inevitable event about which, sincerely, we were not at all enthusiastic. Only those bourgeois devourers of literature, phonies and liars in their speech as in their feelings, could fail to understand that certain human conditions, while in themselves wonderful, become tragic under certain circumstances. Nevertheless, Jeanne was wholly courageous and I admired and loved her more and more.

The waiting was shorter than we had expected, for the trials of our trip were to advance the birth by approximately a month. So, on a January evening in 1915, I had to run to the midwife assigned to us by the Town Hall who had already visited the future mother several times. How surprised I was, how furious and embarrassed, when she told me that she could not come! I went back home to consult with my mother-in-law and together we roamed the neighborhood, in the dark, trying to find a mid-wife. We finally found a sour, cantankerous woman who said right away, "I'll come, but I want fifty francs in advance." We promised her everything she wanted, so she came, but she never stopped humiliating us in hundreds of little ways: the linens were too few, and many other things that bourgeois families prepare for such an occasion were unavailable in our house because all we had in abundance were copies of *Vers et Prose*.

Nevertheless, the baby was well and a little girl; a skinny little creature but with such a vivacious, pretty little face that she immediately captivated us. I did not have her christened because, admittedly, I was in a completely atheistic period and considered such a gesture as illogical as a church marriage would have been. The baby was registered at the 14th Arrondissement Town Hall in Paris with the name Gina. Everything had gone normally but our material difficulties continued to multiply. Having to face so many needs with only four francs a day did not make life easy, as you may imagine. One day, however, we received a visit that filled our

hearts with hope. Jeanne was still in bed, convalescing from the birth, when Signora Margherita Sarfatti from Milan came to see us, sent by Boccioni. She was one of his great friends and, through him, had begun to take an interest in painting, to the extent that later under the Fascist regime, she became a real authority on the subject. Boccioni had sent her to me in London too, at the time of my exhibit, where she arrived when the works had already been crated. She had them all uncrated and bought absolutely nothing. I complained of this to my friend who then made her buy a drawing from me.

I should have remembered her behavior in London, but artists never learn from experience and are always more or less ready to repeat their previous errors. I had several drawings and pastels in the rue Sophie Germain apartment that Signora Sarfatti contemplated and studied at length, while Jeanne and I awaited her decision with palpitating hearts, but the results were disappointing. After smothering the newborn and me with compliments, once again she left without buying a thing.

We really could hardly make ends meet and my health was gradually worsening. Fortunately, there was a solidarity among the artists in Paris during the war, such as had never before been seen. The "Fraternité des Artistes" society was founded to help needy artists regardless of the style of their work. These were given a small daily sum and half as much again for a wife and each child. Beyond that, we also received assistance in the form of linens, woolens, and other necessities for our baby. Every so often we would receive a coupon from the Town Hall for ten kilos of coal, to help us through the winter. Had it not been for my failing health, all this would have made us reasonably comfortable.

Meanwhile, Picasso had returned from Avignon and Max Jacob from the provinces, too. We often met at the baroness' house. We did not usually talk about painting, for we were too absorbed in current events. Besides each of us was working very little and our progress since the war had started was negligible. During my absence, solid cliques had formed in Montparnasse, especially at the Café Rotonde and at the Dôme. Most of the participants had gone off to war; some of the foreigners, such as Kisling, into the Foreign Legion. Modigliani, however, remained in Paris, living in utter poverty as usual.

Just about that time, early in 1915, Marinetti wrote to say that things at *Lacerba* were not going well and that they had all gone their separate ways. He also announced that Sironi had joined the group. He wrote:

"You must already know that *Lacerba*, born a pastist review, then growing semi-Futurist thanks to our assiduous collaboration, has once again turned

absolutely pastist, that is, traditional, frightened, cultured, professorial, and anti-youth-oriented. Papini and Soffici, now under the guidance of Palazzeschi (a Futurist mired in a hatred of liberated words), have broken their ties with us. Pastist fears or megalomania, little does it matter.

They have been snubbed by everyone. Pratella wrote them a very violent letter that ended, "You disgust me."

I must tell you that we have decided, unanimously (Carrà, Balla, Boccioni, and I), to include your and our friend Sironi, whom you and we have highly respected for some time now, in the executive group of Futurist painters.

He will take Soffici's place, his talent at least one hundred times better.

He is very pleased to be associated with you since he admires you immensely and will write to you today or tomorrow. . . . We have been organizing and conducting nightly pro-war demonstrations. I was arrested a second time. We await mobilization from one minute to the next.

Give Paul Fort my best . . . a fraternal hug from your. . . ."

This letter, which is dated, a miracle in itself, was written on the 26th of March 1915.

A few days later I received Sironi's letter as Marinetti had predicted. It recounted his departure from Rome after having quarreled with everyone, and his sensation of rebirth, spurred by a new sense of excitement over *la grande pittura* in a dynamic atmosphere like Milan that was, after all, his own city. He was happy about Boccioni's and the other Futurists' welcome and glad to participate in our group. Boccioni had surely not resisted the temptation to remind him that, during the formation of the Futurist movement, he had originally declared resolute opposition; had this not been so, he could have joined us earlier. By then his gesture was only relatively important, as was the Futurists' secession from *Lacerba*.

In any case, all these things passed into the background in the face of Italy's entrance into the war, anticipated by everyone with a certain sense of anxiety. I never understood the reasons (certainly personal) behind the Futurists' separation from *Lacerba* at a time when their general interest required unity, and since both sides were in total agreement over Italy's entrance into war. I mentioned that the reasons were certainly individual and personal; in fact, Papini and Soffici made a distinction between "Futurism" and "Marinettism," a distinction that infuriated the Futurists in Milan.

The last issues of *Lacerba*, full of pro-war articles, are not totally uninteresting. Collaborating with Soffici and Papini were writers from *La Voce*

and others such as Prezzolini, Tommei, Agnoletti, Tavolato, Folgore, etc.
Papini had never been so aggressive, clear, inventive, or fanciful. In his
article, "What we owe France," he made a sort of summary of what the
one nation owed to the other. He reviewed the entire cultural movement
in France for the past forty years, from Verlaine and Mallarmé to Rim-
baud, Claudel, and Apollinaire, from Boutroux and Poincaré to Blondel
and Bergson, and, finally, from Manet and Cézanne to Cubism—a move-
ment, he correctly said, that any new wave of painting would always have
to consider as its foundation. He ended, "Any country able to offer so
much in a forty-year span is a great nation and its civilization magnifi-
cent. We owe it the best aspects of our lives and minds and will not betray
it in its hour of danger. . . . As artists, intellectuals, poets, Italians, civi-
lized men, we are on the side of France against its and our enemies."

This was written in September of 1914 and the majority of artists,
intellectuals, and poets in Italy agreed with it. When Mussolini declared
war on France in June 1940, in his well-known fashion, that same cul-
tural majority felt exactly as it had in 1914. Why then was there not a
single voice of authority, like Papini, a member of the Italian Academy, to
raise even a sigh of protest? Being an Italian Academician should have
been reason enough for outcry, not for utter silence. The same could be
said for many others.

I did not see Paul Fort often at rue Sophie Germain, but one day he
arrived and told us about one of his projects. He wanted to begin a series
of poems inspired by the war and wanted Jeanne's help in the matter.
Help meant that she was to write innumerable copies of a letter to masses
of people to solicit subscriptions, that she was to read proofs and be re-
sponsible for sending the poems out. My wife, who had learned to imitate
her father's signature perfectly, signed the letters herself. This was the
system adopted at *Vers et Prose*, which, with increasing perfection and
the injection of innumerable new addresses, later and forever afterwards,
constituted the principal source of Paul Fort's earning powers.

That such a poet would have to rely on these means to guarantee his
material survival, even though his lifestyle was highly responsible for his
problem, was nevertheless painful. Jeanne accepted the task and took it
completely in her stride, as it was also to provide us with a small compen-
sation. Paul Fort had "promised" her a franc for each letter and two for
every subscription.

The poems, called *Poèmes de France*, began to appear in a very simple
horizontal format, without any jacket, on the first of December 1914.
The first work was dedicated to the Reims Cathedral and was prefaced by

these words: "On 19 September 1914, the Reims Cathedral was bombed by German troops; Baron von Plattenberg, an Infantry General, general aide-de-camp and chief of the Royal Prussian Guards, is the architect of this attack."

The poem followed with this, the first verse:

Monstrous General Baron von Plattenberg, since I owe to you this love ballad to my church, I return the favor with a slap in the face from poets everywhere and with a gallows on behalf of Rhetoric, fully aware that they are everlasting—and, I am keeping a store of clouts ready for all the Germans I shall ever meet. Facing it [the cathedral], near the "Lion d'Or," I was born.[1]

This is the tone of the poems that attempted, successfully, an unrelenting invective against the Germans and against their systems of invasion and war, and a clear glorification of French virtues.

The seventh of these poems, dedicated to me, is entitled "Les Garibaldi" and is an exaltation of Garibaldi's family and, in particular, of those who generously came to fight in France, where two of them died in the Argonne Forest in 1914. One of the most important poems and perhaps the most beautiful of the series, it appeared in three parts, in three successive issues of the bulletins. It recounts the entire history of Garibaldi as a soldier, which was essentially the history of the Italian Risorgimento.

Above the poem and below the title, the following Sicilian legend is told: "That one is not a man. One day the devil fell in love with a saint. Nine months later Garibaldi was born. When in battle, he takes after his father. When the battle is over, he takes after his mother, resembling a saint in Heaven. He is good and good-hearted. Long may he live!" A song from 1862 is also transcribed:

Lo Garibaldi è nostro popolano,
E porta il cuor sul palmo della mano.*

All the poems are probably not of such a consistently high quality, but in any case, some are very beautiful. Jeanne worked hard to promote and circulate these works. Subscriptions came in steadily, but the promised compensation was far less regular and Jeanne was disconsolate and our conditions very little changed.

[1]Paul Fort was actually born in Reims.
*Garibaldi is our man of the people,
 And wears his heart on his sleeve.

Meanwhile, the state of my health continued to deteriorate, and we and our close friends were rather alarmed. Picasso recalled that a very good friend in Barcelona, Doctor Reventos, specialized in lung diseases and was responsible for treating and saving one of his brothers with such an illness. This brother had been completely cured. My circle of friends decided to send me to Barcelona. Max Jacob and the baroness offered to collect the necessary funds, but I suspect that the majority of these were contributed by her and by Picasso. I was very unhappy to leave Jeanne and my little Gina who was growing prettier and prettier. I was as sad as one can be, but could not presume to bring my wife and daughter along too.

So I went to Barcelona, where Picasso's friends received me very warmly. I never met the cured brother, only the doctor and another of his brothers who was a writer and journalist, up-to-date on all current events, and a very lively, generous individual. We soon became great friends and were inseparable. I learned the history of Barcelona from him, its rapid and wonderful development, and I understood the reasons why Catalans and Castilians cannot and can never be expected to get along together. Reventos, the writer, was politically militant and I accompanied him a few times to revolutionary meetings, although I could not understand what was being said.

As for the cafés where one could meet artists, there were only two, situated at either extreme of the downtown Ramblas; both were beer halls, one near the harbor and the other close to the large Cataluña Square. We often went to them both, but most of the clientele was uninteresting, including many French shirking military service. Only slight echoes of the war could be heard in Barcelona, and life went on calmly and normally. The majority of Catalans were pro-French. Italy's decision was awaited with impatience and, finally, on 24 May, news of its entrance into war against Austria and Germany reached us. This decision was favorably received by the Catalans, but I sorely regretted not being in Paris to witness the reaction of the French.

I had found an inexpensive pension in a small hotel/restaurant, called a "posada" in Catalan, named the Duval Cataluña at 1 Baños Nuevos, a small cross-street of the central Ramblas. One day during my siesta (in June the weather was already quite hot), I was awakened by the shrill notes of a little pipe, while, at the same time, the enormous head of a terrifying commedia dell'arte mask poked into my ground-floor window. The masked character was dancing to the pipe tunes. I went to the window and saw a throng of these Carnival characters, 15 or 20 feet tall, and

many others with the same enormous heads placed on childrens' bodies. These were the giants and dwarfs that were to appear the following day in the Corpus Domini procession. I went to see the procession and was amazed that it was led through the city streets by many of these giants and dwarfs who advanced, dancing to the rhythms of a little shepherd's pipe. Thinking back on it, this traditional ceremony with its symbolic justification later seemed to me less eccentric.

As I mentioned, the summer heat was beginning in earnest. Doctor Reventos was taking care of me conscientiously and I was beginning to get better, but he was not pleased that his brother was compromising the results of his cure by taking me to cafés and other local meeting places. Reventos the poet, however, was trying to distract me, as he realized how painful the absence of my wife and daughter was for me. Distracting someone like me was no easy task. He never succeeded in taking me to a bullfight although I longed to go, because such an important experience had to be shared with my wife.

We were finally obliged to obey the doctor's orders and go to the Pyrénées to hunt for a little town where I could spend the summer. My friend and I had a magnificent trip. We passed through Manresa, Tarrasa, and other beautiful locations and finally came upon a lovely town wedged between tall mountains, at an altitude of about 3000 feet. Reventos knew a family there who would take me in for the summer. I liked the place and the people were friendly and welcoming, but I could not make up my mind to stay. I could not forget that this place was even further away from my wife and daughter; while in Barcelona, knowing that I could catch a train for Paris whenever I wanted, it was easier for me to endure the separation.

I promised to let them know of my decision, and we returned to Barcelona. I stayed for a few more days in that beautiful city and then, suddenly, without any warning, I was gripped with an insupportable nostalgia. I stayed just long enough to send Jeanne a telegram and left without saying goodbye to anyone. Not having enough money for both the trip and for my bill at the posada, the owner (Agustin Llitjos), a wonderful man, let me leave without the slightest problem. So that is why, ever since June 1915, I have had an outstanding bill for 59 pesetas and 55 centavos in my files, and have had the best intentions of going there one day to pay it in person.

I found Jeanne at the station, waiting for me with the baby in her arms. They were both so thin that I barely recognized them. After an absence of less than two months, I found them in this state. The little girl was espe-

cially frightening. To my mother-in-law, to Jeanne's grandmother, and to Jeanne herself, the child's condition did not seem so terrible because they had seen her every day, and also because none of the three, each for reasons of her own, had the slightest practical notion of how to bring up a child.

We rushed to consult a doctor who restored some of her strength with injections of a serum made from sea water. Some of my friends, angry at me for my unannounced return, were nevertheless kind enough to send all three of us to the country outside of Paris for a couple of months. We settled into a small house in Igny, surrounded by a vegetable garden, near the gates of Paris but in the open countryside. Freight trains carrying war supplies passed by the windows day and night. Others transported soldiers and the wounded. I did several paintings of them, the so-called war pictures. Although my inspiration derived from those real objects that passed before my eyes, these became more and more synthetic and symbolic, to the point of becoming, in my paintings made the following winter, true "symbols of war" (fig. 35).

We stayed in Igny until the start of fall; the sojourn was beneficial to all three of us. Upon our return to Paris, we once again found our places in the rue Sophie Germain apartment, but unfortunately Giannattasio's studio was no longer available, for Marcelle, his girlfriend, had moved into it. I could not work at home, where it was barely possible to pass through the apartment, so I went to Mémé's tiny place on rue de la Tombe-Issoire, not far from rue Sophie Germain. Somehow, rather uncomfortably, in a tiny dining room full of 1830's furniture, I installed my easel and began a cycle of important work. The window overlooked the little Denfert-Rochereau station, so I could still observe the military and civilian trains, and continue my war paintings.

As I already mentioned, through gradual simplification I had discovered a sort of symbolism that coincided perfectly with my ideas at that moment, the same general ideas that were then more or less diffused in an atmosphere still saturated with memories of Mallarmé and the Symbolists. Mallarmé had considered each word separately and had written: "An undeniable current desire is to separate, as if in expectation of different attributions, the double state of words: brute or immediate here, essential there." He continued, "What is the use of the wonderful ability to transpose a fact of nature in its almost vibratory essence by the play of words, if not to cause pure notions to gush from it without the encumbrance of a proximate or concrete reference?"

I hope no one will misunderstand or reproach me for justifying a mod-

ern painting movement based on an absolutely pictorial comprehension
of painting and its special requisites, with a writer's theory; nevertheless,
a vision of reality can exist above and beyond painting, and, even more
important is the desire to reach a single point in the mind where forms of
expression are no longer important. Thus, the pure notion or the essential
state of words, so inviting to Mallarmé, could perfectly well apply to all
forms of art. With that kind of vision, I could not express my idea of
"war" by painting battlefields littered with slaughtered bodies, streams of
blood, and other such atrocities. My modern idea-image of war came
from the concentration of a few objects or forms taken from reality and
compressed into "essences," into "pure notion." This Symbolist theory,
so often mentioned, was always more or less the basis of modern painting
in general and of Cubism in particular. And, in my case, I think that I gave
it an even further personal interpretation and special importance.

I was working with a certain success in this direction. Not only was I
painting war subjects, but once again I had gone back to my themes of
dancers and portraits. At the same time, life was very difficult and ex-
hausting for us. Paris was deserted and every activity paralyzed or re-
duced to its minimal terms. It was not a time to think about the
commercial aspect of art. We were all living exclusively on my mother-in-
law's four francs a day, the "Fraternité des Artistes" assistance, and a few
"unemployment" benefits sent, once in a while, by the 14th Arrondisse-
ment Town Hall.

I searched unsuccessfully for any sort of work that would pay me
wages. I presented myself at the "Aux Planteurs de Caiffa," a company
looking for young employees to deliver coffee on tricycles to various
stores in Paris, but many strapping applicants turned up and I was not
chosen.

Aside from this, my daughter was not growing properly. Luckily, we
were told about a clinic behind the Montparnasse station called the Mar-
ino and run by a Doctor Quinton, where children were treated, especially
for enteritis, with powerful injections of sea water. This was not the sea
water serum we had tried previously (with good results), but real sea
water, injected in large doses. Submitted to this treatment on a regular
basis, Gina was completely cured and continued her normal deve-
lopment.

The treatment was the practical application of an entire scientific and
philosophical formulation, controversial at the time, but considered se-
rious. Dr. Quinton's theory was to give cell life a marine origin, which he
called "The Law of Original Constancy." Thus, in Quinton's opinion, the

origins of life were in sea water, in a saline concentration of 8 grams per 1000, at a constant temperature of 44 degrees centigrade. In fact, the injections administered to the children on their shoulders were heated to that temperature. I had a two-fold reason to consider Dr. Quinton's theory interesting and attractive; in the first place he had cured my daughter and an infinite number of other children, and second, his principle of regarding life's phenomena in relation to the ends to which they are ordered, coincided with the explanation of the universe that I found most convincing at that time.

While the child recovered and my work was going quite well, our material problems increased daily. Everything was gradually becoming more expensive and the opportunities for earning money were non-existent. Every evening I would go to the Quai St. Michel to sell the books sent to Paul Fort as complimentary copies, but this only provided meager sums. Moreover, we did not have access to a never-ending source of these books.

Counting the works I had finished recently and others done previously, I had put together a sufficient number of paintings for an exhibit and was seriously considering such an endeavor. However, it was not an easy task, for all the galleries were closed. I finally discovered the Boutet de Monvel Gallery at 18 rue Tronchet, which wanted to give me a show from 15 January to 1 February 1916. I called the exhibit "1st Futurist Exhibit of the Plastic Arts of the War and other previous works."

In order to spark some attention and interest by whatever means needed in that desert that Paris had become, I thought it a good idea to hold a sort of conference on the day of the show, giving it the long-winded, pretentious title "Avant-garde Plastic Arts and Modern Science: 1st part: Physical Origins of Aesthetic Emotion; 2nd part: Fragmentary, Ultrarapid and Prismatic Life, Milieu for Perception; 3rd part: Plastic Analogies, Plastic Synthesis of Ideas, New Plastic Symbolism." The title covered a whole way of looking at things and was an entire program in itself. Actually, it summarized the ideas I had often expressed, emphasizing an almost mystical exaltation of science.

The works on exhibition numbered thirty-seven, including drawings and watercolors,* and one that was particularly curious. It was titled *The Jointed Dancer* with instructions in parentheses, "Pull the string and blow on the moving parts." I had devised a system of strings like those on childrens' toy marionettes where pulling strings moves the arms and legs.

*Listed on the original invitation in the Severini Archives are 18 paintings, 11 drawings, and 8 colored drawings.

Then I mounted two planes on a pivot perpendicular to the surface of the painting. When blown upon, they would rotate on the pivot. A combination of the two movements made it an interesting toy. During the exhibition, I was amused to watch the visitors pull the strings and blow on the revolving planes.

All my friends were amused too, beyond all expectations, and used the occasion to meet again. Picasso came, and Modigliani, Gris, Metzinger, Lipchitz, André Lhote, Survage, the Baroness d'Oettingen with her brother, Serge, and numerous other artists unknown to me. Among these was Pierre Albert-Birot who sided with modern art but was still unsure whether to dedicate himself to sculpture, painting, or literature. His wife, a tall, thin, vivacious blonde, accompanied him. They lived on rue de la Tombe-Issoire, near Mémé's apartment where I was working. Their windows, on the mezzanine floor, overlooked the street, so we saw each other every day and became good friends.

Altogether, the show was a success but I did not sell even one of the drawings. I tempted my luck again and exhibited the majority of the works in a bookshop on rue de l'Odéon, run by a very witty, intelligent, and lively girl, Mademoiselle Adrienne Monnier, a former secretary to Madame Brisson at the *Annales*. Her bookshop was a far cry from her former environment! This exhibition was also unsuccessful in terms of sales. One painting was sold, *Italian Lancers at a Gallop*, to Mlle. Monnier who, as far as I know, still owns it.[2]

However, the one important result of the show was to have awakened a certain interest in art, a desire to move ahead, take action, and leave behind the torpor in which art had been stagnating. I also met Amedée Ozenfant on that occasion. He was at the beginning of his career as a magazine editor, publishing *L'Elan*, to which I was invited to contribute.

The evolution of the Pierre Albert-Birot couple was swift and surprising. Adrienne Monnier, to whom I introduced them, later called them the "Edenic couple." In that same month of January, out of the blue they published a tiny six-page review in which the most up-to-date, daring ideas were expressed with the simplicity of novices, in a clear, condensed form. The review was called *S.I.C.*, and subtitled, *Sounds, Ideas, Colors-Forms.*[*]

It was very inexpensive, was published monthly, and was, in the beginning, compiled entirely by them, alone. Subsequently, I put them in touch

[2]Miss Monnier later bought all the copies of *Vers et Prose* that we used as furniture at rue Sophie Germain from Paul Fort. The little apartment became rather dismal. [The painting is now in the Agnelli Collection.]

[*]Published from January 1916 to 30 December 1919.

with Apollinaire who sent them reports from the Front: in the fourth issue one of his lovely poems appeared. So, Apollinaire and I were the first to collaborate with this modest publication which later was to become extremely important.

The review was the deciding factor in determining the activity especially suited to Pierre Albert-Birot's mind and spirit, that is, to poetry. I think that his first endeavors in composition and poetry were published there. He too, very much wanted to be the founder of an "ism" and called his will to remain in the present, his spirit of actuality, "Nunism" from the Greek word "Nun = Now." But he did not pursue this for long.

Actually, this little review, especially in its early issues, displayed a rather Futurist vein: it contained some of Luciano Folgore's poems which I had translated. The number of French collaborators gradually increased and it acquired a profile of its own. Even then, it was always attentive to whatever was really happening in Italy, so I temporarily realized my dream of a correspondence between the artistic activities in Paris and Italy. The review appeared in a plain, modest format, retained throughout its lifetime even when such authors as Philippe Soupault, Tristan Tzara, Pierre Reverdy, Raymond Radiguet, Aragon, Cocteau, etc., aside from the ever-faithful Apollinaire, were regular contributors.

L'Elan, Ozenfant's magazine, was just the opposite: chic, well-presented, careful, and flawless. It had a slight tinge of amateurism, albeit intelligent amateurism, which basically reflected Ozenfant's own nature. He was a refined, erudite man, but always somewhat amateurish in everything he did. Only two issues of this magazine, both exceedingly beautiful, were published in 1926, as I recall.

Of these two, issue 9 contained an endeavor by André Lhote to synthesize the current ideas of the Paris art world; he called his fairly interesting theoretical sketch, "totalism." In this, he emphasized the fact that as a consequence of the lesson taught by David, every sort of "school" fell into such disfavor that each artist adopted a kind of absolute empiricism as his model of conduct, with sensitivity its sole law.

He wished that artists, taking advantage of the lapse in aesthetic battles and motivated by the conditions of war, felt the need to rest after yesterday's aggressive exasperations and would grasp a "just evaluation of pictorial procedures" and a sort of expressive totalization of these values. He also insisted that a single method was insufficient for an artistic expression intended to summarize modern pictorial tradition and reality, and therefore envisioned various methods and styles of painting in any one work. This had already been happening for some time. One of his conclu-

sions was: "A work's greatness can be measured by the multiplicity of qualities that create it and by the variety of controls to which it can be submitted."

Despite his good, although in truth rather confused intentions, his attempt to define "totalism" made absolutely no impression as I recall. On the other hand, Lhote's aspirations were common knowledge: he tended toward Cubism, later achieving it, as an aspirin is taken for a headache, a universal therapeutic remedy. His love of the eighteenth century was also well known and, in fact, his essay on "totalism" began: "From Giotto onward, whose greatness he shares, David was the most esteemed of masters." Anyone reasonably versed in the artistic atmosphere of those times can clearly understand why totalism did not catch on.

But Lhote was a nice friend. He was small, robust, and curly-headed like most southerners, with a wonderful Bordelais accent. His wife was a kind, round, lively woman with the same accent, as she, too, came from Bordeaux. One day I was invited to their studio and was fortunate enough to encounter Matisse there. I had never before met him personally. I must admit that we were both very pleased about the encounter, for once we had been introduced we became entirely engrossed in our conversation that completely excluded everyone else. Many times I had thought to myself, and finally told him, that it was a pity we had not met sooner. Perhaps I would have progressed faster; certainly I would have seen many things more clearly. Matisse was a mature man by then, nevertheless there was a youthful aura in everything about him. He was strong but not stout, blond with big tortoise-shell glasses, and, at first impression, looked like a Nordic intellectual. Actually, he had been born in Cateau-Cambrésis, near Cambrai. Although he looked Flemish, and his painting had, in certain ways, a Flemish colorist ring to it, the spirit of his art and his entire outlook had the lightness of the Latins. He was "Parisian" and, as I mentioned, it is not necessary to be born in Paris to be a Parisian. I was promptly invited to visit his house in Clamart, or else at a studio where he usually worked on quai St. Michel just above Nôtre Dame.

Paris was visibly coming to life again. In March, if my memory does not fail me, Ozenfant organized a group show of drawings in the salons of a grand couturière, Madame Bongard, the sister of Paul Poiret. Many of the most modern artists participated: Derain, Marie Laurencin, Lipchitz, Picasso, Modigliani, Jacques Villon, I, and many others.

Once again, sales were not brilliant. However, we established a friendly exchange agreement with Mme. Bongard: we gave her paintings and she dressed our wives. Her dresses were often high fashion samples. The art-

ists' wives at that time were thus more elegant than they ever had been. I gave her a large self-portrait that later passed into the collection of the critic, Tabarant.*

Having concluded a few small sales, despite the general crisis, I was finally able to rent a studio. I found a wonderful place on boulevard St. Jacques facing the metro station, not far from rue Sophie Germain. It was large and full of light, but as it was in a wooden building, it was either horribly hot or cold, depending on the season.

Nevertheless I was very glad to have somewhere to work without being disturbed. Pierre Albert-Birot also had a studio in the same building and gave me a couch to furnish the single room that was as vast as a desert. My happiness, though, turned bitter at the news that reached us from the Front. Apollinaire had been quite seriously wounded in the head; Roger Allard, an aviator, had a bad fall and would be kept in the hospital for some time. Later we learned that Apollinaire had been operated on and that the operation had been successful. He was on the mend.

My health, although not perfect, allowed me to work and I could ask for nothing more under the circumstances. My little Gina grew more and more beautiful and she was the source of great amusement to us. Unfortunately she came down with whooping cough. At that very time another child announced its arrival. When living in such a precarious way, things of that nature—illnesses, pregnancies, etc.—throw everything out of kilter. I did not know what to do, especially since Jeanne also caught whooping cough, making things even worse. The doctor prescribed a complete change of air for both mother and daughter. How was I to provide that, when my shows were not financially rewarding and I had no other sources of income?

Although it cost me a great deal, I turned to my father-in-law under these circumstances of urgency. After all, I was not asking anything for myself, but for his own daughter and grand-daughter. Thanks to the numerous letters written by my wife, subscription orders for *Poèmes de France* had been copious. Gabrielle and Robert (cured of the wound but left with an inert hand) had returned to Paris and Gabrielle, too, wrote the letters soliciting subscriptions. Replies poured in, and at the same time rather important sums of money had materialized.

Unfortunately Germaine, Paul Fort's girlfriend, vanished at that very moment, leaving the poet in an incredible state of desperation. He hired a private investigator to comb Paris for Germaine Tourangèle, as he called her in his poems, but Germaine was not to be found.

Portrait de l'Auteur, 1916.

So when I went to Paul Fort to ask him for help in sending Jeanne and Gina to the country, I was unable to obtain anything at all from him.

I was very depressed and deeply mortified for a long time by his refusal, more so by the way it happened. Also, he did not return to rue Sophie Germain again. Little by little he sent for all his books and the things dear to him and then began divorce proceedings against his wife. But she, with the advice of Monsieur Granié, a substitute attorney of the Republic at the Palais de Justice de Paris, always energetically opposed the request and therefore the divorce was never accorded.

Later, Germaine Tourangèle returned to the poet without the marriage as compensation, which she did not care about in the least. We remained furious for almost ten years.

This, of course, did nothing to resolve our situation, which we faced with our usual resignation, patience, and the courage necessary to overcome adversities. Jeanne and the child gradually recovered. As for the child we were expecting, this time we were better prepared in every way for its arrival. So when Jeanne was delivered of a beautiful boy in a neighborhood clinic where the 14th Arrondissement Town Hall had sent us, he was welcomed with great joy.

Both Jeanne and I were very unhappy to have to send him to a wetnurse in Versailles when he was only three months old, because in that book warehouse that rue Sophie Germain had become, where there was already an eighteen-month-old child, it was impossible to keep him with us. There was not enough air, light, and space. How could two little children have lived there under such conditions? But our separation from this little boy was the beginning of a string of misfortunes. I was lucky enough to have time to do a painting before he went to his wetnurse, which remained in a preparatory state and represented his mother nursing him, painted in a simple style reminiscent of our Tuscan primitives. This painting is still in my possession and I do not intend to separate myself from it.* It is part of my personal collection together with one other, painted in the same frame of mind and at the same time, which is a portrait of Jeanne at age 18.** Since Ozenfant had organized a second exhibit at Mme. Bongard's, of paintings this time, I wanted to show this portrait along with other works conditioned by the modern spirit of the moment.

The Cubists, especially Metzinger, were very irritated by this painting. Other artists and critics, instead, found it interesting and regarded it as

Maternità, 1916, donated by Jeanne Fort Severini to the Museo dell'Accademia Etrusca in Cortona.

**Now in the Galleria dello Scudo Collection, Verona, Italy.

the definitive proof of my qualitative and pictorial talents. It had been with this possibility in mind that I had painted that work.

After the exhibition at Mme. Bongard's, André Salmon organized another much more important show in a gallery called the Barbazange Gallery at 26 avenue d'Antin. Actually it was called the Salon d'Antin then and was later taken over by Marcel Bernheim. Almost all of the avant-garde painters of a certain calibre took part in the exhibition.

Picasso sent his large painting, *Les Demoiselles d'Avignon* which, aside from its artistic validity, is a work of great historical importance, as it dictates the beginning of Cubism. I exhibited five works, among which was the large *Maternité* which marked a new orientation in my work, which I will describe later. I also remember that Derain exhibited four nice drawings and beneath each one, in reply to the accusations that he copied Matisse, he had written: "I certify that this drawing is by Derain. Signed, Henri Matisse."

This story greatly amused the artists. The show was a grand success, as the shows curated by Salmon always were.

I was fortunate to meet Mister de Zayas there, an American artist and writer, author of an interesting book on the influence of Black African art on modern art. He organized an exhibition in New York for me, at the Stieglitz Gallery. Not only did he organize the show, but he also included the works in an enormous shipment of his own so that they arrived at their destination without expense or worry to me.

Summer was already upon us when I received the news of Boccioni's death. I had gone to visit Dufy at 5 impasse Guelma. He had taken over my old studio and joined it to his own, next door. As I was leaving the Impasse, before entering the metro station on my way home, I bought *Intransigéant*, an evening newspaper with a small column devoted to the art world. What a horrible surprise it was to find two simple lines in the column, announcing the death of my friend.

Some time had passed since I had broken off all contact with Marinetti and with the other Futurists, except Folgore. Nevertheless, in the hope that this painful information might be untrue and they would confirm this hope, I wrote to Marinetti and to Carrà who, unfortunately, both confirmed the bad news.

This made me terribly sad and I realized that, despite his recent unfriendly attitude toward me, my old fondness for him was still very much alive. I could not accept the unfortunate death of my friend, whose ambitions and talents I knew so profoundly. In issue number 8 of *S.I.C.* I published a drawing of him from memory which was a good resem-

blance, and a fond article as a tribute. He had died on August 16th, 1916, and it was not until much later that I was able to pay a visit to his tomb in Verona.

I continued to work courageously in my boulevard St. Jacques studio despite the terribly hot weather. I remember an evening while I was waiting for Modigliani, to take him home with me for dinner at rue Sophie Germain. At about six o'clock the heat in the studio had reached 100°, my head was on fire and all of a sudden, no longer able to stand it, I ran out, afraid I would go mad. Modigliani had not remembered my address and did not appear that evening.

By this time he had found his artistic style. He had put aside the idea of sculpture, although his exercise in that discipline had been of great use to him, and had turned back to painting. In Montparnasse, where the Rotonde was becoming more clearly the artists' café, he could already claim a certain number of imitators.

I, on the contrary, uneasy and dissatisfied with myself, put aside my dancers (which also had imitators) and started painting static things, deeming it undignified to facilitate my work with "subjects." In other words, I was striving for a dynamic art capable of reaching its maximum potential, but I also wanted to achieve and express a universal dynamism using any random subject and using only pictorial means, that is, through use of lines and colors arranged in a certain order. I had never been convinced by that schism between relative dynamism and absolute dynamism so dear to Boccioni and Carrà.

Absolute dynamism, or if you prefer, universal dynamism, is as present, in my opinion, in a chair as it is in a ballerina. At the same time, I have always been convinced of the fact that modern art, seen as a continuation of Impressionism and Neo-Impressionism, which truly cleared our sights and our minds, could only be aggressively dynamic and not restful and calm. My idea of absolute, universal dynamism, however, does not exclude movement or the displacement of bodies, which can suggest and has suggested many original composites of forms; this, however, regards the subject, which is important only to a secondary degree. Otherwise, the inventor of the cuckoo clock, whose little door opens every hour to let the bird sing, would be a first-rate aesthetic genius, and a precursor. For this reason the point reached by Modigliani, beyond which his development was arrested, interested me only superficially. His position was too full of nostalgia for the past in my opinion, and was overcharged with an ability to simulate what was considered modern. It was not, as I was convinced then and still am, a genuine, clear situation. My friend and I

had long discussions about this, which resulted in an acknowledgment from him that his attitude was momentary. As irascible and hard on himself as he was, were he here today to hear all the gushing dithyrambs that insignificant collectors and even third-rate critics are still proclaiming about his works, he would certainly be furious and his red nudes and long-necked women would be in serious trouble.

Do not misunderstand me; Modigliani is still a well-defined personality and one of the most interesting artists, but the real value of his work, beyond the consideration of a few artists and connoisseurs and in the eyes of the general public, is open to discussion and still to be established.

That summer of 1916 ended badly for me. My beautiful little boy, Tonio, as I had named him in memory of my father, was not thriving as we had hoped in Versailles. We had separated ourselves from him so that he would flourish in the pure country air, and now he was not doing well at all. At first it was a problem of nutrition, so we took him to a good doctor who had treated Jeanne as a child. But the method he prescribed did not produce any results, and, in fact, the boy's condition worsened. There was a famous specialist in childrens' diseases in Paris at the time, Doctor Variot, a very great doctor (or, as we would say in Italy, a great "professore"), but we were too poor for a private consultation with him. However, this doctor received patients without charge several times a week in a day-clinic in our neighborhood. We took our son to him and after an interminable wait, Jeanne and the little boy found themselves before this grand expert, surrounded by his staff and many young students. They did not allow me to enter and perhaps it was for the better. The doctor examined the baby thoroughly and then asked his mother: "How are you taking care of this child and what are you feeding him?"

"This way and that," replied my Jeanne, trembling.

And there were plenty of reasons for her to tremble. The doctor, red in the face with rage, answered her: "You're insane and an absolute idiot. You're killing your baby. Who is that ass of a doctor who gave you such advice?"

"Doctor So-and-So," replied my wife. The doctor's appearance changed before her very eyes. He became sweet and kind, replacing the baby in its mother's arms and said to her, "I know Doctor So-and-So and he's a good doctor. Go back to him." There was no way of convincing him to take the case.

My wife returned to the waiting room in tears and completely disheartened. Seeing her, such a rage took hold of me that I wanted to go in and smash Dr. Variot's head to a pulp. But the nurses all surrounded me and

begged me to be patient and to come back again in a couple of days, claiming that he would not remember anything about the case and would take another look at the baby. So we left the office. Some friends told us about another doctor and we started feeding the baby according to his different system. Back in the hands of the wetnurse who was taking good care of him, we waited for results. Unfortunately, they were not long in coming. The baby, crying constantly, developed a hernia. We brought him back to Paris and put him in the Welfare Children's Hospital where it was necessary to perform an emergency operation on him. His mother had to stay in the hospital too, to assist him. But the baby caught pneumonia in that large, freezing room and since it was not possible to treat problems of general medicine on the surgical ward, they gave him back to us, in such a terrible state that he died at home a few days later.

I hold that aforementioned, famous professor responsible for the death and not from lack of experience, but rather because of his lack of feelings of solidarity and any humane sense of charity. In my opinion, professors of medicine are generally the same everywhere, equally inhuman and greedy, and I still feel a great deal of animosity toward all of them, and a deep, irrational aversion.

Had I been able to pay that doctor to make a house call, he would not have remembered his friendship with Dr. So-and-So and would have treated my baby, who probably would not have died. With this in mind, I do not think that I am wrong in conserving my fiery rancor toward great specialists who are always so attentive and respectful when they visit patient's homes or when they are called into private consultations, while, in hospitals and clinics, they perform their duties hastily and in a perfunctory way, with quite a different attitude.

This was the first terrible, painful blow to strike us and was instrumental to the strengthening of our union.

I will always remember my poor child's funeral, a very dramatic event. We set out on foot from rue Sophie Germain toward the cemetery in Bagneux. Jeanne and I were accompanied by all of our friends from Montparnasse, from Picasso to Kisling; none abandoned us.

I have never recovered from the loss of that child, such a beautiful strong boy at birth, especially since that loss marked the beginning of a dark, negative period in our married life. More or less instinctively, guided by love, I had tried to built a serious, solid life for us from the very beginning. Basically, a married couple is comprised of two complementary forces which confront one another. Popular myth would have it that sometimes it is the woman, sometimes the man who is dominant,

but in truly happy unions it is neither, since harmony reigns over everything.

I consider these two opposite forces like two complementary colors, like yellow and sea blue, for example. If they are placed near one another, these two colors produce a violent dissonance, and it is a sign that it is necessary to turn the yellow into a greenish yellow and the sea blue into purple. Thus a careful shift of tones into the right range achieves harmony. In such a theory, typical of a painter, accepted mutually by my wife and I, it is possible to comprehend any theory on life and human relationships and, above all, to establish a foundation for two newlyweds to build upon, where love facilitates all the shifting of ranges necessary.

I know that my system is a good one, as the harmony of our union, established at the outset, has endured, and the dark, negative elements that unfortunately did not spare us did not produce noticeable changes in it.

War seemed eternal in those muddy trenches. From time to time a friend would return on leave and we would celebrate together. Marcel Pierron, the young doctor in Civray, would come to rue Sophie Germain for dinner while on leave, on his way back to Civray.

Roger Allard was slowly recovering in the Val-de-Grâce Hospital. He had broken his leg when landing his airplane too abruptly. He would show his cast to anyone who came to visit him and tell the story of his crash. As for Guillaume Apollinaire, he had been taken to an Italian clinic on quai d'Orsay founded by the wife of the ambassador, Signora Tittoni. Serge Jastrebzoff was working as a nurse in that clinic and it is easy to imagine how carefully Apollinaire was treated. His room on the second floor was nice, full of light, and the window overlooked the Seine and all the boat traffic, with a view of Paris in the background. His wide, cordial face was emphasized by the large white bandages wound around his head. In the beginning, I would visit him each morning, and always found him jolly and in high spirits. Once he gave me 100 francs on behalf of Ambassador Tittoni. To be honest, I have always had a certain aversion to "official" personalities and have always kept my distance from them. Apollinaire, aware that I had no money to spare, had spoken to the ambassador about me. He then offered that little present which I accepted without hesitation, for I detest touchiness and inopportune pride.

Apollinaire soon got better and began to go outdoors, despite his bandaged head. It was during this period, I think, that he married a gracious young girl, red and white like an apple and therefore called, by his

friends, "Pomme d'api."* We often went to the Café Flore on boulevard St. Germain, near his house, where numerous friends and painters would join him to celebrate. One day they held a large banquet in his honor in an immense hall near Porte d'Orléans. It could be said that all of the literary Paris that counted was there, especially everyone from Montparnasse. Jeanne and I could not attend this banquet as we had lost our child at that very time, but we went toward the end of it for an after-dinner coffee. Apollinaire seemed to be enjoying himself, listening to many curious speeches, some of them in verse like that by Roinard, which ended regularly on the refrain: "Apollinaire est un fasteux danseur."** But real pandemonium broke out when the nice woman poet, Madame Aurel, began her speech with these strange words: "I do not care for banquets. I don't like them because they didn't hold one for Jean Dolent." She never got any further than those few words. The rowdy group from Montparnasse, which in any case did not like Madame Aurel, would not let her continue. But the banquet was, all the same, a grand iose token of esteem, admiration, and fondness toward the poet, who deserved it.

Life in Parisian art circles conserved that median rhythm, not fast but sufficient, of which I had been the initial stimulator with my exhibit at the Boutet de Monvel Gallery. Kahnweiller's Gallery on rue Vignon had naturally been closed and impounded, but slowly, gradually the rue La Boétie galleries began to reopen. A new gallery at number 56 the Galerie des Indépendants was inaugurated. It opened with a show of our works, that is, by the artists who participated in the exhibits organized by Salmon or Ozenfant. It was followed by a show by Marcel-Leonir, with large canvases aspiring to "sacred art" which were basically mediocre paintings. Then the gallery director, a certain Monsieur Cheron who would have been a better shoe salesman, fell in love with the European-Japanese painting of Foujita and gave the painter a series of shows. Such exposure contributed heavily to the creation of interest in this art of compromise, neither European nor Japanese.

But Derain, Braque, Raynal and Léger were still away, in the war. Braque, too, like Apollinaire, had been wounded in the head. Gleizes had married the daughter of a government minister and had finally left the fort where he had been stationed to go to America with his young wife.

I would often visit Matisse in Clamart, where he received his friends, in particular, on Mondays. Discussions would often start at his house and

* "Rosy apple."
** "Apollinaire is a flashy dancer."

continue in the street on the way to the train or else during the short trip
back to Paris. The better I knew Matisse, the more I appreciated him as an
artist and as a man. He was just beginning to enjoy great success and was
already fully mature artistically and intellectually. Many people, looking
at his paintings, think that he worked with great immediacy or almost
without thinking about them. The truth was just the opposite; he re-
flected at length on them all. Some of his works may have been painted
quickly, but others required long periods of work and multiple transfor-
mations. In fact, from one Monday to the next, we would often find the
same painting totally changed. He would explain, sincerely and cordially,
the reasons for putting green, for example, in the space that had formerly
been red, a method of reasoning and discussion intrinsic to painters that
rarely were we fortunate enough to hear. If he discovered that one of us in
the group of young painters was having money troubles, he would come
to that one's studio and buy a work from him. One day, just when my
"terme" rent was due at the boulevard St. Jacques studio, he arrived and
bought one of my paintings. Lord knows how propitious this gesture was
in helping me pay that damned "terme."

We also went to Ozenfant's studio in Passy. But his paintings, to be
perfectly honest, did not interest any of us. To elicit a reaction against the
pictorialism and carelessness of certain modern painters, he painted per-
fectly smooth surfaces, as if painting a door, without any deep contem-
plation of color or form. Yet he would lead us to his paintings to indicate
some strategic point in which he thought that he had succeeded in con-
densing the whole of his expressive energies (more intentional than effec-
tive), and would say, "That's rare, isn't it?"

We found this very amusing. But we visited him because he was, in his
own way, a nice, intelligent man. His real talents emerged later when he
founded L'Esprit Nouveau, a review that was rather important for a time,
especially with regards to architecture.

At that time he was still publishing L'Elan. The latest issue (number 10
of the series, appearing on December 1, 1916), was unique in its presenta-
tion: a large sheet folded in half three times, 8 pages on one side and 8 on
the other. These pages could not be read like those of an ordinary maga-
zine. It was necessary to unfold the whole sheet to read them. Original
certainly, but inconvenient.

However, the contents of the magazine was, as usual, interesting. There
was a lovely poem by Apollinaire, "Fête," dedicated to André Rouveyre,
and others by Roger Allard, Reverdy, etc. A drawing by Picasso took up 4
pages, in other words, half the sheet. There were also reproductions and

drawings by Luc-Albert Moreau, Matisse, Dunoyer de Ségonzac, Madame Lewitzka, and a small drawing from real life that I had done of my wife holding poor little Tonio, before he went off to his wetnurse. A portrait of Max Jacob in the Ingres style was one of the most beautiful Picasso ever painted in that technique. In short, as a single issue it was certainly interesting. But the artists were a bit surprised by an article by Ozenfant himself, titled "Notes on Cubism."

In this article, his first act was to classify himself among the Cubists, which the others found unacceptable, after which he began a series of criticisms and reservations about some of them that he described as "tending to adopt an abstruse attitude, disdainful of the audience, and apt to judge it idiotic."

So, despite salvaging Picasso and Braque, he launched condemnations right and left haphazardly, against those Cubists who, those Cubists like . . . etc . . . and at the same time envisioned a new Cubism that would reunite "the regeneratory efforts of current art to the great traditions of the Assyrian, Greek, Chinese with the admirable, anonymous Black African plastic artists."

His goal was to regenerate Cubism, purified by a new tendency of which he was the inventor, called "Purism." His assertive conclusion was: "Cubism is a movement of Purism."

With this tricky theory, the Cubists, who he had enticed into collaborating with the review, appeared more or less his disciples, thanks to his method of capsizing the facts.

This was all rather comical, and could even have been interesting had it been based on a minimum of mental clarity and cohesion. Unfortunately, his theoretical declaration continued: "Eliminating any literal representation, Picasso, Braque, Archipenko have once again demonstrated what is essential to a work by Claude Lorrain or by an African—the optical relationships of matter."

Whatever he meant by the "optical relationships of matter" is difficult to explain. And to what "matter" he was referring, artistic matter (that is, matter to which art lends form) or so-called material matter relative to the mixing of colors, etc., this too, we will never know. Ozenfant, even later when his ideas were clearer and more orderly, would often take pleasure in concocting incomprehensible phrases. In *L'Esprit Nouveau*, when speaking of geometric construction, the expression "geometrical place of a right angle" was to appear in one of his essays which no geometrician or mathematician has ever been able to decipher.

I have waited to comment upon that article which we often discussed

among ourselves at the time because it was the germ and point of departure of a whole attitude later adopted by Ozenfant when, together with Jeanneret (Le Corbusier), he founded *L'Esprit Nouveau*.

As I mentioned earlier, Ozenfant was, on the whole, nice and, in certain instances, intelligent. It would be useful to formulate a portrait of him, for he was a character in our circles, and not lacking in personality. Physically, he resembled an "Inca" or Native American Indian dressed like a European. Clothed as a redskin, he would have been a magnificent caricature of a native. Intellectually he was quite learned, but often puerile and at the same time serious, and a maniac for meticulousness.

His painting, even when crafted with the greatest devotion, was never particularly convincing, while his sense of editorial presentation where he always invested his good taste and intelligence, was excellent.

In short, he resembled Mario Broglio, the bright publisher of *Valori Plastici* in Rome, with the difference that Mario Broglio had a pictorial talent that Ozenfant quite lacked. On the other hand, the tenor of *L'Esprit Nouveau* was essentially more modern than that of *Valori Plastici*, which had a limited, provincial echo, while *L'Esprit Nouveau* had international resonance.

In the Paris world of arts and letters, many will still recall Art et Liberté which defined itself "an association for the affirmation and defense of modern art." It was sort of a free society, especially promoted by men of letters and poets, which also accepted painters and musicians into its ranks. August Perret, the architect, was elected president while I, a painter, was one of the committee members. Of course, all of the modern artistic personalities participated or sympathized with this society, whose moral statutes included the clause: "To bring a work, to indicate an artist, to enroll a member is tantamount to belonging to the association."

Without great ado, prizes, or recompensations, the society proposed to devote itself to modern art and to help diffuse it.

Such a broad viewpoint gave rise to interesting manifestations, almost all organized as "matinées" at the Théâtre des Champs-Elysées (Salle de la Comédie) since it was a well-known fact that Perret, the architect-president, was the contractor of that building and to a certain degree had use of it.

There were musical programs by Maurice Ravel, Claude Debussy, Eric Satie, Igor Stravinsky, etc., and poetry afternoons with the best of the modern poets. The musicians and dancers and actors who executed the works were all first-rate. Extraordinary performances were held, offered as special auditions, of *Le Sacre du Printemps* (synodical transposition of

two movements of Igor Stravinsky's work, arranged by Sébastian Voirol) and *Exortation à la Victoire* (tragic chorale for Isadora Duncan composed by Fernand Divoire), as well as a "biblical tragedy" titled *Méphiboseth* by M.O.W., taken from Lubicz-Milosz, and a dramatic play in five acts, *La Montagne* by H. Martin Barzun.

On the front covers of the performance programs there were always drawings by a modern artist. There was one of mine, one by Lhote, Matisse, etc. In Matisse's program which I still have, is Eric Satie's signature and address that he wrote on it for me when I first met him that day. I had organized an interesting exhibit of modern painting in the lobby of the theater to coincide with that performance.

Among the "artistes" who performed for us, waiving their usual compensation, were Pierre Bertin and Madame Lara, both Sociétaires de la Comédie Française, the latter a famous actress who felt, at one time, a great inclination toward very modern, extremely avant-garde art and therefore was happy to participate in our performance schedule. But one fine day, no longer able to tolerate that duality in herself, she quarreled with the Comédie Française members and refused to perform with them again. Considering herself ever more revolutionary, not even the selections of Art et Liberté seemed radical enough to her; she yearned to project her concept of theater to a plane of even more pronounced primitive spontaneity.

At that point our group split into factions. Perret, the administrative committee, and various members withdrew, but the association continued to exist, assuming the new name, Art et Action, under the management of Madame Lara and her husband, a retired admiral. The harmony of our group was preserved despite the separation, as, basically, no deep, substantial divergences divided us.

It was, I believe, thanks to the initiative of Art et Action that *Dit des Jeux du Monde* by Paul Méral was performed at the Théâtre du Vieux Colombier, with beautiful, original sets and costumes designed by Pierre Fauconnet. This performance, of a violently modern nature, restored to theater the use of masks and the strong, rhythmic chanting of Greek plays. There was an often-repeated refrain, "The world goes on living," which functioned as the focal hinge to the action.

In short, it was basically a theatrical work intended to infuse that purity of means and thought typical to the other arts, into the theater; pure theater, in other words. It was received by the public as our paintings had generally been received, that is, with animated opposition. Madame Lara, if in fact the one responsible for this, must have been very pleased.

I believe that it was during an intermission of this or a similar play at that theater that Paul Guillaume appeared on stage with several canvases by De Chirico. Having reached Paris in 1914, De Chirico had been obliged to leave again, because of the war.

I remember that one of those canvases had a large red hand against a dark background. Paul Guillaume went to great pains to explain these works but no one was interested in them. The times were not yet mature enough for Surrealism.

At the same time as Art et Liberté, another association was founded in Montparnasse, of an even freer nature if possible, since it had neither statutes nor presidents nor committees nor more or less effective members. As long as someone's works were interesting, he could take part in this group and its manifestations. These were held in a sculptor's vast studio at 6 rue Huyghens (at the intersection of boulevard Raspail and boulevard Montparnasse), near the famous café, Le Dôme.

This ultraliberal association was called Lyre et Palette and differed from Art et Liberté in that the latter, despite all else, still adhered to somewhat traditional uses and customs, while the former was yet freer in structure and less prejudiced.

Those who attended these manifestations were the same artists, writers, and poets who, by now, constituted the heart of the Paris art circles and around whom the famous "School of Paris" began to take shape. The participants were Picasso, Derain, Matisse, Metzinger, Gris, Modigliani, Ortiz, Lhote, Severini, and several others, while among the poets figured Apollinaire, Salmon, Max Jacob, Reverdy, etc. The Swiss poet, Blaise Cendrars, who had enlisted as a volunteer at the outset of the war, came back to our ranks at that time. Unfortunately, he returned without his right arm, but I have never seen such an intrinsically sad thing be taken in stride with such high spirits, ease, and sense of humor. It was incredible to watch the gestural effects that Cendrars managed to express with that empty sleeve.

Among the musicians, Eric Satie, together with "les Six," was an assiduous contributor. The others were Auric, Poulenc, Honnegger, Durey, Germaine Tailleferre, and Darius Milhaud. Once, at the conclusion of a "matinée" while roughly only ten friends still lingered, Satie sat down at the piano and played the whole score of *Parade* that the Ballets Russes had just performed, as we shall see, at the Châtelet Theater.

Many beautiful works of music composed by "les Six" and often sung by Pierre Bertin, who was always on our side, were performed during these manifestations. I am sure that none of my friends has ever forgotten them.

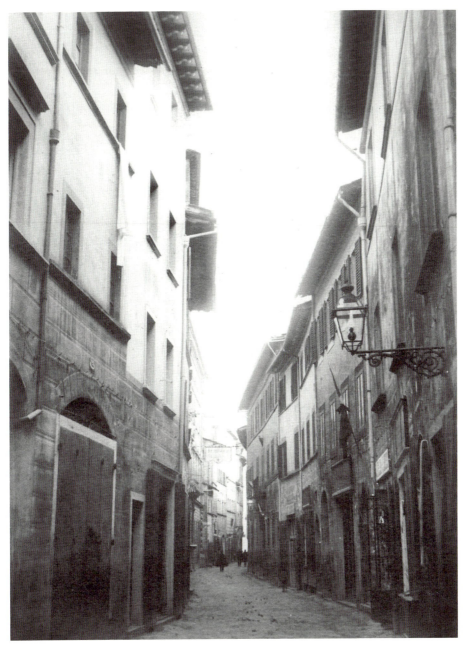

1. Cortona, via Nazionale (formerly "Rugapiana"), late 19th century

2. Severini's mother and father

3. Gino Severini, Cortona,
1895 (12 years old)

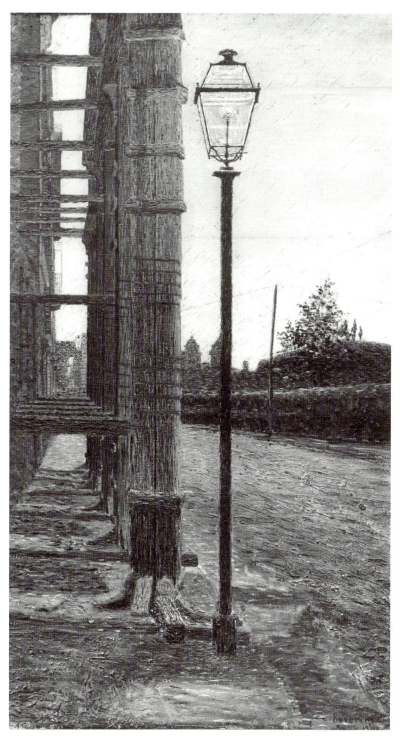

4. Gino Severini, *The Streetlamp (Porta Pinciana)*, Rome, 1903, oil on canvas, 91 x 51 cm. Private Collection. Photo: O. Savio

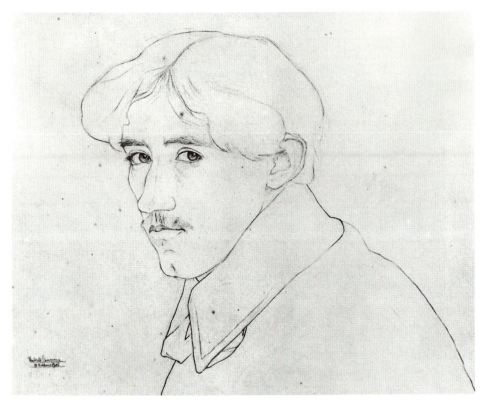

5. Umberto Boccioni, *Portrait of Severini*, 1905

6. Gino Severini, Rome, 1904.
Photo: Kymroles

7. Madame Bertaux, Severini's benefactress from Lyon. Handwritten by
Severini on reverse of photo: "Generous and good to me"

8. Gino Severini, *Le Vieux
Noceur Parisien*, 1906,
charcoal and pastel drawing
on paper, 25 x 16 cm.
Private Collection

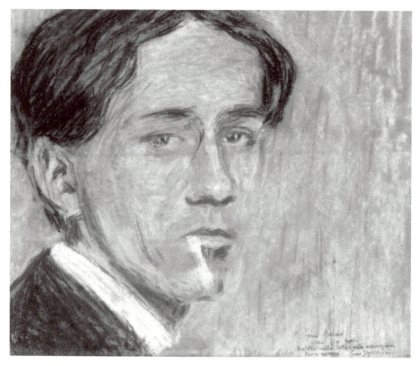

9. Gino Severini, *Self-Portrait*, Paris, 1907-1908, pastel on board, 28 x 33 cm, dedicated to Gino Baldo. Private Collection

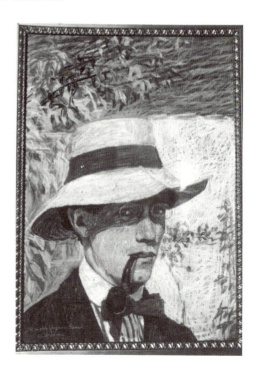

10. Gino Severini, *Self-Portrait with a Panama Hat*, 1908, pastel, 50 x 34 cm, dedicated to Pierre Declide. Coll. Bonnin, Civray

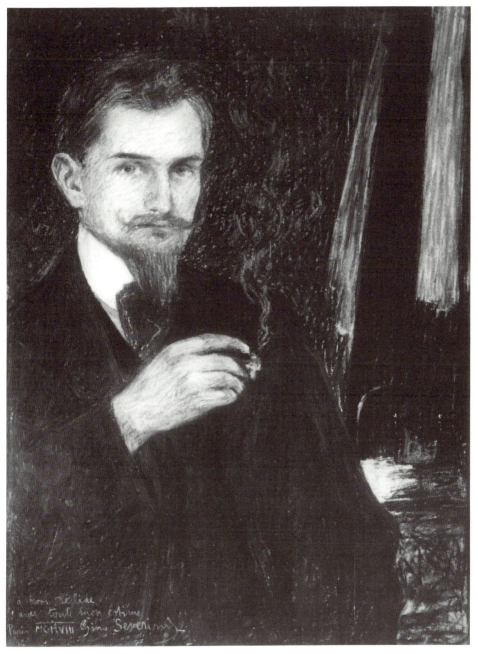

11. Gino Severini, *Portrait of Pierre Declide*, Civray, 1908, pastel on paper, 60 x 50 cm.
Private Collection

12. The Lapin Agile in Montmartre, early 1900s

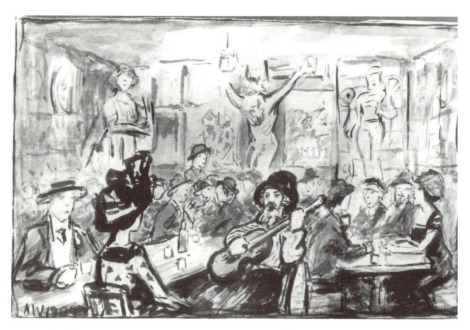

13. André Warnod, *Intérior du Lapin Agile*, 1909. Collection of Mme. Jeannine Warnod, Paris. Photo: courtesy Mme. Warnod

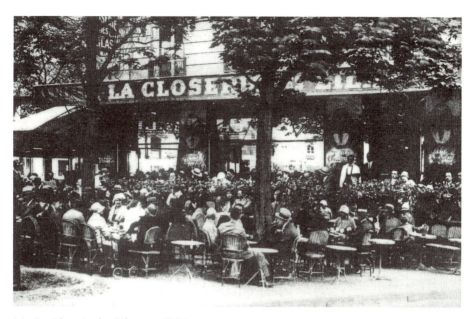

14. La Closerie des Lilas, ca. 1900

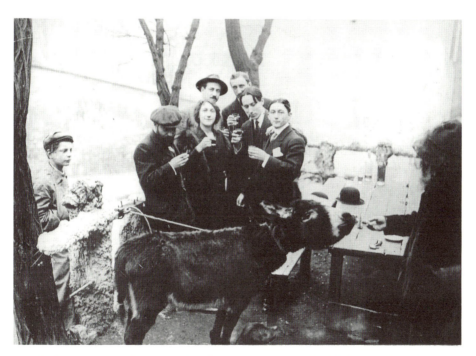

15. André Warnod, Roland Dorgelés, Père Frédé on the right, Madelaine Ausfach-Girieud and the donkey, Boronali, Paris, 1912. Collection of Mme. Jeanine Warnod, Paris. Photo: courtesy Mme. Warnod

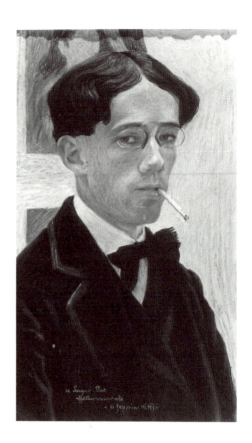

16. Gino Severini,
Self-Portrait, 1909, oil
on canvas, 48.5 x 28.5 cm,
dedicated to Lugné-Poë.
The Chicago Art Institute

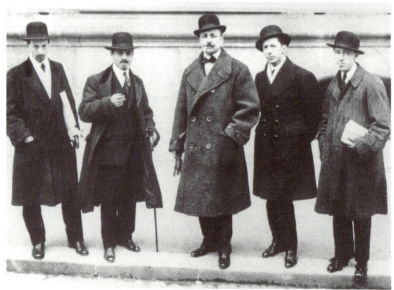

17. Signers of the 1909 Futurist Manifesto, Paris, 1912. L. to r.: Russolo, Carrà, Marinetti, Boccioni, Severini. Photo: courtesy Galleria dello Scudo, Verona

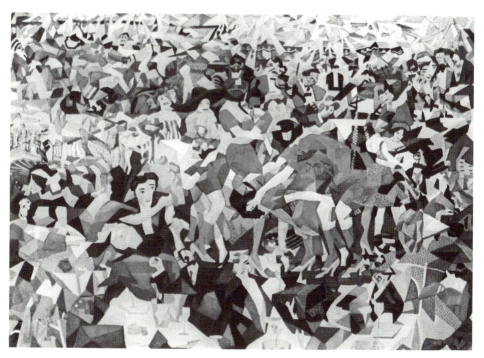

18. Gino Severini, *Pan-Pan à Monico*, 1909-1911, oil on canvas, 280 x 400 cm. Presumably lost during WWII in Germany and replaced by Severini in Rome, 1959-1960 (Paris, Coll. Musée d'Art Moderne)

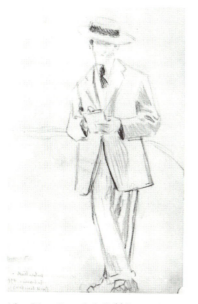

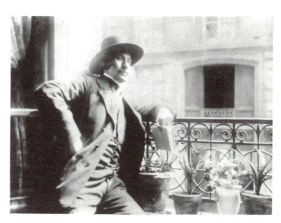

20. Paul Fort, Paris, ca. 1910. Photo: Dornac

19. Gino Severini, *Self-Portrait*, Paris, 1911, preliminary pencil drawing for *Pan-Pan à Monico*. Private Collection

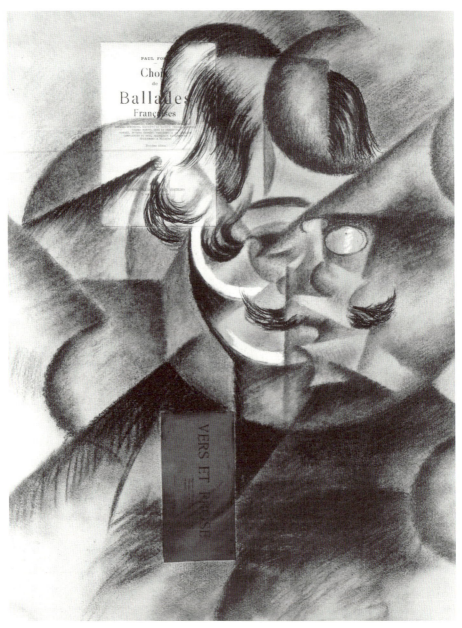

21. Gino Severini, *Portrait of Paul Fort*, Paris, 1912-1913, collage, charcoal, pencil, gouache on paper, 48 x 63 cm. Private Collection

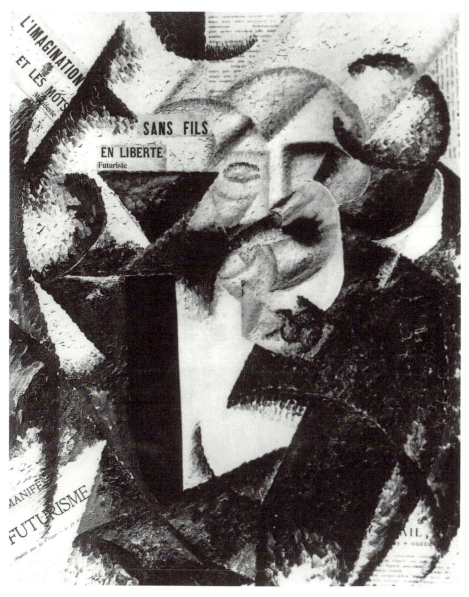

22. Gino Severini, *Portrait of F. T. Marinetti*, Paris, 1912-1913, oil and collage on paper. Private Collection

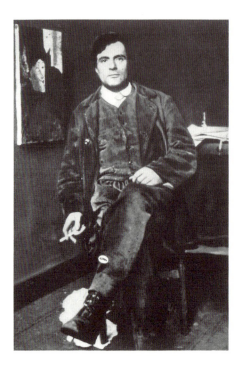

23. Modigliani in his rue
Ravignan studio, Paris, 1915

24. Picasso, 1912

25. Gino Severini, Paris, Impasse de
Guelma, ca. 1910

26. Giacomo Balla, Rome, 1918

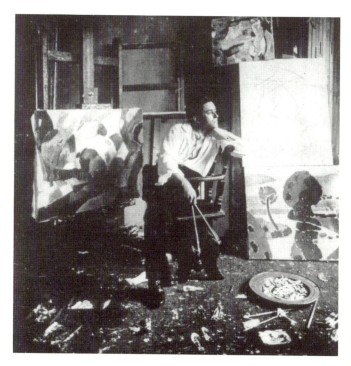

27. Picabia in his studio, Paris, 1911

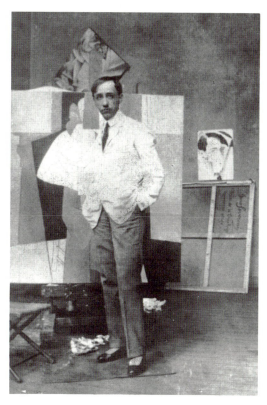

28. Gino Severini in his studio, Paris, 1915. Self-portrait and other works visible in the background

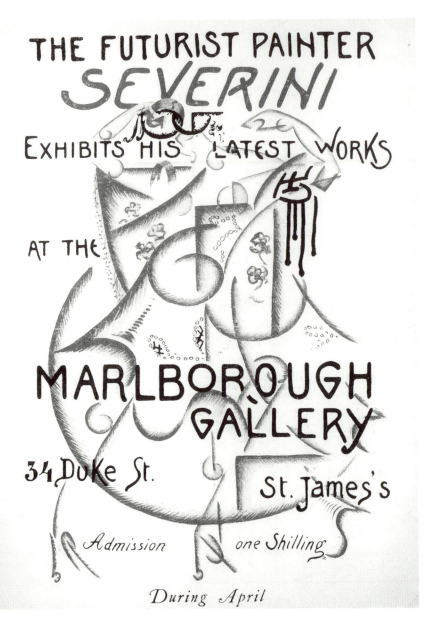

29. Poster (and invitation) for Severini exhibition, London, April 1913

30. Severini in London, opening night of his one-man exhibition at the Marlborough Gallery

31. Marinetti in front of his portrait by Severini hanging in Berlin exhibition, 1913. Photo: courtesy Galleria dello Scudo, Verona

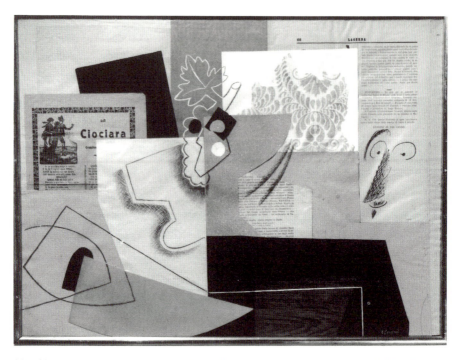

32. Gino Severini, *La Ciociara*, 1914, collage mixed technique on board, 55 x 73 cm. Private Collection

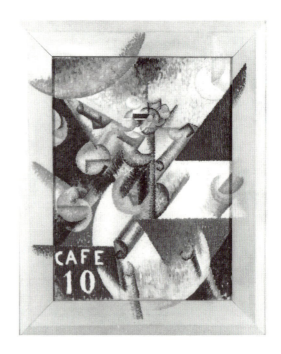

33. Gino Severini, *Plastic Rhythm of July 14th*, 1913, oil on canvas, 66 x 50 cm excluding painted frame, 85 x 68 cm with frame. Private Collection

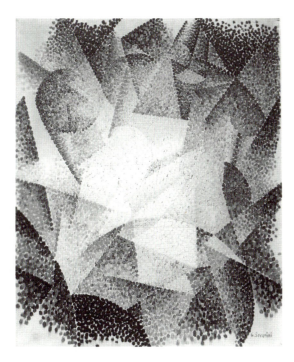

34. Gino Severini,
*Spherical Expansion
of Centrifugal Light*,
1913-1914, oil on
canvas, 60 x 100 cm.
Formerly collection of
Riccardo Jucker, Milan

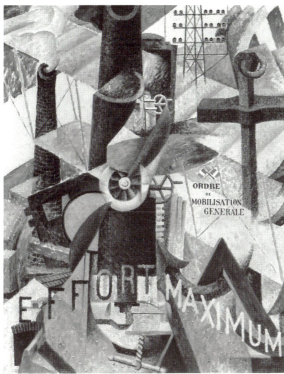

35. Gino Severini,
*Plastic Synthesis of
the Idea of "War,"*
1915, oil on canvas.
Slifka Collection,
New York

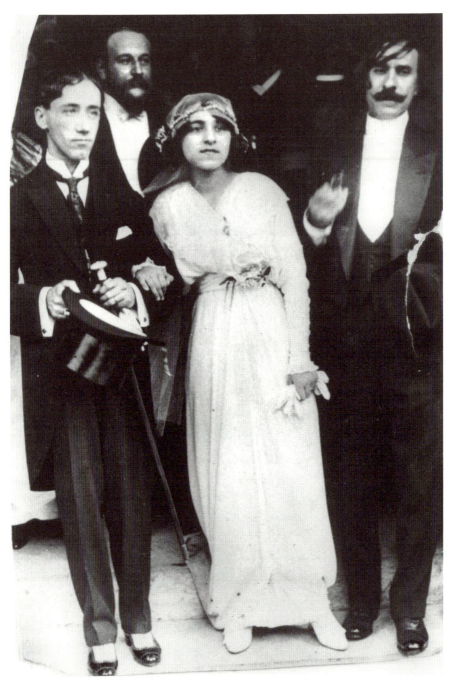

36. Wedding picture, 28 August 1913, Gino, Jeanne, and Paul Fort

37. *Umberto Boccioni*, ca. 1915. Collection Galleria dello Scudo, Verona

38. Léonce Rosenberg, Paris, 1927

39. Modigliani, Picasso, Salmon, Paris, 1915

40. Guillaume Apollinaire, Paris, 1917. Photo: courtesy Roger-Viollet

41. Gino Severini, Bligny Sanatorium, 1920

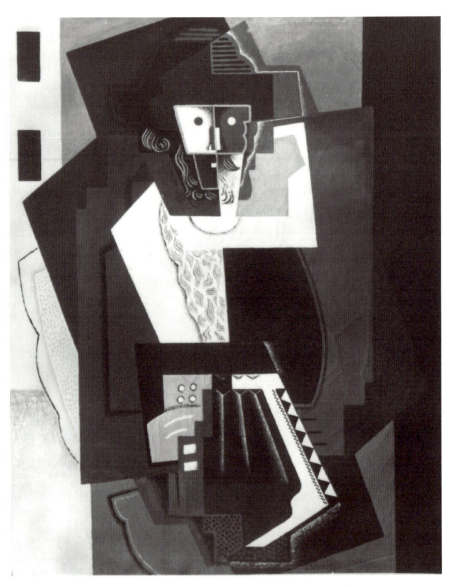

42. Gino Severini, *Joueur d'Accordéon*, 1919, oil on canvas, 92 x 72.5 cm.
Civica Galleria d'Arte Moderna Collection, Milan. Photo: Giacomelli

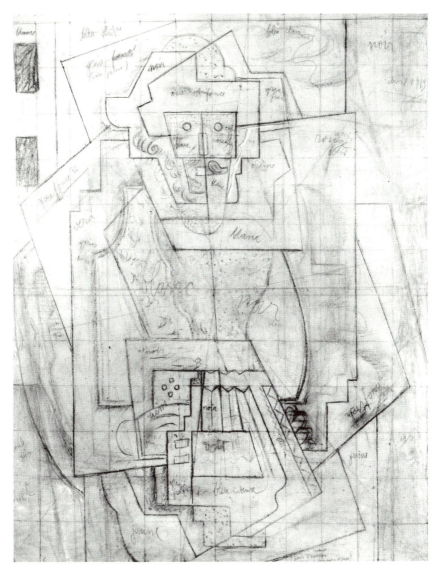

43. Gino Severini, *Joueur d'Accordéon*, 1919, preparatory drawing in charcoal, pencil, and gouache on paper, 120 x 80 cm. Private Collection

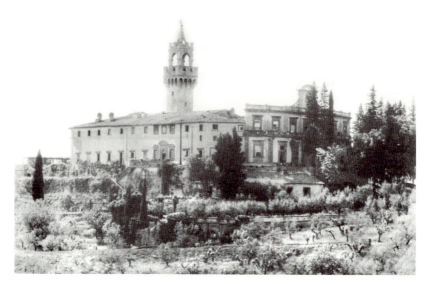

44. Montegufoni Castle (Florence), ca. 1905, eleventh-century structure, seat of the Acciaiuoli family until 1909 when purchased by Sir George Sitwell

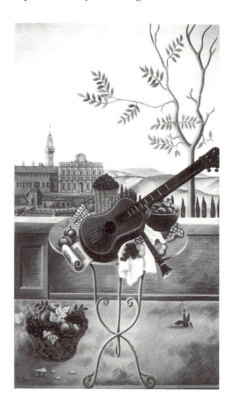

45. Gino Severini, fresco panel at Montegufoni Castle, 1921-1922

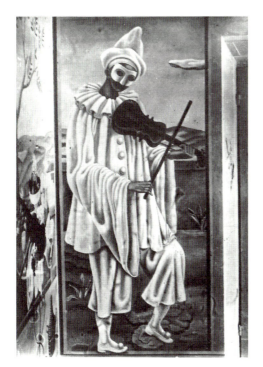

46. Gino Severini, *Pulcinella Violinist*, Montegufoni Castle, 1921-1922, fresco

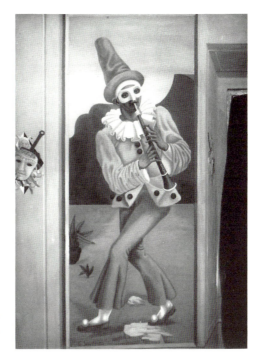

47. Gino Severini, *Pulcinella Flutist*, Montegufoni Castle, 1921-1922, fresco

48. The Severini family with the Gaeng family in Lausanne, ca. 1923 (during work on the church in Semsales). L. to r.: Mr. Gaeng (baker), Gino Severini, Marcelle Gaeng, Jeanne Severini, Gina Severini (8 years old), Albert Gaeng (pupil of Severini in Semsales)

49. Gino and Gina in Switzerland, mid-1920s

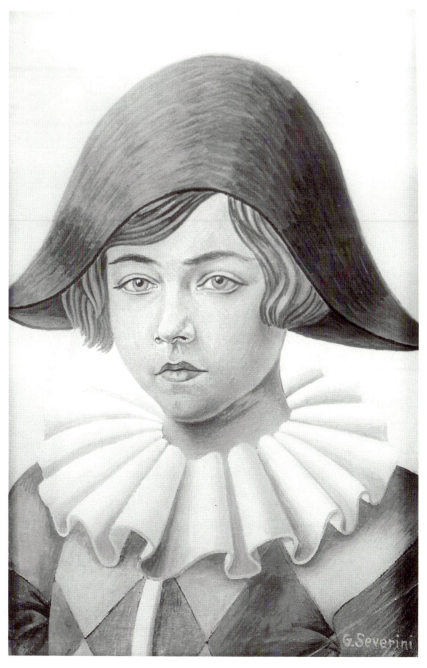

50. Gino Severini, *Portrait of a Young Harlequin (Portrait of Gina)*, 1923, fresco

51. Gino Severini, Paris, 1931. Photo: Allié

52. Henri Matisse in his studio, Nice, 1929. Photo: M. Lenoir

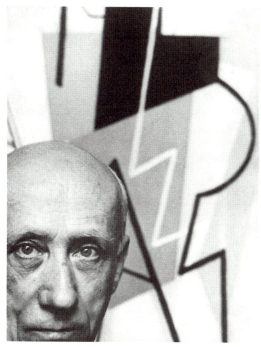

53. Gino Severini, 1950s.
Photo: Sanford Roth

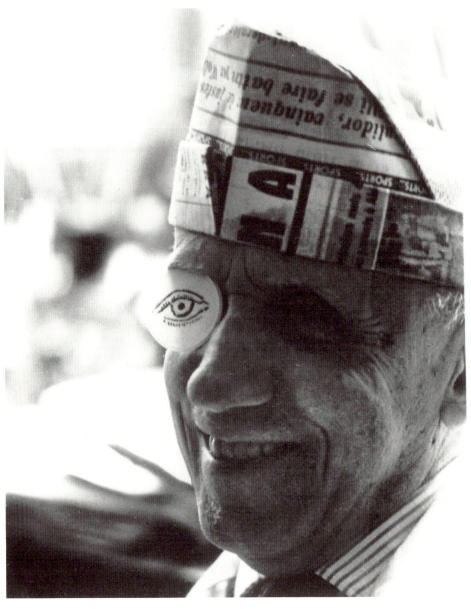

54. Severini in his studio, Paris, 1964. Photo: Marco Glaviano

The exhibit in which I participated was also composed of works by Othon Friesz, Maurice de Vlaminck, André Lhote, Henry Hayden, Olga Sacharoff, and Marewna. It was inaugurated on 28 January 1917 and I held a boring, pretentious conference for the occasion. I was still under the influence of scientific mysticism at that time. "Four-Dimensional Space" was often the subject of conversation in Paris art circles, but the discussions were usually amateurish and approximate, without any real idea of its meaning. Although I had been expelled from the entire school system in Italy, I had nevertheless acquired a passion for mathematics. So, to acquire a serious understanding of the idea of "space" and the ways of measuring it, I began to study that part of H. Poincaré's geometry called "Analysis Situs."

The topic of the above-mentioned conference had been the fourth dimension and the notion of "space" in terms of mathematics. The conclusion I reached was an identification of time and space which Bergson had called "spatial duration."

"Spatial duration" as recognized in our concept of "simultaneity" is, essentially, the basis of all art over the centuries.

As well as these mathematical-philosophical considerations, I also spoke about "composition, color, etc.," the things that I had discussed at length with Matisse and with other friends too, at my studio, so that I was, in a certain sense, expressing ideas more or less discussed and accepted by the majority of the artists of that period. For this reason, my boring conference attracted a certain amount of interest and Cocteau, whom I had never met until that day, lavished compliments on me for it. Since Friesz lived nearby, on rue Notre-Dame-des-Champs, we (several friends, the exhibitors, Satie, and Cocteau) all went back to his house and continued our discussion about these new points of view.

As I had told Cocteau that the text of the conference would be published in *Mercure de France*, as indeed it was (1 June 1917), he repeatedly urged me to add to my line of reasoning that "artists are the architects of sensitivity," and also, "perfect equilibrium leads to inertia; it is imbalance that engenders discussions, or, in other words, energy." We made an appointment to meet again the following day and since I did not seem to him a punctual sort of fellow (actually I was extremely punctual), he wrote out a card which he handed to me: "I am going to meet Jean Cocteau on Tuesday at 5:30, 10 rue d'Anjou."

This is just one example of the infantile, despotic nature of that interesting poet who, at the time, wanted to be "present" in our avant-garde groups at all costs. What made the artists regard him with diffidence was

his formidably devilish spirit, which admittedly ashamed him, like a fart escaping in public. In fact, his witty rebuttals escaped him in spite of himself and were always of such a nature that they astonished everyone. I must add that his spirit was not his only quality and that his potential as a poet and his vivacious intelligence need no ulterior proof of authenticity.

We soon became friends, but to please him, I would have to visit him in the morning around ten o'clock, when he was about to get out of bed. Of course, there were always other friends there too, often musicians (especially Auric who was an intimate friend of his), and our poet would then rise, surrounded by his retinue as if a "lever du roi." I rarely went there, as my style of living was based on other habits, although for a certain time we were friends all the same.

At Lyre et Palette I also met Halvorsen, a large devil of a blond Norwegian and an extremely nice man. He was married to Greta Prozor, a good actress, who was also Norwegian. I had often seen her perform at the Théâtre de l'Oeuvre in plays by Ibsen.

Halvorsen had practiced painting as a craft but at that time was busy turning himself into a dealer of modern paintings, an occupation he exercised with great intelligence, tact, and gentility. So we would all meet in various studios, from that of Matisse to those in Montparnasse, where the cafés were becoming overcrowded.

Among the people with whom we shared friendship and ideas at that time, aside from Kisling, Zadkine, and Hayden, was Maria Blanchard, a small, deformed, hunchbacked, but highly talented woman, and Rivera, a Mexican half-caste, the subject of one of Modigliani's beautiful portraits. Rivera was very bright. As I had, he too had begun by admiring and deeply "feeling" the Neo-Impressionists. Later he gradually approached the Cubist concept of painting. He had found and reconstructed a theory on perspective in which horizontal and vertical planes were both thought to submit to the same deformations, and objects enriched with dimensions beyond the ordinary three. He often explained this theory to me which, in all sincerity, I found unclear and seldom convincing. But he perfected it later on and turned it into a fixed and mysterious rule of his which he kept secret and called "the thing." Since "the thing" in Parisian slang meant "merde," the Montparnasse group pretended that he painted using "merde."

After all, a painter can utilize anything, even that, to create a good work, and Rivera certainly was not lacking in talent.

Another of the Montparnasse meeting places was Lipchitz' small apartment on rue Montparnasse. We would go there every Sunday and some-

times a large crowd squeezed into that tiny room. Juan Gris would come, and Metzinger, Hayden, Laurens and his wife, Lhote and many others that I do not recall at the moment. We held lively discussions, after which we all would go out to dinner together, either to a neighborhood bistro or to Maria Blanchard's studio where, truthfully, there were never enough plates and flatware. But we were happy to do without them.

Meanwhile the so-called School of Paris was solidifying without anyone realizing it. These artists often came to my studio too. Eric Satie came on surprise visits, as he liked to see works in progress, how they advanced and were transformed. He followed the "painter's reasoning," responsible for all those various stages, with great interest and would say, "I am learning a lot from you." Actually, he had nothing to learn from us. Satie was a man who inspired affection. He wore a Mephistophelian pointed little beard and had two lively, mischievous eyes, but his spirit was as lily-white as that of a child. He lived in a little town beyond Porte d'Orléans called Arcueil-Cachant. He had to return home at night by tram; the last one left at roughly 1 a.m. from Porte d'Orléans, but by the time he would get there to catch it, the tram would already have left. We always wondered what guardian angel accompanied him home every night.

One night he suffered a great disappointment as a result of his childishness. A certain Monsieur Poueigh** reigned as the leading music critic at the time, and being a failed musician himself, he was full of animosity toward any real talent and all new forms of music. Not letting an occasion slip by where he could "wound" poor Satie with his most aggressive criticism, our musician once replied, sending him a postcard covered with various expletives among which, "You don't give a damn." It would seem that this accusation had actually been sent several times, on open postcards.** Naturally, the critic seized the opportunity to offer our friend another proof of his aversion and, at the same time, demonstrated the smallness of his soul, denouncing Satie to the police.

We did not abandon our friend on the day of the trial. Cocteau at the head of the delegation, many Montparnasse friends, among whom were Jeanne and I, all went to the courtroom and noisily underscored the most significant passages. Finally the inevitable happened and Satie received a large fine. All of us, under the scrutiny of several police officers, were conducted to the nearest police station. Once there, we appointed Coc-

*See Erik Satie, *Ecrits* (Paris: Champ Libre, 1981), p. 240, note 5; p. 256, note 1.
**The postcard in question said, "Monsieur, vous n'êtes qu'un cul, mais un cul sans musique" [Sir, you are just an ass, and an unmusical one at that].

teau our spokesman and luckily so, for the police chief, upon learning the name of our poet's father (who was a high and well-known bureaucrat), immediately altered his tone and we were released with nothing more than a good scolding.

Therefore we were all able to participate in the celebration of the "moral victory" won by Satie, who had refused to retract anything he had written to Poueigh. The judge repeatedly treated the latter as just the slipshod sort that Satie had called him.

The material side of life, too, began to take a turn for the better. At that very moment I passed within a hair's breadth of real wealth. I accepted a commission from an important gallery in Genoa to compile a collection of modern French art, from Impressionism to Cubism, excluding the latter only momentarily.

Once I realized how difficult a task this would be, I asked Matisse for assistance. He, with a kindness and competence that amazed me, busied himself with me for several days to compile the collection. We went together to all the dealers in Paris and it was a good opportunity to see wonderful and lesser-known works. Matisse revealed an intelligence and business sense that I never would have imagined and it was thanks to him that a first-rate collection under advantageous conditions was assembled. There was a marvelous Seurat, a Van Gogh, a Renoir, a Cézanne, in short, something of each of our masters, including Rouault, Bonnard, Vuillard, Derain, and Matisse himself. Everything was ready but, at the last minute, the French government refused to grant an export permit to the works of art. Without having to face that hurdle, I would have received a correct percentage which would have permitted me to work peacefully for quite a while.

But even if this "great fortune" slipped through my hands (they always do), at least I had a more modest success elsewhere.

Diaghilev visited Lyre et Palette one day and bought a painting of mine for Massine's personal collection. Halvorsen bought another one for a private collection in Norway and, last of all, Picasso appeared one day at my studio with one of his great admirers, Madame Erasuriz, whom he had buy a small work from me.

We were quite glad when some good news arrived at our house and was brought to the studio by Jeanne. It was the "non plus ultra" of good news: a letter from America with an important check enclosed. The letter was translated by my neighbor, an American painter, and we learned that almost all of my show at Stieglitz' gallery in New York had been sold and that soon another remittance would be on its way to me.

THE "EFFORT MODERNE" ERA

The Ballets Russes

EARLY IN 1917, good news of the Italian art world reached me from Rome in a periodical called *Avanscoperta*. The review proposed to broaden the horizons of Futurism, calling upon such authors as De Pisis (more of a writer, as I recall, than a painter at that time), the Futurist poet Buzzi, and Prampolini, a young talent close to the first-generation Futurists from the outset.

A series of exhibits of the so-called secessionists was held in Rome; I was unable to judge the importance of such shows from afar, but the very fact of their existence left me with the impression that the Futurist manifestations had not all been in vain and had, at least, reawakened intellects.

When Diaghilev appeared at Lyre et Palette to buy my painting he had just returned from Rome. He more or less confirmed the general news and confessed his intention to stress each artistic aspect of his ballets, by means of tighter cohesions between the music, the choreography, and the set design. Larionov's and Gontcharova's beautiful sets were typically Russian and well-suited to the music of Rimsky-Korsakov and Borodin, for example, or to some of Stravinsky's works; but Diaghilev's vast project extended beyond such frontiers, and he envisioned collaboration between French, Italian, Spanish, etc., musicians and painters on his ballets. He wanted each aspect of his programs to be earmarked by a particularly innovative character and high artistic level. In Rome he had already asked the Futurists Balla and Depero for set decorations and counted seriously on their collaboration. In addition, he told me that Picasso, Cocteau, and, I think, Satie too, would soon be heading to Rome to work on a ballet together. This would be *Parade*, whose music we had already heard, albeit in a private audience.

I was working hard and productively at the time, in a serene atmosphere, especially since the rest of the money from the sale of my paintings had arrived from New York, keeping me out of the grip of necessity for a certain time.

I often saw Apollinaire and Picasso but never again saw Eva after her sudden disappearance. I forget the exact moment when she fell ill and

died*, but since then Picasso had moved to Montrouge, to a very ordinary and nearly deserted little house beyond Porte d'Orléans, near the village where Satie resided. He lived there, with an elderly housekeeper and a large dog. Because he was not far from my own house, close to the Paris side of Porte d'Orléans, I often went to visit him, especially in the morning. I would almost always find him still lazing in bed. He worked hard, nevertheless, and his rooms, empty of furniture, were full of stacked canvases. Rarely have I seen such a wonderfully unrelenting worker. Apollinaire, on the other hand, came to my house (and sometimes Picasso too) because he cooked good Italian food and prepared magnificent dishes of macaroni. When he came, he would put on Jeanne's grandmother's apron and take over the kitchen. He boasted that his ossobuco was better than any Italian's and, in fact, we found the dish excellent. I, too, visited him, at his tiny, top floor apartment on the faubourg St. Germain, where I inevitably found André Billy and, often, Fernand Fleurat. Toward the end of January as I recall, Cocteau came to my studio to say goodbye before setting out for Rome. He promised to send me detailed information regularly, but I received no news at all from him for quite some time. A few months later a magnificent and exhaustive postcard arrived, written all over, in every direction, in the chaos of which an occasional phrase or two of the following nature was legible: "My dear Severini, I will tell you everything. We have a lot of work to do and therefore I am delaying my return. Sun and pouring rain alternate. Diag. is consolidating your canvas. Tram, tram, tram, Jean Cocteau." (On the canvas bought by Diaglilev I had glued some sand here and there and had asked that it be consolidated.)

But the missive contained other news. "Seen very beautiful fairylike décors and costumes made by the technical staff. The manager (Teatro dei Piccoli) copying operatic gestures lovingly as Rousseau a tree, a house, a wedding."

In another corner he wrote, "Balla wears a dynamic suit and the Marchesa Casati emerges from between old stone walls like the handsome snake of Eden. Tell our comrades that we are thinking of them. All going well, kiss the Rotonde on Pâquerette's lips."

Pâquerette was one of the lovely habituées of the Rotonde, but there were many others just as pretty, and among these, two girls who were always together and were introduced to me by Pierre Albert-Birot as two very modern painters, brimming with talent. One of them had rather

*She died in the winter of 1915–16, while still with Picasso.

ginger-colored hair and was as pleasant and fresh as a rose, but that was all. The other one immediately displayed a remarkable personality.*

She was very dark-haired, nicely mannered, her features regular, with large orientalish almond-shaped eyes. Also typically oriental, there was a dreamy, absent air about her. She wore a sort of cylindrical turban made of gold-specked damask over two long dark braids that fell down either side of her chest.

They called her "Noix de coco" in Montparnasse, because of her dark colors. Modigliani fell in love with her; "Noix de coco" was the woman who followed him to his death, killing herself after he expired. I know that all of his friends think back on that tragedy with deep sorrow.

Other news arrived from Rome from various sources; for instance, that of Picasso's marriage to one of Diaghilev's Russian ballerinas.** Upon his return, Picasso showed me various works he had completed, especially a large canvas in a very linear style, the forms two-dimensional and extremely limpid, treated almost in black and white. This painting, its pictorial poetry transposed and abstracted to an extreme, was titled *Masks*, and was inspired, as Picasso himself told me, by Ingres' purity of form and contour. He had chosen Ingres as a filter to the strong influence of the Italian museums. However, it was not so easy for him to escape this powerful painter's hold. In fact, many representative works dating from that very moment, such as the *Portrait of Madame Picasso*, the *Harlequin* at the Barcelona Museum, the *Seated Pierrot* in the Lewisohn collection in New York, and various other paintings and drawings, are qualified by critics as "tending toward classicism in the manner of Ingres."

I had already satisfied (exhausted it could be said), this need to *momentarily* return to forms attached to a reality of the senses, although sometimes transcending into style, as in my *Portrait of My Wife* and *Maternità* exhibited by Madame Bongard in 1916. As Apollinaire said to me one day (we discussed such problems in the clinic where he was convalescing), those essentially representative forms belong to a language of the past, which cannot be totally ignored at the same time that a new language is being composed; this, too, is in its own way representative of external reality and does not exclude its predecessor. Then he asked me to paint his portrait in the style of that of my wife, but his sudden death prevented the venture.

As I mentioned earlier, my painting was veering in a different direction

*Jeanne Hébuterne.
**Olga Koklova, mother of Picasso's eldest son, Paulo.

from the style of my 1910 to 1916 works. Having abandoned subjects in movement, I was almost automatically steering toward more ample forms and toward a concept of construction and composition close to that of the Cubists. Of course, I had always worked in that direction, since 1910 before I was painting ballerinas, buses, etc. To be honest, my idea (later shared by many Cubists and approved even by Matisse) was to take artistic expression toward a form that could reconcile the Futurists' desire for extreme vitality (or dynamism) while maintaining the intentions of construction, classicism and style present in Cubism.

We also discovered a characteristic formula for that desire: *art should be Ingres plus Delacroix*. In short, we longed for a lyrical realism along the lines of Romanticism, penetrated by a substantial, intrinsic, and non-acquired classicism. We linked such aesthetic problems with others of a technical nature; the idea of classicism needed to be expressed with appropriate technical means. A great wish to satisfy the exigencies of métier, too long ignored and generally misunderstood, seethed in the artists of that period. The whole modern painting revolution had been accomplished often at the expense of this blessed métier, which, while of secondary importance, had nonetheless a certain significance for art. The best-informed of all was probably Braque who had acquired notions of housepainting, as it seems that his father ran an enterprise of this nature. As for Picasso, he could just laugh about métier and all its exigencies: if he decided one day to put "Ripolin"* or enamel varnish over ordinary oil paints, his colors would wrinkle up or crack in such a lovely way that his "fundamental error" would become a rare expedient.

It was around this time, or rather in the fall-winter of 1916, that the well-known art dealer, Léonce Rosenberg, was brought to my studio for the first time by Juan Gris. In truth, not all the Cubists were happy to put me in touch with this dealer; Metzinger in particular had had a violent discussion with Juan Gris lasting almost all one night, but Gris won the argument, and Rosenberg came to see me.

Rosenberg kept his gallery closed at the time because he had been enlisted in the French army as an English interpreter and even wore an elegant uniform. My first contact with him was pleasant, as he was a nice, cordial, and extremely well-mannered man, almost too polite. His features were those characteristic of his race, grown more gentile by centuries of Christian civilization. One day Lipchitz defined him morally, with

*A popular brand-name of enamel paint, often used at the time to mean any paint of that kind.

great exactitude: "a man who has worked hard to make himself liked but in such ways that he has instead made himself hated." We will often encounter his name, for he had an extremely important influence on the development of modern art. He also had a brother, Paul Rosenberg, who, at that time, was marketing nineteenth-century works and those of the Impressionist masters.

Léonce Rosenberg even bought modern artworks sight unseen. Perhaps he hoped to monopolize avant-garde art and make it wholly dependent upon him, as the Durand-Ruels had done with the surviving prolific Impressionists. Rosenberg began by buying from Picasso and Matisse, then from Metzinger, Gris, Laurens the sculptor, and from a few others that he later abandoned.

He was interested in many of my works and immediately bought my large painting, *Woman Reading** that I had exhibited at Lyre et Palette. We also established a verbal agreement then called "first sight rights"; on the basis of this agreement, or option, I could not sell any of my works without having first shown them to Rosenberg. Once he had made his choice, the remaining works could be freely sold or exhibited. We also established a price schedule calculated according to conventions then valid in Paris. At first I was quite happy with our agreement, later much less so.

In March 1917 a small literary review appeared in Montmartre which immediately rose to an important status among poets. *S.I.C.* welcomed it in an original manner: "In France," they wrote, "there were, up to this point, 333,777 magazines to put readers to sleep and one to wake them up; now, against 333,777, there are two of us: *S.I.C.* and *Nord-Sud*." The latter was the name of the new periodical directed by Reverdy, with contributions by Apollinaire, Max Jacob, Dermée, and later, André Breton, Tristan Tzara, Philippe Soupault, Savinio, and many others.

Apollinaire was always faithful to *S.I.C.* too: on the other hand, *Nord-Sud* aimed at creating a movement with Apollinaire at its core. In fact, it was presented by the following preface:

The war persists. But we already know how it will turn out. Victory is certain. Therefore, in our opinion, it is time to focus on the humanities, to reorganize them among ourselves, by ourselves.

Just a short time ago, young poets turned to Verlaine to rescue him from obscurity. So it is not extraordinary that today, we consider it time to

* "Femme Lisante" or "Jeanne dans l'Atelier" or "La Lecture #1."

rally around Apollinaire. More than anyone else, he has struck new paths, opened new horizons. He deserves our enthusiasm and our total admiration.

At the same time, weekly Café Flore reunions became established. As with Paul Fort at the Closerie des Lilas, numerous friends and admirers grouped around Guillaume Apollinaire and his amiable companion, Ruby.

In an article called "When Symbolism was Dead," in the inaugural issue of *Nord-Sud*, Dermée summarized and evaluated the literary situation of the moment and charted the course of the periodical. Briefly outlined, that declaration of faith was proclaimed in the following manner:

Poetry in France has been exclusively Romantic or Symbolist for the past century; poets such as Baudelaire, Mallarmé, Verlaine, and Rimbaud are ambivalent, that is, they belong to both currents. [Dermée calls them "poet-centaurs."]

Our century is one of lyricism, of an even greater wealth and brilliance than that of the Renaissance, but this abundance is left to the demon of inspiration and is an abundance fraught with disorder.

A period of exuberance and strength must rightly be followed by a period of organization, re-ordering, of science, that is, by a *classical* era.

Further along he wrote: "The poet's aim is to create a work with a life of its own, independent of its author, situated in a special celestial realm, like an island on the horizon."

I have lingered on the transcription of this declaration of poetic faith for the simple reason that it coincided perfectly with the ideas currently held among painters. I hope that its use here will help to clarify and illustrate the artistic atmosphere in Paris toward the end of the war. Furthermore, Reverdy wrote an article, titled "On Cubism," to specifically emphasize the effective sharing by poets and painters of these convictions.

Without suggesting a particular theory of painting, he noted and deplored that confusion and misunderstanding existing in painting as well, and focused his reprimands accordingly:

Some claim to have surpassed Cubism, which is the developing artform of our times, and have turned back toward the past to elude it. . . . Thanks to the titles imposed upon their works, they left the field of plastic arts in favor of literary symbolism, whose imaginative capacity is, in view of future painting trends, absolutely worthless.

In fact, if finding new means for an artform is difficult, the researching is worthwhile only when the means are suitable to that specific artform and not to another.

This was a slightly elaborated, allusive criticism of Futurist painting, and of the "States of Mind" in particular.

Reverdy was never a critic or profound theorist on the subject of painting. Nevertheless, during the time that I had known him, he had made great progress, and that particular article of his, full of good sense, more or less summarized the ideas current among painters.

Our friends—Picasso, Cocteau, and Satie—returned to Paris in the spring along with Diaghilev's dance company. Performances of the ballet began at the Châtelet Theater, and all the painters and sculptors in our group were authorized to attend them. Diaghilev was kind enough to give each of us and our wives a permanent pass to all performances.

From what I could gather, collaboration with the Roman Futurist painters had not produced the results Diaghilev had envisioned; consequently, Diaghilev did not perform any of these works in Paris. Stravinsky's *Feu d'Artifice* had been assigned to Balla and his *Chant du Rossignol* to Depero. I was told that Balla had an entirely new approach to the problem that relied heavily on electrical lighting to play incessantly on the plastic forms, to complete his set decoration. Unfortunately, the technical resources of the old Costanzi Theater did not live up to the expectations of this supporting role, but that did not detract from his innovative idea.

It seemed that Depero's sets and costumes, instead, were highly successful. In any case, Diaghilev did not cancel his plans to collaborate on his ballets with all the avant-garde painters of our group in Paris. We were very pleased about that, but our satisfaction was short-lived.

Almost all of us were bound by contract to Rosenberg, who was extremely jealous of his rights. Just at the point of concluding our agreements with Diaghilev, he wrote us a confidential form-letter of this nature: "Despite the fact that many of you would like to collaborate on ballets, be they the Ballets Russes or any others, and to also avoid assuming any responsibility for failure, often due to the lack of homogeneity in the works of multiple collaborators on the same ballet, I must nevertheless point out to you that I cannot tolerate, either now or in the future, your participation in a category which, in my opinion, is more of a craft than a form of art. Your work will hatch precedents, a 'style,' to which

those artisans with intelligence and good taste, capable of tracing plans and slapping paint on the sets of a ballet, will adhere."

These were his orders regarding our collaboration with the Ballets Russes. To paint the most exact possible portrait of Rosenberg, faithful to my principle of transcribing the precise words of the person concerned, I will quote what followed in his confidential form-letter, for it renders him very well:

> God created *Nature*, men made *gardens*.
>
> It is difficult for me to conceive of Giotto, Rembrandt, Cézanne, willing to devote part of their time, thereby neglecting the seriousness of their own art, to embellish something as fleeting as a smile or a ballet. Great art does not recognize laughter or tears, it is serene. It does not experience an instant's joy, a moment's pain, but that which Humanity conserves of the absolute and the eternal. It leads to God.
>
> In a different order of ideas, it is not possible for me to even imagine Homer, Dante, or Shakespeare composing sonnets for tasty menus at Palace Hotels.
>
> Great poets do not express the joys and sorrows of individuals, but sing the Destiny of Man. When their heroes are happy or complain, it is all of Humanity that is moved.

The amount of literature, rhetoric, and religious philosophism behind his attitude (which corresponded perfectly with his personality) is easy to ascertain; thanks to this background, he could rise to the sublime in general ideas and immediately afterwards decline to the lowly plane of commerce in the art market. The hundreds of letters he wrote to us and his constant behavior reflect these two opposite circumstances. His attitude was basically that of an intelligent commercial defense, painted over with culture and esoterics; for example, at the end of this group letter, after defying men of letters too often concerned with painters, and after having told us that he would present Cubism as the "true heir of the disturbing mystery of the Chaldeans, the Egyptians, the Chinese, the Toltecs, the Indians, the Greeks and the primitives," he ended with this postscript:

> It is of *vital* interest that in the future, no one see your latest works, finished or not, *in your studio*, ready for consignment. Among other reasons, the fact that their existence would then be known, would not only pose an obstacle to my efforts at propaganda and proposals to certain collectors, but would also heavily influence the placement of previous works, the circulation of which throughout the world is as necessary to you as it is to me.

Thus we were all defrauded, like the odalisques in bygone sultan's harems. In fact, Metzinger, back-biter that he was, used to say that we were the "demi-mondaines" and Rosenberg our customer.[1] On the other hand, our main interest was to work in peace, sheltered from the daily harassment of material needs.

Rosenberg's hostility, however, did not prevent Diaghilev from staging his wonderful program; nevertheless, he was obviously unhappy to have to forego our collaboration. Of the whole group, only Picasso could do exactly as he pleased, having freed himself of Rosenberg's chains, while Matisse and Derain were still bound by certain commitments to him.

Already during the winter of 1913 to 1914, while Jeanne and I were in Anzio, the Ballets Russes had enjoyed an extraordinary, raging success in Paris, with Stravinsky's *Sacre du Printemps* danced by Nijinsky. However, the success was even more violently contested this time. Satie's *Parade*, with a Cubist personification (a typically Picassian construction) that danced in center stage, was a rather indigestible thing for the packed upper middle-class French and Continental audience. That in no way diminished the fact that this series of performances constituted an important, unforgettable event. It resulted in a new concept of theater and the performing arts that was self-sufficient and whose means were conceived strictly as a function of its particular artistic genre.

One could say that these first attempts to forge new paths were the purest, while other performances enacted later in collaboration with valid painters such as Braque, Dufy, Derain, and others, were less interesting from the point of view of integrity. The majority of those painters, in fact, took care to transport their own style of painting onto the stage, making it as easily identifiable as possible, instead of adapting their personalities (which would have emerged in any case and in a more integral way) to an artform that was not strictly painting and which required fusing various activities. Only Picasso could not be accused of this, because he carefully studied every ballet in which he participated as a separate form of endeavor, not as painting.

The Ballets Russes left an indelible impression on Paris. A month later, more or less—24 June 1917—we had the opportunity of seeing another show, of an altogether different nature, but not any less interesting. *S.I.C.* decided to stage Apollinaire's *Les Mamelles de Tirésias* in a small theater in Montmartre, on rue de l'Orient. It was a brilliant success.

[1] "Miche" in Parisian slang of the period.

The sets were sketched out, simplified to an extreme, and the costumes were designed by Serge Férat (Jastrebzoff); the accompanying music had been composed by Germaine Albert-Birot. The costume for Teresa, who transforms herself into Tirésias, was created by Mademoiselle Irène Lagut, Serge Férat's girlfriend whose career as a painter was just beginning under Serge's guidance; she showed a fresh sensitivity and the hand of a primitive.

Apollinaire called the play a "dramme sur-réaliste"; it was composed of two acts after a prologue in which the author expressed some of his ideas on modern theater: "It is right for the author of dramatic works to utilize every illusion at his disposal, and to make the audience, and inanimate objects too, speak out, and to ignore time and space. The work must be a complete universe together with its creator, that is, Nature itself, and not just a representation of a small part of that around us or things that happened in the past."

For the first time the words "Surrealist" or "Surrealism" appeared in avant-garde arts programs. Later the Surrealist poets drew a large part of their theories not so much from the word that they appropriated, but rather from the substance of the ideas. *Les Mamelles de Tirésias* was a drama steeped in refined irony, full of fantasy, and interwoven with a carnivalesque atmosphere. Nevertheless, beneath the mask of carefree gaiety was a deep sense of humanity in symbolic form. Obviously it was difficult to comprehend all the sophisticated references in a single, stormy performance such as the one held.

Certainly when Teresa, tired of her duties and of a woman's suffering, suddenly decides to become a man and grows a full beard and throws her breasts into the audience, the unprepared spectators were undoubtedly puzzled, wondering at first if the gesture was serious. Those more or less aware of the work's theme understood the sense of that detail and enjoyed it. There was also a refrain that everyone found amusing:

Et cependant la boulangère
Tous les sept ans changeait de peau
Tous les sept ans, elle exagère.*

One point of the show that was clearly underlined by vital contrasts was when Teresa's husband, dressed as a woman, proclaimed the neces-

*Nevertheless the bakery woman
Changed her skin every seven years
Every seven years, how exaggerated of her.

sity of conceiving children without women, and said: "Women no longer make them. So, let men do it." At the same time he agreed to show an important offspring, nine days later, to a gendarme with whom he made a bet:

Come back in nine days
And see how Nature
Will have provided me, without a woman,
With an offspring

There was no need for the actual text to remember these excerpts, because we all knew them by heart, and for a long while, whenever we would meet, would recite them back and forth to one another. In short, the work alternated between the burlesque, jest, humanism, transcendentalism, and the real world, in perfect order, well-calibrated and with great elegance.

On stage was one of those newspaper kiosks familiar to Paris street corners, which displayed the current dailies; *Le Journal*, *L'Action Française*, *Paris-Midi*, etc., a slice of reality that had the same effect as a piece of material or a book in a Cubist painting. A few journalists thought they recognized ironical allusions directed at them, but later understood that there had been nothing of the kind.

At the end, the play earned the praise it merited. Many, although not everyone, felt its poetic validity and its message. *Intransigéant* and *Bonnet Rouge* published useless, rash polemics about the work and I, too, was slightly but involuntarily involved in this; however, Apollinaire as well as Albert-Birot and Serge Férat, aware of the true circumstances, never held this against me.

Return to Civray

The Declide family understandably led a sad, aimless life in Civray after Pierre's death. I had informed them of my marriage and of Gina's birth and I suppose that good Madame Declide was anxious to see how her adopted son was managing with a family. In fact, a letter from them arrived, saying that they would welcome me fondly if ever I wanted to come to Civray during the summer. Paris was starting to feel the effects of summer heat and, fortunately, thanks to the New York sales, I had the means to undertake the trip. I gladly accepted their invitation.

Having suffered through terrible heat and intense cold in the boulevard

St. Jacques studio, I decided to break my contract and rent another, smaller, more comfortable one on the fifth story of a more conventional building on rue Ernest Cresson. I planned to move in when I came back from the country, in time for the October "terme." So I left for Civray with Jeanne and my daughter.

Father Declide came to meet us at the St. Saviol station, on the main Paris-Bordeaux railroad line, and in the carriage that took us to Civray he soon made friends with Gina who was not easy to conquer. Madame Declide was very moved by our arrival. I knew her well enough to read her heart like an open book. On the other hand, it was not difficult to guess the thought processes of a mother in her situation. Of course, we were received as I had been in the past, that is, as family, as welcomed guests.

We always ate our meals with one of the employed tailors who was also a guest of the Declides. Everything was as it had been, except that Pierre was no longer there. I would often see Madame Declide's face cloud over, but my little girl, with her timely mischief, would instill the atmosphere with serenity. Monsieur Declide was extraordinarily attached to the child, and would play soldier with her endlessly. He would allow himself to be dominated as if he were her own grandfather. As usual, I worked a little, painting a couple of landscapes and a few still lifes*. I was glad to see friends again, among them Marcel Pierron, the doctor who on his way to Civray, on leave, had often stopped at rue Sophie Germain to see us. He was home on vacation attending to his wedding preparations. He was not like Pierre, who always hesitated over the choice of a bride; when he decided that the right moment had come, he promptly became en- gaged to a very young, very rich girl. The wedding was performed during our stay in Civray, but we were not invited to the ceremony. Madame Declide was very disappointed but Jeanne and I were not at all offended, understanding how distant we really were from that provincial, middle- class world. We were very content in that house where the hospitality was so simple and affectionate, but the absence of Pierre, who had been the backbone of the household, weighed on everyone. I could not help but feel that the spectacle of my small family was a source of regret and dis- comfort to the Declides, although in their hearts they were happy to see me harmoniously settled. So, roughly a month later, Jeanne and I decided to profit from the slightest opportunity to leave.

*For example, such paintings as *Paysage: Civray* (1917), *L'Eglise de Civray* (1917), and *Nature Morte à la Cafetière* (1917) dedicated to the Declides, in memory of Pierre.

I wrote to Matisse asking him to indicate some little town on the sea-coast where we could go for the rest of our vacation. He wrote back from Clamart, where he was hard at work, that he was not familiar with the region and that Monsieur Lhote (as he called him) would be the proper person to ask.

In fact, Lhote answered right away from Le Piquey, on the Bay of Arcachon, where he had leased a fisherman's hut. He offered me a similar one, in a neighboring town, Le Canon. Naturally I accepted immediately and we set out for Arcachon. The Declides were desolate and, at the same time happy—I am sure—to see me leave. I was overcome with sadness, for I knew that I would never again see those dear, generous friends to whom I will always feel indebted and grateful.

ON VACATION WITH COCTEAU AND LHOTE

We quickly installed ourselves in the simple little shack. The location was beautiful beyond description. We were on the Bay of Gascony, in a region called Les Landes, but we could have been across the globe, in Australia, or somewhere in those islands so dear to Gauguin; in short, thousands of miles from the trappings of our pseudo-civilization. We lived right on the shore, in sand up to our knees. Behind the hut was a magnificent pine forest with a fountain and an outhouse with all the conveniences. The forest provided fuel for our cooking, in a wide fireplace; this was rather impractical but adequate for the simple life we led.

Gina was happy to live almost completely as she pleased, like a wild creature. I was only able to do a few drawings and a little painting on a board* as souvenirs of that magnificent place inhabited by such cordial, helpful people. The women wore large black bonnets called "benaises" and were capable of piloting motorboats or even fishing sailboats. The town's industry consisted of oyster farming, but at that time of the year it was impossible to sample any of the produce.

We often went to Lhote's place where Cocteau also lived. Lhote had built himself a sort of studio under a shed on the sand where he painted his luminous watercolors. Every so often we would all take a hike to-gether, across the forest to the Atlantic seacoast. Cocteau would carry Gina on his shoulders. The others would bring a sort of picnic and every-one would be happy and content. There were always remnants of ship-

Arcachon (1917), now in a private collection in Rome.

wrecks washed up on the beach and Gina collected many beautiful odds and ends.

Naturally, the topics of our conversations were the recent art events in Paris, which lent themselves to infinite commentary. In that way we were, at least spiritually, tied to our friends, from whom, quite truthfully, we rarely received news. But one day, in response to my postcard, another arrived from Erik Satie, covered with his characteristic melancholic phrases:

> Good day—You have been very kind to send me this card from Le Canon. Are you well? And Madame Severini, the same? And your little daughter? Do not brutalize her, no? When are you coming back? I am alone, with no one nearby. You left, stranding me here in a corner of the Seine region, totally isolated.
>
> That's sad, at my age!
>
> Cordially, I am.

This postcard, communicated to everyone in Piquey, made us all contrite and awakened our sense of nostalgia for Paris. I do not recall what our friends did, but my family and I left that lovely, relaxing place a few days later.

My New Studio

Artists, in my opinion, should never change studios and should also travel as little as possible. I really believe that creative intelligence needs a certain amount of calm and external continuity, which in no way limits the variety and movement in the works produced.

Upon entering my new studio, I immediately felt that it had been a mistake for me to relocate. I found the new walls, freshly painted grey, disorienting, while the grey in the old studio had already mellowed, was rarified, thanks to years of life and light, and therefore was familiar to me. Even the light was different, all things that matter to painters.

My new life there, too, began with an unpleasant incident with my dealer. Despite the drawbacks, I had begun to work vigorously and a while later was able to show Rosenberg several completed works. He came to the studio and, in accordance with our agreement, chose from among the canvases I showed him, buying those that he liked best. Among those left behind, which I could dispose of as I pleased, was

a grey still life* which seemed good to me, but not to Rosenberg.

At that time we often saw Halvorsen and his wife, and their friends. I must add that, already before the war, Riottò had married Reverdy and the two of them got along very well together. Within our group, it was supposed that the review *Nord-Sud*, edited by Reverdy, was financed by Halvorsen whose commerce in paintings was ever more intense. In any case, we often spent time together and all enjoyed one another's company. Halvorsen would have bought several of my works, but my agreement with Rosenberg prevented any such arrangement. Nevertheless, after the dealer's visit to my studio, and well within my rights, I had Halvorsen come for a look at the rejected painting. He found it interesting and bought it. I had nothing to reproach myself, as I had acted according to the established conventions, but some time later Rosenberg went to Halvorsen's place on business and found my painting. He seemed surprised, as if never having laid eyes on it before, and then asked, "When did you buy that Severini?" Halvorsen replied that he had gone to see me several days after Rosenberg's visit and had bought the previously viewed and rejected painting. "Not the case at all," replied Rosenberg. "I never saw that work. It's one of Severini's best paintings and he's broken his word to me. Look, it's still wet!" Because I signed it at the last minute, the signature really was wet.

There was no way to convince him of his error. He went back to his office and wrote me a letter full of insults, breaking off our agreement. I was amazed and sad. Fortunately, Braque had returned to Paris in the meantime and, his wound completely healed, had taken a studio on rue Costantin Pecquer where he was again at work. He, of course, had immediately reestablished contact with Rosenberg with whom he also had an agreement concerning his paintings. I had the idea of having Braque intervene to make Rosenberg listen to reason. But Halvorsen put great financial pressure on Rosenberg, threatening to break off all their business transactions were he to persist in his error. With Braque's moral and Halvorsen's material pressures, we managed to win the set. My former relationship with Rosenberg was reinstated, but the dealer was absolutely determined to have my painting and made an exchange with Halvorsen, against works by Braque and others.

*Probably *Nature Morte en Gris* (1918), now at the Rijksmuseum in Otterlo, Netherlands.

I was happy about the settlement for many reasons, but now after several years, I realize that I would have been better off liberating myself then and there from that man's commercial hold over me. Meanwhile another dealer who was a friend at the time, Paul Guillaume, had left his apartment on avenue de Villiers where I had often accompanied Modigliani, to move to a shop at 108 faubourg St. Honoré, in the middle of the antiques district, where everyone had plenty of Lancrets, Fragonards, Bouchers, etc. on display. Paul Guillaume wanted to inaugurate his gallery with a group show including works of mine, but of course Rosenberg categorically refused me permission to accept the invitation. Thus began that isolation lasting for many years which kept me out of all the important Paris art events, forcing competing dealers to close their doors in my face.

Once discharged from military service, Rosenberg started to exhibit our works in his lovely gallery on rue de la Baume. Representative younger poets would also meet in his gallery every Sunday to express ideas, hold discussions, read poetry, etc. These were our old friends, including Apollinaire, Reverdy, and Cocteau, as well as members of the coming generation, now also gaining recognition, such as Breton, Soupault, Aragon, Radiguet, not to mention Albert-Birot, Max Jacob, Dermée, Salmon, and Roch Grey, who was none other than our dear, kind Baroness d'Oettingen.

I have not said enough about that admirable lady whose personality was remarkable in terms of vitality. Of Russian origin but culturally European, she was completely aware of everything happening in the arts and invested those interests with all the ardor of her race, all the vivacity and fantasy typically Russian. She was not a scholarly person, with professorial attitudes. Her culture was more visible in her acts than in her words.

She could seem nasty and even odious, because she was sharp and prickly, but she had a heart of gold and a rare capacity for affection. She was friends with all the deserving artists of her time, and to many others she was a mistress of favors rendered. She lent an element of effervescence to the poets' and artists' reunions. A valid writer in her own right, she always revealed a curiously witty attitude and an original way of looking at things in every activity she undertook. Apollinaire, Picasso, Max Jacob, and many other mutual friends were very fond of her and tolerated her eccentricities with good graces.

These Sunday afternoons, which the Effort Moderne poets spent in rooms hung with Cubist paintings, in many cases had a good, decisive

influence on their future development. One Sunday, as I recall, I met Ungaretti, who showed up in a tattered, threadbare Italian infantry uniform.

These conferences attempted to make some order of the various theoretical aspects of modern literature and poetry; for example, the influence of Black African art was discussed and Paul Dermée once tried to make a series of analogies and confrontations with manuscripts collected in insane asylums. We will have the opportunity to discuss this later.

Meanwhile the war, whose burden had so far been tolerated without great effort, began to make its grave impact felt in many ways, especially with the violent airplane and airship (the famous Zeppelins) bombardments. Several times a night we had to flee to the cellars; those considered safe were marked with a white symbol on the walls of the buildings. Our shelter was in the cellar of the house across the street. Gina discovered her friends, the baker's daughters, down there and together they all turned the retreat into a party. Sometimes, however, we did not make it out of the house in time; one night I stayed behind the front door of my building for over an hour, with Gina sleeping serenely in my arms, wrapped in a blanket.

That night bombs fell relatively close by, at the Ecole des Mines on boulevard St. Michel; I had not realized how dangerous my hideout had been. Divine Providence came to our aid that time and many others. That same year I believe, during the 1917 winter, a bomb caused many deaths at the St. Gervais church near the City Hall during a Holy Friday ceremony.

A great surprise was in store for us at the beginning of 1918, as I remember, from the Germans, then as now masters of the diabolical. One night when the alarm sounded, we went as usual to the cellar where we waited in vain for hours, until early morning when danger had passed. Tired of waiting, the majority of Parisians had gone back to their apartments to do their usual housework, and many exited early, heading toward various destinations. However, loud explosions could be heard every twenty minutes, quite nearby and right on schedule. No one could understand who had been dropping those bombs regularly since the previous night.

I raced back and forth between rue Ernest Cresson and rue Sophie Germain to reassure my wife. I do not remember how, during one of these short trips, around six o'clock, I discovered that the commotion had been caused by a long-range cannon, the reason for such regular explosions. Satisfied with the explanation, I told my wife the news when meeting her in front of a paint and knick-knack shop at the head of short little rue

Sophie Germain. Such information spread very quickly, but no one could believe it; more and more people began to gather in the street, regarding me suspiciously and somewhat threateningly. An accusation of "defeatism," at that time, could cost anyone his life, and just then everyone started muttering the word. I was well-known and also well-liked by everyone on that short street, but after all, I was a foreigner; in short, things were looking rather bad for me when all of a sudden we noticed our cousin, Robert Fort, coming out of the Avenue d'Orléans metro station with *Intransigéant* in hand. The newspaper confirmed the news of an enormous, monstrous cannon, and therefore I was saved from danger. It is now common knowledge that the Parisians named that cannon "Big Bertha" and even grew quite used to it. But Jeanne did not grow used to it at all. That cannon's line of fire passed 20 or 30 meters above my studio; once a house was hit and my wife became very agitated.

Roger Allard was in the studio one day after lunch (he had been wounded again and was convalescing) expounding on the various ways to compose poetry; I was very interested in his explanations but, for some reason, the explosions seemed to be coming closer and closer and, after each one, my wife would call me from the courtyard, below. We were finally obliged to leave.

That evening Jeanne and I decided to leave Paris with the child; I still had a small part of the American sale revenues. The agreement with Rosenberg was valid and bringing results, so we decided that I could work better in a calmer location. It was early spring, April 1918; by accident we bought tickets to Aix-les-Bains, intending to go to the mountains in the Haute Savoie region. We encountered snow and intense cold in Aix-les-Bains; as soon as we arrived, Gina fell ill, but fortunately we were able to find an army doctor on leave, otherwise her ailment would have become very serious. The doctor immediately diagnosed diphtheria and sent me to a hospital outside Aix to get the necessary serum, insisting that I hurry. I ran there and back; the doctor injected the serum and the child was saved. Luckily she had no complications, but I had several serious ones. I had been in relatively good health when leaving Paris, but the race to the outskirts of Aix, the nights of anxiety, the change of climate, together resulted in a relapse not unlike the previous one that had caused me to sojourn in Barcelona. We were temporarily discouraged, but neither Jeanne nor I conceded much time to the contemplation of negative matters.

Meanwhile the child quickly regained her health. I had discovered a

special wallpaper in that house which I instantly liked and which provided me with elements to use in several paintings. What I found most interesting was the use of little black and white dots in a judicious, pictorial pattern, on a warm grey, tonal background.*

As soon as the child could travel, we took a bus to a town in the Haute Savoie called Le Châtelard at an altitude of 2500 feet. I thought I would do better there; although there was a good pharmacy, the doctors were unreliable. The town was very beautiful with incredible views of the mountains. We had found a place to stay in an old villa near the outskirts of the town. There was a large garden with a stream around it. We had also been promised a pine forest, but only found three or four of those trees; it was, in fact, a "symbolic" forest and such a painter as I had no objections on that account. Besides, Apollinaire had represented the population of Zanzibar (in *Mamelles de Tirésias*) by a single character and a few pots. In other words, it was fine by me. Gina was almost as free as she had been in Le Canon, and got better, always out in the pure air. My condition was more difficult, and it took me a long time to regain my physical equilibrium. My young bride was submitted to the worst difficulties, having to take long walks through the surrounding areas to gather food. But she was such an expert about everything by now, and so courageous that she overcame all the difficulties with gaiety and good humor; our stay began very well.

I started working again, painting a few landscapes and still lifes to send to Rosenberg.** Besides the landlady, there was another family at the villa, with whom we built a good relationship. The father was some sort of tax collector, a greedy materialist, while his wife, an extremely thin, almost transparent woman, was all idealism and spirituality. She always read and was very religious. They had a daughter and a little boy who, although older than Gina, often played with her.

This woman soon became aware of my wife's and my attitude toward religion, but, at least to me, not a word was ever mentioned on the subject. However, she lent me a few books of scarce interest. In spite of this, the problems of man's destiny, the finality of human life which I had deliberately pushed aside, began returning just then, very gradually, to worry me. But the moment for me to resolve such problems in my own mind had not yet arrived.

*See *La Chitarra* (1918), Mattioli collection, Milan, for example.
**See *Nature Morte dans un Paysage (Le Châtelard)* (1918), now at the Kröller-Müller Rijksmuseum in Otterlo, *Nature Morte* (1918), and *Paysage (Le Châtelard)* (1918).

We spent about three quiet, happy months in Le Châtelard, when suddenly the child fell ill again. We had learned from the newspapers that a terrible epidemic of Spanish flu had erupted across Europe, taking more victims than the war.

There was no doctor in Le Châtelard. Worried and frightened, I ordered a car from Aix-les-Bains to take us back there. The three of us returned to that pretty city, to the same little furnished apartment where Gina had been sick the first time. It turned out to be a case of the Spanish flu and soon Jeanne caught it too. So I took care of them, performing my duties so well that they recovered completely in just a short time. Luckily theirs had not been malignant cases.

Seeing that wherever we went, if not Bertha, other troubles or difficulties of every sort always arose, Jeanne and I decided to return to Paris. There, at least, we were familiar with such problems as Bertha, but while traveling to different places, we had been prey to sudden surprises of unknown origins.

DEATH OF APOLLINAIRE

We found Paris much as we had left it, perhaps slightly more vivacious; poets and men of letters had distinguished themselves with many books, novels, and poems. It could be said that the best works of that period had seen the light of day between the summer-fall of 1917 and the current fall of 1918: from Reverdy's *Le Voleur de Talan* to Pierre Albert-Birot's *Trente et un Poèmes de Poche* from Max Jacob's *Le Cornet à Dés* to Apollinaire's famous *Calligrammes*, and many other publications that I forget. All of these came out more or less in the space of one year, testimony to the serious revival of the art world in Paris.

Suddenly sinister news spread through Montparnasse like lightning that Apollinaire was ill with the Spanish flu and, immediately afterwards, that he had succumbed to it. I barely had time enough to race to 202 boulevard St. Germain to pay my last respects to my friend. He had been laid out, with a crucifix that Madame Faure-Favier had put in his hands, in the large pink room where he worked, where we had so often met. On the wall behind his bed hung one of Picasso's most recent and best paintings. The room was full of people, but I do not remember anyone. I think I left, dumbstruck, while gradually the pain burrowed deep into my inner being.

It was 9 November 1918. The following day excellent news of the war

circulated throughout Paris, and on the 11th, as everyone knows, the Armistice was declared. Paris was instantly draped in flags, and wonderful celebrations and rejoicing exploded everywhere. People poured into the streets while innumerable cannons were fired and churchbells rang all over the city to highlight the event. It was during this blaze of color, in the midst of this joy, that Apollinaire's casket, covered with flowers and followed by countless friends, crossed Paris to the Père Lachaise Cemetery the next day.

I immediately felt the gravity of this loss, not only for culture in general, but also for myself. I must have looked very distressed because Paul Guillaume, who was walking beside me in the funeral procession, repeatedly tried to console me; but I knew that I had lost, in Apollinaire, my best advocate, my greatest moral support in the face of the many difficulties that I already foresaw.

It is of no importance that he, as far as I know, never wrote long articles about me; besides, it was my own fault, as I had often asked him to abstain, to wait for a more propitious moment in the development of my painting to write one of his serious essays. I still have a postcard from him sent to me in Anzio in 1914, where he wrote, among other things, "Write and tell me what you are doing and I will write an article for *Paris-Journal* or for *Soirées*.[2]

We hardly ever disagreed, but just when I was in Anzio our opinions conflicted over various works by Picabia reproduced in an issue of *Soirées de Paris*. I have always considered Picabia a highly intelligent, learned man, capable of doing everything well, even painting if you like, but not a "painter" in the true sense of the word, as we defined it at the time. Having written to tell Apollinaire my point of view, he replied in the aforementioned postcard: "If you don't like Picabia's painting you are wrong and probably should come back to Paris." What he meant was that in the atmosphere of Paris, I would have seen those paintings in a different light, and perhaps he was right, but I considered myself a better judge of pictorial "validity" than he. In any case, Picabia's subsequent work has not induced me to change my opinion.

On that same postcard Apollinaire said, "I hope to see you soon in this wonderful Paris. I have seen Papini, Soffici, Carrà, Palazzeschi, all ex-

[2]This review, *Soirées de Paris*, was founded by Apollinaire, Salmon, Tudesq, and René Dalize in 1911; however at the time to which I am referring, 1913–14, it was experiencing a new spurt of vitality under the direction of Apollinaire and Jean Cérusse. The latter was none other than Serge Jastrebzoff, the "brother" of the Baroness d'Oettingen. ["Cérusse" was a playful reference to his origins, "ce russe," that Russian.]

tremely nice, friendly Futurists, here in Paris. Boccioni was in Paris too, but didn't come to see me. Who knows the reason? . . . Have you been thinking about my painting? I've thought about your books and they're all ready for you. I'll give them to you when you get back to Paris and we'll have a macaroni meal together." This was a reference to the gastronomic parties that took place at his house at 202 boulevard St. Germain. He loved good food and abandoned himself to it with such passion and good humor that he was a pleasure to watch. It was not true that these plentiful, succulent meals burdened his intellect, for in those moments when most people take a little nap, he was even more wide awake, more brilliant and funny than ever. Baroness d'Oettingen reprimanded him for his enthusiasm for the culinary arts, to the extent that she wrote that he had founded a culinary movement in the world of letters; but that was an exaggeration.* Nevertheless, it is possible that such a passion as his caused his case of Spanish flu to be more violent, even lethal.

As for the painting that he mentioned, he was referring to a sort of exchange that we had planned, his books for my painting, which I gave him, but much later. When he died, this painting of mine was at the framer's shop—he mentioned it to me himself, a few days earlier—and afterwards it disappeared. Some of his books too, which I had lent to friends, were never seen again.

Thus memories are dispersed, and enter the darkness of oblivion, but even if great lengths of time have since gone by, the image of my friend is still extraordinarily vivid in my mind's eye. His way of laughing while taking his pipe out of his mouth, his way of joking, his way of observing events and people are all very vibrant to me. He often signed his letters, "My friendly hand," and his was surely the hand of a true, honest, and forthright friend.

I later realized how typical Apollinaire was, with that complicated and at the same time simple personality of his, a genuine example of the modern poet (not only one who writes poetry, but the artist in general, considering that poetry dwells above art and, like metaphysics with which it can be compared, is projected straight into the intellectual and spiritual structure of art).

So then, Apollinaire was the type of modern poet (and perhaps of all eras) that was naive to the point of childishness, and at the same time extremely shrewd; innocence and cunning alternated in his psyche as in-

*See Apollinaire, "Le Cubisme Culinaire," *Fantasio*, 1 January 1913. His text made fun of the two movements then in fashion: Cubism and Dramatism.

stinct, immediacy, and reason revolved in his activity as a poet. He could summarize the past, the present, and the future, multiple and one, with an expression that everyone could and can feel authentic. Highly learned, he knew prosody and syntax perfectly. More than once I heard him say: "You must know the rules even if you intend to or must violate them." He also said, "Classic tendencies are in the substance, not in appearances" even if "it is necessary to know how the classics operated."

From Baudelaire on, a new sense of poetry had come to light, incarnated and precisely defined by Apollinaire as far as humanly possible. The value of what he did is evidenced, rather than in his intelligent critiques, by the development of modern poetry in general, which could not have existed without him. He alone could have comprehended my goals in the wake of Cubism (as it was then shaped) and Futurism; he certainly would have supported, defended, and helped me immensely. For this reason too, it was not easy for me to find solace after his death.

The "Effort Moderne" and Post-War Cubism

ART GALLERIES in Paris customarily have large display windows facing the street, for the public to view works by the painters they defend and support. But the Effort Moderne Gallery—at 19 rue de la Baume, Paris 8e—was unlike all others. It occupied the first three floors of a townhouse and had no show windows at street level. It was, as they are called in Paris, a "petit hôtel particulier"* and appeared more of an aristocratic than a commercial building. This fact intimidated many of the artists and visitors in general, despite the presence of a doorman dressed in black who opened and closed the glass door with extreme courtesy. Once inside the door, as there was no separate entrance foyer, one walked directly into the first exhibition room hung with paintings. Off of this, to the right, were three little rooms used for various purposes: sometimes for exhibitions, sometimes for offices. A staircase, with walls entirely covered with our drawings, gouaches, and watercolors, led upstairs, from the ground-floor room to the big exhibition hall on the second floor, which had a small room behind it.

The stairs continued up to the third story, which was almost entirely devoted to office space. The large, second-floor hall not only hosted the exhibits, but also accommodated the aforementioned Sunday reunions for painters, poets, and musicians, as well as occasional evening receptions, reserved exclusively for the gallery's artists and their wives or companions.

These receptions, fortunately rare, were always terribly boring because we were much more inhibited than when meeting in our various studios. Such gatherings fluctuated between social and informal functions. Courteous Madame Rosenberg received us, of course, and did everything in her power to adapt to us. Invariably, and gracefully, she would ask her guests, "Beer or syrup?" Once however, the poor lady became extremely upset when Juan Gris replied in his unrivaled accent, "Tap water!," poignantly underscoring his hosts' parsimony when catering the receptions for the gallery artists.

Besides, we were all dubious about the necessity of such functions and

*One-family townhouse.

why Rosenberg obliged his amiable wife to make similar efforts. Perhaps the gesture, like many others, was instinctive to his nature, which was characterized by his never *entirely* devoting himself to one specific circumstance. He was neither detached from the arts nor from culture, nor was he content belonging to the middle-class, nor did he succumb exclusively to his commercial inclinations. He tried to embrace all three attitudes and occupations at the same time. It must be acknowledged that this triple aspect of his personality allowed him to conduct his business with great elegance and dignity, and his manners enthralled those unable to venture beyond mere appearances.

The activity probably best suited to his natural gifts was that of a man of letters or scholar. He was no longer entirely himself when yielding to the fascination of the other two demons. As a dealer, he may have had negative features and made mistakes like everyone else, but generally he was forward-looking, or, more precisely, felt "quality" with a sixth sense, the way hunting dogs smell game.

No comparison can be made between him and the other rare dealers who materialized in Paris and in Italy before or after the war. In Italy, particularly, few dared to risk capital on such untrustworthy merchandise as modern paintings or, had they done so, their efforts had been so timid as to be utterly unremarkable. Only a government like that of the Fascists could have established prizes for such dealers; and such a gesture was just one of the thousands of forms of demagogic propaganda employed under Fascism.

Rosenberg, on the contrary, bought our paintings in the middle of the war when no one else wanted them, defying public opinion that attributed avant-garde art to German origins. In fact, our friend Granié, assistant attorney to the French Republic, was obliged to hold an important conference to defend us against this stupid accusation, only one of many similar allegations. Rosenberg and his money permitted us to get on with our work as if the war were nonexistent, an important consideration for the artists. I remember that at a certain point, while I was in Le Châtelard, he had been in rather serious financial trouble, and had had to resort to engaging an English bank on Place de l'Opéra to pay our bills.

To better understand the man and to be in a position to judge his conduct, I must describe the Paris art market at that time, its great importance and perfect organization. To render the idea, I will transcribe some excerpts from a letter that Rosenberg sent in 1923 to the painters in his stable, as was his habit:

The *permanent* stock belonging to antique and art dealers throughout the world is valued at approximately 5 billion francs, and 70% of business transactions regarding such merchandise occurs between *professionals*. If, as a result, there were as many collectors as artists are wont to imagine, not only would this fantastic stockpile not exist at all, but the dealers would neither need to nor be occasioned to deal among themselves. In other words, the *buyers* are the dealers.

95% of the acquisitions during all of the public sales are made by dealers.

Art dealers are like bankers or industrialists, capitalists attempting to make their principal earn higher interest than government bonds offer. Otherwise there would be no reason for their business activity to exist; this does not prevent them from conducting their profession with love and devotion. But it is of little importance whether the buyers be collectors or dealers, the essential thing is that someone buys.

Every so often, as you will see during these memoirs, Rosenberg would revert to form-letters or personal letters about the art market, the duties of dealers, etc.; one thing that cannot be criticized is his laying the cards on the table. The negative aspect was that, at the same time, he tried to appear as a patron, while the role or fate of a dealer is to replace patronage. At other times he acted like a missionary preaching his own esoteric religion. Many of our misunderstandings derived from this transmutation of his inclinations and roles.

On the immediate heels of the Armistice, Paris witnessed an incredible resurgence of activity, an amazing enthusiasm for everything. Foreign artists flowed in from all parts of the world. Many had been there before the war, such as Hayden, Mondzain, Kisling, Lipchitz, Zadkine, Pascin, Giannattasio, Mazzei, Colucci, and many others unknown to me. The majority of them had enlisted in the Foreign Legion, had been in battle, and those who had survived slowly trickled into Montparnasse with war crosses pinned to their lapels and a few with the Légion d'Honneur. One of the most unfortunate Italians was the Futurist Giannattasio. He had served in the war for over a year, in the Foreign Legion, had been wounded, and wanted to go back to Italy to convalesce. As Italy was already at war at the time, instead of being sent back to France, my friend was sent to the Austrian Front as an Italian soldier, where again he was wounded and taken prisoner. When he finally returned to Italy, his artist friends and colleagues gave him such a "welcome" that he chose to continue his career as a soldier. Had he returned to Montparnasse, his fate would have been altogether different.

Modigliani and I were the only Italians considered avant-garde artists; but, as I have said, many foreigners soon flocked to Paris and, at a certain point, there were approximately forty thousand artists. The famous School of Paris which has been criticized at length, favorably and not, but mostly unfavorably, was already in existence before the war, but in the post-war period enjoyed an unbelievable renewal. Numerous academies were opened in Montparnasse, enlisting the services of respected modern artists as teachers. There had been a Matisse Academy before the war, but after the Armistice, Matisse chose not to reestablish it.

Many large and small galleries also opened. Rue de la Boétie, which ran into the faubourg St. Honoré, became more or less the focal point for the big galleries, while the smaller ones were, preferably, on rue de Seine, rue Bonaparte, and in that general neighborhood. The Effort Moderne also enjoyed a period of extraordinary activity. Léger had been back for some time, before the Armistice I think, and had started working again; he, too, sold to Rosenberg. There were over a dozen artists in varying degrees in the Effort Moderne stable: Herbin, Gris, Laurens the sculptor, Metzinger, Hayden, Rivera, Maria Blanchard, Lipchitz the sculptor, Braque, Valmier, Zarraga, Lhote, Picasso, and Severini.

But Zarraga, Lhote, and Rivera ended their association with the gallery shortly thereafter; the works of Picasso, Matisse, and Derain were bought up by Rosenberg in a discontinuous, intermittent fashion, especially since his brother Paul had opened a gallery on rue de la Boétie and had started to broaden his circle of interests formerly devoted to Corot, Ingres, Manet, Renoir, Cézanne, etc. Recently he had decided to introduce some aggressive modern painters, such as Picasso and Matisse.

Maurice Raynal had come to our gallery as secretary. Having returned from the front, he had accepted the job, I suppose, to busy himself with some sort of work, but it was impossible for him to conceive of getting along with Rosenberg. In fact, a few months later, he left without having made any significant contributions to the gallery. Besides, Rosenberg's management blocked the path for any initiative.

Rosenberg offered me a three-year contract early in 1919, confirming and cementing our 1916 agreement. But the foundations of such an agreement were made even more severe by additional clauses; for instance, there was one prohibiting us from distributing photographs of our works for reproduction or from handling the commerce of even the most insignificant drawing ourselves, without his specific permission. Under such a contract, an artist's entire production belonged to the gallery; he only existed in terms of the gallery. If these conditions were not met (by

the artist, naturally), he was fined 25,000 francs, regardless of the eventual damage caused to Rosenberg. As for the prices established, I began with twelve times the number[1] according to the customary Parisian procedures of the times, a price that Rosenberg nevertheless soon decided to increase.

Obviously, a contract prohibiting an artist from any sort of material freedom of activity is hard to tolerate, and often prevents him from noticeably improving his standing in life. On the other hand, it offers, at least theoretically, the chance to work without ulterior preoccupations, be they daily needs (even if modestly assured, nevertheless assured), or frames, exhibits, shipment of works, photographs, and so forth—all those headaches that require time, energy, and expense, without taking into consideration the difficulties and embarrassment of selling directly to collectors. The trick is to free oneself of it in time, something I never learned.

Then, as during my whole lifetime, I considered things important in direct proportion to how much they influenced my artistic goals. As for everything else, I thought that something could always be arranged. And as an artistic period, this immediate post-war time was wonderfully interesting.

As I said before, in the Paris art world the current focus was on order, discipline, classical tendencies, and their opposites, an unlimited lyricism that led to a sort of pictorial Romanticism. In these two currents, however, everything depended on the "quality" of the artist necessarily emerging and becoming dominant. Some, Picasso and even Braque for instance, were ambivalent, with one foot in each stream.

The Symbolists still existed, with Maurice Denis as their leader. Other valid artists searched for an orderly form of art like that of the classicists or rich in humanity like that of the Romanticists, but the results obtained often seemed out of tune with the spirit of modernism that sparked our labors. In fact, they were particularly discordant with it.

After Neo-Impressionism, another current appeared in direct response. Already antiquated and forgotten since its appearance around 1888, it was nevertheless worthy of consideration, because in it, as in Symbolism, can be found some of those ideas recaptured and made extremely intelli-

[1]The dimensions of canvases in Paris are always designated by numbers [points]: for example, number 5 is 0.35 cm x 0.27 cm.; number 10 is 0.55 cm. x 0.46 cm.; number 15 is 0.65 cm. x 0.54 cm., and so forth. Therefore twelve times number 15 meant that I was paid 180 francs.

gible by post-war Cubism. This tendency was called "Cloisonnisme"; it was initiated by Emile Bernard and supported and encouraged by Gauguin. The fad for unpublished formulas probably began with that artist. This tendency also aimed at synthesis; it decreed that the local tone be subordinated to the general tone and color of a painting. In other words, it concentrated the artist's attention on the needs of the picture, independent of scientific or aesthetic theories. Other adherents, besides Bernard, were Van Gogh and Anquetin, among others, who had originated more or less in Impressionism.

Emile Bernard always put a great deal of intelligence into whatever he said and did, but had little luck in spite of his qualities, and the reason was this: at a given time, saturated with the ideas of order, classicism, painting technique, etc., he went to Venice and was not strong enough to resist the influence of the local masters, who incarnated the very aspirations of order in harmony inherent to his own nature.

I was well-acquainted with him for we were vaguely related; he had married one of my wife's aunts and was therefore an intimate of the Paul Fort household. I had already met him in Montmartre during my occupancy of the studio next to the Théâtre de l'Oeuvre. He was living on rue Cortot, near the Lapin Agile, and was the editor of a culturally valid but not particularly lively or up-to-date periodical called *Rénovation Esthétique*. He claimed that Seurat's Neo-Impressionism prevented the modeling of form, and under this pretense, defended "Cloisonnisme." I could have replied that Seurat's *La Grande Jatte* and many other paintings proved just the opposite; and I think I answered him more or less in that respect, but I also had the infinite sense of pride to invite him to my studio to show him how I could *model* perfectly using the division of colors. After this we met rarely, for our ideas did not coincide.

But, back to the present, that is, to the post-war era so full of theories and formulas, and errors too, but so rich in youth and intelligence. For my own work, I always considered Neo-Impressionism my point of departure and Seurat my master. In my opinion, the idea of classical tendencies was brilliantly represented, as well as by Cézanne, by Seurat, and I continued to work in that direction. I intended to bring to line and to form that scientific spirit that the Neo-Impressionists had brought to color.

In Paul Signac's wonderful book, *D'Eugène Delacroix au Néo-Impressionisme*, given to me by Dufy when we occupied neighboring studios, the laws of color are well summarized from a pictorial, not from a scientific, point of view, though based on serious scientific concepts. And by that time, all or almost all of the artists were aware of these. But the

counterpart for line and form was still to be discovered, in order to reconstruct what was called a "law" or "school" in the highest or almost abstract sense of the words, that is, as a métier.

For this reason I began researching ancient essays. Each day I went to the library, often accompanied by my wife. She copied out the passages that interested me, while I examined other sources. I began by consulting the architects and architectural theoreticians, from Vitruvius to Leon Battista Alberti, from Viollet-le-Duc to Choisy, etc. In all of them I found the confirmation of what we painters had often discussed, but without ever pinning down the ideas, because, basically, none of our ideas was precise enough; I found that there were geometric and numeric laws fundamental to architecture that served as its backbone.

Many artists liked to discuss geometry and mathematics; among these Metzinger dared even to drag in non-Euclidian geometry and the spherical trigonometry used by navigators, but all of these were approximate notions. In the case of a valid artist, such intentions helped him to compose, to rationalize his paintings; these same theories were helpful to many a distinguished work. But I found this insufficient. I thought that geometry and mathematics should be used more precisely, that artists should apply, and would benefit from, strictly observed laws of geometry and mathematics. These rules had meanings (I was beginning to realize) beyond their constructive value. I am referring not only to that universal, cosmic sense that the Greeks gave to mathematics and to numbers, but to something strictly innate to artistic creativity.

In fact, somewhere beyond a painting, a statue, a poem or a symphony, lies the art and poetry contained therein. Poetry and art belong to a profound stratum of being, common to all forms of expression, and therein is the pure source that animates everything, holds everything together, that is, the artist to the universe, the work to the cosmos, the individual to the collective soul; the measurement of all this is in numbers. This accounts for its metaphysical value, beyond human values, divined, moreover, by Rimbaud.

So I glimpsed the path leading to the infinite, toward absolute purity, superhuman poetry and perfect harmony, in numbers. Nonetheless, for the time being I was obliged to simply enrich my knowledge of technique and construction.

In many essays on painting, as in those by Bernard du Puy du Grès, or by Felibien, or Henry Testelin, Algarotti, or John Burnet, etc. (without counting the more ancient manuals that were generally focused on partic-

ular trades, like the treatise by Brother Theophilius, the *Mappae Clavicula*, the Lucca manuscript, and up to the famous essay by Cennino Cennini), I confirmed that clear and precise rules had dominated artistic creativity in ancient times; this creative regimen included painting, both in the geometric and mathematical structure of the work, as well as in its technical execution. It was, therefore, a whole métier to be restored, a vocation ignored by the academies and that only some of the artists of my generation had envisioned.

Maurice Denis, in his book *Théories* often refers to this craft or métier, to such laws; he tells of a Benedictine monastery in Beuron, south of the Black Forest, where a handful of monks painted according to rigorous, scientific methods. Not only did they paint, but they also created objects, mosaics, invariably inspired by the greatness, solemnity, and dignity of hieratic Egyptian art or archaic Greek art, whose laws they had discovered.

The activist of this group of monks was Father Pierre Lenz, whose theories are summarized in a little book translated into French by Paul Sérusier with a preface by Maurice Denis.[2] The aesthetic of the Beuron convent is summarized in these few lines: "The simple, the clear, the typical, whose roots are in numbers and the simplest of measurements, remains the basis of all art, and measuring, counting, weighing are its most important functions. The aim of all great art is the transmission, the characteristic application of fundamental geometrical, arithmetical, symbolic forms, originating in Nature, to serve great ideas." Later he quotes Plato: "When one removes all that is measurement, numbers and weights from Art, what remains is no longer Art, but manual labor." It must be remembered that these artists were monks, whose art was aimed at the glorification of God; so, as a support to such an aesthetic, these words follow: "and what is said in praise of God, is not in vain: You have everything arranged according to measurement, numbers, and weight" (*De Civitate Dei*, II, 30).

In their own way these monks consummated another trend in Parisian art circles, especially among the Effort Moderne Cubists: a collective, anti-individualistic art, in which, as in Greek times or during the Roman Republic and the Early Christian era, anonymity was the rule. This idea subsequently vanished, for with the development of the Paris art market, artists were encouraged, even pushed by the dealers to realize their partic-

[2]Pierre Lenz, *L'Esthétique de Beuron* (Paris: Bibliothèque de l'Occident, 1905).

ular personalities in the most unmistakable and individualistic style possible; this eventually verged on the excessive.

The step-by-step process of my transformation from extreme ignorance to a good, if not remarkable, knowledge of my métier would be too long a story to recount, so I will mention only the most important stages. Dürer's famous essay on proportion and construction put me on the right path; obviously even the most ignorant of artists knows the proportions of the human body, studied in every academy, but in Dürer this is something wholly different. He established a ratio, and used it to construct and measure the human body, even in its most minute details. Once constructed, he put it into movement with a few geometrical operations that I was totally unable to decipher. These consisted of placing squares upon one another vertically and then in another parallel pattern. These same squares were turned around a center point. I found those operations impossibly mysterious.

I was extremely disillusioned and discouraged, when I suddenly noticed in a Paris newspaper that a mathematician, a professor at the National Conservatory of Arts and Crafts, had held a lecture on geometry and the fine arts. I decided to go to him for an explanation of Dürer's mysterious geometry. I was received very courteously by Monsieur Raoul Bricard (the mathematician), author of books on descriptive geometry and perspective, and examiner at the Polytechnical School. In no time he understood the problem: "This is descriptive geometry," he said, "that Dürer elaborated before Monge; do you know anything about descriptive geometry?" "Absolutely nothing at all," I had to reply, and was really terribly ashamed and humiliated.

He understood my embarrassment and began to explain that those squares represented cubes and that in the second figure those cubes had been made to turn on an axis, etc. He also told me about vertical and horizontal projections, but immediately realized that these terms were obscure to me. What saint made this mathematician's heart and soul compassionate and interested in me, such an ignorant artist, I will never know. Perhaps he was moved by my fervent desire to learn. The result was that he offered to see me several times a week to reveal the secrets of descriptive geometry, especially that part of it that concerned conjugated orthogonal projections; he made me begin with algebraic addition, studying mathematics, and then started on the properties of triangles, geometry.

Artists often talked together about the "Section d'Or" (Golden Mean),

and under this heading, an exhibition had been held in 1913 I think,* but very few, including myself, knew the exact meaning of the term. Now that I knew what a "ratio" and a "proportion" were, I knew what the Golden Mean meant. Later I became an expert in the historical and artistic validity of this famous ratio; for the time being I was happy to understand, even in a rudimentary fashion, its geometric value, to be able to use it in my compositions. Monsieur Bricard also explained the relationship between sides and diagonals of squares and also "harmonious proportions," the topic of Theognis of Smyrna's opus.

DADAISM

While I was forcing myself through severe discipline to master the solid foundations of my work, other artists were returning to us with problems about freedom, absolutes, those that Rimbaud and Mallarmé had already questioned and invited us to resolve.

One possible reason for this was that northern European artists were more deeply shaken by the war and its consequences than we in France. They were generally overwhelmed with pessimism nurtured by philosophers such as Husserl or Jaspers, who contributed to our Cartesian scholastic atmosphere a penchant for annihilation and desperation, for jokes and hoaxes.

Thus the general idea of harmonizing culture and technique, spiritual and human life, became increasingly deplored and laborious despite the presence among the newcomers of valid poets and artists, with great creative potential, such as those of the "Dada" group. Regardless of the fact that the relationships and negations conveyed by Futurism were now widespread and appreciated to varying degrees, the Dada group immediately captured Paris' interest, just as several of the Effort Moderne and Puteaux artists had done before them.

Everyone wanted to know what the new tendency called Dada was. Many discussed it, but in such a way that made comprehension difficult. We now know that at the outstart, Dadaism had no bearing on art and was essentially an expression of the disorientation caused by the war. It was a publicity stunt created in Zurich in 1916 by a few friends who never imagined that it could have such a vast international echo.

*Actually in 1912 at the Galerie de la Boétie.

Its initial function was to salvage a café, the Cabaret Voltaire,* from imminent doom. The owners were a certain Hugo Ball and his wife, Emmy Hennings; its director, Richard Hülsenbeck,** a physician by profession, was my source of information. The café's clientele included artists such as Tristan Tzara, Marcel Janco, Arp, and, it seems, the great writer, Thomas Mann: all talented people reacting to the pitiful atmosphere created by the war which had brought a world of revolutionaries and spies to Zurich. Despite all their efforts, the cabaret was on the decline; so it was necessary to create something to interest and amuse a clientele made nervous by the war.

They finally found a nice girl who agreed to sing and dance before an audience; while incapable of both activities, she was fortunately quite beautiful. Her youthful freshness and girlish vitality communicated such an impression of exhilaration that the cabaret finally attracted a considerable following of excited, curious clients.

The young lady was called Mademoiselle Leroux. No one knew what she had done before and who she really was, but Madame Emmy, jealous of her success and beauty, pretended that she belonged to a spy network. Evidently the others realized that the motive for this conviction was her jealousy and invented a name for the girl, Mademoiselle Dada, a word they had laboriously discovered in the dictionary and that seemed to embody an element of surprise; it had no meaning*** and was reminiscent of childish innocence. One of their aims was to convey this very sensation, relayed through anti-rational spontaneity (they forgot however that this was possible with *real* children to the age of six or seven, but inevitably impossible as they grew older).

The best part of the story was that our friends also attracted the attention of the police, and one evening the cabaret was raided and everyone arrested. At the police station they learned that they had been accused of "Dadaism," interpreted as an insult to the laws of the country. They were held all night at the station and, in the morning, after having been admonished about learning a lesson from the experience, discovered that

*Its life span as a café was shortlived (January 1916-March 1917), and it turned into the "Galerie Dada" on 17 March 1917. This hosted various exhibitions, by Arp, Janco, Van Rees, etc., and prints by Picasso and drawings by Modigliani, both on loan from Arp. Various Futurists also performed on stage there.

**After having acted as one of the mentors of Dadaism, he emigrated to New York, changed his name to Charles Hulbeck, and practiced Jungian psychoanalysis.

***To children it meant toy or hobby horse. The choice of this word was attributed to Tzara.

the incident had incited great interest in the press. Therefore, Tzara and Arp considered Futurism and Cubism already surpassed.*

It was time to get back to work. It seems that Arp's first painting was an entirely Futurist work, with a box of matches, a real one, not painted in, glued to the middle of the painting. But I had already done that in Paris, in 1912.** Perhaps Arp was unaware of my gesture and was happy to discover a way to surprise his friends, even though they did not grasp his intentions.

Meanwhile Dadaism in Zurich, originating as a reaction to the war and a desire to destroy all previous, recognized values, began the search for the passage toward an art form with a primitive base similar to that of a child's, dependent on a devaluation of visual reality and on fantasy as its sole directive.

Moreover, the idea was to supplant Cubism and Futurism, which they knew to perfection, as is evident from this Dadaist verse:

bra bra bra
o ca sa sa ca ca sa ca ca

Undoubtedly well-informed in general, as was Marinetti, they were not unaware of the epigraph that Charles Lassailly dedicated to himself before committing suicide:

Ah!
Eh! hé?
Hi! hì hì!
Oh!
Hu! hu! hu! hu! hu!

As I recall it was Tristan Tzara who mentioned it, in an article titled, "Essay on the Condition of Poetry" for the review *Le Surrealisme*, no. 4

*As Piero Pacini notes in his edition of *Tempo de "L'Effort Moderne"* (Florence: Vallec-chi, 1968), "the Dadaists do not allow for fixed liberties in avant-garde movements, approving only the incessant dynamism of freedom: that is, freedom which is in continual change and denies its own existence. That is why the Dadaists consider Futurism and Cubism already extinct at that very moment when a theorical/critical examination is initiated; and, coherent to their beliefs, admit that even Dada, in order to survive, is compelled to continually self-destruct. However, beneath this paradoxical theoretic formulation, the Dadaists aspire to much more concrete and real results: they attempt to translate poetry into action, to weld together the fissure between Art and Life, that such artists as Van Gogh and Rimbaud had previously felt and suffered."

**See reproduction in *The Sketch*, 16 April 1913.

(1932). He confirmed the incapability of words insomuch as they are vehicles of logic, which becomes evident in the continuation of Dadaism in Surrealism.

That assumption was considered valid for two years during which they held exhibits, poetry readings, dance recitals, musical auditions, etc.; but after the 1918 Armistice, the association in Zurich closed its doors. Some tried to revive the movement in Berlin, founding a Dadaist artists' club and, above all, using the Dada label to conduct business transactions, with varying measures of success. Artists such as Tzara, Arp, and Janco moved to Paris to attempt similar operations. The former owner of the Cabaret Voltaire, Hugo Ball, retired to a Swiss monastery where he died in 1927, followed by his wife, Emmy. The lovely Mademoiselle Leroux, who had fallen on hard times, was found dead in a hotel room.

That is how Dadaism came to an end in Switzerland and Germany, but it continued in Paris,* where ingenious young men like Aragon and Breton became very interested in it, seeing in Dadaism the point of departure and stimulus for what became the Surrealist Manifesto.

In Paris, in fact, in 1913, soon after the 1912 Futurist exhibit, Picabia had shown a painting, *La Procession à Seville* which was a parody along the general lines of my *Pan-Pan à Monico* in appearance, but lacked any reference to reality, nevertheless conserving such things as the same arrangement of color. A friend told me about it while I was ill in Anzio. I complained about this in a letter to Apollinaire who had praised Picabia's work in *Soirées de Paris* and he wrote back saying that I was mistaken. But I think that, had his life not been cut short so suddenly, he soon would have recognized his error.

This first attempt at "non-figuration" which, moreover, we had already tested in Montmartre, was perhaps the origin of the total negation of reality that the Zurich Dadaists had envisioned as a new basis for creativity. As you know, the war erupted soon thereafter and the artists dispersed. Picabia and Marcel Duchamp went to New York and immediately met a group of artists led by Stieglitz who ran a review called *291*. Picabia wanted to found a review too, and he christened it *391*. Only nine or ten issues appeared. It was similar in spirit to that of *291*, that is, against the war and encouraging the total destruction of all values.

*Arp, Duchamp, Ernst, Picabia, and Man Ray were the principal exponents in Paris, where the movement reached its peak in 1920.

News arriving from New York was rather vague, but it led us to believe that there was a sort of revival as well as a reaction to the Futurist sense of irony and emancipation in those circles. In fact, Futurism both in Zurich and New York was generally used as a trampoline to attain that lasting confusion between metaphysics, poetry, and the social sciences that persists today.

When Picabia returned to Paris around 1918, as soon as the war had ended, he offered a clearer explanation of the situation, of the ideas currently championed in America. Actually, the artists there were still in revolt against the war and the society that had provoked it; therefore, their attitude still stood somewhere between the philosophical, even though they were anti-philosophical, and the poetical, though anti-poets. Basically, such an attitude pushed the hatred of conventional ideologies, systems, mercantilism, that we Futurists had advocated, to extremes. In our group instead, there had always been an artistic goal, together with the idea of destroying the past to attempt to reconstruct a present and a future. Those in America proclaimed the suppression of artistic activity, of all activities in general, so that painting, sculpting, or writing were to cease; but they, the artists themselves, went on painting, sculpting, and writing. Such a desire, contradictory, incoherent, fragmentary as it was, undoubtedly came from badly digested revisitations of Rimbaud.

This attitude, especially as embodied by Marcel Duchamp who had given proof of his first-rate pictorial talents in 1912, was a surprise to the artworld. His painting, *Nude Descending a Staircase* is one of the best paintings of the period. But Duchamp's lively, inventive intelligence showed itself in other ways that assumed the semblance of jokes, witticisms, jests, a mien generally adopted by those anxious to distinguish themselves at all costs, but at the same time irrelevant to artistic creativity.

Art viewed as a joke, had been partly foreseen and intended by the Futurists; later it gained in aesthetic and ethical consistency. Nevertheless, it is true that Marcel Duchamp had professed to be anti-art, anti-painting, affirming that any ordinary object was, in itself, a work of art. As an example, he exhibited an iron stand for drying bottles (*Séchoir de bouteilles*). Later, toward 1915, he produced other paintings with bizarre, illogical titles which always revealed his taste for the absurd and nonsensical; subsequently he abandoned painting to devote himself to the game of chess. Those artists who knew him well always recognized the genius that he was, behind his penchant for humor. It was easy to gather from this that the artists from New York found much in common with those

from Zurich; such was the real origin of Dadaism as a cultural attitude, that neither excluded nor denied poetry and art.

DISORIENTATION AND VITALITY AT "EFFORT MODERNE"

Between the 5th and 31st of May 1919, Rosenberg held my first one-man show in his lovely, large upstairs hall. This series of exhibits had been inaugurated in December 1918 by the sculptor Henry Laurens. It was followed by those of Juan Gris, Léger, Metzinger, and Braque. Each artist designed his own invitation, a small, colorful composition printed with stencils. I made a little, four-color still life, in blue and yellow, black and grey, also using the white of the paper. One of these invitations came back to me at the gallery, its reverse side decorated with an obscure pen drawing, and these words scrawled:

> It's not so difficult, after all!
> It represents a pretty cubic woman.
> Those not understanding it are
> Philistines, backward and ordinary.
> Dr. G. Léo

Several times in my life I have received compliments of this nature, written on the back of reproductions of my works. Once, at a show in Rome in 1942, a color reproduction was delivered to me with rather straightforward comments.[3] I suppose that other artists are addressed in this manner too. The fact of the matter was that my 1919 show was unsuccessful, totally unsuccessful, which made me fear that Rosenberg, after such an experience, would break his contract and business relationship. Instead, he seemed very satisfied and, it must be said to his credit, acted in just the opposite way to what I had foreseen. He proposed a rider to our contract, raising the basic sum. Nevertheless, I realized that it was logical for my works to be displeasing. I had started to apply my ideas of geometric composition to them and, naturally, the result was somewhat severe. Between the great fantasy and freedom typical of the Futurist era and the discipline I now desired, it was difficult to render a correct middle ground right away. Nevertheless, the exhibition taken as a whole had a

[3]This testimony is not a matter of time or place; presumptuous people and those with low intelligence quotas exist in all times and places.

very personal character and showed a clear position, something generally acknowledged by the other artists.

Francis Carco came to see it and was so disconcerted that he told me: "I'd like to write something about these works of yours, but quite frankly, I'm very embarrassed because I don't understand them." I replied, "That's simple; don't write anything." He took my advice without, of course, ruining our friendship. Maurice Raynal, the gallery's secretary, felt obliged to write an article, which was published in *S.I.C.* It was one of those sweet-sour articles of his, which made it difficult to gauge whether he approved. In any case, he accused me of a "charming monotony" and especially of a slight abuse of rhyme. "I see perhaps too many sonnets and Parnassian Alexandrines in your work," he wrote, and deep down I was very pleased that he had recognized my symmetries and geometric equivalencies, because that meant that my intentions were beginning to show in my work, even if he failed to penetrate their meanings.

Maurice Raynal was one of our old friends with whom we used to dine in Montmartre at the little restaurant beneath Gris' studio. He had followed the development of our painting, step by step, and therefore was an intelligent and well-informed witness, but, I am afraid, little more. Each of us has surely experienced a long-term friendship with someone with whom we almost always agree because we need only a few key words about certain topics, the rest being implied, and never delve into matters deeply. The day on which that happens, we are both surprised that we do not agree at all. Perhaps that was the case of my relationship with Raynal, but it is inevitable and does not hinder friendship.

During my show Maurice Raynal gave a lecture called "Quelques Intentions du Cubisme," to which we were not invited, at a social club at the house of one Monsieur Fich. His text was later published in the *Bulletin de l'Effort Moderne*. The conference was meant to have more of a philosophical than critical tone and strongly defended the "sensation" that art was more a way of "knowing" than a way of doing.[4] Kant and Hegel were called upon to back up an idealistic concept of reality that would have turned all of Cubism into Apollinaire's scientific or conceptual Cubism, while instinctive, or lyrical, Cubism, imparted by Futurism in general and by me in particular, gained instead increasing importance

[4]This was partially justified by a few works by Picasso and, in general, by pre-war Cubism. Raynal, back from the Front, perhaps did not sufficiently feel how much the situation had changed.

and homogeneity to pre-war Cubism, so that Raynal himself was also obliged to cite the intuition of Bergson.

In short, the conference reflected, as in a mirror image, the ideas and intentions of that time, but in a rather approximate fashion. We were all dissatisfied with the phrase used as a sort of conclusion: "Remember only that Cubism is just an attempt at a new annotation open to further perfecting." To the Cubists of that moment, even if in a rather unclear and imprecise way, Cubism was already much more than a notation; without being an esoteric religion, such as Rosenberg would have made it, it was already a way of conceiving art which embraced the past, present, and future. And perhaps, it had already become tradition itself, *brought to life*.

I feel it my duty, in passing, to point out an attempt made at that time by our friend André Salmon to loosen the dealers' hold over the artists. He may have already felt the serious danger that such a gradually tightening hold constituted for art. The fact remains that he had been assigned by the famous publishing house, Georges Crès, to create a sort of gallery in its new office space at 21 rue de la Hautefeuille, in which those artists considered interesting could freely exhibit their work, without any direct interest on the gallery's part. It was, in other words, a sort of society, club, or community house for artists, where they would be welcome guests. Plans also included exhibits in foreign lands. Salmon's initiative and Crès' generosity in executing this project met with the approval of the majority of the artists, but not of the dealers.

As was predictable, Rosenberg countered immediately. He sent us all his usual form-letter, from which comes the following excerpt: "Dear friend, I would like to inform you that, due to the spirit and the letter circulated by Monsieur André Salmon to the artists friendly to the "G.E.M." (Galerie de l'Effort Moderne), I have decided to indefinitely postpone the matinée dedicated to said journalist scheduled to be held here, and that the G.E.M. is also suspending him for the period of one year; consequently, he will no longer collaborate with any of the Gallery's future publications." For a certain period the poets' and writers' Sunday reunions were dedicated to one or another of the authors friendly to the gallery, and the next one on the schedule was to be a matinée dedicated to Salmon. Once again, such a reaction revealed the essential nature of Rosenberg's personality, which was perfectly in tune with the style of the Paris art market dictators. Despite our rejection of Salmon's and Crès' invitation, the gallery nevertheless opened with a good show by Derain, Vlaminck, Friesz, Dufy, and the sculptor Archipenko, and had a solid moral and financial success.

The Sunday reunions at the Effort Moderne continued in the absence of Salmon, but at one of these, I forget which one, a violent discussion exploded, profoundly irritating Rosenberg. Paul Dermée proposed a confrontation, in conference form, of the similarities between modern poetry and writings collected in mental institutions, a bad idea which he would immediately regret, for everyone reacted vehemently against him. I think that this was the final Sunday literary reunion at the Effort Moderne.

At that time Roger Allard was publishing a small periodical, *Le Nouveau Spectateur*; he thoroughly enjoyed himself, and could wittily say whatever he pleased to anyone. He unfailingly reported the incident, in the following terms: "Messieurs Max Jacob and Reverdy were shocked at a recent conference by Paul Dermée at which he compared the literature written by his friends to that of the insane. The author of *Beautés de 1918* went to great lengths not to tinge his comparison with malice, all in honor of the new spirit, or so he thought. But his mistake was pointed out to him, and at the same time such meager esteem as was accorded to his talent. Such adventures only happen to those teeming with convictions."

In the same issue of *Nouveau Spectateur*, Roger Allard, who was quite a good friend of mine, did not exclude a criticism of me, too: "Here is a show," he wrote, "where you mustn't linger too long if you intend to retain the first moment's pleasant impression." Later he says, "Monsieur Gino Severini sometimes seems tempted by the recollection of his Futurist period, and a certain large figure of a seated woman is reminiscent of his *Pan-Pan à Monico*." After having manifested the hope of a Futurist and Cubist retrospective show, he observed that in these most recent works of mine, he found a calculated leanness; to him this constituted an aesthetic of the waxed canvas and of "Ripolin"* and he avowed that my true nature was worthy of better.

This critique affirmed my increasing lack of success. It is strange how certain reservations or disapproval by even intelligent critics can gratify an artist who knows what he wants and how he wants to obtain it. The fact was, at that time, that I wanted to simplify forms to such an extent that they would almost be impersonal, and could be created almost mechanically, as with oilcloth.

It is also amusing to watch critics argue among themselves over ideas that, basically, are more relevant to us than to them. When the brochure on Raynal's lecture was published, Salmon praised it in an article in *Europe Nouvelle* (2 August 1919). He courteously lamented that a poet-

*Brand of enamel paint.

critic such as Roger Allard could turn his back on friends next to whom he had fought for a mutual cause, and that he was preparing, for *Nouveau Spectateur* as a reaction to the new spirit, laws of a more docile neo-classicism.

The reply that Allard published in his *Nouveau Spectateur*, imbued with refined irony, making a correct distinction between neo-classicism and classical tendencies, was worth the reading. It is certain that Roger Allard was never friendly to extremist tendencies. The Cubism acceptable to him was moderated Cubism, that of Luc-Albert Moreau, La Fresnaye, de Segonzac, Marchand, reaching as far as Dufy. Nevertheless, he respected and understood "quality" in whatever form and could find it wherever present. What he found indigestible was Metzinger's non-Euclidean geometry and, in short, all the aestheticisms more or less philosophically justified, all bluffs, all the processes contrived to create innovations, ostentation, and a modernity more apparent than actual. These were all factors that later facilitated the establishment of a sort of academy of extravagance, whose first symptoms were already present in exhibits in Paris. This does not mean that Roger Allard's prejudice against these attitudes was perhaps less justified (considering the times) than the opposite prejudice adopted by André Salmon.

Meanwhile, I peacefully continued my studies of geometry and mathematics, together with other purely technical research. Having by now learned the painting techniques of the ancient masters, especially Van Eyck and the Venetian school, I devoted my time to preparing paints with resins and turpentine, and was intent on learning properly, from an expert gilder, how to prepare a panel with plaster and glue.

Having become quite accomplished at using conjugated orthogonal projections, one day I gave Raoul Bricard, my professor, a large drawing of a vertical and horizontal projection of a human head and torso. Next to the full-face and profile projections, I had drawn the same projection on a horizontal plane to which I had imposed a 25-degree rotation, one to the right and one to the left. Accomplishing the consequent operation on a vertical plane, my figure was three-quarters turned, and full of life. My professor was completely amazed and enthusiastic and said quite frankly: "I taught you these things just to appease you, but thought that it was a matter of an artist's peculiarity, not that you would put them to use." The most amusing part was that I was surprised by this too. It was a bit like a doll manufacturer who, all of a sudden, sees one of his creations jump up, walk, and talk; Geppetto, the carpenter, who feels his wig being pulled by Pinocchio, while he is still in the act of carving him. In fact, the

expression of life that springs out of certain forms is extraordinary. These are the ones conceived exclusively in our souls, and from pure geometry they pass to an even more distant imitation of reality. They provoke intense, vivacious emotions. I then began to understand how certain great masters of the past, the Greeks for example, were able to construct according to numbers or geometric shapes, and thereby to express life.

While aware of the immense danger of such notions and knowing that art, as such, is something else, it nevertheless seemed to me that vast horizons were opening up before me. I hoped to extend the application of certain harmonic relationships even further and managed to establish a certain analogy with harmonic musical relationships. This came to me through Theognis of Smyrna's skilled essay on Plato[5] and through Leonardo's book on mechanics.[6]

But, if for linear composition the problem seemed relatively simple— since the chord Do Fa La is equal to 3,4,5 and can be perfectly expressed geometrically by the Egyptian triangle, whose sides are equal to 3,4,5— as far as color was concerned, everything became terribly complicated and difficult. You must remember that mixing or juxtaposing the colors of the spectrum and mixing or juxtaposing powdered colors (or pigments) are two essentially different things; the former *emit* light while the latter absorb all the rays of light, except that of color considered in terms of experience, whose light is also emitted or radiated. I was not able to find any seriously scientific theories referring to what I wanted to learn (a desire certainly not unique to me); therefore, I had to proceed by conventional approximations.

I had the idea of asking the only man in Paris who could give me the proper information, Charles Henry, who had supported the Neo-Impressionists with his science and continued his research and lessons at the Sorbonne's Physiological Laboratory of Sensations, which he directed. I managed to be introduced to him and he found my ideas interesting. I hoped to bind the matter of line, color and light to scientifically established harmonic relationships. He did not hide the difficulties I would encounter and meanwhile gave me a book of his, *Le Cercle Chromatique*, to study, and another work of his on the law of simultaneous

[5]Théone de Smyrna, Philosophe Platonicien, *Exposition des Connaissances Mathématiques Utiles pour la Lecture de Platone*, trans. into French by J. Drepins (Paris, 1892).

[6]In this book the well-known law is expressed: "Soundwaves and lightwaves are regulated by the same law of mechanics as waterwaves: the angle of incidence is equal to the angle of reflection."

contrasts. I learned many important things from these (such as the *direction* of colors) which the ancients had not been able to utilize and which greatly enriched my store of useful notions.

Having left Paris and gone to the country, I sent him some theoretical fundamentals that I had conventionally established, and he immediately replied: "The correspondence between colors that you have transcribed on the enclosed sheet makes no sense, scientifically speaking; the colors are characterized by certain bands or λ that should be indicated, and the relationships between the various colors thus defined are very different from the relationships of numbers of vibrations of the diatonic range. I cannot encourage you enough to research such matters in depth: one or two years of mathematical preparation, two years of preparation in physics and biology should suffice. But these are necessary." After having insisted again on the study of mathematics, he concluded: "You will immediately be able to resolve a quantity of problems that interest you, *on your own*: and this is the result that you must attain."

I was, therefore, to continue along my appointed path, adding biology and physics to the bulk of my studies. The immediate result of my contact with Charles Henry was a scientific notion of rhythm, based on rhythmic numbers that mark rhythmic sectors of circumferences. This formula of rhythmic numbers, being common to all sensations, could be applied to musical harmonies as to harmonics of color and form.

In fact, Charles Henry had invented and built an "aesthetic protractor" and a triple aesthetic decimeter by which it was possible to establish rhythmic angles and ratios of length, but these two instruments had already disappeared from the market and had to be consulted at the Sorbonne Library. Besides, to use them effectively, a certain mastery of mathematics was necessary. As Charles Henry had told me, the farther I went in my studies of that science, the more problems would be resolved by themselves, so to speak, that without mathematical reasoning, I would not have even considered. One consequence of these studies was that I began to question myself seriously about the value of positivist and idealistic dogmatic truths on which, for the most part, the construction of my interior world was based. The history of mathematics, from the Greeks on, suggested many reflections that were slowly maturing in me.

Unfortunately, the more passionate I became in my studies, the less I worked, and I found myself in a curious position in relation to Rosenberg. Under contract, according to which everything I produced belonged to him, he often complained because I did not bring him a sufficient number of paintings. It should be noted that he probably reprimanded my

colleagues at the Effort Moderne for the opposite reason. With this system, I condemned my family to poverty while I could have provided them with a certain well-being; moreover, it required enormous efforts on my part, with a state of health that was over-delicate. Nonetheless, we survived and I was happy to fill my paintings of the moment with an order, a measure, and a conscience that had only been possible by virtue of the studies undertaken.

I would sometimes talk to Rosenberg (he would bring up the subject) about Plato's or Pythagoras' mathematics, and this never fell on deaf ears, for he was always ready and willing to look at art and at Cubism from the point of view of esoterics. I recall, around this time (that is, summer-fall of 1919), one of his famous letters addressed to Léger that was sent to all of the G.E.M. artists (when Rosenberg wrote his "eternal maxims" or some severe reprimand to one of his painters or sculptors, he would send it to everyone as if it were a confidential message). Léger had probably complained that our dealer had not offered his support in a sufficiently arduous manner, for the letter began: "Dear Léger, your letter, phrased in friendly terms which I greatly appreciate, reminds me of one sent by a woman whom I dearly loved 18 years ago or so. Since my linguistics were not ardent enough and I did not cry out in high shrieks, she accused me of not loving her and of preferring one of her rivals. Like you, she wanted to be loved 'overmuch.' Calm down. I love your painting, but not so much for its actual state, as for what it promises."

This time the letter was particularly lengthy; it told of the various races and subspecies of races that supplanted one another through French history, furnishing great men such as Vercingetorix, Jean-Bart, Clémenceau, Gambetta, etc., but I will only quote the following excerpt which refers to that aforementioned esoteric religiosity: "You tell me that you are currently immersed in the reading of works by Stendhal, Balzac, and Dostoievsky. They are undoubtedly interesting authors, but how insignificant are their books next to the one I am reading for the one-hundredth time, the Bible. This is not a book, but 'the Book' as its name, 'Biblios' indicates, not unreasonably: the book of Genesis, David's Psalms, the Hymn of Hymns, etc. As such, it is gigantic and of unequaled poetry. To you, who loves the grandiose, I would recommend the frequent reading and rereading of this monumental work."

Those who knew Léger, even by sight, with his tall, heavy Norman physique, an extraordinarily astute man of serious but craftsmanlike intelligence, intolerant of morals, could just picture him with a Holy Bible in hand, devoting himself to the reading and rereading of it before and

after having dedicated himself to his "tubes," as they said about him in Montparnasse.

We had always found Rosenberg's confidential messages amusing, but they often poisoned our lives too. True, certain grotesque matters were part of his psychological structure, he would mention them seriously, and was passionate about them. He actually did envision Cubism as the basis of Plato's *Republic* or Pythagoras' *Rules*; or, to the contrary, as ignoble merchandising. In one of his articles in *L'Esprit Nouveau* (issue no. 5 , I think) he defined Cubism in this esoteric manner: "Cubism is the expedition to a star. That is, after four centuries of empiricism, the prospect of an imminent return to initiation."

I got along well with my Cubist friends, but my ideas coincided with those of Gris, especially where we considered transferring the intuitions we reached during the early stages of Cubism, and still fundamental to many a valid work, into the area of serious geometry and mathematics. These intuitions opened a vast horizon, touching even hyperspace created by four-dimensional geometry. The trouble was that many artists had little knowledge of plane or spatial geometry, of which the geometry of hyperspace is the so-called prolongation. The only correlation that, for the moment, could be found between Cubist painting and the new geometry consisted in the fact that a painting was considered a *space* divisible into several spaces. Each of these spaces was destined to a particular category of sensations and emotions so as to avoid confusion among them of the various aspects represented. For example, the local color of an object or its actual matter or its interior form could not be placed in the same space destined to the *conceived* form of that object. Intending to express it as completely as possible, the object was to be represented as discerned by the painter's eye, as *sensitive reality*, and as received by his *mind*: visual reality and conceptual reality could not occupy the same space. The various spaces of a painting thus partitioned allowed us the possibility of paraphrasing, of exalting the object, of repeating it frontally and laterally, like the musical phraseology of Gregorian chants.

Both visual and conceptual realities have been expressed by artists painting throughout history and in all geographical locations, by syntheses formulated spontaneously in their souls, and with varying degrees of lyricism. But Cubist painting differed from painting of the past (with the exception of that of the Neo-Impressionists) in that its aspiration toward order was not only aesthetic but also scientific, and furthermore, was only one of many such historical examples. All of this was suggested to us primarily by that contemporary state of mathematical and mechani-

cal civilization, the era of wireless telegraphs and innumerable inventions in the field of physics, in which a new world can be constructed, whose phenomena can be situated in four-dimensional or N-dimensional space.

Nevertheless, paintings remained basically plane surfaces in which, however, the play of form and color really could suggest a more elevated concept of space. Besides, these painters' techniques, as intuitive as they may have been, were not lacking in comparisons and miraculous contacts with the principles of four-dimensional geometry.

The whole play of rotation around an axis or around a plane, which is the basis of the Cubist system, discovered fixed rules in this new geometry; however, at least for the time being, these are probably inapplicable to painting. Furthermore, the painter's fantasy, intervening in the work at a given moment, conciliates the whole, using conceived forms and visual forms (which are always poetically interpreted), to achieve a *dynamism* exemplified by certain Futurist works that I was unable to forget and which Picasso kept marvelously in his mind's eye. They were compositions expressing a synthesis between the conceptual and the visual that were realized in our own terms, that is, in a modern fashion. It was hoped that these would improve with time and with the process of maturity that it inevitably generated.[7]

Now that Apollinaire was dead, only Gris and his mistress, Josette, came to lunch or dinner at our little rue Sophie Germain apartment, and we to theirs in Montmartre, on rue Ravignan.

Picasso was seen less frequently. He had taken a luxurious, bourgeois apartment in the dealers' neighborhood on rue de la Boétie, almost directly above Paul Rosenberg's gallery, which had a quasi-exclusivity on his works. It was rumored that his wife pushed him, as far as this was possible with a man like Picasso, into certain high-society circles. Actually, when paying him a visit, the door would be opened by a maid in a white apron, then one would be shown to the floor above, to another apartment where he worked. This, however, was wholly impregnated with a typically Picassian atmosphere. The vast apartment was empty of furniture but full of canvases, much like his former Montrouge villa. These were stacked in every room, rarely touched by the maid's routine dusting. Picasso had used many of the motifs of his richly decorated

[7]Although this book of memoirs makes no pretence of being a compendium of theories, I must resume, albeit summarily, the theoretical attitudes in order to give a precise idea of the practices embraced by certain artists of the moment.

apartment, rife with Rococo capitals used in fireplaces and beautiful gilded mirrors, in his Cubist and non-Cubist paintings, always transforming them into poetry. Other friends often met at his house, for, even if his lifestyle had changed with his marriage and financial success, he would still see his friends and was still the same old Picasso of Place Pigalle, the Ermitage, etc. Perhaps he was more serene. In any case, his presence imparted an atmosphere of calm.

Braque, on the contrary, stayed at rue Costantin Pecqueur in Montmartre, not far from rue Cortot where Reverdy published his review, *Nord-Sud*. Braque exercised a sort of spiritual influence over that publication: two drawings of his and several of his axioms about art were published in it, as I recall. He was the only painter to contribute to that review.

Surrealism

FROM MY ACCOUNTS of Dada, it is easy to see that the artists and writers of this movement continued to exchange and discuss their ideas, and shared many opinions. For instance, they agreed about disapproving and opposing (theoretically, for the moment) anything belonging to or coming from governmental bureaucracy and that constituted the body of social activity; in this there were no distinctions between the bourgeoisie, the proletariat, and the class of self-employed professionals. I felt that society was becoming increasingly complicated, deteriorating each day, but did not understand such hatred for current convictions, which were relatively unimportant in any case, and non-existent from an artist's point of view. Our solid bonds to galleries contributed to such an outlook.

While it was not my intention to actually critique poetry and literature, my conversations with Gustave Kahn, Paul Fort, Stuart Merrill, etc., held principally at the Closerie, informed me about the ideas of Jules Laforgue, about his particular linguistics and especially about his self-proclamation as the creator of free verse, rather than Gustave Kahn, as Marinetti had insisted. It was extremely important to understand that in painting we lagged thirty years behind. Those writers and poets adhering to Breton's 1st and 2nd Manifestos directly followed in the footsteps of Rimbaud, Laforgue, Verlaine (also very familiar to us), and concealed with varying degrees of irony and humor that sense of mystery which they had not contemplated, having misunderstood the self-edification bursting from *Les Illuminations*. Perhaps the consequent disorder and misunderstandings derived from a poor interpretation of the likes of Rimbaud, Laforgue, Mallarmé, etc., that furnished words, signs, and images with somewhat erroneous meanings. André Breton, probably expecting to continue and develop Dada and to clarify its mystery regarding spiritual life, envisaged the same association of painters to Surrealism that Marinetti had accomplished with Futurism, but this did not engender another *Saison en Enfer*.

The following artists adhered to the *Le Surrealisme et la Peinture Manifesto*, at least along general lines: Max Ernst, De Chirico, Miró, Arp,

Picabia, Man Ray, Yves Tanguy, Masson, Braque, Picasso. The manifesto
was published in 1928 and it was my impression that Picasso's and espe-
cially Braque's adhesions were, more than anything else, acts of solidarity.

I aided and abetted De Chirico's trip to Paris. After lunch one day,
André Breton paid a visit to my new rue Ernest Cresson studio. The
sculptor Lipchitz was there already. Breton immediately asked me if I
knew De Chirico, my opinion of him, and if I had his address in Rome. I
knew him, of course, considered him a highly intelligent, creatively valid
artist, and gave Breton his Rome address. Breton was grateful and told me
frankly that several reproductions he had seen of De Chirico's works were
admirable expressions of his own idea of a new, Surrealist pictorial drift.

As a friend of De Chirico, I did not offer him my opinion, but Lipchitz
violently attacked Breton's ideas, calling them "literary," illustrational
and untimely, since an important nucleus of the Effort Moderne group
was working to return painting to its ancient technical splendor. I, too,
exaggerated in this sense, having studied mathematics for two years, the
very subject that, years earlier in Cortona, had procured me expulsion
from every school in Italy.

Privately, I agreed with Lipchitz, but did not want to put De Chirico in
a bad light. The latter's painting, more or less related to that of Böcklin
(whose pupil he had been), to the fantasy of the Ferrara school and to that
of Hieronymus Bosch, was, in my opinion, particularly interesting. Evi-
dently the two of them were unable to reach an agreement and nothing
ever came of their discussions, but the incident served as a vehicle to
inform me of Breton's intentions.

I do not know whether Breton contacted De Chirico directly, but seem
to recall that Rosenberg decided on a trip to Italy with Léger and his wife
that same summer. He asked if I knew any interesting painters in Italy
and I gave him the following names, in my opinion the most valid: Carrà
in Milan, Soffici in Florence, De Chirico in Rome. He missed Carrà and
Soffici, both away on summer vacation, but he did find De Chirico, busy
with his salted herrings and boxed crackers, animating architectonic fan-
tasies. Rosenberg thought him interesting. He bought several of his works
and began maneuvers to bring him to Paris, where one fine day, we found
him in our group of friends. Thus began De Chirico's new life in Paris. He
became a master of Surrealist painting. I believe that it was he who gave
this tendency its impetus, all the while under contract to Rosenberg.

The Surrealist group comprised a separate clique despite an excellent
sense of comradeship between us. Other names were added to the group,
for example, Paul Eluard and Michel Leiris, Soupault, Robert Desnos,

Cocteau, and others. A journal was founded in 1925, *La Révolution Sur-réaliste*. Later, in 1930 as I recall, another appeared, *Le Surréalisme au service de la Révolution*. But those reviews published few issues and were not sold to the public. They could be procured only through friendship and connections. There were also special editions, such as Dali's "La Femme Visible," which caused a scandal, just what the Surrealists craved.

Nevertheless, this desire, expressed with various words whose meanings the adherents did not properly understand such as *freedom of spirit*, the *unconscious*, *magic*, etc., revealed a strong intention to discover a world beyond that of the senses, earning them the respect and friendship of the intellectuals and artists, uncomfortable in the world of *real things*.

On the other hand, we felt that our Cartesian, Bergsonian, etc., world was no longer entirely pertinent to the true creators of art and of poetry. The Northern artists had perhaps unwittingly brought Heidegger's theories to Paris, introducing a new idea of objective truth. Husserl's idealism, which transformed our spontaneity into the creation of objects or essences, led to spontaneous abstraction which was not really a *productive act*, to an abstraction that was meaningless in terms of creativity. Pure abstraction, wholly insignificant as an idealogy and creation, derived from this. I think that Phenomenology provided the vacuous, negative atmosphere surrounding the Surrealists, against which they were struggling.

We, of the Effort Moderne, understood certain ideas and boiled them down to a desire which we, too, shared for an ultrasensitive world, and also a desire to reconcile instinct and reason, things and being. However, our realist background drove us to search for notions of true métier, pushing toward forms we could create to mirror *life* and not the exceptional fantasies exemplified throughout history by such artists as Dürer, Bracelli, Bosch, etc.

As you can see, a philosopher would probably be better at explaining this aesthetic trend than a Futurist painter, especially since my attempts at plastic dynamism had become aspirations to poetry, the consummate ambition of any artist. Many publications on Surrealism are very thorough, such as Marcel Raymond's book, *De Baudelaire au Surrealisme*. Who better than the Surrealists themselves to furnish definitions? When the second Manifesto was released, it was prefaced by the following declaration:

Deeming that colossal abortion of the Hegelian system our point of departure, Surrealism strives toward nothing but the outer limit where contradictions cease to be perceived. Just as the idea of love tends to create a being,

as the idea of Revolution tends to hasten the onset of such a Revolution (were this not to happen, all these ideas would be senseless), we want it remembered that the idea of Surrealism tends to totally recuperate our psychic energy by means of what is only a dizzying descent into ourselves, the systematic illumination of secret, unknown places, and the progressive obscuring of other places, the perpetual stroll through altogether prohibited areas; there is no serious danger that such a pattern of activity will come to an end until Man is capable of distinguishing an animal from fire or from a stone.

The *First Surrealist Manifesto* allowed us to shed spiritual light onto this nighttime of the eye, constant prisoner of the tricks of vision.

The same introduction also claimed: "The *Second Manifesto* offers every guarantee for appreciating what is spent and what is more than ever alive in Surrealism." It is impossible to be clearer than that about its intentions and theories. However, how the Surrealists actually reacted to the ideas of Marx, Engels, Heidegger, Husserl, etc., that were sweeping the entire planet, poisoning it, and how they actually discovered a way to harmonize the contradictions so abundant in Dada and Surrealism, needs examining.

True, the two Surrealist manifestos were serious documents as far as ideas, intentions, and style were concerned. But it is also certain that their little periodicals were much less interesting, and many reservations could be voiced about their pictorial accomplishments, above all about the sadistic and sexual aspects that have now become obsessive. (It is not my intention to write history nor even less a critique, but simply to chronicle as precisely as possible what was actually happening at the time, especially in the artworld. I will leave it to those more competent than I to delve into these problems, but do guarantee the precision and authenticity of my statements.)

Returning to the discussion of Breton's theories, I can say that they hardly met with any serious opposition at all. The artists in general felt the personal need to look inward, to escape from the tyranny of life and the meditation of theories. Generally speaking, their defense of the *unconscious* aroused a great deal of debate; they alluded to that automatic *unconscious*, an idea of Freud. Had they spoken of the *spiritual unconscious of the human soul*, their defense of spiritual freedom would also have assumed quite different character and direction. Besides, this was especially related to their desire for an *absolute*, while nevertheless recognizing it as unattainable. Even Laforgue had proclaimed: "Everything is

relative." Valéry confirmed this attitude in his works and ideas. And it was often remarked that proclaiming absolute freedom of the spirit while associating with communism, which was the negation of freedom, was not compatible with art and poetry.

Thinking back on Rimbaud, who had deeply influenced our youth, we thought it no longer necessary to poison our souls, to make them storehouses of all vice, rendering them monstrous and turning ourselves into good-for-nothings, drunks, opium addicts, or pretending to be insane, in order to become poets. We all thought such attitudes passé. Instead, Surrealism returned them all to the foreground and even today (1965) we have writers/poets who cannot write, painters who cannot paint, unless they are full of mescaline. In short, a kind of sect emerged, sustained by sadism and manic sexuality pushed so far past just limits by some, that several decades later, sex has become a subject taught in schools and a social evil discussed at length even in Catholic periodicals.

Jean Cocteau, perhaps unintentionally, furnished great impetus to this Surrealist spirit, for he had always wanted to belong to an avant-garde bohemia which he considered the seat of true values. But, coming from a rich, middle-class family, he had a genteel concept of *la vie bohème*, one dressed in white gloves (ours was gloveless and often poorly clad). So he introduced some real ladies into the avant-garde circle, countesses, princesses, as well as actresses, male and female high-fashion designers, brilliant demi-mondaines, a group later called "le tout Paris" whose importance was, above all, in notoriety. I knew few of these people, but often met the famous designer, Paul Poiret, an intelligent, stimulating man who, by virtue of associating with painters, began to paint one fine day himself, unfortunately with rather futile results.

Another incoherent Surrealist endeavor was to print phrases of the following nature in their *First Manifesto*: "It was more or less the end of pipes, newspapers that are not even tomorrow's editions, of guitars, etc.," at a time when especially Picasso and Braque were subjecting such everyday objects to their pictorial scrutiny. With plastic dynamism as their objective, the Futurists had already shown other subjects gleaned from real life that lent themselves to poetry, but no one thought to mention this fact. Evidently the 1910 concept of art had been revived. "Chauvinism!" Boccioni would have said. But I, better acquainted with this predominantly literary world, saw the ideas that generated the moral revolution of Rimbaud, of Young and Jarry, of Verlaine, etc., still strong and vibrant in them.

I considered their desire to deepen their sources of inspiration sincere.

Meanwhile what emerged was Sadism, Dreams, Eroticism, Magic, and finally, Freudian automatism, without taking into account Blake's statement about artists who, when in the clutches of dizzying creativity, are so immersed in their subjects that they cease to be alone, even if unaware of the fact. They are in the company of another who is performing. This explains the phrase written by Rimbaud in a letter to Izambard: "I *is* another" (Je *est* un autre). Their pride prevented them from realizing that it was their souls, divinely inspired, that helped them to *create*, imitating that which only God can achieve. Rimbaud was not a victim of his own pride, since he wrote in the same letter: "More's the pity for the wood that discovers itself transformed into a violin."

In short, we in Paris were divided between the *rational* and the *instinctive*, and it was difficult to establish a unification of the two. The Surrealists misunderstood Rimbaud, so they attempted to work by instinct alone; however, theirs was often a willed, rational instinct and therefore without creative validity. So, as I said, their Freud-rooted automatism was all too often provoked and simulated, and very detrimental to their works. Such an aesthetic posture was also related to an inclination for jokes and pranks that had initially spurred their poetic activity, and was willfully deprived of that intelligible meaning that established a contact with the universe of intuition; thus their poetry lost its *indicative* function and any likelihood, except for its snob value, of being a means of communication. The result was an unintelligible sort of poetry, like painting whose meaning is incomprehensible; snobs loved it, while the artists turned it into law, thereby causing a widespread disappearance of art and poetry.

Raïssa Maritain correctly says that "logical meaning cannot be required in poetry itself in the name of rational clarity, but that logical nonsense, voluntarily and systematically imposed, is incompatible with poetry." In other words, if a poem or a painting is naturally obscure and difficult to understand, this has no bearing on its validity, but if such obscurity and insignificance are calculated and created on purpose, the work becomes entirely worthless. Also, the Surrealists failed to account for the example of Paul Valéry. "The unknown to which we aspire can only be reached after the known (and much suffering of the soul)," says Marcel Raymond. "Images, it has been said, are nothing but the magical form of the principle of identity."[1]

[1] Pierre Guisguen, in *Nouvelles Littéraires*, 1 June 1929.

Nevertheless, I evaluated the Surrealists' experimentation, even if some-times debatable, as a sincere and desperate attempt to infuse the present with that absolute innocence of primitives and with the purest form of instinct. Unfortunately, in the realization of their various ambitions, in-spired by a sort of misconstrued phenomenology, they intentionally set out in the opposite direction from poetical works. By force of convolu-tions of conscience, they created their own trap, in which poetry, sepa-rated from its own finalities, became a scientific means, a metaphysical method. Thus they confused poetry with metaphysics and morals. They destroyed poetry's power of seduction with their extravagant strategies. In short, it seems to me that Surrealism was more interesting in its intentions than in its results. This is not to say that the representatives of this move-ment were not remarkable artists and poets, but without the paintings of Max Ernst and the poetry of Breton, the Surrealist creative yield would have been conspicuously limited.

They found it very amusing to use linguistics as an instrument of one's own physiological individuality, turning it into poetic language, and in many cases, they turned art, poetry, nature, freedom, life into nothing more than jokes, pranks. Everything suffered from that nihilistic ontology that is a non-Latin philosophy, one of desperation and pessimism. Nature was denied and destroyed, and with it, poetry and art. Thus, a drama of incalculable duration was engendered by a joke. The thirst for a better world resulted in absolute nothingness.

They achieved their passionately desired Freedom, but unfortunately, as Gide said, "Art is achieved by restraint, not by creating slack." And po-etic intuition, essential to any creation, is nothing more than *"perceiving both things and characteristics together,* by means of existential emo-tion," in Maritain's words.

The Surrealists did not understand these things, for, with so many in-teresting dreams and problems, they only managed to provoke disorder and nullity. Not that they alone were responsible for the "Deluge of 1965" which has been destroying art in general and all forms of creativity for at least the last fifty years, but they made a considerable contribution.

VALORI PLASTICI AND METAPHYSICAL PAINTING

While in Paris painters have tried to grasp, specify and express in their own works and according to their own abilities, that classical tendency dear to

Cézanne, in Italy the artists grouped around the review, *Valori Plastici*, were striving toward similar objectives. Mario Broglio, whom I had met in Paris in 1913 when he was still little more than a youth, had organized this movement. Broglio was a highly refined, intelligent man and a rather good painter. His Achilles heel as a painter was probably his priorities; he was concerned *first* with making money, *then* with painting, like his close friend Efisio Oppo who managed to become a member of the academy under the Fascist dictatorship before realizing his talent as a painter.

Some of those "painters" were like the eternal fiancés who wait for many years to get married, until they have earned enough money; when they finally amass a comfortable sum, love has paled and the two intended spouses are like strangers to one another. Art is like love, it must be practiced while red-hot and not once it has cooled. I say this to explain that Mario Broglio's virtues, rather than being elements in his paintings, were the taste and intelligence he put into his publications. With *Valori Plastici*, the review that he directed, he managed to create a movement in Italy of the country's best possible talents.

Broglio envisioned his magazine under the hallmark of the exciting Parisian artistic furor, whose most courageous and well-balanced representative was the Effort Moderne group. So he wrote asking me to collect material, reproductions, and essays by Parisian painters, sculptors, and poets, for one of the initial issues of his review. I discussed this with Rosenberg and, despite what had happened with Crès, with André Salmon, he accepted the task of compiling the issue. Rosenberg wanted to do a sort of introduction, in letter form, of his ten Cubists, reproducing their works and printing their reflections or "eternal maxims." But the real artistic introduction, not limited to us alone, composed basically to exalt the faculty of painting (in fact it was titled "To Paint") was by Salmon, in verse, full of spirit and poetical refinements:

Painting, it is wonderful!
To paint a rose with animal blood
And the sun
With a terrestrial lemon and its vegetal juices.

And to each of us was dedicated a poetical introduction, such as:

Comparing Nungesser's terrible flight
With Picasso's boundless works
And notice a promise of infinity
In this oval and deliberate bouquet by Severini

A pink kiosk by Dufy
Suffices
To hide what is marvelous, the honey of paradise.

There were also poems by Cocteau, Max Jacob, Paul Dermée, Pierre Albert-Birot, Blaise Cendrars, André Breton, Philippe Soupault, and Louis Aragon. All this appeared in the second issue of *Valori Plastici*, published in February-March 1919.

I do not know how it was received by artists in general, but Broglio was very pleased with it. Since he was well aware that we had scarce common ground for agreement, he wrote me many long, long letters in which he intelligently defended so-called metaphysical painting. But the very fact of slapping such an adjective on painting was nonsense, rubbish, and I, obstinate about clarity and coherence as I was then, found it intolerable. I said that only someone ignorant of the meanings of those words could put two such together, as all painting is *metaphysical* or else is only the coloring of doors. Therefore, to define painting as metaphysical was absurd. It was just a continuation of Boccioni's and Carrà's Futurist approximations, their attempts to distinguish between objective and subjective, between internal and external, between absolute dynamism and relative dynamism, and so forth.

The significance of that altogether dubious attitude, advocated by my friends, was revealed to me as I read the ideas and general essays that appeared in subsequent issues of the review, signed by De Chirico, Melli, Broglio, Soffici, and especially by Savinio, who was, more or less, the theoretician of metaphysical painting.

That such a painter as Carrà with his raw, artisan's mentality, could proclaim, under the influence of De Chirico, "Ah, the horrifying Beauty offered by the ascent to arbitrary paradises of the Unique-Almighty," is somewhat surprising, provoking the same effect as a bear sniffing a bouquet of violets, but is only of relative importance. It is quite something else in the case of Savinio, a cultured, intelligent man committed to undertaking nothing less than a "philosophy of art," although he himself declared, "with a more genuine faith than that in Taine's own heart."

It is certainly not my intention, now that so much time has gone by, to undertake a critical (or even polemical) study of the theories of metaphysical painting. But, as certain errors are still active in the minds of some artists and critics, and since these are the continuations of various theoretical Futurist assertions which hindered Italian art instead of helping it, I feel it my duty to point them out, albeit summarily.

The first is that of a scarce evaluation or, rather, of a systematic devaluation of the intellectual, spiritual, and artistic values that are the substance of French art which, along broad traditional lines from Poussin on, is a continuation of Italian art. Savinio wrote: "Analyze the entirety of French art (the same can be said of poetry and literature), and you will see that it is and always will be inevitably naturalistic."[2] Therefore, Fouquet's *Pietà d'Avignon* and his *L'Homme au Verre de Vin* are, in Savinio's opinion, naturalistic works, and the same must be thought of the paintings of Le Nain, Chardin, Poussin, as well as of the Chartres and Reims sculptures, of the fifteenth-century Bourgogne sculptures in stone and wood, to Carpeaux, Ingres, Delacroix, Corot, Cézanne: all petty naturalistic French art; as, too, in poetry, the works of Racine, Baudelaire, as well as those of Rimbaud, Mallarmé, Verlaine, etc.

According to Savinio, there are political reasons that "prohibit France from fathoming spirituality," but it is useless to discuss this for, if France is hampered from grasping spirituality, this is principally by virtue of its "congenital inability." Instead, this "spirituality found, in modern times, its true expansion in Germany." These are the philosophical reasons with which Savinio justified metaphysical painting, as well as his own and his brother's affinities to Böcklin rather than to Cézanne.* This is extremely surprising for a man as erudite as Savinio. There are only two possible answers: either the term "naturalistic" means "transcendental realism" and in this case it is improperly employed, or else the term is used in bad faith or with great ignorance.

By that time (1919), positivism had steadily lost ground among the intellectuals and in France could only count a few, rare partisans in its ranks, in political circles especially, while instead, there was a healthy reaction to materialism and also to German conceptual idealism: a spiritual, philosophical, and metaphysical awakening, grounded on names such as Bergson, Blondel, La Berthonnière. Concurrently, Maritain's new scholastic philosophy steadily acquired importance, constituting a valid opponent to the Northern philosophies which inspired the Surrealists. Hegel's idealism and Kant's pure concept were still dominant in Germany at that time. As for Nietzsche, more poet than philosopher, although artists have always found him attractive, his

[2]These errors are repeated in 1944 in exhibition catalogues such as that of the Galleria del Secolo, with a preface by Bellini, Nov. 1944.

*Savinio and De Chirico were brothers.

influence and importance were not limited simply to the field of philosophy.

Savinio contested the great French spiritualistic currents of our times with the "Neapolitan" (as he called it) philosophy of Vico, Campanella, and Bruno; not a single word was mentioned about Benedetto Croce. A second grave error, in my opinion, was the same one made by the Futurists in 1912–13; they appropriated everything they could from the prevailing artistic tendencies of the moment in Paris, and then bad-mouthed them. In substance, and almost literally, Savinio says that French artists (or those working in France) aspired in vain toward "classicism," for, starting with Cézanne (he too accused of decadence), and by way of Matisse, Derain, or Rousseau, all that they were capable of producing was "the dung that indicates a horse's trail"; true classicism can only be accomplished by De Chirico's horse (with the Parthenon in the background, of course) and by metaphysical painting in general. This is pure polemics and neither a critique nor a history at all. Once again, they wanted to turn a general, universal tendency, conceived in France for particular historical reasons, into a national tendency, thereby seques-tering it into the usual Italian provincialism.

A third serious error, moreover one of an artistic nature, was the search for novelty, originality, and spirituality more in the "subject" than actually inside art, outside of painting and not within it. To them, it was the "subject" that was metaphysical, or more precisely, they demanded that the subject (that is, artistic matter and not art) irradiate a certain metaphysical light, while actually such a light should emanate from art or from paintings themselves.

On this point they opposed the Parisian currents that looked to painting for all innovation and spirituality. Thus it was impossible to talk about metaphysics in theoretical terms, but rather about "metaphysi-cism" or even about classical intellectuality. I suppose that De Chirico realized this and therefore changed courses.

Nevertheless, I have often said that a theoretical system, even an erroneous one, cannot keep the artist from creating valid works of art. That is just the case here, as works by Carrà and De Chirico at that moment were certainly superior to their theories. Carrà, in particular, lent his skillful Lombardian style, which never failed him, to certain paintings from that period, while De Chirico, content to put some color onto a drawing, was gifted with richer fantasy. In spite of this, in my opinion, those works belong to literary poetry and to the genre of

illustration, in its most noble sense, and even for the works themselves, it is better not to judge them on a strictly pictorial basis.

In fact, although these metaphysical painters sometimes talked about such topics superficially, they were not really interested in problems of volume, space, form, composition, rhythm, light. Nor were they interested in Rimbaud's tragic lyricism that so influenced Surrealism, etc. In other words, they had none of those worries that constitute the theoritical and spiritual backbone of painting. The expressive quality of their very own fantastic perspectives and arbitrary shadows was purely literary, and not either pictorial or ultra-sensitive.

For these reasons the movement supported by Mario Broglio's review so intelligently and amorously, had little influence on the artists and was useful, essentially, only to Carrà and to De Chirico.

Death of Modigliani

One early autumn afternoon (1919), I was sitting on the terrasse at the Closerie des Lilas with my wife, when we noticed Modigliani walking by on the far side of the intersection, heading toward boulevard Montparnasse. We called to him and he came over immediately, but declined to sit with us as he was on his way to an appointment nearby. We exchanged updated personal information and I complimented him on his prosperous, healthy appearance. He was wearing a light grey corduroy suit which was almost new, had a lovely scarf tied around his neck, and had had his two missing front teeth replaced. "It's obvious that you're married," I said to him, "and that Coconut doesn't let you go around looking sloppy. Are you happy?" "Je suis très heureux" he replied very seriously, "and am also doing well financially." We shook hands and he left. That was our last encounter.

By that time I rarely went to Montparnasse, first because I was using every scrap of time to study and, second because my health was deteriorating. It was very tiring to paint and to study at the same time, but I did not want to stop, especially since I saw good results every day both in my work and in my inner development, as well as in the contemplation of art and life.

Because the moment to face the conclusions beginning to take hold in my mind and conscience had not yet arrived, and because I intended to reach that moment as a consequence of maturity and an urgent internal need despite all else, I needed to come to terms with great internal

changes that I felt; therefore I could no longer tolerate the weight of responsibility represented by having left my child unchristened. Considering that I came from a family of long-standing Christian, Catholic tradition, my attitude toward Catholicism was rather polemical, consistent with the polemical artistic attitude that I still had not completely outgrown. So, in accord with my wife who has always been close to me both morally as well as physically, I decided to have Gina christened, now that she was a beautiful, florid child with a very keen mind, who even dictated curious little poems in verse and prose to her mother, and made nice Harlequins like her father.

We baptized her in the church at Montrouge and our cousins Robert and Gabrielle Fort were her godparents, even if rather indifferent to matters of religion. In choosing them we felt that we were sanctioning the ties of sincere affection already existing between us.

Rosenberg must have been satisfied with the works I gave him, from all points of view, since he, himself, proposed a new contract overriding the old one; this was called an "avenant." According to this avenant, valid for three years, the price of my canvases was raised from 12 times a point to 15, as of the first of January 1920. This was possibly a strategic move on his part, for Rosenberg must have known that Kahnweiler, a man he had every reason to fear, was back in Paris. In fact, shortly thereafter, Juan Gris switched to the other's gallery.

In December 1919 there had been an interesting exhibit in rue de la Boétie that again harked back to the "Golden Mean." Many good artists not tied to other dealers took part in it, but, naturally, we of the Effort Moderne could not participate, just as we could not take part in the Salon d'Automne or des Indépendants, which were both reopening their doors.

It was at this exhibit that I met Kahnweiler and talked with him at length, but for more than a half an hour, thanks to my deplorable idiosyncrasies, I had not recognized him. He intimated that he would be opening a new gallery, as he actually did a while later, calling it the Galerie Simon. He was sad that all his sacrifices in the name of avant-garde painting— reduced to just a few artists—had resulted in an outright loss to him, and not only financially, since his shop had been impounded and the date of a public auction at Hôtel Drouot was being discussed. His "painters" had moved on to other infatuations. But he was a man due for a comeback.

The event that saddened the vast family of Montparnasse artists and all of Paris was the sudden death of Modigliani. As in the case of Apollinaire, the news spread quickly, but it was already too late to ever see my friend

alive again. So, on a grey, cold, and foggy January morning, I went to
the Charity Hospital to join all the other friends who accompanied his
casket to the cemetery. All of Montparnasse had gathered in that grim
courtyard. I was unable to follow the sad procession for long as I felt very
ill; my emotive state had aggravated the frail health caused by the winter
climate, and I was obliged to return home early. There was no question of
working that day. And that same evening, I think, I heard that there had
been another terrible tragedy: pregnant, our dear "Coconut" had thrown
herself out of a window and had died instantly. For a long, long time
afterward, all the artists suffered profound sorrow, not visibly but in the
depths of their hearts, for the loss of those two beings loved and esteemed
by all of them, indiscriminately.

Many versions of Modigliani's death circulated around Montparnasse,
but this is the one I was told. As he himself had recounted, his financial
affairs were going rather well. But in a momentary plummet, Zborowski,
who was handling sales, was losing a prospective client at the Rotonde in
the presence of Modigliani, who was very nervous and irritated.
Suddenly, in the midst of the most heated moment of the negotiations,
and tired of such evasiveness, my friend told him to sell the painting at
any price whatsoever and meanwhile headed for the bar where he was
served a hot drink by the café's owner. The latter had the unfortunate idea
of advising Modigliani to calm down and go home to bed, as his influenza
had given him a fever. What a mistake! In the throes of fury, Modigliani
removed the scarf tied around his throat and, opening the door, exposed
himself to the icy air. I was told that they literally had to drag him back to
the studio, but that his influenza had already become much more serious,
and eventually killed him.

How often, when I was not well, had he tried to encourage me saying:
"Look, I was much sicker than you are and I'm fine now." And, if I asked
him how he had cured his illness, he would answer: "Most of all, I didn't
take it seriously." I had taken more or less the same attitude, and made
the best of things. But the time was approaching that I would have to take
my illness much more seriously, for otherwise, like Modigliani's, it would
eventually carry me off.

L'Esprit Nouveau—A Forsaken Biography

Rosenberg, who was always full of projects and who dreamed of
producing all sorts of rare art books, suddenly decided to publish a series
of monographs of the artists in his gallery. He wanted to call it "The

Masters of Cubism." The texts were to be entrusted to one or another of the writer/friends of the Effort Moderne artists; however, these were few and far between by that time. Rosenberg had found ways to thwart nearly all of our relationships and the gallery was becoming quite isolated. Unfortunately, Rosenberg himself proposed to write the text of my monograph and I could not refuse his offer.

Business at the gallery must have been going quite well, for the premises were being renovated and the number of employees increased; among these was a charming, intelligent new secretary. My dealer would bring her to my studio every Sunday to take notes, intended to lend a sense of technical precision to my monograph. As long as he stayed within generalities, things went quite well (for instance, that sort of esoteric magic of triangles, pentagons, etc., which seemed right up his alley), but eventually he was obliged to get down to particulars, and at that point I realized that he had not the slightest idea of what a "ratio" or a "proportion" was, not to mention irrational or rhythmic numbers and the like. So I was forced to explain the relationships and properties of certain geometric figures, which was boring for both of us and ended up tiring him. I was more fatigued and irritated than he, and since summer (1920) was approaching, we put a stop to the geometry lessons.

It was at that very moment that I had the bizarre idea of painting a maternity scene composed like Raphael's Madonna, whose lines and forms were regulated according to rectangular triangles placed in a rhomboid pattern. I wanted to try controlling certain operations, applying them along unknown lines and hoping for a technical result that would bar discussion. I used my wife and child as models, but, as in Raphael's painting, everything was reinvented geometrically. I had subdivided the lengths of lines up to $1/72$nd. I had chosen color harmonies in Chevreul's "Chromatic circle" according to his laws on contrasts: the little landscape visible from the window was composed according to the Golden Mean, with additions and subtractions. In short, I had applied certain rules of composition in their entirety, fishing them out of the works of various old masters. The painting, done in casein pigments, was a brilliant success chromatically and of an indisputable perfection in its every part; everything was in its rightful place, but the result was as cold as ice and utterly lifeless.[3]

This was a silly experience that perhaps I should never have undertaken, for it furnished false leads for many people about my real

[3]This painting is reproduced as an example of composition in my book, *Du Cubisme au Classicisme* (Paris: J. Povolozky E., 1921).

intentions, and for me, as a means of control, its results were essentially useless. In any case it was my last work of this period, for reasons of deteriorating health.

Meanwhile my family underwent some serious misfortunes; first of all our cousin Gabrielle gave birth to a boy who lived only a few hours before perishing; then her husband Robert, probably weakened by a series of operations performed in various southern hospitals, was suddenly felled by a pulmonary illness which came upon him very violently. Luckily, being a war veteran, he was immediately admitted to the Bligny sanatorium, just a few kilometers from Paris. All of a sudden, that happy, united little family fell to pieces: one person seriously ill in a sanatorium and the other alone with her sorrow over an unhappy, thwarted maternity.

As my illness was the same as Robert's but much less serious, I decided to cure it by going to the seaside for three months and by using a new treatment that was rather controversial in Paris. I asked Rosenberg for an advance so that I could leave as soon as possible, but he replied that the Effort Moderne was not a bank. Luckily I was able to procure the advance from my friend Auguste Perret, the architect, and to leave immediately for a small village in Normandy called Langrune. I was not so lucky with the weather, which was cold and rainy, and the cure I had started had no positive results. Nevertheless, I painted two little still lifes in which I also used ordinary laws of perspective; although they were good, they did not appeal to Rosenberg on first impression. Later he changed his opinion, as he often did, and claimed that they were among the best that I had ever given him.

We returned to Paris in September. During my absence there had been an exchange of rather displeasing letters with Rosenberg concerning the text of my monograph resulting in his decision not to write the text; he told me to find another author for it. But I, driven by pride and anger, did not want anyone else intervening and decided to write the book myself.

In the brief period when I felt rancorous toward Rosenberg and the whole Effort Moderne operation, I composed my book, *Du Cubisme au Classicisme* which, unfortunately, often reflects my aggressive state of mind. Many of the Cubists, excluding Braque and Picasso, felt that they had been the butt of this work and held it against me for years, and rightly so. I should have delayed the publication of that book but, driven by the desire and necessity to regain my health as quickly as possible, I had applied to the Bligny sanatorium where Robert was convalescing,

and wanted to relieve myself of the matter of the book before entering the hospital. I had found a publisher in the person of a kind old friend from the Closerie des Lilas, the Russian, J. Povolozky, who had an important, modern bookshop on rue Bonaparte, facing the Beaux Arts Academy.

One day I received a note from Paul Dermée who, in rather mysterious terms, asked me to come to an appointment. When I showed up he revealed that he was creating an important new review and was counting on my collaboration. He frequently mentioned Ozenfant's name, so I finally asked him, "Which of you is going to run the review?" He confessed that it would be Ozenfant, who confirmed Dermée's invitation to me as a collaborator. The review was to be called *L'Esprit Nouveau*. That day, at Ozenfant's, I met Jeanneret, otherwise known as Le Corbusier, a young architect who had worked with Auguste Perret.

We had long discussions about harmonic ratios, about geometry and mathematics in general, applied to the arts and, hearing that I had given Povolozky a book on this subject, they asked me to retrieve it, so that they could publish it in *L'Esprit Nouveau*. But I refused categorically. That same day, Ozenfant who had helped Kahnweiler move his gallery, now called Simon, into new quarters, told me there might be a chance to conduct business with that dealer. Unfortunately I had just signed a rider to my contract with Rosenberg and could do no such a thing. Therefore, I had refused to commit two bad acts in one day; my conscience was repaid, but inside I knew that I had acted against my own interests. In fact, had I left Rosenberg for Kahnweiler (Simon), perhaps my fate, from a commercial point of view, would have been quite different.

In the meantime, I was notified to enter the sanatorium on the 21st of October. My book was finished and in the publisher's hands. My wife had found a job at the Finance Ministry in the tax department and therefore could contribute a high percentage of my expenses at Bligny. The missing part was supplied by a bequest from the Rothschilds. So, one Thursday at the indicated time, I took the little train from the Denfert-Rochereau station that I had often painted from the windows of Mémé's apartment.

This was the second separation, and for the same reasons, from my wife and daughter. As short as the trip was, it was nevertheless a sad one. In a small country station I left the train to take the omnibus sent especially for the patients. I arrived at the sanatorium at night where, luckily, Robert's presence made this phase more bearable.

Bligny—*L'Esprit Nouveau*

The sanatorium was in the countryside, on a hilly plain covered with trees and villages. The landscape was emerald green, with light cobalt blue, transparent purples like mother-of-pearl. Behind the large buildings we had a lovely woods and the window of the two-bed (of which one was unoccupied) room to which I had been assigned, overlooked it.

It was a public military sanatorium, in the sense that the majority of the patients had been soldiers and many of these had been victims of gassing. They were robust men in apparent good health, yet they could not take two steps without breaking out in a high fever: they were almost all incurable. How many pitiful cases I saw! One of the distressing sides of a sanatorium is watching what happens to the other patients.

Everything started off on a good foot for me. Robert had made friends with the young doctor on our ward and had prepared the way for me with his companions, so I was practically adopted by them and helped in thousands of ways by the doctor. The seriousness of my illness was not the cause of any worries. I had decided to take the cure early enough and was told to rest completely for my six months there in the pure air and to follow the militaristic regimentation of daily life, regulated by the ringing of bells. Of course, no mathematics books and other study material was allowed, not even a sketchbook. I led an absolutely vegetative life and my health soon returned. But time passed so slowly. The company of Robert, who was also getting better quickly, and that of the other companions, despite their kindness and attention, could not substitute for my family, my studies, and my work.

Every Sunday I looked forward to a visit from Jeanne, who came in a large bus scheduled especially for Bligny, that left from Porte d'Orléans around eight in the morning. By eleven these visitors would arrive and, as you can imagine, were received with everyone's great enthusiasm. Married patients would put their arms around their wives and disappear into the woods. My wife brought lunch and ate it in my room while I had to go to the lunchroom with all the other patients, but once in a while I had lunch with her and we would use the bed as a table. We were so happy to be together! Soon the painful moment of departure would arrive, as the bus left again for Paris around four or five in the afternoon, according to the particular season. We patients followed its course with our eyes until it was out of sight, then slowly returned to our halls or our rooms.

The Bligny period was not extraordinarily jolly, but I had no right to complain compared to many of the other patients I observed there, whose cases were thousands of times worse than my own. Actually, I experienced a part of life that, without realizing it, had enriched my inner being.

Toward the end of January I was given permission to visit Paris for a short time and could visit an important exhibit that Ozenfant and Jeanneret, the two publisher/editors of *L'Esprit Nouveau*, had organized at the Drouet Gallery. As I mentioned previously, Ozenfant contemplated the creation of a new trend that, in his opinion, would impede the decline of Cubism and would lead it to a purer form of expression. He named this tendency "Purism."

Ozenfant and Jeanneret dedicated their considerable intelligence to the pursual of this goal and, from the solely artistic point of view, displayed a certain comprehension of the "turning point" in the history of modern painting, but they were unable to draw a large enough following among the Cubists in the first place, and in the second, even those "mysterious currents" sovereign to the world of dealers were hostile to them. So the result was not brilliant. But it must be said that in Paris at that time, had Ozenfant and Jeanneret even been Raphael and Michelangelo, the result would have been no better. The evolution of the arts in Paris then was no longer based on artistic criteria, but on scattered, competitive interests demanding obedience, bonded as they were to a highly critical political and social situation.

It is not my duty to express a critical judgment of that exhibit, but I do think it important to clarify the theoretical point of view heeded by those two artists, which demonstrates a certain understanding of that particular moment. In fact, many artists felt themselves ever more attracted to "visual reality," while many others felt the same proximity to abstract reality, as distant as possible from appearances. Actually, the majority of the artists believed that analyses of spiritual life were tied to solutions of the metaphysical "idealism-realism" problem. This was a profound error, as phenomenology was a method, not metaphysics, and its objectivism tied it to medieval philosophies. For this reason we were often accused of retreating to the Middle Ages in our research on spiritualism and objectivism.

Ozenfant's "Purism" searched for a single point of encounter between the two opposites, the two aspirations. He stated: "Purist composition comes from Cubist composition, but it is clear that the object, point of departure in Cubism, is often modified to extremes, in view of its

organization in a painting. Purism, on the other hand, maintains that it is important for objects to retain their own constitutional properties." Hence, Ozenfant was defending a sort of idealized realism.

In my opinion, the fact of modifying (or deforming) objects according to the organizational necessities of a painting constitutes one of the most legitimate theoretical bases discovered by Cubism thanks to Futurism. Serious, however, was the critique of Cubism denouncing its symbolic-decorative strain that could potentially lead to a downfall. The artists were astonished that Raynal, such a highly-experienced man who had witnessed the birth of Cubism, had championed this exhibit, having written a brochure that served as its catalogue.

Nevertheless, as a review, and as an animator of ideas, despite everything else, it must be admitted that *L'Esprit Nouveau* was of superior importance. In the ideological chaos of the world at that time, the publication accepted and reflected everything like a mirror. So, it actually constituted a sort of "analysis" of all the cultural elements that presented themselves, in a confused and muddled fashion, to our desires for knowledge, precision, and clarity. It was a sort of "know-it-all" of a loftier plane, not purely informative, but also critical, providing fruit for discussion and, therefore, from a cultural point of view, interesting and informative about current events.

It is unfortunate that the foundation of its organization and management consisted of a mentality based on broad skepticism and eclecticism, maladies of our century probably resulting from a lack of faith in ourselves. Both Ozenfant and Jeanneret made proposals, but without actually believing in what they were proposing; essentially, not believing in anything. Religion, science, philosophy, art, everything was presented objectively, and therefore anyone religious, mystical, a free thinker, an anarchist, a communist, and even a delinquent were all put in the same boat. For this reason it was possible to find, in the review, as if in two mirrors close to one another, a photograph of a fetus with two heads next to a drawing by Picasso, a perfected bidet next to a painting by Cézanne, and so forth. It should be remembered, though, that two very distant realities, if in the correct position, can generate a spark, a light that quickly illuminates a given idea; however, that sort of activity can often turn into demagoguery. Interesting, but dangerous.

On this basis Ozenfant wrote a rather interesting book called *Art*, published in 1928 as I recall. In truth, that refined man expended his best efforts and the wealth of his knowledge for that sort of cultural, artistic moving picture show that constituted *L'Esprit Nouveau*. Perhaps the most

positive results of so much energy were obtained by Le Corbusier in the field of architecture. His theoretical activity, which stemmed from Cubism, legitimately obtained international historical importance.

My collaboration with *L'Esprit Nouveau* was limited to an article that I contributed that first day of our encounter and which was published in issues 11, 12, and 13, titled "Cézanne and Cézannism." It was an article inspired by a reaction to the aesthetics of the "oblique fruitbowl," a deviation of the Cézanne-like spirit that dominated painting at that time and was leading it in the direction of the extremely vulgar picturesque. My works had been often reproduced in compilations put together by Rosenberg, but our personal relationship, after he refused what Ozenfant requested of me, was virtually over.

Before returning to Bligny I made a brief visit to the Effort Moderne and Rosenberg was ecstatic about my healthy appearance. He made me promise to send him four gouaches for an exhibition that he was organizing and reminded me that our contract was still in effect. On this trip to Paris he also told me that the Société des Indépendants had learned about my illness and had sent him Luc-Albert Moreau, the current secretary, to ask if I needed financial aid. Without consulting me, Rosenberg had replied that I was not needy. Nevertheless, I was very pleased by this gesture of solidarity.

A TIMELY CONTRACT

I had only been back from Bligny for two weeks when I received a wonderful letter from Rosenberg; he announced that some clients from London wanted someone to fresco part of a castle that they owned outside of Florence. They had hesitated between Picasso and me, but had eventually decided in my favor. The conditions that Rosenberg exacted were excellent. Those English gentlemen would pay for: round-trip expenses for me, my wife, and daughter between Paris and Florence; expenses for our stay; and lodging for the three of us in the castle for the duration of my work. I would be given 4,000 francs a month or, if the work took six months, 20,000 francs for the whole time. 3,000 francs were advanced upon my dismissal from the sanatorium, and the frescoes would be decided upon, once at the site.

I could not have been happier. This commission gave me a chance to realize my aspirations in the best possible way, at a very important moment in my life. But Rosenberg's letter ended with two phrases that

were like clouds in an otherwise blue sky, little clouds that for the moment were not very bothersome but had the potential of creating a storm of unknown proportions. For a clearer delineation of Rosenberg's personality, I will quote an excerpt from this letter: "As much as my time, energy and my clientele could give me the right to a vulgar 10 percent commission on every transaction benefitting of my intervention, I do not want to raise this matter between us because of our friendship. The only compensation that I would like to receive, in view of our relationship and your talent, is roughly a score of gouaches of commedia dell'arte characters painted in the style of the Harlequin that you sent to Sitwell (the owner of the castle near Florence), according me the right to reproduce them in a beautiful album, in color with poems, a luxury edition of 100 copies, of which I have the pleasure of offering you one printed especially for you."

I would have preferred to give him that vulgar 10 percent of 20,000 francs, not only because the twenty gouaches at the price he was paying me, 125 francs each, added up to 2,500 francs, but mainly because composing twenty gouaches constituted an enormous, terrible bulk of work. That is the reason for my appraisal of the clouds, knowing Rosenberg, as a storm warning.

But, as you can imagine, I accepted all these conditions, with repeated thanks. I soon sent the four promised gouaches, which were appreciated, and received the contract from Rosenberg, regularly signed by his clients from London, or rather, signed by their father since the initiative had been undertaken by two very nice young English poets named Osbert and Sacheverell Sitwell, while it was their father, Sir George Sitwell Bart, who actually owned the Montegufoni castle near Florence where I was to go.

In the letter announcing this contract, Rosenberg warned me—as he always did when things were going too favorably for the artists—not to become too sure of myself because of this excellent transaction: "I suggest that you not lose your sang froid or your good practical sense of things. Commissions like this from the Sitwells only happen once in an artist's lifetime, etc."

He went on to explain to me (as he had already done with each of us thousands of times) that artists in Paris must always exhibit new works, and that the public must recognize that when an artist is defended by a serious, renowned dealer, any work of his to appear at a public auction will be energetically championed. This threat of a public auction at the Hôtel Drouot was often waved before our eyes. It was used as a sort of

sword of Damocles to dangle over our heads. However, both out of recklessness and naivete, I never paid much attention to this, just as I was not very attentive to my so-called market.[4] In this same letter, under the guise of a corollary, he announced that "next Saturday" he would be selling, at whatever prices he could get just to rid himself of them, works by Marie Blanchard, Ortiz, Rivera, Zarraga.

During this final period at Bligny I had hoped to enjoy some peace and quiet, but once again the locks of Rosenberg correspondence were opened to flow into my bright valley. I was obliged to receive and digest another "confidential" letter which, to be truthful, was fundamentally flattering, but did not lack an occasional warning. It included the excerpt of a letter sent to a "well-known critic" that must have been Salmon, in which he described the political reasons that had motivated him, between 1914 and 1919, to purchase all the works that more or less referred to Cubism, and said that, in order to purify the Effort Moderne environment, he would now rid himself of all those that he considered superficially Cubist.

I must add that, with respect to the Sitwell contract, Rosenberg sent me a second rider to the agreement between the two of us, for my signature. It was to take effect upon termination of my work at Montegufoni, that is, on the 15th of October 1921, and it raised the price of my works to 35 times the point number for the first year, to 45 for the second year, and to 55 for the third. These were good conditions for the times and I was very pleased with them.

In his most recent letter, to which I have already referred, Rosenberg said: "The reason for my having formulated a new contract with you is because I think that an active and serious artist such as you are, merits encouragement and support, and because I believe that the results that you have now reached promise forthcoming works of considerable interest."

Everything was progressing very well. I must say that the latest gouaches I had given Rosenberg did not have the same Cubist *appearance* as the previous works; instead they were very representative and it is therefore to his credit that he detected their Cubist construction and spirit, beneath surface appearances. In fact, by that time Cubism was overstepping the limits of a group tendency and the particular "means" exclusive to that group.

Having rediscovered the *spirit of painting* and the elements essential to expression and construction, it was not important whether a work

[4] I would sorely regret such infinite stupidity much later.

adhered to a reality of the senses. It was important that poetry, and constructive science and expression emerge in a work. So it was claimed that Giotto, Piero della Francesca, Paolo Uccello, Fouquet, Chardin, and others of our old masters had been painters of a Cubist spirit. The only tendency that can historically survive after Impressionism and Neo-Impressionism is Cubism, for it closes the cycle, and many generations of artists will find the solutions to their problems therein.

At the end of his letter, Rosenberg added: "I have had no news from Gris, who still owes me the money that I lent him during his illness and who now ignores the very one who kept him from starving during the war, buying 275 paintings from him, of which I have only been able to sell two!!!, as most people find his painting too poor and too sad." In other words he was saying, "Look out, if you do not keep to a straight course, you now know what is in store for you!"

On the other hand, he had threatened me various times with the Hôtel Drouot auction block, but never sent my works there. I suppose that it was because he was selling them privately. This was both positive and negative for me. Positive because, not being numerous on the Paris market, they were not likely to devaluate, and instead maintained slowly increasing medium-level prices. Negative, as they were not the object of commercial fluctuations, avoiding, it is true, sharp descents but also any dizzying ascents, as highs and lows often end up constituting a certain commercial activity around the works. Rosenberg placed my collections on a superior plane where they were safe from all commercial storms and crises and sheltered from many critiques and hard words. I have always accorded only relative importance to such things; yet now, having reached a certain age, I realize that they too were of significance.

I left Bligny during the second half of April, accompanied by so many affectionate good wishes and demonstrations of real friendship that I was very deeply touched. Robert had to stay on for a couple of months more, but he too was virtually cured. It was true that this spring was also the beginning of a new life, based above all on work executed enthusiastically and with an unusually generous recompensation. Perhaps Rosenberg was right about one not "getting a swelled head" when things are going too well, but for other reasons, not those that he imagined. But the truth was, that for the present, things really were going well and I was very glad to take a trip to Italy with my wife and daughter.

The Montegufoni Frescoes

THE TRIP and the assignment virtually marked the beginning of my interest in mural art, which later, after this happy experience, I would invest with so many false hopes.

Jeanne and I had left Montepulciano almost seven years earlier, in the fall of 1914, in quite desperate straits. Now, in the spring of 1921, we were returning under totally different conditions. And, this time, there were three of us, counting Gina: "the three friends," as we called ourselves.

Before starting my Montegufoni project I wanted, of course, to pay my family a visit, and was delighted to see them again. My father's health was poor; slightly paralyzed on his left side, he had difficulty walking and performing his duties. As for my sister, she was nearing her twenty-first birthday and for some time had been writing me desperate and worrisome letters in Paris. Jeanne and I had even suggested that she leave school and home and come stay with us, where we would have found her some sort of occupation. But my parents opposed the idea and she did not have the courage to leave without their consent. Nevertheless, a while later, she was on the verge of running away from home to join a group of touring actors. She told me of this decision* just as I was about to enter the Bligny sanatorium. It takes no feat of imagination to suppose how she would have ended up had she followed through on her project. I had tried to make her understand that dedication to the dramatic arts was not such an easy task, even with such a pretty little face as her own, as I meanwhile tried to buy more time.

The main reason for her craving for freedom was the fact that, having failed an exam at the school she was attending, her degree would be delayed and perhaps even jeopardized. My mother was certainly unlucky with our student careers: a few years later, in somewhat attenuated conditions, my own lack of success resurfaced in my sister, who in the meantime had fallen ill. My poor mother's state of mind, she who had permitted her children to study at the cost of great sacrifice, and who saw

*See letter to Severini from Marina dated 24 October 1920 [Severini Archives].

in that teaching diploma her only hope for my sister's future, was entirely comprehensible.

There is a certain drama afflicting a large number of people, neither working class nor peasants, nor the well-off of the middle class, but somewhere between these two levels of society. They suffer the disadvantages of both, and desperately aim at gaining a hold on the lower and more accessible echelons of the middle class.

Upon arriving in Montepulciano, I soon realized the true state of affairs, and reproached my parents for their ways. As a result, they invested me with all their hopes of at least restoring my sister's good health. They made me promise to bring her to Montegufoni as a distraction, and also to have a doctor in Florence try to cure her.

I promised everything they asked, and quickly left to tackle my own work, as I was very anxious to get started; the appointed date for my meeting with the Sitwells had arrived. So, after just a few days of Gina's delighting her grandparents, we set off to Florence.

For both economic reasons and its proximity to the terminus where we disembarked, I took my two ladies to one of the many small hotels near the station. It was a very curious place, full of shiny ornaments, colored balls, carpets, mirrors, curtains, all of which was very shabby and dirty. The owner was an absolute poem: pleasingly fat and all curls, with a particular, typical spit-curl plastered to her forehead. I should have been suspicious and realized her true profession. It took Soffici to open my eyes. Having alerted him of my arrival, he came to see me right away and, after the first affectionate words of greeting, in his kind and forthright way of speaking, he said, "Oh, don't you see that you're in a bordello?" It was not quite that bad, but close enough. He took us to a more respectable place. This was occasion for my first encounter with his wife. He had been married since I last saw him, upon his return from the war. His wife was a pretty woman from the north of Italy. Carrà too, had recently married, and Russolo, and even Marinetti had or was about to be married. Everyone with the exception of poor Boccioni, who was dead, all those that had been so disapproving of my marriage ended up following in my footsteps.

I soon made contact with the Sitwells through the English firm of Allen & Proctor which managed their affairs. Located on a tiny street near via Tornabuoni, the business had lent their office a real Dickensian flavor. They, and the Sitwells too, all seemed like characters out of a Dickens novel. The elderly baron, Sir George, was, of course, cordial, but distant. I immediately established a bond of friendship and warmth with his two

sons, Osbert and Sacheverell, each intelligent and pleasant in his own way, ready to discuss any subject, on any plane. They were both poets, so we were necessarily destined to be either enemies or friends straight away; we became friends and, if they enjoy the same fine memories of me as I have of them, we still are and always will be friends.

We left right away for Montegufoni, located along the road to Montespertoli and the Certosa, roughly fifteen kilometers outside of Florence. I will never forget my impressions of that trip in a splendid automobile, with the two beings dearest to me in the world. Among those hills bathed in a light that reflected in me as in a mirror and made me feel that I had belonged there for centuries, all of a sudden, at a turn in the road, there before our eyes the castle on the hill appeared, an overwhelmingly romantic sight.

It was situated at the top of a hill, but beneath the road. On the way to the tiny nearby town of Montagnana, the long driveway lined with old cypresses led up to the castle. It had been built by the Acciaioli family in the thirteenth century and therefore had a tower not unlike that of Palazzo Vecchio in Florence. A well in the center of a courtyard, dating from the same era, was still in good condition, but the rest of the building dated from the 1600s, and the vast main courtyard, in the style of that time, was one of the most beautiful that I have ever seen. The surrounding gardens were terraced and covered with roses in bloom.

Our entrance into the castle was really sensational. In these vast edifices over three hundred families had been sheltered during the Socialist postwar repercussions and had turned the drawing rooms and other quarters and the gardens into absolute pigsties. The baron bought the castle for mere pennies, so to speak, but then spent enormous sums restoring it to its former splendor and, at the same time, satisfied the inhabitants by relocating them. He had even been so generous as to satisfy their need for music. In these Italian villages music is one of the principal distractions, so Sir George encouraged the founding of a music society, first directed by the parish priest of Montagnana (a curious curate), and later by a particularly gifted cobbler, good at conducting the "band," who assumed both the job of manager as well as that of conductor. Of course, Sir George paid for the instruments for the fifteen or twenty musicians. You can imagine how they loved him. Surprisingly enough, they had never laid eyes on him.

All the musicians were gathered in the vast ballroom. As soon as the baron and his two sons appeared—Jeanne, Gina, and I behind them— the trumpets started to blare with such zeal that the ancient walls trem-

bled at the din. Old Masti, the small, robust caretaker and steward of the adjacent estates, was also on hand. Once the music was over, Sir George made an eloquent speech in English. His son, Sacheverell, translated it into French and I repeated it in Italian.

The following day I was given a tour of the castle, not only to become familiar with the premises, but also to decide with me the work to be done. Back and forth, around and around, we finally stopped in a wing of the building that had been completely allotted to the two young poets. It was entirely, typically sixteenth-century: tiny windows set into the thick walls, half-arched ceilings, heavily molded doors, and so forth. In this wing, a small parlor with two windows and three doors was, so to speak, "surrendered" to me.

Evidently the baron did not have much faith in his sons and even less in me. Deep down, he must have said to himself, "In this out-of-the-way room, whatever happens will happen." And to myself, I said, "This out-of-the-way room will be the most beautiful of the whole castle." The matter was never again discussed with the baron. I deliberated over the subjects of my work with his sons. They were very keen on having me paint subjects from the commedia dell'arte, for they had purchased a gouache and some drawings of mine from Rosenberg on these themes, and were very fond of them. I could not have asked for more than making them happy. Their request was no imposition. Had I refused, they would have accepted any subject I chose. But I was glad to have the opportunity to paint a subject that allowed me to keep within the realm between humanism and abstraction, between fantasy and reality. This corresponded exactly to the state of my art at that time.

In a small room near the parlor that I was to decorate, I installed two easels and an engineer's drafting board, and immediately began my compositions, dividing the walls into harmonically defined spaces. I based my compositions on the geometric properties of rectangular triangles: very simple foundations suited to murals lacking excessive depth or relief. I composed two large open-air still lifes with landscaped backgrounds on two panels (fig. 45). On the others I depicted Harlequins and Pulcinellas (figs. 46 and 47), Peppe Nappa and Tartaglia. I would have liked to add a Stenterello and a Columbina, but could not fit them in.

I had not yet completed the compositions when the baron and his sons departed, leaving me and my family with the run of the castle. They even left me their cook, while one of Masti's daughters worked as the maid.

As soon as they learned that I was alone in the castle, my parents imme-

diately sent my sister to us with orders to take her to a learned medical doctor in Florence, to keep her with me in Montegufoni, and to keep her amused. In fact, I took her to the most expert doctor in Florence, Professor Frugoni, who later became famous, and he found her, above all, highly neurasthenic with a vague risk to one lung, requiring a rest at the seaside. I was busy with my frescoes in Montegufoni and could only offer her that castle isolated in the middle of the countryside where there certainly was not much to keep her amused. In fact, only Gina and I found the place entertaining; in less than a month Gina had forgotten her French and had learned authentic Florentine Italian from Masti's children and those from Montagnana. As for Jeanne, after what she had gone through in Paris with her duties at the Finance Ministry and her trips to the sanatorium, she was not at all well and no one knew what was wrong with her. Meanwhile, she took frequent rests in the garden and my sister could well have done the same, but instead she was always discontented and protested about everything and everybody, so agitating and ruining the atmosphere at the castle that I had to beg my mother to come and retrieve her. Summer was on its way, and the heat and mosquitoes, both typical Florentine plagues, made their presence felt.

Together with an apprentice house-painter from Florence, I began the frescoes on the thick walls between the windows and the doors, but the heat was so intense that the walls drank up the paints like sponges. I loved painting frescoes. No matter that I had never had real lessons in that discipline, and that I had never painted an important work in the medium. I worked on the plaster with an innate mastery, perhaps because I had watched my grandfather and his workmen painting building facades as a child.

Despite this, it was impossible to continue working, and I was also endangering the good health of my recent recovery. So I interrupted the work for a couple of months and traveled to the mountain region around Pistoia, to Vizzaneta, a lovely little town surrounded by a forest of chestnut trees.

There, I received the proofs of my book, *Du Cubisme au Classicisme*, to correct. Doctor R. Allendy had written an intelligent preface. I did not yet know Doctor Allendy, and Alexandre Mercereau had obtained the preface from him. He would become instrumental to our friendship.

The stay in Vizzaneta was beneficial only to me and a bit to Gina, but Jeanne did not get better, only steadily worse. I consulted a Florentine gynecologist who finally discovered the cause of my wife's malady. On his

advice I installed Jeanne and Gina in Viareggio, in a house right on the beach. A daily maid took care of them and I was obliged to leave them there and return to my frescoes.

I think it was the month of October when I started working on them again. Before leaving Montegufoni I had had all the plaster stripped from the walls and, on the advice of an elderly expert mason, had had it prepared and redone with a more reliable sand and a minuscule amount of cement. This was true heresy for a fresco painter. But I must admit that it made my job much easier because it allowed me to keep the wall damp without having to wet it constantly all day.

I followed the rules of Cennino Cennini for the complexions of the faces and hands; that is, I prepared a pigment with green earth and finished them with three tones of red earth. For the other colors, I sometimes prepared them directly in little pots or often improvised them on my palette, adding lime to some and not to others according to what the wall dictated. This responded magnificently to my purposes. The characters and the other compositions began at ground level (about 6 inches from the floor) and reached up to the ceiling. Therefore the paintings were at eye level and I had to be technically careful to the point of perfection. That is how I treated the composition, and the result was even better than I had expected.

I had a Florentine house-painter by the name of Simoni for an assistant, who prepared the preliminary charcoal pounce outlines, the pigments and even some of the secondary parts of the paintings, but one day he abandoned me because the food prepared by the baron's cook was done in such an unclean way, in his opinion, that he could not eat it. A fine-arts student from the Academy in Florence was sent as his replacement, a fellow who had just earned his teaching diploma. But his efforts produced less than a third of what the house-painter had been able to offer. The young professor did not know how to project a decoration to the right side of center in the same way as it had already been done to the left, because he was incapable of transposing shadows. This was just proof that the fine-arts academies were useless (even from the point of view of professional skills or craftsmanship), as they are in the present and always have been.

I spent an entire winter working in Montegufoni, a season of absolute solitude. As I finished each panel I would go for a brief visit to Viareggio where my wife was slowly making progress and Gina was flourishing. At a certain point of that 1921–22 winter, in January as I recall, my

book *Du Cubisme au Classicisme* was delivered and the edition seemed attractive.

Once the frescoes were finished and before leaving Montegufoni, I invited Soffici to visit and look at my work. He arrived and liked the frescoes very much. The subjects were treated as large popular images, full of spontaneity, which instantly revealed my Tuscan origins. It was also clear that I had enjoyed painting them. He approved of them, but we had some discussions on the ideas in my book that he found excessive. On the principles of discipline and method, we were in perfect agreement.

We returned to Florence together where an exhibition, a sort of annual review of the arts, had opened. We came upon De Chirico who had almost an entire room to himself. He was exhibiting a series of portraits in the so-called pre-Raphaelite style, that is, three-quarter view heads, with wide and rather yellow whites of the eyes, the conventional color restrainedly low in tone and warm, as in antique paintings, with their typical dark skies in the background. Everything was painted with mannered diligence. Soffici told him about Giovanni Costetti and other Florentine friends who had created a new "pre-Raphaelite" movement around 1900 on the same general lines as the English movement, and how his works particularly recalled that second-hand pre-Raphaelitism. He was perfectly right. In any case, this underlined the fact that the *Valori Plastici* metaphysics trend was undergoing a crisis. I believe that De Chirico, intelligent man that he is, understood the proper significance of our sincere and non-malevolent observations.

It seems to me that Soffici had just started his very sensitive and pictorial little landscapes, situated (in order to be understood) between Cézanne and Bonnard. I had promised to go to Poggio a Caiano to see them and visit with him a while longer, but the arrival of the Sitwells obliged me to return to Montegufoni for the final consignment of my work.

The little parlor that had been entrusted to me was now unrecognizable. Those large characters seemingly engaged in a strange celebration all around the room, playing unusual stringless instruments, created an aura of fantastic joy and greatly enlarged the space. The baron was enthusiastic about them. He declared that it was to be *his* parlor, and that his sons could only have rights of passage through it. So, I had avenged his lack of faith in me, and my friends Osbert and Sacheverell were more satisfied with me. They called their father "Ginger" for some unknown reason and did not let an occasion slip by to make fun of his "House of Commons" style of behavior. But I have no reason to complain about

him. It would certainly be ungrateful of me to complain about his typically English correctness and affability.

I left Montegufoni with all the roses blooming. I joined my wife and daughter in Viareggio and together, the "three friends" headed toward Montepulciano for farewells to my parents.

The train station was just outside the small town and there was a good stretch of road before reaching via Garibaldi near the upper part of the city, where my parents lived. My sister, having regained her health, had come to pick us up and we were all climbing silently toward the house when we ran into a group of crazed demonstrators preceded by a dirty, faded little flag and a few trombonists and drummers making a terrible commotion. I had stepped aside to let them pass, but they seemed annoyed with me and glared at me menacingly, all the time shouting and gesturing as if obsessed. I asked my sister about them and she told me to remove my hat right away. I did, and they, still yelling and gesturing, moved into the distance. My sister explained that these were "Fascists" that had probably come from the outlying countryside where they had held a demonstration, followed by abundant libations. In fact, they were clearly intoxicated.

Those were what were called "pre-Fascist" times, during which the socialists and communists battled hard against these partisans of the new political party, largely recruited from among discontented ex-soldiers, the unemployed, and people of ambiguous extraction. I had seen groups of these Fascists in Florence and also in Montagnana, but their curious costume, between that of a Garibaldino, a Bersagliere soldier, and an operetta bandit, convinced me not to take them seriously. That was an error: Italy was in the grip of a very grave political moment and I should have realized this, but it was also a period in which everything outside man's inner being, his spirit that is, or his humanity, or art, his most elevated manifestation, passed to the back of my mind.

This time too, I could only stay in Montepulciano for a few days because time was short and Rosenberg was impatient for our most recent contract, signed previously in Paris, to take effect, as it had already suffered a six-month delay. I was obliged to leave, but with a heavy heart, full of sadness. I will always remember the vision of the dejected figure of my father, framed in a narrow window, when, at the first turn in the road leading to the station, I turned to look at him again and wave a last time. Certainly it was an acknowledgment (without really knowing it) that this was truly a final farewell. How often the artist leaves a fragment of his

heart at a street corner! Yet, when he is eighty, there is still enough left for more of such strong feelings, and how!

What can one cling to? What law can one seize? What useful certainty? It cannot be that the true path is the one leading nowhere.

Ernest Psichari[1]

RETURN TO PARIS

Of the twenty thousand francs earned with my frescoes, it is useless to recount how few I brought back to Paris. My wife's stay in Viareggio, her treatment, and the various trips had absorbed the greater part of the sum. Nevertheless, with what was left, we wanted to make some changes in our life. In any case, we could no longer stay at Paul Fort's apartment at 6 rue Sophie Germain. So we decided to reorganize things in a place where I could have my studio at home. After a long search, we finally found a small villa in Nanterre, with a vast, beautiful garden, at the end of which were two rooms with skylights that could be turned into a studio. We regretted having to settle for a place outside Paris, even though it was close by; nevertheless, we were foolish enough to rent this little house.

After arranging the rental, to get our strength back, Jeanne, the child, and I all went to the Haute Savoie mountain region for the summer months, to Vallorcine, a pretty village next to Switzerland, at an altitude of approximately 4500 feet. While we were up there, my mother-in-law and Jeanne's grandmother cleared out the house and studio so that when the cold weather forced us out of the mountains in the fall, we would come back to find the Nanterre house more or less ready for us.

In Vallorcine I began to work again on some paintings, but these were clearly influenced by the knowledge I had acquired doing the frescoes. Among the better ones were *The Two Pulcinellas*, now in the J. E. van der Meulen Collection in Utrecht*, Holland, and a Harlequin against a view of houses as background, in the Dr. A. R. van Linge Collection in Maarsen, again in Holland, that I brought to Nanterre, unfinished.

While in Vallorcine I received reverberations from Paris of the impres-

[1] *Terre de Soleil e Voix qui Crient* by Ernest Psichari.
*Currently in the Gemeentemuseum in The Hague (on loan by J. E. van der Meulen).

sions made by my book, *Du Cubisme au Classicisme*. As I already said, my reproach of the artists for their general lack of knowledge about true notions of geometry and mathematics caused a great deal of hostility toward me, but the aggressive reaction of *L'Esprit Nouveau* surpassed every possible prediction. My old friend Raynal, perhaps in league with Ozenfant, wrote such an article in *Intransigéant* that I remained angry with him, as well as with *L'Esprit Nouveau* and its staff, for a decade.

Carrà's reaction to my book, on the contrary, was very favorable. I had passed through Milan on my way back to Paris and had, of course, paid him a visit at via Vivaio, where I met his kind, intelligent wife and his child. I gave him a copy of the book and he spent the night reading it through. The next morning he came to my hotel and said that he was enthusiastic about it and would write one of his most important articles on it.* We discussed it at length during my short stay in Milan and agreed on many points. His own work at that time was in the final phases of his metaphysical period, which was often the subject of our discussions, when we especially focused on its principles and not on the works, to which they were infinitely superior.

RETURN TO CATHOLICISM

The arrangement in Nanterre with the two studios at the far end of the garden was satisfactory. I used one of them for preparing my paints and all the materials necessary for the technical aspects, and the other for painting.

Thus I began a life of work and contemplation that could have been quiet and much more productive, in quantitative terms, than it actually was. It was difficult to remain calm around Rosenberg. Nevertheless, it was a fecund period of accomplishment, for I made important decisions at that time that regulated the rest of my life.**

I do not think it the case to call such decisions a "conversion." Actu-

*C. Carrà, "'Dal Cubismo al Classicismo' di Gino Severini," in *L'Esame* (Milano, 1922).

**The two versions that follow were both in the handwritten manuscript. The topic was obviously of great concern to the author and he was particularly anxious that his position be made as clear as possible. He reworked both versions many times, as his abundant corrections testify. As in the original edition, I have included both versions here. It seems impossible to exclude one or the other.

ally, my situation was extremely simple, even banal. As I probably already mentioned in the previous chapter, I allowed those things in me, dictated by my conscience, to ripen in me.

I do not even imagine trying to demonstrate the existence of God, or man's need for God. If by chance these memoirs are read by an atheist, which is probable, I know through experience what his reaction will be to philosophical discussions on such a subject and how much these will nourish his hostility. In any case, I do not think it proper for me to discuss such things, and, besides, the philosophical proof of the existence of God and the soul's immortality have always been convincing to those who are already believers. It is an internal need of the heart that drives one to believe, not an effort on the part of reason. Everyone knows Pascal's famous phrase: "The heart has reasons unknown to reason"; and André Gide's lesser-known words from *Nouvelles Nourritures*: "the recognition of my heart makes me invent God every day. Since my awakening, I am surprised at my existence and unceasingly amazed." Any longer explanation is superfluous.

Nevertheless, a discussion causing an atheist to reflect—as it made me reflect when my turn came around—on the impossibility of Science to explain life's mysteries; the object of Science, to collect and clarify external knowledge, does not quench man's thirst for knowledge and therefore cannot entirely satisfy him. I always had an enormous faith in Science, until such a time as I was obliged to realize—as prominent scientists themselves have admitted—that Science's possibilities are limited, and that its promises to provide absolute knowledge of the Universe are fallacious, like those of certain Italian barbers who hang signs in their shops saying, "Free Shaves Tomorrow."[2]

If one is dissatisfied with the explanations offered by Science, and feels the instinctive need to conceive the world in an inner and more exalted fashion, then he must resign himself to pass from the plane of "mathematical physics," so honored in our times, to that of metaphysics, that has been esteemed for centuries.

On this plane, atheism will encounter another potent adversary that does not need the force of reason to defend itself, but rather formally opposes it: "Poetry." Boccaccio claimed that Poetry is Theology. In fact, from Baudelaire on, it is clear that poets cannot attain the spiritual eleva-

[2]We owe the well-known "principle of incertainty" to Heisenberg in which it is demonstrated that we will never know the "last word about the Universe."

tion to which they aspire, nor penetrate into unexplored regions of which they dream, without at the same time approaching the supernatural.

Rimbaud's *Illuminations* currently enjoy a great influence on poets. Among the best of these, following the example of Max Jacob and Reverdy, some converted to Catholicism. In reestablishing unity within myself, I had to avoid falling into "deism" at all costs, as far from the truth for which I was searching, as atheism itself. There was no course other than an unconditional return to the Church.

This acceptance of the Church will perhaps be surprising, as artists in particular, in the best of circumstances, try to fabricate a God for themselves, and a natural religion to their own specifications. But that is really too simple to be beneficial. I know, too, just how much the word "Church" is the object of bitter controversy, and the quantity of misunderstandings it will foster, but that is of no importance to me. In my opinion, if you accept Christ as the living expression of God, you must accept the Church he has established, since, in the words of Saint Paul, "He is the head of the body that is the Church."[3] There is also considerable human and social wisdom in the Church, and such a deep knowledge of man that, compared to its Saints and Fathers, the world leaders today—the "group-leaders" as Steinbeck calls them—are merely pretentious and unfortunately unlucky fellows.

It would be absurd to believe the progress of Science is capable of shaking its foundations; "Shall we strip God of his divine anger for having understood the formation of lightening?" asks André Gide elegantly. In short, it is apparent that the Church can be reproached on a natural plane; but anyone spurred by a fair, free spirit and in possession of a certain level of culture, cannot deny its virtues, among which is a dynamism and a capacity for renewal that, despite its dogmas and its bureaucracy, in twenty centuries have produced a civilization so varied in form and united in its fortune, that today it would like to destroy itself.[4]

Proudhon himself, in *Justice dans la Révolution et dans l'Eglise*, reiterates that "the Church represents the most perfect form of transcendentalism, and the only completely logical one." As for problems of transcendence or sovereignty of Justice, established by Proudhon, everyone is

[3]Colossians, I, 18.

[4]These phrases were written in 1943, when the Germans had taken over Rome. History has made great strides since then; especially after the famous Vatican Council, the Church was subjected to essential changes that I consider superficial. The decisions of the Council are in my opinion unacceptable on many counts; nevertheless, for me, the essence of the Church remains unchanged, and I remain entirely faithful to it.

free to study them according to his own culture and intelligence, but must remember what Baudelaire said on the subject of seeking edification while denying existing precedents.

I think it useless to insist on this subject, since it is not a question of clericalism or anti-clericalism or of a clash between politics and culture, but only of defending authentically human and spiritual values, whose importance should not even be under discussion.

I allowed what my conscience dictated to ripen in me. Thus, I was faced with problems of a spiritual, moral, and also social order that any man worthy of the name must resolve with total frankness and honesty, not avoiding or sliding over them as I regularly saw happening around me.

The point at which a man is confronted with his own soul and does not recognize it because his inner unity is destroyed is a tragic moment. Plant life and animal life know no such dramas, as problems of the soul are non-existent to those who accept things without questioning them. But a man is neither a plant nor an animal: he asks himself why things are as they are, for he has a conscience and if it is silent or is not heeded, his value as a human being is reduced to zero. The trouble is that the human value of men in general was, at that time, very low (the best of them had been lost in the war), and I have the painful impression that it has not risen since. So I felt an ever more pressing need for confirmation, a certainty against all doubts or deviations, against the profound disorder in which we were living.

My Tuscan sense of reality and the concrete reality of art saved me, allowing me to understand that man, without inner support, is an empty container that can only resist artificially and precariously. Essentially, man is like a clay statue in the hands of a sculptor: a block of earth reinforced by an iron rod running through its length, propping it up. Around this backbone, there can be a succession of varying forms, for they are always held upright by the internal support. The statue can reach a state of perfection or can stop halfway there, but it will always be a live, concrete, and authentic reality. Whoever among us has never felt the need to rediscover true, authentic values and to reorder his inner self, does not deserve to consider himself alive.

It would be a tragic error, costly to humanity, to pretend that matter is able to put itself in order and that such an order stems from Nature, for Nature is without a conscience, or to hope to glean from Science the explanation of all mysteries, and expect Science to furnish that order which can be furnished only by pure intellect and the soul.

Among intellectuals and artists there have been and are some who, from lack of culture, or simple ingenuity or ambition, accept or pretend to accept such errors. But, usually, authentic artists and poets do not fall into that trap. If they happen to succumb, theirs is a brief, temporary uncertainty, and not a definitive state.

Cocteau is perfectly right when he says that poetry "is one of the most insolent forms of clear and on-target thinking"; in fact, as a desperate approximation of absolutes, poetry is on the same track as many problems of human and supernatural life, and for this reason Boccaccio could claim that Poetry is Theology. It must be remembered that, at that time, poetic spirit often approached a mystical, religious spirit, which generated confusion among those impulses that drive men toward God and poets toward unexplored regions, toward inaccessible peaks, toward an *absolute* that can only be found in the supernatural. One has only to recall the influence that Rimbaud's *Illuminations* had upon so many souls; from that time on, Art and Poetry began to glimpse goals that were outside their own confines. There were several poets who, following in Max Jacob's footsteps, returned to Catholicism. Among the most important were Cocteau and Reverdy. However, before them and perhaps by a different route, I understood the necessity of a "new departure" toward a more vast and serene universe. Organizing my life on natural and supernatural planes, which are the continuation of one another, I was finally able to reestablish my own inner equilibrium and unity of soul.

If I have so far described my own observations and meditations about problems whose importance is generally understood, let me now return to accounting for my actions. Consequent to my beliefs, I unconditionally returned to the Church, under whose aegis I had been born.[5] The concept of a vague God, custom-made, and that of an exaggeratedly human Christ, concepts dear to many contemporary poets, were not compatible with my personality, diffident and thirsting for absolutes at that point. I do not consider myself either rebellious or ambitious, though maybe I am. My ambition is to be a simple but authentic Christian. This is the

[5] The Church, particularly in Italy, is still viewed as it was by 18th-century anti-clerics; but the Church is not only a bell tower overlooking villages or cities in three-fourths of the world; nor is it only the clergy with its bureaucratic and dogmatic traditions. The Church is a vast whole, whose roots are in Nature and peaks in the supernatural. Saints, Martyrs, and the Fathers of the Church are beams of light throughout the world.

only access to a discovery of respite in God, guidance in Christ, and support in the Church.

Nevertheless, returning to the Church was not easy for me, and necessarily had to begin with that religious wedding ceremony that I had spurned at the time of my marriage in the Town Hall. A fortuitous and provident circumstance suddenly made everything easier.

Having been rather severe with the painter, Maurice Denis, on several occasions, I decided that I should get to know him personally and somehow repair my attitude with a declaration of esteem for the theoretician. In fact, more through his writings than through his paintings, Denis had advocated that union between sensation and thought indicated by Cézanne and appropriated by Cubism in a more violent manner. The Symbolist painters, of whom Denis was the most important member, were basically a link in the chain that brought us around to Cézanne again.

Our mutual friend Auguste Perret offered to take me to Maurice Denis, and one day we went to his house in St.-Germain-en-Laye. I was received with a certain reserve at first, but then our conversation became progressively more cordial and everyone present was respectful and even friendly toward me.

Among those present was a young priest who held and occasionally thumbed through my book, *Du Classicisme au Cubisme*. As soon as I had a chance, I asked him if such problems interested him. "Enormously," he replied with an obvious southern French accent. I invited him to visit my studio in Nanterre, thinking to myself that the young priest might be able to help me out of my dilemma. He came, and I explained my situation to him. He was of such help to me that a month later, deeply touched, I completed my civil marriage ceremony with religious rites in the Nanterre parish church. The parish priest assisted him in the ceremony, as our friend had only recently been ordained after having served throughout the war, and ours was the first marriage ceremony that he celebrated.

Needless to say, it was a simple, reserved ceremony, about which we had not told anyone, but that satisfied both of us and gave us considerable moral tranquillity. This time my wife and I had reached the same conclusion together (not one after the other), truly together, as both of us had thought about these matters at the same time. We became great friends with Abbé Sarraute (the young priest who married us) and later corresponded regularly with him. Only in the most recent years of this second,

horrible war did any period of time go by without news from him. Then, in 1946, we found him again, the canon of Carcassonne.

CUBISM IN CRISIS

Now, back to my life as a painter. It was the beginning of 1923 (my religious marriage ceremony had taken place in March); without any particular foresight, I soon realized that all was not right with things at our gallery, the Effort Moderne, and in general, in the Paris art world. Picasso, and Braque too, to a certain extent, began to stand to one side and other Cubists were individually on the defensive. Cubism as a general trend was starting to crumble, thanks to the behavior of the dealers and that of the artists themselves.

The auction of those paintings impounded during the war at the Kahnweiler Gallery, which took place at this time, practically marked a historic moment, for it revealed what a bitter struggle for personal interests the Paris art market really had become. Thanks to post-war inflation, paintings, considered real values or gold-based values, were selling extremely well, and Paris discovered America as a wonderful market outlet.

Thus the race for high prices began on the part of artists, and an entire policy on the part of the dealers. A great deal of antagonism was actually brewing between the two factions, beneath the most cordial of appearances.

When the government held the aforementioned auction, all the dealers were consulted, but not a word was passed on to the artists directly involved, whose works were going on the block. The artists could not even get the auctioneer or the sale directors to receive them. The usual procedure at the Hôtel des Ventes was to send catalogues of the works on sale to interested parties, but this time the artists were not among the recipients. Braque wrote Rosenberg a letter of protest and he, in turn, replied that sending the catalogues was not a mandatory practice, but done as a *favor*. This infuriated Braque. On the day of the sale, the artists were not even granted entrance to the salesroom but had to wait outside, in the hall. To exit from the salesroom, the dealers had to pass through the hall and when they appeared, Braque, enraged, confronted Rosenberg and said to him: "When you risk your neck in the war, you have a right to respect and to favors." Of course, this led to a violent argument which eventually conveyed everyone to the police station, but faced with a

wounded war veteran—Braque had recently been subjected to a cranial operation, and his head was still bandaged—things calmed down. However, the police commissioner made Braque promise not to rekindle the fight, at least on that same day.

As for Rosenberg and his colleagues, after having threatened to sue Braque, they abstained from making formal charges for the insults received, and nothing more was heard about the incident. I do not precisely remember the prices received for the works sold at auction, especially since they were by a wide range of artists, from Van Dongen to Picasso, in part dating to 1913 while I had been ill in Italy. Naturally, many of them were repurchased by the dealers, who concentrated their attention on a few signatures to the exclusion of others, and in that way a real market for artworks began, that slowly, in many instances, degenerated into manipulated sales, into false quotations, whose purpose was to disturb the regular process of "supply" and "demand" and to impress eventual buyers.

Unfortunately, this also disturbed any sort of critical judgment and if this, taken all together, procured serious material advantages for certain deserving artists, at the same time it poisoned and, you might say, disrupted the entire Parisian art world: the ascending curve of Cubism was over. It was now imperative for each artist to construct an original, even singularly original profile for himself. Actually, rather than developing a personality, he needed to coerce his own creative capacities to create a sort of "characteristic mannerism."

It is easy to imagine the terrible confusion created in the Paris art community. A certain number of talented artists, along with a lot of worthless ones, came to that wonderful city from all parts of the globe. We witnessed a grand display of fireworks, as well as some true pictorial spectacles in which there was a bit of everything, even silly things, a "triumph of painting," a sense of elation from painting as probably was never seen before or after.

In this supreme effort to create individual validity, there were, naturally, those who were "sincere" and others who were "impostors"; these were numerous and very often successful (so many of the public and dealers have limited intelligence) and the others had to make do with a heroic and difficult life.

It seems that, at a certain given moment, there were roughly 40,000 painters and 150 galleries in Paris. To accommodate the demand from abroad, the dealers organized the market and standardized their contracts with the artists. One of them told me that each young foreign artist

who came to Paris, after having been informed of the Parisian "tastes" (a year or so was necessary for them to conform), had his own contract, mistress, and automobile.

At that time the practice began—and I think that Picasso initiated it— of painting thirty or so canvases after having discovered a personal theme present in one or two of them, a vehicle of surprise, an attention-getter; then an exhibit based on such a "series" would be staged. The one-man show would lead more or less to a "quotation" on the market. A certain breed of critics became affiliated with the galleries, and as a consequence, these shows were generally praised by the press. To tell the truth, my dealer, Léonce Rosenberg, always kept his distance from such procedures although he held a choice position among galleries.

As to myself, I must say quite frankly that I did not see things with the same clarity as I do today (and it is nothing to be proud of). It was just that I always considered the financial side of things of secondary impor- tance, not that I was being virtuous, but because of that state of oblivious- ness and lack of a practical sense that, as I already mentioned, was inherent to my nature. From early youth on, my friends accused me of having my head in the clouds. Used to being poor, being able to work without too many material worries seemed to me to be a great conquest. Everything else was secondary.

I remember that one day—visiting exhibits in Paris with Gris and Lip- chitz, I think—I was surprised to witness a violent attack on Rosenberg by Gris, who did not consider his "market" properly defended by our mutual dealer. He revealed his intention to leave Rosenberg, and in fact, soon thereafter switched to Kahnweiler's gallery. I, unable to accord this "market" the same importance as Gris did, tried to placate him, which only exasperated him all the more. Today I realize that he was entirely right. Nevertheless, shortly after having left Rosenberg, Gris confided to me that the situation with Kahnweiler was just the same, if not worse, as with Rosenberg. While remaining as impervious as possible to the atmo- sphere of that period, I nevertheless felt a great sense of disgust for it, and that is probably what drove me toward an ever more personal attitude vis à vis the other Effort Moderne artists. Mine was basically a posture of "resistance."

The Montegufoni frescoes had been the beginning of an art that I con- sidered more pure, in comparison with Parisian "pictorialism" and the various aesthetic and moral deviations that contributed to the emergence of Surrealism. In any case the commedia dell'arte characters, which I had

already branded with my own style, allowed me to humanize my geometry and to express that mysterious and fantastic sense that the Surrealists then exploited as much as possible.

At the same time, Picasso had discovered Pompeii and Roman sculpture, but this did not stop him from painting some of his best Cubist still lifes, as well as some portraits in a style close to Ingres. When I say that Picasso discovered Pompeii, of course I do not mean that he went to work redoing Pompeii as, for example, Funi later did in Italy. Picasso discovered "styles" and played with them like a perfect magician. But "d'après l'art" art, "d'après le style" styles, "d'après l'amour" love, as Cocteau says so well, are the same as "extracting salt from the sky."

Perhaps the entrance on stage of so-called neo-classicism, a term applied to Picasso and to me, dates from this moment. But I must say, on behalf of both of us, that the critics that dredged up that word were seriously mistaken. In any case, it is certain that Picasso's robust Pompeian or Roman women have one reason for existing, and that my "Pulcinellas" and "Harlequins" have quite another. It is up to real critics to clarify these matters.

In my case, I can only help them by making a confession: it is true that the geometric and mathematical rules that I discovered and reconstructed from the classics did weigh heavily on my art; what distinguished me from Picasso was the idea that style had to spring from that severity of "means" nurtured by a sentiment, and from a personal, intrinsic gift. Perhaps I accorded them too much importance without, however, confusing them with art, but, if I was able to paint a few authentic works despite this, I consider myself redeemed. It is nevertheless certain that style can only arise out of the spiritual unity of an entire era, and this no longer existed in Paris or elsewhere. As I said, the Paris and particularly the Effort Moderne art worlds were considerably chaotic and tumultuous.

Some of the artists of our gallery regained a certain affinity for images sensitive to reality—in some of them, such as Braque, with dignity, moderation, and talent; in others, such as Metzinger or Herbin, in a more objective and less elevated sense. It is not my task to criticize Metzinger's "lady horseback riders" or Herbin's flowers or still lifes or even Léger's chunky figures: history will accord them, as it will my Pulcinellas, the place they deserve.

I must mention, however, that it was Rosenberg who had the highest esteem of all of us for Herbin. In the classifications that he loved to compile, cutting slices out of history as out of a cake, and strolling self-

confidently through Academicism, Classicism, Realism, Idealism, etc., or else jumping from the subjective to the objective, from empirical to rational, etc., in his eyes the perfection of perfections, the absolute of idealism was always Herbin.

This sort of return to the apparent reality of things, for which I feel a certain responsibility, did not leave even Gris and Léger indifferent. Certain of Léger's figures with wide round faces in which reality appears simplified, but in a very readable form, painted in blues, yellows, and reds, that go from a maximum of saturation to white, can be dated to this era.

Juan Gris, who had left Rosenberg at that time to join the Simon Gallery,[6] painted some "Harlequins" which clearly indicated that his talents were unsuitable for treating the human figure and only appropriate to still lifes. In fact, we were experiencing (and basically still are) the "still life era." Certain of Braque's nudes, with flowers and fruit, recalled the palette but not the drawing or form of some figures of Corot and his Roman landscapes. Perhaps that more Expressionist than Cubist period of his was beginning, to which he remained ever-faithful. But Braque always lent nobility and talent to whatever he did.

Among the important painters of that era was Survage, already prominent and respected in Apollinaire's time. Survage painted landscapes with sharply divided zones of light and color, like the wings of a stage. He also utilized symbols; a large leaf in the middle of a painting represented a whole tree or trees; a large curtained window was the whole house and its intimacy seen from outside. But he, too, at that time drew figures, and landscapes closer to visual appearances, which were nevertheless always extremely refined and sensitive.

Gliezes had returned from America; interested in the geometric and numeric theories of which I had chosen to become the defender, his abstract paintings lacked humanity, and were more intelligent than sensitive, but not totally uninteresting. Chagall, too, returned from Russia, and the Effort Moderne exhibited an important painting of his, *Le Vieux Rabbin,* which is now, by chance, in the Modern Art Museum in Venice. Delaunay, as well, had returned from his exile as a deserter, but he seemed to us drained as a painter.

This, briefly summarized, was the state of painting at that time. My dealer seemed perplexed and troubled about the ideas and trends clashing

[6]"Simon" was the name Kahnweiler assumed after the war.

at his gallery. His romantic, esoteric mysticism made him unable to decide between classical order and the mechanical. He liked my paintings and they sold well, but from time to time he reproached me for the changes I made. (I wonder if these were not, to a certain extent, provoked, as a reaction, by his own changes of position and mood!)

The fact is that, shortly after my return from Italy, our relationship cooled, in part because he immediately began to demand the twenty gouaches as his percentage on the frescoes. The little black cloud that I had noticed at the Bligny sanatorium when he wrote me about the wonderful commission, turned into an annoying rainfall in Nanterre, and it was not long before it became a furious storm. It reached the point where I stayed angry with him for three months or so after an exchange of letters in which neither one or the other of us was able to hold back bitter, harsh words.

Unable to sell my works independently because of our contract, I was in difficult straits, for Rosenberg, naturally, did not provide a single cent. So I tried to sell some of my Futurist works, and Paul Guillaume promised to handle the transactions for me. A certain Dr. Barnes who had founded a museum in Méryon [sic], near Philadelphia, had come to Paris at that time, to buy works of modern art for the museum. Paul Guillaume tried to make me sell some of the works predating my contract with Rosenberg, but he clashed with the violent opposition of Raynal and his Cubist friends who, still very angry about my book, *Du Cubisme au Classicisme*, did not let an occasion slip by for revenge. So, Dr. Barnes did not visit my studio, but later, perhaps even he realized that he had been ill-advised in Paris and that buying, for example, from Miss Perdriat and Iréne Lagut, as he did, and not from me, had not been an intelligent move nor useful to his museum.[7]

Having missed that opportunity, my only hope for a sale, I was obliged to lay down my arms and try to reach an agreement with my dealer. I had finished the "Arlecchino" painting started in Vallorcine (that later would become part of the Dr. van Linge Collection in Maarsen, Holland), so I

[7]Dr. Barnes was the president and owner of an important chemical plant, and the museum that he decided to found in America was aimed at educating the mass of his workmen, all virgins with respect to culture in the arts. It would seem that he attributed great personal enrichment of the individual to art. In any case it was an interesting experience, perhaps suggested to him by the "philosophy of experience" by William James, of whom he was a fervent admirer. For the purchases of Dr. Albert Barnes, see Maurice Raynal, "La Fondation Barnes," in *L'Esprit Nouveau*, number 18 (November 1923).

offered this painting to Rosenberg in exchange for the sixteen gouaches that I still owed him. I had already painted four of these, but absolutely did not feel like doing any more. Rosenberg accepted my proposition, and we made peace.

It seemed that tranquil times conducive to my work had finally arrived and, to start off well, Jeanne and I took a little trip to Chartres, partially paid for with the proceeds of her salary as an employee at a pasta factory, and partially with the sum that we were able to collect once the argument with Rosenberg was over. We arrived in Chartres in the evening and immediately went to see the cathedral. The architect Perret had often told me that certain Gothic cathedrals, such as that in Chartres in particular, were thousands of times more beautiful than St. Peter's in Rome, despite its marvelous dome by Michelangelo, which is, in itself and separated from the rest, one of the most wondrous works ever created by man's genius. Seeing Chartres in real life greatly surpassed any idea of it that I might have had. Moreover, that precise moment was particularly favorable for me to understand the order of such beauty. My friend Auguste Perret and I had often talked about these things in our long conversations, and now I recognized how right he had been.

For example, it was undeniable that the Gothic principle of multiplying divisions, makes a building seem much taller, grander than it actually is. This does not happen with St. Peter's, which actually is much larger than it seems, because that fractionating and those divisions of Gothic constructions are missing. Jeanne and I visited all the vast roofs of Chartres. From up close we could better admire the quality of that science that made possible such a harmoniously built structure, consolidated and sustained by "flying" and regular buttresses, building elements that not only remain visible but are at the same time ornamental.

This conversion of a decorative element into a constructive element, in other words, of conceiving a building in such a way that there is no need for decoration because the architecture and its constructive elements are themselves the decoration, is an idea that the moderns have intelligently retrieved. What they have not yet been able to recover (not all the fault of architects, painters, etc.) is the spiritual unity among men and in each one's inner being, that is, as Renoir notes,[8] the essential condition for realizing collective works of such high perfection. From the greatest master to the most humble artisan, continues Renoir, medieval artists did not

[8]In a letter from Auguste Renoir to Henry Mottez. Preface to the book by Cennino Cennini.

work in order to make their fortunes but rather to conquer the heavens. Today one works to conquer one's dealer, who in turn will make us conquer a high standing in the market hierarchy. And presumably achieving a style is the aim. Nevertheless, there was once a time, as I probably have already said, in which a unity of thought, a spiritual order, and a style could have been engendered by Cubism and the School of Paris generally speaking, more or less under the influence of Cubism. Commercial interests caused everything to be tossed out the window, at least for the time being.[9]

[9]It is useless to describe the magnificent stained-glass windows and the sculptures in Chartres, which are highly important parts of that whole, the utmost of perfection, seeing that I do not propose to write a history of art.

Birth of the Rome Quadriennale

I DID NOT LIKE my house in Nanterre at all: in the summer horrible beasts called "aoûtats",* which crept under the skin to produce an atrocious sense of itching similar to that of mange, would fall out of the trees into the garden; in the winter the humidity was unbearable. In all seasons of the year a tram raced by our windows every fifteen minutes making infernal scrap-iron noises and shaking the whole house. There was also a horrible smell that wafted over from several factories, poisoning the air. In addition, despite the short distance from Paris, no one came to see us anymore. As a last straw, the climate was not salubrious to my little Gina, who could not attend school for even fifteen days straight without contracting bronchitis. As a result I was obliged to send her to a children's camp in a lovely little village called Le Moutchic, on the Côte d'Argent. This colony had been built on the banks of a small lake, and was so well-situated that it could take advantage of both the sea air (being located at a stone's throw from the Atlantic Ocean), and of a magnificent pine forest; the child's health was fortified for the rest of her life by this holiday.

At the same time Jeanne's mother and grandmother also left Nanterre. My mother-in-law gave up her job at the 14th Arrondissement Town Hall to open a small vegetable, fruit, and flower shop, which sold the produce from an estate that was ostensibly (or would have liked to be) a sort of school for the reeducation of wounded war veterans suffering nervous disorders. Actually it was one of those enterprises (called "oeuvres" in France and "enti" in Italy) that, under the guise of a humanitarian, social program, instead serves the interests of the person or persons who found them. In our case, the director of the institute was the wife of the Symbolist poet, Ferdinand Hérold, one of the assiduous participants at Mallarmé's meetings, and a collaborator of *Mercure de France, Vers et Prose*, etc. The produce grown by the institute's wounded was sold by my mother-in-law, assisted by her mother who, at the time, was roughly eighty years of age. Therefore, my wife and I were alone together in the Nanterre house and I took advantage of a rather favorable period in my work.

*Larvae of insects similar to ticks.

The paintings, *Pulcinella in a Room* and *Poor Pulcinella's Family* both belong to this period, and are now in the Kröller Museum collection in Rotterdam (but what happened to these paintings and many others after the 1940 invasion of the barbarians?); I painted other works too, of course, among them *Pulcinella with a Mandolin* in the Rosenberg collection, but it would be impossible to list them all. Around this same time I received visits from two Italian artists in Nanterre, the sculptor, Alfredo Biagini, and the painter, Efisio Oppo, who had come to Paris to organize the French selections for an international exhibit that they intended to organize in Rome to take place every two years like the Venice Biennale, but which later became national in scope and took place only every four years.

Those two artists brought news directly from Italy, where Fascism had already triumphed with its famous "March on Rome" the previous year, which had placed and consolidated supreme power in the hands of Mussolini. Seemingly, the new patrons of Italian destiny intended to grant greater importance and all sorts of encouragment to the arts. I wonder why all political heads of state new to power feel it their duty to smile upon the arts with such charm, full of promises that they never maintain.

Oppo, whom I did not know, came to me because he could not accomplish the task he had been assigned. Neither the dealers nor the artists showed any faith in him and he was unable to attract participants. Biagini's story was different: a good sculptor and admirer of Maillol and Despiau, he knew Paris and the artworld quite well, to the extent that he managed to convince the publisher Herbrard to give him the famous Degas sculptures which were numerous (72 as I recall).[1] I was very willing to help them in their enterprise; I accompanied them to several dealers, among which were the two Rosenberg brothers, and many artists. I remember our visit to Derain, who showed us a series of small heads, one more beautiful than the next; he was enjoying a good period and promised to send some works, but later, for some unknown reason, did not send anything at all. My dealer, too, as usual, was undecided, but finally agreed to participate. Eventually Oppo, seeing that his presence was useless, left me a large number of invitations printed in gold, complete with envelopes also written in gold; he gave me carte blanche and then left Paris. There, where invitations are usually printed on simple cards, every-

[1]Herbrard also gave him some sculptures of animals by Bugatti, and others entrusted him with works by Rodin, Bourdelle, and Bernard. But neither Maillol nor Despiau nor Rodin and even less the extreme modernists, Laurens, Lipchitz, etc., were represented.

one was amazed by those large envelopes addressed in gold, which became the object of great hilarity. No matter; I was very amused to invite, aside from the artists associated with dealers (such as Picasso, Matisse, Léger, Marie Laurencin, etc.), some of those who had shown at the Salon d'Automne and at the Indépendants that seemed interesting to me, that is, Gromaire, Yves Alix, Favory, Marguerite Crissay, Dubreuil, Lhote, Chavenon, Le Fauconnier, De Waroquier, Utter, Jacques Villon, and many others, which together would give a clear idea of the Paris art world. Jacques Emile Blanche was invited too, but not by me. From the photographs and reviews that I saw later, I realized that the Parisian participation had not sufficed to raise the quality of that exhibit to an acceptable artistic level, or to brand it with a clearly modern, contemporary personality.

Almost all the Italian artists, first among them De Chirico,[2] had fallen back into that provincial state of total slavery to reality, typical of the pre-Futurist era and even worse. In such a sea of banality, what light could shine through from Matisse's *Persian Screen*, from the works of the Effort Moderne Cubists or from Picasso's reminiscently classical women? It is common knowledge that a beautiful, interesting painting hanging in the midst of ugly ones, will not beautify the latter nor make them more interesting, but becomes ugly itself or, at best, its own light is extinguished. For that reason, exhibitions of that kind are the stupidest conventions imaginable.

What I regretted most was the thought of the time wasted on that project, and the discovery of the depth of the chasm between European art, or, rather, between universal art created in Paris, and its provincial counterpart created in Italy, where prejudices were all too evident. Only the works of the most important artists were reproduced in the catalogue, such as Matisse, Picasso, and a handful of others, and a few by the less aggressive of the French artists; none of the most daring and significant artists from the Salon d'Automne claimed that honor. So, the more I tried to establish and maintain cultural contacts, the more the others burned their bridges. The heinous aspect was that there was a hostile state of mind not only among the mediocre artists such as Oppo and his entourage, but also shared by the more admirable artists such as Soffici, Carrà, and others. It had been demonstrated in *Valori Plastici* how French art had been treated after its representatives had been invited practically as guardian angels to the review! And while I was in Vallorcine, Soffici wrote

[2] It seems to me that Carrà, Soffici, Sironi, and Casorati did not participate in that exhibit.

me a letter in which he claimed, without mincing words, that today's French representatives were no better than illiterates, charlatans gone astray. "Their art (!) [he added] is boring, tiresome, basically disgusting (even that of the best of them: Picasso, Derain, Braque). It is fruit of spiritual onanism, and sterile, false, and imbecilic as well, now that I think of it. One ends up preferring Bonnat or Detaille!" This is what Soffici wrote me, while he had chosen in favor of realism in the traditional, Greek sense, in the Italian Renaissance sense, in the modern French, universal and perpertual sense.

The connection between the Italian Renaissance and modern French realism, in the Courbet style for example, is unclear; the statement is even more surprising for the fact that it was written by someone who in 1920, just two years previously, at the end of the war, had published a little book titled *First Principles of Futurist Aesthetics*,[3] full of accurate observations and intelligent ideas about art universally appealing to all moderns, and the result of what we had been doing and theorizing since 1910.

Carrà viewed French art with Soffici's same convictions. He had recently written the preface to a monograph on Derain, in which he concentrated all the resources of his dialectic gift to provide a certain critical consistency to the ferocious attacks that, in his opinion, should do away not only with Derain but with "all art of the Parisian avant-garde group!!"[4]

Whatever might have been convincing in the restrictive evaluations and criticisms of my friends, once multiplied by thousands at every available occasion, they lost every sense of contact with reality and became mere declarations of vulgar partiality. The only motivation for such behavior must have been personal reasons and ambitions, for even that overabundance of vitality then existing in Paris, that created a certain chaos, was not in the least bothersome to those with strong personalities. There is absolutely no truth in the claim that the quality of the works of Picasso, Derain, Braque, Matisse, and many others deteriorated because of that state of disorder; its consequences could have been more effectively avoided in Italy, and were generally useful too, in their own way.

What actually happened was that with the arrival of Fascism, many personal ambitions surfaced (that sooner or later would be achieved); for this reason many things were tolerated by Italy's most valued cultural exponents through collaboration between individuals of caliber and the

[3] Ardengo Soffici, *Primi principi di una Estetica Futurista* (Florence: Vallecchi Editore, 1920). However, the volume was written between 1914 and 1917.

[4] Carlo Carrà, *Derain* (Rome: Edition de "Valori Plastici," 1921).

mediocre politicians in charge of the arts. This, in turn, created such disorder in Italy, qualitatively lower than its counterpart in Paris which, like a medal, at least had its reverse side (and what a reverse side), while the Italian chaos was an ugly medal whichever way you turned it.

The responsibility for this state of affairs (and of the stability that Fascism eventually acquired) could, in large part and along general lines, be traced to all Italian cultural representatives, including poets and men of letters. For this reason, Italian museums lack works by Renoir, Cézanne, Van Gogh, Gauguin, and even Courbet, Delacroix, Ingres, Corot; there are even fewer by the Impressionists, the Fauves, the Cubists, etc. Similarly, works by the early Futurists were never safeguarded in Italian museums;[5] instead, they are full of works by Tosi, Morandi, De Pisis, etc.

I want to be clear in my accounts of these facts, for later everything will be attributed to Fascism which, politically speaking, was already as we knew it (this is not the right place for socio-political criticism); in this case it was responsible for having for twenty years entrusted the destiny of painting to the hands of a failed painter, the destiny of sculpture to the hands of a failed sculptor, and that of architecture to the hands of a failed architect.

It is no secret that Mussolini gave that trio of mediocre, ambitious men the greatest of freedom and large sums of money. For example, no one kept Oppo (who consequently became a sort of dictator of painting) from buying Renoirs that are now worth millions, for just the 10,000 francs that he would have paid then. Had only he written to me, the transaction would have been concluded in a mere eight days.

To satisfy the curiosity of intellectuals and young artists, an exhibition was held every two years in Venice, to introduce officially selected works of French art; however, this was no replacement for that constant source of information that is a museum, where one is free to go any time, not only when it suits someone else. It took many years, in Italy, to reach definitions that could have been made clear at once, and much more profoundly.

ENCOUNTER WITH BENEDETTO CROCE

Let us get back to where we left off, that is, to life in Nanterre. As I said, the visits we received were few and far between; however, one day the renowned English writer, Douglas Ainslie, came to see me, whether sent

[5]In 1934, the Modern Art Gallery in Milan, upon the advice of Niccodemi, decided to purchase one of my most important Futurist works. But the price they offered was so low (less than 5,000 lire) that I was obliged to refuse. At the same time, Niccodemi had been ordered by the Fascist Government to purchase a work by Sartorio for 40,000 lire.

by my friends, the Sitwells, or by Roger Fry or Nevinson, I do not recall. The fact remains that he did come. He was a very peculiar, very interesting man. He had come to France especially to interview a certain Monsieur Coué, a pharmacist in a city in the North who had invented a new way to cure every illness. This method was based on auto-suggestion. The patient was supposed to convince himself that he was cured, frequently repeating to himself, "I feel that I am getting better ever day," and "I feel that my ailment is going away, going away, going away," etc., out loud. This pharmacist and his method enjoyed a moment of glory and success, and for that reason Mr. Ainslie had bothered to make the trip from London. But he too was quite an exceptional fellow. He had intellectual or social connections with everyone, everywhere in the world. Somehow we began to talk about Benedetto Croce and he told me that Croce would be coming to Paris in a few days and that he would introduce me to him.

I had already discussed Croce's *Aesthetics* (though I had not yet read it) with Soffici when he had come to Montegufoni from Florence. I would have been delighted to clarify Croce's theory on art which seemed to me from what Soffici recounted, a magnificent construction riddled with many truths on which our views coincided, but based on a non-truth, the existential unreality of things or existential world of things.

Perhaps the creative, educative process of a work of art is clearer to the philosopher than to the artist, for he tends, in his work, to abandon himself to what is usually called inspiration. This does not mean that an artist, aside from those moments when he is modeling his impressions, sensations, or intuitions into forms, does not feel the need today to account to himself for his acts or to have a particular awareness of them, and of how and why he is performing them.

The first point that needs clarifying is his position with respect to the real world, to real things, and this is the path on which his logic coincides with his philosophy. We have seen that materialism establishes that reality (whether called nature or matter) exists outside ourselves and our consciences, while idealism instructs us that reality is thought, and Bergsonian philosophy claims that an object is movement.

The latest pictorial theories had reestablished the preeminence of a certain Platonism and a certain Aristotelianism, the latter still somewhat unclear to artists, some of whom, however, had already glimpsed within themselves a possibility, of identifying, camoflaging themselves in reality, thereby becoming safeguarded from materialism and idealism. The question of art was therefore steered back to *knowledge*, to which it is intimately bound, though separate.

Benedetto Croce's theory, based on intuitive knowledge, established an

affinity between intuition and expression, which then concluded in an analogy between art and intuitive knowledge. Such a position agreed rather well with our views on sensations that, as Cézanne had said, we wanted to order and develop. Nevertheless, sensations, especially to painters, are something more than just labels slapped on things to recognize them in everyday life.

Perhaps erroneously, we make a distinction between the sensation that an ordinary man receives from a thing and the one a painter receives from the same thing, because we know that the painter, when empathizing with the thing, *sees* it differently, or rather, creates it. We know this very well because, unfortunately, it sometimes happens that we also see things just as the ordinary man does, which is the cause of many moments of desperation.

There is a difference in quality and quantity between the intuitive knowledge of an ordinary man and that of an artist, because the artist's knowledge is a poetic knowledge which, as I previously said with respect to Surrealism, belongs to an absolutely different world from that in which we live.

It would have been very interesting for me to discuss these things with such an undoubtedly admirable man as Benedetto Croce. In fact, a few days later Douglas Ainslie invited me to his small apartment where he had organized a sort of reunion of intellectuals and philosophers, in honor of that great Neapolitan philosopher.

I no longer recall which other dignitaries were present, for I focused all of my attention on Croce, who demonstrated his brilliance, his youthful aggression, and dominated everyone else. In such an impressive assembly, I was not able to talk to him for long, unfortunately, as he was the highlight of the reunion. Nevertheless, I was able to converse with him briefly about the return of the arts to skillful workmanship, which greatly concerned me, and about my book, *Du Cubisme au Classicisme* . In any case, he showed esteem for me and I seemed to interest him. Having authorized me to send him my book, a few days after his departure I received the following letter from him:

Naples, 19 July 1923

My Dear Mr. Severini,

Thank you for your letter and the book and, were I not in the midst of preparations for the departure with my family to the mountains (Bardonecchia), I would write you a longer letter. But I would like to tell you right away that I have read the book and admired a *cautiousness* in your thought processes that is extremely uncommon. Your letter makes the reason and the meaning of that cautiousness even clearer. I, too, am of the opinion that

the *practices* of the old masters are of great value. It is true that I have contested them, but only as *theories* of art and *philosophy*, or else because they were presented or misconstrued in such capacities.

Their significance, which I would call *pedagogical*, still needs rehabilitating. In my field, which is more specifically that of literature, I ended up defending (from the practical and pedagogical points of view) even the *ars rhetorica* of the ancients. Therefore I consider it plausible for you to revert to those rules of geometry. I would be pleased if you would historically reexamine the Golden Mean doctrine, the rules of Luca Pacioli, of Michelangelo, of Hogarth, etc., whenever convenient. I see that you, too, acknowledge that the first and last words, in painting as in all works of art, are inspiration, intuition, etc. So-called techniques (and I would call this the practical stage) is only an intermediate phase for you. And, like your book, your work as a painter confirms that in those rules and in that geometry, you are searching for a discipline, a ἄδκηδις,* and not only in art itself. I liked the works that you sent me reproduced in photographs, especially the feminine figure. How the Tuscan artistic tradition resurges spontaneously in you, thanks to your experience in art and modern techniques!

Please excuse this rather confused chatter, because, as I said, I am writing in haste.

With a cordial handshake

Affectionately yours,
B. Croce

I have transcribed this letter in its entirety because, in the first place, it is possible to glean from it the Crocian concept of art, very close to our own, and secondly because the confirmation of such an eminent man's comprehension is very important to me. He was the only one, at the time, to have correctly interpreted the intentions of that book. Neither *L'Esprit Nouveau*, nor the article that Margherita Sarfatti later wrote, nor my colleagues in France or Italy wanted or were able to appraise it for what it really was. I suffered a great sense of isolation because of this, a state from which my dealer could certainly not extricate me.

ENCOUNTER WITH JACQUES MARITAIN

While, in Paris, the most colossal art market ever to exist was in its preparatory stages, Rosenberg was complaining to his artists. Perhaps he

*An inclination.

imagined what was about to happen and felt overwhelmed by the Paris atmosphere and by the fact that new dealers were appearing each day. Along general lines, he was content to develop what the Effort Moderne artists had previously prepared, that is, a sort of poetic realism.

To my great surprise, the *Maternità* that I had painted in 1916 purely for reasons of experimentation, had an unexpected repercussion. Some years later Picasso had painted a portrait of Olga, his wife, and while inspired by Ingres, it was also very beautiful. This contributed to making the artists generally believe that art was heading toward "transcendental-surrealism." In any case, the Effort Moderne artists, from Léger to Braque, began dedicating themselves to figurative art. Unfortunately, this provoked horrible results in the works of Metzinger, Herbin, and others; Braque, alone, maintained his usual competence.

It was around that time that I met the great philosopher, Jacques Maritain, who effected the transformation of a number of somewhat atheist poets into Christian artists, chief among them Jean Cocteau, who was baptized in Maritain's private chapel in Meudon. This period was called "Boeuf sur le toit,"* but unfortunately it was all too brief. One of these poets, Maurice Sachs, wrote about this conversion intelligently in a polemical book titled *Le Sabbat* which, if you omit the maliciousness toward his colleagues, is a book of great historical importance.

Naturally ambitious, Cocteau derived a maximum of publicity from his reconversion to Catholicism. It was he who was the animator of the "Boeuf sur le toit"; but such unreined ambition led him to an impasse. I think it was at this time that he had the idea of becoming a painter. He arranged a show at the Quatre Chemins on rue Godot de Mauroy in Paris, where he exhibited many small compositions that, rather than paintings, were pictures made out of ribbons, cloth, paper, and pinned down with thumbtacks. He had, essentially, put the "collage" technique to use, with results similar to those of Picasso and of other Montmartre artists. These works were titled "Têtes aux punaises."** Unfortunately he had the poor idea of giving the following explanation in the catalogue: "A farmer finds the arms of the Venus de Milo in one of his fields. To whom do they belong? To the farmer or to the Venus de Milo?"

Clearly it was Picasso who was the primary butt of these pranks which were often very witty. Picasso was irritated because he knew who the owner of the Venus de Milo arms was; he was very angry about this affair

*Literally "steer on the roof." The phrase is a metaphor for a time of excesses.
**Heads with thumbtacks. "Punaises" = thumbtacks or fleas, hence the play on words.

and broke off his friendship with Cocteau for nearly ten years. Cocteau was never again received by him and was entered on Picasso's list of "pests." Perhaps these inventions by Cocteau were the launching point of the vulgarization of "collage" in Paris.

My dealer had never been enthusiastic about "collage" and had never purchased any of the examples that Braque and I had been assembling since 1912 (fig. 32). Both he and his brother, Paul, wanted real paintings, paints on canvas, as merchandise.

Léonce Rosenberg continued to hunt for original, innovative paintings, but for some unknown reason he, who was always an excellent connoisseur of pictorial quality, often allowed himself to be seduced, and bought works of scarce value; the gallery began to decline. His *Bulletin de L'Effort Moderne* published inadmissable things; despite this, his ideas about art were always intelligent. For example, he wrote such verities as: "He who is not an inventor does not deserve to be called an artist. One must beware of modernism to the same extent as academicism, for neither of them is capable of recognizing the beautiful or the divine in the spectacle before them, nor consequently, to free reality from appearances. Art is the transition from the natural to the marvelous."

His brother, Paul, claimed that paintings were not bought only out of infatuation, but also for reasons of narcissism and profit. He considered a canvas beautiful when it was saleable, and discovered painters when they already had reached notoriety and their works were already requested by a vast clientele. Paul Rosenberg was the real dealer; his brother, Léonce, with all his defects, was admirable by comparison.

One thing the Paris artworld found extremely surprising was the strange evolution of Léger's works. Everyone recalled his paintings from 1908 to the beginning of the war; the postwar works became figurative in a so-called caricatural sense. In the first place, it was immediately clear that they were willful and not products of intuition; they were large figures with big, round faces and inexpressive features, and were usually identical in all of these paintings. These were works suited to the decoration of carnival merry-go-rounds or, at best, the waiting rooms of out-of-the-way train stations. Whenever asked about the reasons for this transformation, he would reply frankly that he desired, at all costs, that his paintings be dominant over all others, even over masterpieces. Not only did he impose this viewpoint on Léonce Rosenberg, but also on many writers and critics, and with such skill that he succeeded in procuring himself a lasting importance.

Every pretext was a good one for Rosenberg to send us letters claiming

that rising living costs and heavier taxes were eliminating clients of average financial possibilities from the art market, and that the equilibrium between the supply and demand of paintings (as if they were shoes or stockings) would be shattered, and so on.

To keep production down (but this was more pertinent to others than to me), he decided to have us do ceramics, and immediately made each of us sign a contract. This idea remained in the planning stages, as did a proposal by Auguste Perret (suggested by me) to turn the Effort Moderne into a sort of artisans' center, in which a workingman's deep sense of fraternity would permeate and reunite the artists, motivating them to collaborate on vast commissions to decorate, furnish, etc. particular projects, mainly proposed by the government. Perret was to obtain State backing and contributions. Rosenberg accepted the project, but had little faith in government subsidies. He did not have much faith in frescoes either, and wrote me about them to the effect that, in his opinion, this technique did not wholly correspond to the needs of modern organization: "I believe, on the contrary that the following generation will try to express itself in substances solid enough to defy the passage of time. The modern world offers new, inexpensive durable materials, so why not use them?"

He was right, partially. But when in 1937 at the Paris Exposition, experiments along these lines were attempted, the results were not entirely satisfactory. So that plan, too, went up in smoke, and the Effort Moderne painters continued to paint their pictures, which Rosenberg had the contractual right to sell.

All the same, he got malicious pleasure from removing us from our regular lives and placing us in the bustle of financial affairs that were increasingly hostile to the arts. "The love of art—he once wrote me (and it must have been one of his confidential group letters)—is, unfortunately, *forever* dead; speculative placement or commercial transactions have replaced it. No one wants to buy paintings any more, no matter how beautiful they may be, unless they can be *resold universally*." He always kept us in a state of uncertainty, with his numerous letters and conversations of this sort.

To meet all eventualities, I had an idea that seemed brilliant at the time, but later was not so wonderful after all. I decided to open an academy. There were many such institutions in Montparnasse; Lhote taught a brief cycle of lessons on Cubism; Léger, in similar haste, taught his "stove pipes" (as his mischievous comrades called them). Why should I too not

teach students to do "pulcinellas" or guitars or vases, based on the Golden Mean?

Not possessing the small sum necessary to rent a studio in Paris, I consulted the young priest, abbé Sarraute, who had performed our wedding ceremony, and a few days later he announced that he had found me one. A gentleman wishing to remain anonymous would lend me one thousand francs; I could collect the sum from Jacques Maritain.

I barely knew that philosopher by name, and never imagined that one day I would know him personally. The ways of providence which lead us where we need to go are a mystery; however, it is a fact that each time I needed help, I always found the very person that the circumstances required. My encounter with Maritain marked an important point in my life. I went to Meudon immediately, and was received cordially and simply in a small parlor that reminded me of certain canvases by Degas. There were several people present, among them the writer Henri Ghéon; the philosopher's wife; a small, dark-haired woman with two immense eyes that radiated a formidably intense vitality. Jacques Maritain was a rather tall, thin man with a rebellious head of hair and two lively eyes not always entirely open, by choice. Cocteau says of him: "The wonderful thing about your glance is that it is pure and sagacious." It was very clear to me that I was being submitted to a thorough examination on the part of these intelligent, discerning men, and that my every word was significant to them.

As I always do when embarrassed, I launched into discussions with my eyes open, but as if they were shut, or as if talking to myself in an empty room; on the other hand, I deemed it correct for a man like Maritain and his friends to be thoroughly informed about my nature, unclothed and without ornamentation. I do not know if I made a good general impression, but it is certain that, as I was saying goodbye to Maritain at the front door, I read into his gaze, and felt inside, that it contained much more than simple cordiality. What is more, as I left, he put a book into my hands, saying: "Take a look at it when you have time." On the electric train that was taking me back to Paris, I looked at the little book with its horrible jacket of a drawing of "Saint-Sulpice"* caliber. Curious, I opened it and a few sentences read haphazardly sufficed for an immediate understanding that beneath its modest appearance, this book was a aggregate of intelligence and wisdom. In fact, Maritain had given me a first

*Works of art intended as souvenirs for the tourist trade.

edition of *Art et Scolastique*.[6] When finally able to dedicate full concentration to the reading of the book, I was amazed at the extent to which it agreed with the most modern goals, and at the profound sense of freedom, from what supreme heights of intelligence, the author could observe, put in order, and clarify, everything related to art.

For example, when he examines the various ways the idea of "integrity" can be manifested, or that of perfection or entirety, he says: "The absence of a head or arm is a very appreciable lack of completeness in a woman, and very unappreciable in a statue, despite the distress felt by Monsieur Ravaisson, unable to complete the Venus de Milo. A rough sketch by Leonardo or Rodin is more *finished* than the most exhaustive Bougereau. And if a Futurist decides to paint only one eye or a quarter of an eye in a portrait of a lady he is painting, no one should deny him his rights. One can only ask, and herein is the problem, that the quarter eye really be all of the aforementioned lady's eye necessary under the given circumstances."

Later Maritain told me that he had been thinking of one of my Futurist paintings while making that consideration, more specifically of the *Danseuse Obsédante*. He spoke of the painting with the same freedom of spirit that we painters did, that is, detached from any external limitations.

Maritain's and the scholastic philosophers' definition of beauty was the best and truest that any modern artist could espouse: "Splendor of form on the proportionate parts of matter." Considering art in this manner achieves an accord between *sensitivity* and *intelligence*; what life, emotion, and direct sensation could offer to art, could merge with that offered by sentiment, reason, the soul, and spirit of the artist.

Had the talent of certain artists not existed, first among these Picasso, all of Raynal's philosophical explanations would never have justified "subjectivism" on the basis of which a painting was fabricated according to "an idea of painting" and not according to "real and true painting"; similarly, had the talent of certain painters not existed, all the pompous Futurist manifestos would not have substantiated that pseudo-Bergsonian intuition that approached truth, but was not yet real truth.

I wrote in my book, *Arguments on the Figurative Arts**: "There must

[6]In the last and most recent edition (the third), this book was published in two volumes; the first preserved the title, *Art et Scolastique*, while the second was called *Frontières de la Poesie et autres Essais* (Paris: Louis Rouart et Fils Editeurs, 1935).

*G. Severini, *Ragionamenti sulle arti figurative*, 2nd ed. (Milan: U. Hoepli Editore, 1936).

be proportions between two terms in a work of art: subject and object, ordered according to a third term that is the opus. Thomistic philosophy allows us to concretize this Platonic proportion, for it is located halfway between specifically pictorial activity (that leads to art deprived of its contents) and the human quality that nourishes art."

Before my encounter with Thomistic philosophy through Maritain, I had almost reached the same conclusions through the logical development of my work, intuition, and thought, but what a great sense of joy I felt upon discovering, in Maritain, the confirmation of certain thought patterns, certain ways of clarifying these to myself and to others, and, what I considered most important, of discovering a friendship and human comprehension of the most profound sort. Later the formidable significance of *Art et Scolastique* became clear to everyone, as did the caliber of its author, the transparency and clarity of whose soul recalls the purest of rock crystals.

THE SEVERINI ATELIER

It was not easy to find an available studio in Paris. At that time, spare housing was very rare and the object of great speculation. I finally found one in Montmartre, in a sort of artists' village composed solely of studios. This village was located at 22 rue Tourlaque, near my friend Costa-Torro's department store. So I cancelled the contract for the little house in Nanterre and moved to that small, square box of a studio, one wall of which was glass. We arranged our room and the so-called household necessities in the loft, while the academy was located in the studio, downstairs. I sent out cards that read:

Atelier Severini.
Starting in November, courses on techniques of the pictorial arts according to Italian and Flemish traditions will be held on Mondays, Wednesdays, and Fridays, from 9 a.m. to noon.
The lessons will cover theory and practice, and will especially treat the media of fresco, gouache, and oil painting.

Various Americans, French, Russians, and one Swiss student signed up right away. I became great friends with the Swiss. His name was Fred Sulzer; he had a keen mind and was a learned man. Later, through my friendship with Maritain, I took a very nice student into my studio who

soon made a name for himself with the critics in Paris, who recognized his talent. Hernando Viñes was a nephew of the famous Spanish violincellist, Riccardo Viñes. Together with Cossio and Borés, he later initiated a neo-Fauve movement that *Cahiers d'Art* actively promoted. When Viñes came to me he was very young, but already showed a highly refined pictorial sensitivity.

My academy fared rather well. I began a small still life with my students, starting out with a simple, but correct geometric outline. We then painted it in gouaches, and afterwards varnished it, and finished it off with thin layers of oil paints. The best canvas was done by a young Russian girl who brought an ingenuity and freshness to the subject and to the interpretation of forms that recalled the primitives. Although things progressed well, after fifteen days I realized that I was not cut out to be a classroom teacher and that my own, personal work was seriously impeded by the presence of extraneous individuals. In fact, that month I was only able to give Rosenberg one little painting. So, for the next fifteen days I taught my students to do several gouaches, had them try their hand at frescoes, and, then, at the end of the month, closed the academy. My experience had been a failure, but returning to Paris was advantageous to me for various reasons, particularly because I constantly received interesting visits.

CONSTRUCTIVISM AND SUPREMATISM

One day, sent by Maritain, the Swiss painter Alexandre Cingria (brother of Charles-Albert, Max Jacob's friend), came to see me. He told me that there was a lot of interest in mural painting in Switzerland and that often churches there requested important decorations. The same day that Cingria was in my studio, I also received a visit from a young Russian painter, Ivan Puni, accompanied by his very pleasant, spirited wife. He had come directly from Russia and brought me a review (written in Russian, but printed in Berlin), full of reproductions of very modern works of art, four of which were my own. Puni pointed out that this just went to show how much I was respected in the art world in his country. I liked Ivan Puni and his wife very much: he was a small fellow, reserved, prudent, and precise in his choice of words; she very lively and expansive. We were very glad to have direct news from Russia; I was concerned about the treatment of the artists there by the new revolutionary regime.

It must be acknowledged that the Russian revolution was viewed favorably, especially in Paris intellectual circles. On the other hand, Russian intellectuals, according to Puni, opposed the new government which had tried to conquer the young, in particular, with every possible means. Museums had been founded, clubs, schools that opened their doors to everyone, where modern art, in particular, was taught. In fact, the review that Puni brought contained works only of the extreme avant-garde. All the Paris painters and sculptors of any worth were represented, and among these, several Russians, but Picasso and I were even more extensively represented.

Evidently Russian revolutionary art was oriented strongly toward daring, modern trends. Of the modern art already extant and that still being produced in Paris, the Russians were particularly influenced by several 1912–13 works in which Picasso and I had applied various materials such as paper, cardboard, cloth, metal, etc., to our canvases. These applications, Puni explained, had a more absolute value for the Russians. They had an extraordinary cultish attraction, a sort of fetishism, for these "real materials."

Russian Constructivism stemmed from that exclusive use of "real materials"; it later became a theory and was applied not only to theatrical sets (as in the plays at the Kamerny Theater), but to an entire concept of art considered modern. However, more than a movement in the plastic arts, especially after 1917 and even more clearly in 1920, it was a social movement influenced by Marxism. Constructivist theory aimed at suppressing the idea of the canvas, as this represented the psychology of the middle-class person that would buy it. The picture was to be replaced by objects made of various materials which had been treated almost mechanically, with techniques resembling those of industry, and representing the proletarian psychology. Such were the principles proposed to create an art of the proletariat.

Puni himself criticized these ideas, observing that even an "object" made out of various materials is never the result of an entirely mechanical process, and that it, too, requires collaboration with the intellect. Besides, an artistically valid painting is also an "object," and one of the Parisian painters' primary goals had been to consider works, above all, "objects."

Were one to exclude socially oriented literature saturated with certain ideas, the rest would depict a sort of reaction to subjective art, an art intended as an end in itself, a reaction comparable to the one taking place in Paris. The Russian Constructivists, however, carried this reac-

tion to the point of suppressing the metaphysical sense of art that must be retained.

Evidently it was necessary to account for the particular revolutionary moment that those artists were undergoing and to retain the "constructive" side, not the "reactionary" side of certain ideas, in the hope that things would sort themselves out, later. In fact, Puni himself told me: "You know, intuition is always the mainstay of Russian art which, thanks to its logical nature, has essentially failed to discover anything new." So, everything depended on clarifying those ideas and putting them in proper order, on viewing them with a free spirit and without the filters of reaction or prejudice. With that in mind, I immediately asked Puni: "Can the object fabricated out of various materials, according to Constructivist demand, be useful?" He replied frankly that these were perfectly useless. "Then [I added] after having produced a reaction to *art-as-a-game*, or art as an end in itself, we're back at the beginning again, at an art which is even more of a game, even more useless." This was the key to my idea; in my opinion it was not a question of making an object out of one material or another; the fact that it was fabricated out of cardboard, or metal, or cloth, or simply painted, did not matter. The important thing was to have a clear idea of this object in light of one's intentions each time: do I want a *beautiful* object, or a *useful* one, or a *useful* and *beautiful* object? And what does each type of object mean?

Certain things cannot be discussed as if one were a mason or a carpenter, albeit intelligent, but as, for example, Baudelaire[7] would discuss them, ferrying us back to the fundamental principles of cause and effect. Everything becomes clear at that point. For example, the purpose of an automobile is its *driveability* and *comfort*. However, the fact of having perfectly accomplished those goals does not make a car automatically *beautiful*, as claimed by certain moderns such as Le Corbusier from an architect's point of view, or Léger as a painter, etc. If it has taken more than thirty years for an automobile to become a beautiful object, this is thanks to the design engineer who finally decided to imprint the material with a certain *beauty*. He intended to confer two distinct forms of perfection on the material in question: *beauty* and *utility*. It is clear then, that an object can be *useful* and, at the same time, *beautiful*; the problem lies in not confusing these two perfections.[8] The fabrication of a useless ob-

[7] I have chosen Baudelaire whose capabilities are known to everyone and can therefore be acceptable to everyone.

[8] Later, after the 1925 decorative arts show, a society was founded in Paris called the Union of Modern Artists (UAM). Members of this society were architects, engineers, sculp-

ject without the minimum intention of making it beautiful, such as the material object of the Constructivists, is obviously nonsensical.

Another misunderstanding that needed rectification, according to Puni's account, was that of eliminating art from human life, as an element no longer necessary. Art, as such, is subordinated to *beauty*. Can we do without beauty? "The need for beauty is greater than it might seem," says Léger with reason, when being coherent with himself.[9] But here, too, we must be precise. If it is a question of beauty imposed from the exterior, by culture, by an ideology, or by any external idea (and therefore a fabricated and imbalmed sort of beauty), then of course it must be eliminated.

The kind of beauty in which we believe is scattered throughout the world, and it is the artist's mission to express it by expressing himself. What meaning would history have without such expression? Without Greek sculpture, architecture, and poetry, would we have such a great respect for Greece and its civilization? Can a civilization without art also exist? How important would it be? The arts are the yardstick of human civilization.

If a return to a sort of barbarian state is considered necessary, where everything is thrown down the drain and started again from scratch (an idea that can obviously be claimed), then why bother with so many useless debates, and why not face the new problem directly? Such words as these would suffice: "We are at the beginning of a new era in which there is no room for art; either it disappears from the face of the earth or it assumes new forms."

I once thought, for example, that painting might disappear, to be replaced by multi-colored fireworks shot into a dark, night sky, or else by clusters of lightbulbs and electric sign-writing, like some of those magnificent luminous constructions on Parisian rooftops, on the Eiffel Tower, or in any large city. This, too, was an admissible idea; but I now think differently. Here, too, it is not a question of the colored materials with which the artist expresses himself; whether fireworks or electric lights or postcards and metals or simply colors on a canvas, it makes no difference.

tors, interior decorators, lighting technicians, glass technicians, and a few painters, of which I was one. It was a very intelligent, constructive, free society, the seat of which served to discuss such problems as these in serene surroundings.

[9]Rosenberg published a small illustrated review in 1924, the *Bulletin de l'Effort Moderne*, open to the most dissimilar of values. In the 1st and 2nd issues Léger published the article, "L'Estétique de la Machine"; and I published one in the 7th and 8th issues, titled "Vers une Synthèse Esthéthique. Finalité de l'Art."

That is not the problem. It is a matter of imprinting a form of our times upon beauty, even when the threat of enduring a barbaric period is real.

Being of one's own times, as Courbet said, and tolerating all of its annoyances, at the same time also understanding its virtues, is what is demanded of us. "The only thing required of artists is that they not be weak," says Jacques Maritain; the only thing required is to avoid being consumed by contingencies, by ideologies, by changes in one's exterior life, and, instead, to dominate and assimilate these. That is what should be done, for example, with *machines*, that the Futurists first, and later the Constructivists, elevated to the ranks of a *religion*, of mysticism.

How can man have "faith" in something he, himself, has fabricated, and for that reason is *inferior* to him? *In any case a machine is a lesser entity than a man.* Even if we accept the materialistic principle according to which man is made of the same matter as steel, the fact remains that steel, without man's intelligence, would never become a machine, and would be eternally immobile. Belief in the progress of material means and in scientific technology (which change, it is true, the conditions and psychology of material life) as capable of changing even spirituality, the substance of art, is a profound error. Spirituality is on a higher plane than psychology and, originating in the depths of one's "being," cannot be corroded by conditions of exterior life. So once again, clearly, modernity does not come from the adoration of machines and from copying machinery, and adhesion to one's own times is not grounded in an exterior, pedestrian conformity to the various systems of social life, which are necessarily contingent and transitory.[10]

Puni also told me that, contrary to the ideas of the Constructivists and their mysticism concerning machinery, there was another avant-garde trend in Russia. This aimed toward an object-free art, a "pure creation" independent of visual reality and of all other established criteria. "Means" of Cubist expression were grafted on to principles of Futurist plastic dynamism, as for example in works of Carrà and Boccioni; this form of art was called "Suprematism" and its most representative painter was Malevich.

It seems to me that this tendency had many similarities to 1912–16 Futurist painting, both in its intentions of rhythmic, dynamic lyricism,

[10]I have only grazed the surface of these subjects here, treating them as if they were topics of after-dinner conversation, but they deserve fuller development. Perhaps the right occasion will arise as I continue my story.

as well as in its use of "Cubist means" to express them. Puni was somewhat reluctant to admit this. Then I remembered that the painter Larionov, too, had talked about Futurism in unclear terms and with many reservations at the time of a visit to my studio in 1916. He liked my work very much, however, and proved this by buying a small painting from me. Nevertheless, filtering through his reticence was a feeling that in Russia artists had been more futurist than the Futurists and prior to the Futurists. He was unable to explain to me the intended aims of the Russians.

All of this was and is only relatively important. Nevertheless, to set things right from a historical point of view, it must be acknowledged that Marinetti went to Russia the first time in 1910 and made a deep impression on the Russians, especially on the poets, who then created Russian Futurism. It is impossible to deny that this movement of revolt against the past and of ardent aspirations toward forms of art more correspondent to modern times, was mainly provoked by Marinetti's early conferences held in Moscow and St. Petersburg. During his second trip there, in 1914, he found the artworld divided into two currents: one that accepted him as an innovator, and one that rejected him. The painter Larionov, who was part of the "Donkey's tail" group of Futurists, belonged to this second category. Moreover, he participated actively in an argument with Tasteven who wanted to receive Marinetti with bouquets of flowers, while Larionov wanted to throw rotten eggs at him. Larionov and the woman painter Gontcharova, his pleasant companion, had carefully avoided telling me these things.

Raising questions of priority, even going so far as to falsify publication dates (as the "Guilée" group of Russian Futurists had done), seems puerile and dishonest to me. It is more intelligent and more to the point to say, as Mayakovsky later wrote,[11] that Futurism, as a general trend (an intellectual attitude, as I see it) had different effects in Russia than in Italy, all of which is perfectly natural: effects subject to the Russian language, to Russian history, and to the creative, spiritual capacities of the Russians. But it is true that "hermetic futurism," as the Russians themselves called the period that preceded the revolution, according to Mayakovsky and to

[11]The letter in which Mayakovsky more or less says these things was written on 15 February 1914 and was signed by Bulgakov and Cherchenièvitch, though its sole author had been Mayakovsky. This information has been supplied to me by a doctoral thesis titled "De Marinetti à Mayakovsky" presented at the University of Fribourg (Switzerland) by its author, Graziella Lehrmann.

others, was the twin of that Suprematism of the painters discussed at my studio. While we conversed about such problems with the Puni couple and with Cingria, it occurred to me how right Apollinaire had been to see in Futurism a sort of fermenting and radioactive potential that, had greater intelligence been employed, would have produced better results.

But back to the Russian painters. From what Puni had said, in Russia then, in 1924, there were two principle currents that sometimes complemented and at other times opposed one another; that is fine and agrees with history. Basically we were in perfect correspondence in our desire to emphasize the artisanal, craftsmanship aspect of art which did not exclude true art itself. In other words, to modify life's system, simplify it, guide it toward a sort of workingman's brotherhood, out of which that inner and outer unity, so desired and necessary, could emerge. Working solely on commission, as in medieval times, is also possible, on the condition that the creative act is absolutely free, for it has inherent written laws and cannot be externally controlled by anyone. The state of human life today, though, is not what it was in the Middle Ages.

I had already had a brief experience of that sort of artisan laborer's life in Montegufoni; during the seven months of my work there I had an excellent relationship with my worker-assistants (masons, house painters, carpenters). As a peer among workmen (but in the hierarchy I was in the commanding position), on our work-site and confronted with the job to be done, we were all equals. This is one of the best grounds for social equality. Men who do the same work understand one another without long explanations and their birthplaces or the languages they speak are unimportant.

Could these "considerations" be examined by employers, by the leaders of peoples whose activities they regulate, everything would be splendid. But who among them is "integrally" revolutionary enough to realize that a small still life can better conform to their ideology and better serve it than a big painting of a conformist subject, inexistent as far as artistic merit is concerned?

Is there anything more academic than the art of the French Revolution? The art of the French Revolution was not David's neo-classicism, but Impressionism, a century later.

To understand such things, one must be an entirely *new* man, *free* from all prejudice, as only an artist can be, but not always is. Instead, men in general are prone to renewing only one part of themselves and, as the Swiss writer Ramuz says, the other part automatically obeys old habits and conventions. Under this light we see the great theoreticians of revolu-

tions, the organizers of society, living on two planes, so to speak: one revolutionary and one conservative. Unfortunately and almost always, they look upon artistic activity from the second of these perspectives.[12]

The Punis, especially the wife, recounted various amusing episodes of the so-called commande sociale, or governmental commissioning of a given work. With her devilish *verve*, Mrs. Puni told us how, all of a sudden, they had been chosen to paint propagandist subjects on the rooftops of Moscow, and to stroll through the streets of the city as human billboards covered with Constructivist compositions aimed at advertising and propagandizing. Basically, they had not complained at all, but understandably, at a certain point, they must have reached their fill of "commandes sociales," and, in fact, as soon as they were able, came back to Paris and took up permanent residence. Chagall had the same experience. He held an important and interesting job with the Soviet Republic, but he had to leave, it was said later, because "the wheels were never round enough."

THE DEATH OF MY FATHER—AN IMPORTANT DECISION

It was around this time, or shortly thereafter, that I received another important, pleasant visit. The famous choreographer, Léonide Massine, whom I had met in 1917 in Paris with the Ballets Russes, came from London to compose a ballet for which I was to do the sets, and Auric, the music.

He had met the two Sitwell poets, who naturally had told him about my frescoes in Montegufoni. We then composed a ballet, whose subject was based on those frescoes and on the commedia dell'arte tradition. Not only did we use many of the commedia masks as characters, but we also added the two young English poets, their father, Masti the caretaker, and many classical roles such as Indolence, Lust, Pride, Ire, etc.

[12]Puni, the painter, had informed me about the state of Russian art in 1924. Many Russian artists that I knew, living in Paris, glorified modern Russian art at that time. But the Russian pavilion at the Universal Exposition in Paris, in 1937, was a great disillusionment to everyone. There was not a trace of the Constructivists or the Suprematists, only the basest sort of illustrational art, the most vulgar sort of pictorialism. What had happened to the figurative arts in Russia? André Gide, a trustworthy witness from all viewpoints, gives quite a clear account of it. [See A. Gide, *Retour de l'U.R.S.S.*, Paris, 1936.]

Combined with Massine's lavish imagination, the ballet would have
been wonderful. The title we chose, *Coucourroucou*, was taken from
J. Callot's *Balli di Sfessania*, the principal source of inspiration for the
ballet.

The Count of Beaumont organized a series of theater soirées at the
Cigale. We were to convene at his place, to make our decisions definitive.
But it was "written in the books" that even this second time (the first time
it had been Rosenberg to abort the project), I was not to collaborate with
Massine.

I was busy painting the canvas, *Giocatori di Carte* just then, a painting
that later went to the Frederic Clay Bartlett Collection in Chicago.* I had
decided on a replica of Cézanne's card players, according to my geometric
"means" of composition. Instead of using peasant men, my characters
were two sailors, a Pulcinella and a Harlequin. The painting was coming
along well; as usual, I had prepared it in gouache, with the help of Viñes.
But one morning, while working on the section of sea visible through the
window behind the card players, a letter for me arrived to upset and
destroy my serenity. My mother, in simple, moving words, informed me
that my father had died suddenly in Pienza, where he had gone on busi-
ness matters. The letter had been written three days after the funeral, so it
was not necessary, or in any case not urgent, that I leave for Italy.

After having read the letter I would have preferred to demonstrate
strength and continue working, but pain suffused my being more and
more deeply, leaving me unaware of its force. I was obliged to beg Viñes to
leave, and had to stop working. That evening my lung ailment began
again; it was a light relapse, but enough to keep me away from my easel
for a certain length of time. So when Massine made the appointment for
us to see the Count of Beaumont to decide about our ballet, I was unable
to attend and had to give up that project. Luckily, my recent friendship
with Maritain offered me the moral support that I needed, in these
grievous circumstances. Even Doctor Allendy, with whom I had made
friends, was generous with his support and medical knowledge. A
painter's greatest opportunity for evading real life is furnished by his own
work; so little by little, I went back to my canvas and continued, cau-
tiously, to paint.

After having terminated the *Giocatori di Carte*, I longed to paint a
larger canvas, focused on a single character. Using geometric block trac-

The Card Players, now in the collection of the Galleria dello Scudo, Verona, Italy.

ings and real-life studies, I invented a handsome Pulcinella holding a guitar.*

When the life-size charcoal study was completed, Rosenberg came to the studio; he had not been there for some time, but had called on the telephone and above all, unfortunately, had written to me. In his most recent letter he had advised me not to abandon the commedia dell'arte subjects in which, he said, "you are excellent and are achieving the success that little by little will make your reputation."

He used the example of Watteau, who had limited his works within the bounds of well-determined subject matter. "Anyway [he added] when a painter is very experienced with a subject, he ends up treating it with such mastery that his works become great art." His final theme was this: "When the public is used to a certain aspect, it has a hard time recognizing its beloved painter in another." I was very fond of the commedia dell'arte characters, but all of these arguments were enough to make me hate them. Thus, the quarrel that exploded between us had already been prepared, before he even set foot in my studio.

I remember well that Rosenberg began by profusely complimenting me for my latest paintings, all of which had been sold and engendered favor with collectors. He told me that I was the best-selling painter in the gallery, while he was unable to sell even one Léger; but the business he conducted with my paintings allowed him to shoulder the situation with Léger.

Having sold all or almost all of my works, there was no more talk of holding my one-man show which had originally been set for April 26 through May 19, 1923. It was now 1924 and there was no likelihood of it on the horizon, while for Léger and others the gallery continually held exhibitions. According to Rosenberg's own accounts, this was the second time that my paintings had kept the gallery's head above water. By that time I was aware of the meaning of my dealer's maneuvers: he tried to sell and ship the works of the less-favored painters far from Paris and from France, to put reserves on and raise the prices of the favored and, if possible, national artists. In that sort of dealers' trickery, the intrinsic value of the works themselves does not matter in the least. I realized then, and what followed confirmed my impression, that I was being sacrificed to ends to which I was entirely extraneous.

*Pierrot Musicien, now in the Boymans-van-Beuningen Museum, Rotterdam, Holland. The charcoal drawing for this painting is in the Stichting Hannema-De Stuers Fondatie Museum, Heino, Holland.

What brought my resentment to a head was that he liked the drawing of the large Pulcinella very much, but claimed that it would be better to cut off a piece of the composition, below the knees, or else the painting would be too large and too difficult to sell. Subsequently, there was an ugly exchange of words between us, but the most important thing was that, at that very moment, I made a decision that probably influenced the rest of my life.

When, slightly earlier, Cingria had come to see me on behalf of Maritain, he had told me about a church that a young architect was constructing in Switzerland, in the Fribourg Canton. A competition was to be held to determine the author of the decoration of this church and, a short while later, Cingria had written advising me to participate. I have always regarded that sort of contest with repugnance, so I said neither yes nor no; but Rosenberg's words and attitude made me decide to send my participation (at the very last minute).

The required sketches were a mere child's play for me: a Crucifix to be painted in "sandstone" tiles, to be placed above the entrance door of the church. I sent in the sketches and won the competition. I was then invited to Fribourg to discuss the project with the architect. So I left Viñes to prepare the large Pulcinella gouache, and departed for Fribourg. At my own risk, I was soon to undertake a serious collective, social experience in the mural arts, essentially in the role of manual laborer.

Index

THE PRESENT VOLUME brings together the two most important and complete of Gino Severini's autobiographical works. Over the many years that I have been a member by marriage of the artist's family, I have received frequent requests to make these books available to an English-speaking audience but, had Jeanne Fort Severini not suggested the undertaking to me and personally supported it, I might not have seen it through to publication. I regret that she did not live to see it in print.

It is possible that the original title of the first volume of memoirs, *Tutta la vita di un pittore, Volume Primo, Roma-Parigi*, published in 1946 by Garzanti, echoes the memoirs of Paul Fort, Poet Laureate of France, *Mes Mémoires, Toute la Vie d'un Poète 1872-1943*. I suspect that Severini used this title in the first edition as a symbolic wink of complicity toward Fort, his father-in-law, for the subsequent edition of Severini's book was titled simply *La vita di un pittore* (Edizioni di Comunità, Milano, 1965). The third edition, published by Feltrinelli in 1983, retained the second title but included Severini's second autobiographical volume, *Tempo de l'Effort Moderne*, first published by Enrico Vallecchi in Florence in 1968. In the present translation I have followed the Feltrinelli formula in which both parts appear together, but I have consulted all published versions of the books as well as the author's own annotated copy of the Garzanti edition and his original longhand manuscript.

Severini left Italy at an early age, attracted by Seurat and the artistic activity in Paris to which his teacher in Rome, Giacomo Balla, had introduced him. Well versed in Tuscan Renaissance traditions, he was drawn by new ideas and friends into the currents of what we now regard as the vanguard of all modern art. The past few decades have witnessed a rebirth of interest in Futurism and Cubism, especially in English-speaking countries. Severini, whose circle included the influential poets, writers, and critics of the day, was the liaison between the original Futurist school and all the other stylistic trends that emerged in Paris in the wake of Cubism. Besides being one of the five original founders of the Futurist movement, he was "largely responsible for the return of the Cubists to

clear bright colors" (see Gino Severini, *The Artist and Society*, trans. Bernard Wall, Harvill Press: London, 1946).

The translator and publisher wish to thank all those who made this volume possible, but especially Gina Severini Franchina and Romana Severini Brunori.